BARBRA

BARBRA

The Way She Is

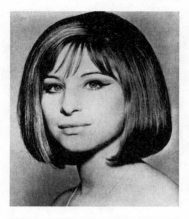

Christopher Andersen

ᵂᵐ

WILLIAM MORROW

An Imprint of HarperCollins*Publishers*

Grateful acknowledgment is made to the following for permission to reprint the photographs in this book:

Alpha/Globe Photos: 52, 53, 58
AP/Wide World: 1, 14, 16, 17, 23, 25, 28, 29, 32, 42, 62
John Barrett/Globe Photos: 50, 51, 61
Judie Burstein/Photoreporters/Globe Photos: 48
Nate Cutler/Globe Photos: 45
Barry Dennen: 9, 10
Getty Images: 13, 19, 20, 21, 24, 64
Globe Photos: 11, 12, 15, 18, 22, 26, 30, 31, 33, 34, 35, 36, 37, 38, 40, 41, 43, 46, 47, 65, 66

James M. Kelly/Globe Photos: 57
Barry King/IPOL/Globe Photos: 49
Si Litvinoff: 5, 6, 7, 8
MG/JB/Globe Photos: 55, 56
Arthur Pollock: 59, 60
Phil Roach/IPOL/Globe Photos: 39
Lisa Rose/Globe Photos: 63
Steve Schatzberg/Globe Photos: 44
Adam Scull/Globe Photos: 54
Irv Steinberg/Globe Photos: 27

HarperCollins books may be purchased for educational, business, or sales promotional use. For information please write: Special Markets Department, HarperCollins Publishers, 10 East 53rd Street, New York, NY 10022.

FIRST EDITION

Designed by Jo Anne Metsch

Printed on acid-free paper

Library of Congress Cataloging-in-Publication Data

Andersen, Christopher P.
 Barbra: the way she is/Christopher Andersen.— 1st ed.
 p. cm.
 ISBN-13: 978-0-06-056256-4 (alk. paper)
 ISBN-10: 0-06-056256-0
 1. Streisand, Barbra. 2. Singers—United States—Biography. I. Title.

ML420.S915A67 2006
782.42164092—dc22
[B] 2005058389

06 07 08 09 10 WBC/RRD 10 9 8 7 6 5 4 3 2 1

For my own funny girl, Valerie

I always knew I'd be famous.
I knew it. I wanted it.

PREFACE

She is a one-name legend, a global icon, the ultimate diva—one of the most beloved and detested, worshiped and feared, admired and reviled figures of the age. The word *superstar* was invented to describe her, and she remains the very definition of the word today.

Yet most of what we know about Barbra Joan Streisand is the stuff of caricature: the Brooklyn goil-made-good, the ugly duckling who blossomed into a modern-day Nefertiti, the brash upstart accepting an Oscar in see-through evening pajamas, the political dilettante driving to the barricades in her Rolls-Royce, the Hollywood powerhouse capable of turning her hairdresser boyfriend into a bona fide movie mogul, the greatest female interpreter of popular songs who ever lived, a skinflint, a philanthropist, a connoisseur and a boor, the woman whose physical characteristics were instantly identifiable around the planet—the tapered nails, those slightly crossed eyes, that nose, the *voice*.

Long ago she achieved the vaunted status of a one-name legend, and with good reason. Her life and career are described almost exclusively in superlatives. She is, according to a Reuters poll, simply the greatest female singer of the twentieth century (Frank Sinatra was deemed the greatest male singer). With over thirty platinum albums, thirteen multiplatinum albums, and fifty gold albums, she is second only to Elvis in record sales—and ahead of such groups as the Beatles and the Rolling Stones. Barbra is also the only artist, male or female, to boast number one records spanning four decades—the 1960s, 1970s, 1980s, and the 1990s. She is the only

artist to have won the Academy Award (twice), the Tony, the Emmy, the Grammy, the Golden Globe, the People's Choice Award, the Peabody, *and* the American Film Institute's Life Achievement Award. Moreover, Streisand has proven herself not only as "an actress who sings," as she puts it, but also as a director, a producer, a songwriter, a collector, a businesswoman, and a political activist.

With such unparalleled accomplishments comes unparalleled speculation—about her Callas-size ego and the awe-inspiring temperament that goes with it, about her many failed love affairs, her unbridled ambition, her fiery politics, her cringe-making tantrums, her relationship with one president and her vendetta against another, and her unfortunate habit—so common among those who claw their way to the top and stay there—of using people and then discarding them.

Whether she's a bulldozer or a whirlwind, Barbra stirs passions with her talent and a mystique she tends as carefully as her roses. Even to the multitudes around the world who idolize her, Streisand remains aloof, unknowable, tantalizingly just beyond reach. To understand the woman behind the voice is to realize that, whether you love her, hate her, or are simply spellbound by her titanic talent, Barbra is one thing above all others—a true American original.

In all the years I've known Barbra, I've seen her happy,
but always with a cloud. This time, it was a clear blue sky.

—Marilyn Bergman,
Oscar-winning songwriter and friend

Beneath that world-famous icon, there's a little girl.

—Linda Thompson, friend

I feel like a princess.
I'm a bride for the first time, with a bouquet,
the whole schmeer.

1

—

W hat?" Barbra Streisand blurted into the phone, her voice hovering somewhere between anguish and resignation. "So he'll be in China?" She had given concerts that raised millions for him and his party, despite paralyzing stage fright and her own abiding fear that someday she would be assassinated onstage. She had defended him against charges that now threatened to topple his presidency. She had not put up a fight when Hillary Clinton, furious that Streisand had been an overnight guest of her husband's at the White House while the First Lady was at her dying father's bedside in Arkansas, reportedly banned Barbra from staying at the Executive Mansion. And while speculation ran rampant about the true nature of her relationship with the President, Streisand gallantly held her tongue. She had even befriended his mother, and consoled him following her death from breast cancer in 1994.

After all Barbra had done for him—and had been through with him—Bill Clinton had no intention of altering the dates of his nine-day visit to China so that he could attend her wedding to James Brolin. Nor was there any point in postponing the ceremony in hopes of catching Clinton on his way back from China; the President was simply "unavailable."

It came as less of a surprise that Hillary, who had always been suspicious of Barbra's motives in cozying up to Bill, also turned down the invitation. As it happened, both the First Lady and First Daughter Chelsea Clinton would also be heading for China at the end of June 1998. There was one Clinton who would be attending Bar-

bra's wedding: Bill's little brother Roger, a failed rocker who once did prison time for selling cocaine.

"She was disappointed, of course," said an Arkansas friend of the Clintons, "but I think she understood that there was no way Bill could postpone that trip to China, even for her."

Barbra was not about to complain directly to the President. She had other ways of coping with disappointment; she took her frustrations out on the hired help—and, whenever possible, on the press.

July 1, 1998
Malibu

A squadron of press helicopters churned high above Malibu's Point Dume, the din from their rotors competing with the relentless banshee shriek of White Zombie's "Thunder Kiss 65." It was not enough that reporters were held back by barricades fifty yards down the road from the sprawling Mediterranean-style estate. On Barbra's orders, a large black van equipped with gigantic speakers was parked within a few feet of the barricades, blasting heavy metal so that it was virtually impossible for television reporters to file their stories. Neighbors seethed, but no matter: The black van was parked far enough away so as not to disturb the mistress of the house, or her guests.

"Can they do this?" she had pleaded to anyone who would listen. "Can they fly over my house like that and take pictures of my goddamned *wedding*?" Legally, reporters were well within their rights to do so—as long as the helicopters did not descend below what was considered a safe altitude of five hundred feet.

Still, Streisand publicist Dick Guttman had warned them to keep their distance so "sacred vows can be heard." Since the press was not about to comply, Barbra decided the earsplitting White Zombie counterattack was her only recourse. While hapless reporters shouted into their microphones, straining to be heard over the mayhem outside, beefy, grim-faced security guards in dark suits and sunglasses manned the front entrance of Streisand's estate, matching names to lists, checking badges, and muttering into walkie-talkies. They were

just part of the sixty-member security force hired to police the property as if it were a U.S. embassy under siege.

Behind the walls of the embattled compound, another, even larger army of floral arrangers, musicians, bartenders, cooks, busboys, waitresses, handymen, and parking valets scurried about as they prepared to man their posts. At the center of it all, the tiny figure in bathrobe and slippers strode purposefully down one of the brick walkways that snaked across the grounds, trailing a hand-wringing cadre of caterers and gardeners in her wake. It had been two years to the day since she first met veteran television star James Brolin, and Barbra Streisand wanted nothing less for their wedding than she wanted for every other project she undertook: perfection.

While she had played the part—most memorably as Fannie Brice camping it up onstage during the pregnant-bride sequence in *Funny Girl* ("I am the beautiful reflection of my love's affection . . .")— Barbra had never had a real wedding of her own. Her 1963 marriage to actor Elliott Gould had been performed by a justice of the peace in Carson City, Nevada. This time, Brolin, fully aware that his fiancée had felt cheated, was urging Barbra to pull out the stops. The groom's disarming naïveté notwithstanding, Barbra was more sensitive to the perception of any fifty-six-year-old woman—much less one of the world's most famous, wealthy, and powerful ones— trying to play the blushing bride. It was a daunting assignment, but one that Barbra believed she could pull off. There was only one requirement: that everyone do *exactly* what she told them to do.

Control. It was the one thing Barbra Streisand had sought to assert, with varying degrees of success, in every facet of her life. Control over her art and, by extension, over her career—over the music she recorded, the movies she made, the concerts she gave. Control over her fortune—now estimated at more than $120 million—and total command of all that that entailed: the details of every clause in every contract, of every share of stock purchased, of every acre acquired, of every dollar doled out to charity. Control of her environment, right down to the subtle gradations of color in the roses grown at her sprawling Malibu estate. Control over her own psyche, though after more than thirty years of therapy, that seemed as elusive as ever. Control over her spirituality, rooted in Judaism and a yearning to connect with a father she never knew.

Barbra even strove to assert control in the realms of politics and national policy—or at least as much of it as she could acquire through the judicious application of her talent and fame. As the country's single most important celebrity fund-raiser, she had the ear of every Democrat from the president of the United States on down.

When it came to her romantic life, however, Barbra seemed to be anything but in control. After her marriage to Elliott Gould ended in divorce in 1971, Streisand careened from one failed affair to another—some lasting years, others a matter of days—until finally admitting to herself in 1996 that her love life was probably over. "I was liking my solitude," she said. "Maybe a relationship was something I could never have—and that was okay."

After two failed marriages of his own, James Brolin was pretty much resigned to the same thing. "All I needed was the newspaper, a great cup of coffee, and a view of the ocean," said the ruggedly handsome fifty-eight-year-old actor. "For the first time I wasn't worrying about when I was going to find someone who made me complete."

It was at this point, when neither was looking for romance, that they found it. "Within two minutes" after he was seated next to Barbra at a dinner party, Brolin recalled, "I was totally infatuated." Before long, he was calling her "Beezer"—the rough slang equivalent of "schnoz"—and, incredibly, a smitten Streisand embraced her unkind-seeming new nickname.

Over the course of their two-year courtship, she had undergone a major transformation. According to friends, Barbra was less prone to the soul-destroying lows and the manic highs; the awe-shucks, laid-back lover had made her more mellow, more serene.

Maybe not so serene today—just four hours before her wedding. To be sure, for someone whose tantrums and demands were the stuff of legend, Barbra seemed remarkably sane. But that didn't mean that Streisand, who often said that she welcomed anxiety as a constant companion, was entirely immune to prewedding jitters. Like every other bride, she had agonized over the guest list, over the vows, over the flowers and the lighting and the food and the music. And like every other bride, she had the capacity to strike terror in the heart of anyone who, either by design or through incompetence, might do anything to spoil her perfect day.

Her instructions had been characteristically precise, and no one—*no one*—paid closer attention to detail. Nevertheless, there had been a minor slipup or two—the kinds of mistakes that at other, more lonely, more desperate times could easily have ignited a tantrum or resulted in a summary dismissal. "What's this?" Barbra had asked a startled waiter, plucking a bottle of San Pellegrino mineral water from a crate and holding it up to his face.

"Water?" the young man answered quizzically.

"*Perrier.* Not Pellegrino. I was very clear on that," Barbra said. "I want Perrier. *Now.*"

Periodically, Streisand would stop to peer at the reporters outside her gates, milling about even as White Zombie boomed from the unmarked black van. Her plan to foil the press, or at least to keep it at arm's length just this once, seemed to be working.

Barbra took no small satisfaction in this; she had wanted to be married in her magnificent garden, where the species of rose named after her bloomed in abundance, but the press helicopters had made that impossible. She had no desire to stage a replay of Madonna's 1985 Malibu wedding to Sean Penn, when the frustrated groom fired several shots at press helicopters before scrawling a defiant FUCK YOU on the beach in letters twenty feet high.

This wedding would have to be conducted away from the prying lens of the paparazzi, in Barbra's living room beneath a chuppah, the ceremonial Jewish canopy. But at the last minute, Streisand canceled plans for the chuppah. Worried that somehow the press would be able to photograph the whole thing through the living room's ten-foot-wide picture window, Barbra instead ordered Hollywood florist David Mark to fashion a visual barrier out of amaranthus, smilax, blooming stephanotis vines, ivy, gardenias, plumosa fern, and eucalyptus.

"Great," Barbra declared triumphantly as she assayed the florists' handiwork. "Nobody's gonna be able to take a picture through *that.*"

Mark's ten designers, who had arrived at the house in four flower-crammed vans just before dawn, also had their hands full decorating the ocean-view pool with pink water lilies and floating candles, not to mention entwining the banisters of the front staircase—the staircase down which the bride was to make her dramatic entrance—with 750 red roses.

The press had been swarming around for two days now, ever since workers pitched a 2,800-square-foot ivory voile tent on the grounds of the estate. That resulted in another minicrisis, as Streisand ordered her gardeners to tear up the flower beds that had been trampled on by the laborers and start from scratch with new plantings.

At six P.M., guests had already begun to arrive; the tension in the air was palpable as Barbra inspected the grounds one final time as an unmarried woman. Like a general surveying the battlefield, the bathrobe-clad bride-to-be slowly made her way from the newly planted shrubs to the reception tent. Inside, she walked among the nine round tables each set for six couples. She had agonized for weeks before deciding on the French silver flatware, the eighteenth-century Sèvres porcelain plates, the fifty-year-old damask tablecloths, and the fruitwood ballroom chairs. "She walked among the tables, fidgeted with a place setting, then bent down to smell the gardenias that covered one table," a member of the catering staff recalled. "We were all, well, terrified."

Instead, Barbra turned to them and proclaimed the results of their hard work "breathtaking. It all looks *gorgeous*."

Out front, however, the scene more closely resembled *Apocalypse Now* than *Father of the Bride* as White Zombie and the press helicopters drowned out every other sound. John Travolta climbed out of a limousine with his wife, Kelly Preston, shielded his eyes as he looked skyward, and asked the question that would be repeated again and again by those arriving at the Streisand-Brolin nuptials: "What the f——?"

It was seven P.M.—just an hour before Barbra was to walk town the aisle—and the press choppers were still churning overhead. The bride had no intention of unplugging White Zombie, and despite her neighbors' protests, the cacophony would continue through the wedding and the reception that was to follow.

As soon as they arrived, Travolta, Tom Hanks, Quincy Jones, *The Way We Were* director Sydney Pollack, and the other guests were greeted by strolling violinists clad in black tie and tails. They were then escorted to a broad swath of lawn that led to one of the other houses on the estate. There, while ethereal Irish pipe music wafted from speakers concealed in the rocks and bushes, guests drank lemonade and nibbled on sushi and smoked salmon canapés. They

were jolted out of their reverie when, without warning, one of the fifteen choppers overhead broke away and swooped down over the crowd. The pilot would later be fined $500 and grounded for thirty days for flying too close to the 105 guests.

Barbra, meantime, was upstairs in the main house, being attended to by various minions. Her old friend, designer Donna Karan, had flown in from New York with two assistants for the express purpose of dressing Streisand. It had been three weeks since Karan showed up in Malibu with her pattern maker and draped a large swath of chiffon over her. "Are you sure about this?" Barbra asked, sizing herself up in the mirror. "This looks . . . odd."

"No, no, Barbra," Karan insisted. "It'll hang differently in the right fabric. Trust me."

But as Karan knew all too well, Barbra was congenitally incapable of fully trusting anyone. Brolin weighed in with doubts of his own, telling his bride that he intended to surf the Web until he found a more suitable gown. Two days before the wedding, however, Karan presented Barbra with two versions of the dress that had started out as a shapeless cloud of chiffon. Streisand picked the more daring, low-cut, bare-shouldered version of the two—a white tulle sheath hand-sewn with thousands of crystal beads, all shrouded by a fifteen-foot diaphanous veil. The delicate beadwork ("It's so fragile," she marveled) and the classic design appealed to Barbra's passion for antique clothes. Barbra was ecstatic: "It takes my breath away," she told Karan. "It's reminiscent of the past and yet totally in the present."

Streisand was also more than a little relieved, though she never apologized to Karan for doubting that she would deliver. For her part, Karan never wavered. "The minute I saw Barbra in it," she later said, "I knew it was the dress for her and her alone. It just couldn't have been anybody else's." The bride was even happier about the price tag: the gown, Karan informed her, was the designer's wedding gift to the couple.

In the final moments before the ceremony, Karan stood by nervously as two assistants helped the bride into her dress. Someone helped fasten an Edwardian diamond-and-pearl choker around her throat while yet another assistant put the finishing touches on her blond, upswept hairdo.

The mood was no less tense downstairs, where Marvin Hamlisch

anxiously briefed members of the sixteen-piece orchestra on precisely what they were to play—and how. The Academy Award–winning composer had been a friend of Streisand's since he worked as her rehearsal pianist during the 1964 Broadway run of *Funny Girl,* and listened carefully to her instructions. She wanted him to warm up the crowd with a personal favorite, André Previn's somber "Four Horsemen of the Apocalypse," and then segue into the "Wedding March." But not just any run-of-the-mill rendition. "I don't like traditional wedding music," she had told him. "Could you do a more *atonal* version of 'Here Comes the Bride'?" She had also asked the violinists not to play her music. "I don't," she said flatly, "want to hear 'People' at my wedding."

But not even her old friend Marvin was immune to flashes of the famous Streisand temper. Four hours before the wedding, Hamlisch was rehearsing with his musicians at a nearby church auditorium when Barbra checked in to hear their progress over her cell phone. When they had finished playing, recalled violinist Don Palmer, "we could hear Barbra *screaming* at Marvin at the top of her lungs. There was something about the arrangement she didn't like, or the way we were playing, and she just went nuts. It was getting pretty hot, and he kept reassuring her that everything would be fixed in time for her wedding. But she just kept screaming, and he just stood there and took it. You could tell he'd been through this a hundred times before."

While Hamlisch and his musicians worked feverishly to accommodate the bride's wishes, she took one remaining issue into her own hands. When she saw the large Victorian bridal bouquet that had been prepared for her, Streisand opted instead for roses picked from her own garden. She then arranged them herself. There was a simple reason for Streisand's last-minute requests. "I had to make quick decisions," she later said. "I couldn't ponder for months. Choices had to be instinctive and from the heart."

Finally, at 7:55 P.M., members of the wedding party—Barbra's eighty-nine-year-old mother, Diana Kind; her half sister and maid of honor, Roslyn Kind; and best man Josh Brolin, the groom's son by the first of his two earlier marriages—took their positions. Barbra waited a beat—no one knew better how to make an entrance—before finally appearing at the top of the stairs. There was an audible

gasp from the crowd. "She had every dream come true," Karan said, "of what one could want to look like at a wedding."

Barbra stood for a moment, gazing out over a room that was filled with reminders of past loves—hers and the groom's. There was Jon Peters, the womanizing hairdresser she fell in love with and, over the course of their nine-year affair, transformed into one of the film industry's major players. A few seats away sat another longtime lover—Baskin-Robbins ice-cream heir Richard Baskin. Peters's daughters, Caleigh and Skye, carried the bride's train; Brolin's daughter Molly and grandson Trevor were ring bearers, and his granddaughter Eden scattered rose petals. And even though Barbra's first husband, Elliott Gould, had not been invited, their son Jason— her only child—was there to give the bride away.

"Barbra looked like a vision from a dream time," her friend Joanne Segel later said. The silver-maned, six-foot-four-inch Brolin, who wore a double-breasted tuxedo, gazed down at his five-foot-four-inch bride "with total adoration." During the fifteen-minute ceremony, the groom, the guests, the rabbi, the musicians, even the kitchen staff peering from behind a curtain, wiped away tears. But not Barbra.

"As two years have gone by," proclaimed Rabbi Leonard Beerman, "you've had the time to deepen, reflect, and remember. And now you have committed your life to a new way. Love has spoken to you in its own private language." Once the rabbi pronounced them husband and wife, Brolin followed tradition by crushing the ceremonial glass under his foot, then swept the new Mrs. Brolin up in a long, passionate kiss. "Did you see the way he looked at her?" Kelly Preston asked her husband. When he didn't answer, she turned to see that he was fighting back tears.

Thirty minutes later, the guests were seated inside the tent when Marvin Hamlisch struck up the newlyweds' favorite song, George Gershwin's "Isn't It a Pity?," and announced "Mr. and Mrs. James Brolin." The crowd leaped to its feet and gave the couple—her hair was down now, cascading to her shoulders—a standing ovation.

Everyone dined on soft-shell crabs, roast beef, roasted potatoes filled with crème fraîche and caviar—dishes selected by Barbra because they were her favorites. "We don't need brownies, chocolate bread pudding, and warm chocolate gâteau with vanilla ice cream,"

the weight-conscious star explained, "but we love them all, so why not?" It hardly mattered; Streisand would later say that she and her husband spent so much time "hugging and talking to everybody" that they never ate.

Despite Barbra's request that her music not be played, the newly-weds smiled broadly as they danced to "I Finally Found Someone," her hit duet with rocker Brian Adams. The party grew rowdier over the next two hours as Travolta, Hanks, and their wives tried to out-limbo one another. "That's us," Travolta said sardonically, "the lives of the party."

After the couple went through the ritual of cutting their flower-covered five-tiered tiramisù wedding cake, Hamlisch rose to give the first toast of the evening. "Everyone here knows and loves Bar-bra and particularly knows how she wants everything to be letter-perfect," he said. "Therefore I have been asked by Jim and Barbra to thank everyone who came to this, their third wedding rehearsal. All of you who weren't that effusive might not get an invitation to the *real* one, which will be August tenth, nine P.M."

The other toasts were more flowery. Josh Brolin recited a poem he had written. "My father and his bride," Josh said, gushing. "Look at how they watch each other . . . I'm glad," he added, "you didn't go off to Vegas." Renata Buser, Barbra's personal assistant for nearly a quarter century, turned to the groom and said, "Jim, you have the rarest flower . . ."

Then the seriously nearsighted Mrs. Brolin put on her reading glasses and began to thank everyone for coming. Hamlisch came in for special praise. "After all Marvin's Grammys, Emmys, and Oscars [she neglected to mention his Pulitzer Prize for *A Chorus Line*], he's back playing weddings!"

Her guests were moved to tears again when Barbra, once so par-alyzed by stage fright that she refused to perform on the concert stage for twenty-two years, sang two love songs to her husband. Brolin, beaming, knelt down before her and held the lyric sheets high enough so she could read them. The first, written for the oc-casion by Ann Hampton Callaway, was "I've Dreamed of You." Looking into Brolin's eyes, Barbra lingered on the final lyric: "Come dream with me as I've dreamed of you all my life." "It was," Hamlisch later said, "an absolutely stunning moment."

Still, Barbra was all business as she launched into "Just One Life-time," also penned specially for the Brolin–Streisand nuptials, this time by Grammy-winning singer Melissa Manchester and Tom Snow. The emotional reaction of Brolin and the couple's friends was, said Segel, "something no movie could capture."

Now it was the groom's turn to say something. "You expect me to follow *that*?" he joked. "I don't think so, I'll only screw it up." But with Barbra gazing on adoringly, the ruggedly handsome star of *Marcus Welby, M.D.* and *Hotel* also managed to tug at the heartstrings. "I can say at this point that you've made me so happy that you're all here to witness my deep, deep love for this woman," he said. "I'm the happiest person in the world. . . . I have married the woman of my dreams. I can't tell you how lucky I am that this would happen to me so late in life. Every night is a new adventure. Sleeping is a waste of time. I can't wait to see her again in the morning." Then he concluded, only half-jokingly, "I have to go look at all the flow-ers. I wasn't allowed in the house before the ceremony."

The party wound down by one A.M., and the couple packed up a car and took off for a secret destination. While the press speculated that they had jetted off to Barbados for their honeymoon, Brolin and his bride had actually driven to nearby Santa Barbara and boarded *The Huntress,* a 110-foot yacht, for a three-day cruise around the Channel Islands. (They did not go alone: Karan and her husband and business partner, Stefan Weiss, trailed behind aboard an eighty-two-foot yacht called *Quiet Heart.*) Before they departed, Barbra left specific orders that none of the flowers be given away or disposed of. She wanted the spectacular flowers—*all* $100,000 worth of them—there when she returned.

In the end it was "an honor" to be at such "a magical wedding," Travolta later declared. The bride's half sister agreed. "Everybody was crying, and Jim just looks at her with such love in his heart," Roslyn Kind said before she returned to the cramped, somewhat shabby apartment she shared with their mother. "Barbra was daz-zling, she was happy, she was glowing . . . Her gown was exquisite, but I think it's the happiness from within that meant the most . . ."

Happiness, however, was something that would elude twenty waiters who had worked feverishly to please Barbra's guests. When they left Streisand's Malibu estate in the early morning hours, the

waiters—some of whom were ardent fans who sobbed openly as Barbra sang to her new husband—discovered that their cars had been gouged with keys ("keyed") and their tires slashed. The Los Angeles County Sheriff's Department would come up dry, though there was speculation that someone in the neighborhood or a member of the press, furious over the White Zombie music Barbra had blared at camera crews, was responsible.

Members of her serving staff may have wound up in the red after having to pay to have the damage to their cars repaired, but it turned out to be a wildly profitable day for Barbra. With Deborah Wald, the wife of Brolin's longtime manager and friend Jeff Wald, serving as official photographer, Streisand had her agent peddle her wedding shots to the highest bidders in the United States and abroad. As soon as she returned from her honeymoon, Barbra pored over hundreds of shots before culling out the handful she felt were flattering enough for publication. (She had always insisted on being shot from the left. "My nose is longer from the other side. My left side is more feminine.") The event itself had cost $500,000, but Barbra's wedding pictures raked in more than $1 million.

It was almost enough—*almost* enough—to make her forget about the day's biggest disappointment. "I wonder," she asked her new husband, "how Bill and Hillary are doing . . ."

I had to go right to the top or nowhere at all.

*It's only wind and noise. I open my mouth
and the sound comes out.*

*Elliott Gould: The trouble with Barbra is that she can't let
herself be happy.
Barbra: Happy? I'd be miserable if I were happy.*

2

―

June 6, 1960
A Thursday

She had no idea The Lion on New York's Ninth Street in Greenwich Village was a gay bar, or even that Barry Dennen—the man she was soon going to be sleeping with—was gay. But Dennen, an aspiring actor who had befriended her when they both appeared in something called *The Insect Comedy,* believed that the kooky girl with the crooked nose, slightly crossed eyes, and disarming Flatbush patois would instantly appeal to the homosexual audience. He could not have imagined, however, that she was about to be catapulted into the pantheon of show-business greats—or that she would ultimately surpass even that distinction to become nothing less than an institution.

For now she was simply Barbara Joan Streisand, a Brooklyn native who had finally, grudgingly, signed up to compete in The Lion's weekly amateur talent contest. Incredibly, while Barbara was sure of her acting ability, she was not entirely convinced that she could *sing.* Even at Erasmus Hall High School, where Streisand sang in the chorus (along with fellow student Neil Diamond), she was never given a single solo; another girl with a classically trained voice was the school's singing star, and teachers and students agreed that she, not Barbara, was destined for stardom.

She had yet to earn a dime as a performer and did not even see herself as a singer, but eighteen-year-old Barbara already had an

entourage—albeit a small one. In addition to Dennen, who helped her select the right songs and then coached her on how best to sing them, Streisand already had an up-and-coming stylist, Terry Leong, designing a wardrobe for her. Within days, Dennen and Leong would be joined by Bob Schulenberg, an illustrator, photographer, designer and makeup artist who would soon play a large part in molding her image.

Schulenberg, who had just flown in from Los Angeles to see his friend Dennen, would never forget the first moment he laid eyes on Streisand. He and Dennen were leaving Dennen's building around midnight and headed for a local coffee shop when Barbara came running toward them shouting, " 'Barry, Barry,' " Schulenberg recalled. "She's carrying two shopping bags in each hand, and hanging out of the bags was all this glittery stuff—sequined scarves and feather boas. She's wearing 1927 gold lamé kid-trimmed shoes that I recognized from *Vogue,* a red velvet skirt about an inch above her knee, rose-colored nylon stockings, and a red brocade top with Elizabethan sleeves. I had never seen anything quite like her. I was *fascinated.*"

"Everyone was very protective of her," Leong said. "We were willing to work for nothing because we all knew there was just something magical about Barbara even then. I don't know what it was . . . it's impossible to explain, really."

As she walked out the door of Dennen's apartment and headed for The Lion that night, Streisand suddenly collapsed on the floor, shaking—the first of what would be a long series of crippling panic attacks. "I can't go through with this, I can't," she told Dennen. "I'm not a singer. I don't *want* to be a singer!" When Dennen told her not to sing her songs but *act* them, she suddenly fell quiet. It was a defining moment. Barbara, who had aspired to become the next Eleanora Duse or Anna Magnani, now saw the way to reconcile her dreams of becoming a great actress with pursuing a career as a vocalist.

An hour later Barbara, wearing a pleated chiffon skirt and a mauve secondhand feather-trimmed jacket she had purchased for twelve dollars ("It belonged to a countess"), made her way toward the tiny stage at the back of The Lion. The upscale club was packed with well-groomed men in suits, and only now did it occur to Barbara that these were, in her words, "guys who like guys."

There were only three other performers that night: a soprano who sang light opera in the style of Jeanette MacDonald, a comic, and Barbara's only real competition: jazz legend Lionel Hampton's niece Dawn Hampton, a smoky-voiced singer who on any other night would have won handily.

Once Hampton had finished taking her bows, it was Barbara's turn. She stepped over to her accompanist, handed him her sheet music, and, with all the confidence of a show-business veteran, whispered last-minute instructions into his ear.

Then Barbara stepped into the spotlight and looked out over the heads of those sitting ringside, through the blue haze of cigarette smoke, to the men standing at the back of the room. Dennen, now clutching Leong's hand in nervous anticipation, might have expected her to search out her friends' faces, if for nothing more than a bit of reassurance. But she didn't. Instead, she kept staring, smiling benignly, until the chatter subsided and the last throat had been cleared and all eyes were at last on her.

Barbara's song choice was a far cry from "Oh, What a Beautiful Morning." With Dennen's help, she had picked "A Sleepin' Bee," a languid ballad from the ill-fated Broadway musical *House of Flowers* by Harold Arlen and Truman Capote. "Sleepin' Bee" is based on a scrap of Caribbean lore—that if a girl holds a sleeping bee in the palm of her hand and it doesn't sting her, then she and the man she's thinking about are truly in love. The song was closely identified with the show's star, Diahann Carroll, the elegant African-American singer who later appeared in Richard Rodgers's *No Strings* and would go on to become the first black woman to star in her own prime-time television series, *Julia*. But as Barbara closed her eyes and began to sway to the music as if she were in a trance, it was clear she was about to offer a version that was, in the very real sense of the word, unique.

"When a bee lies sleepin' in the palm of your hand . . ." Barbara kept her eyes closed as the song built to a crescendo, then opened them as she sang the final few notes. The song was over and Contestant No. 4 simply stood there, staring at a point somewhere in the distance. For what seemed like an eternity, there was nothing but silence—until the place exploded in wild applause. The crowd whooped and whistled and shouted for more—and Barbara, for the

first time feeling the adoration of an audience wash over her, gladly gave it to them. No sooner had she finished the melancholy ballad "When Sunny Gets Blue" than the strange-looking girl from Brooklyn with the undeniably prominent nose, the purple Fu Manchu fingernails, and the otherworldly voice was declared hands-down winner of the talent contest. The prize: fifty dollars, a week's booking at the club, and, she would later remember, "a great London broil." (Ironically, although hers would be the best-known version of his song, Capote hated the way Streisand sang "A Sleepin' Bee.")

When it was all over shortly before midnight, Barbara, Dennen, and Leong rushed to a nearby coffee shop to celebrate over cherry Cokes and pie. Understandably, she was nothing less than delirious; for the first time in her life, she had received some affirmation— tangible evidence—that she indeed had talent. Not the garden variety, either, judging by the response of the crowd. Barbara and her friends were mobbed by well-wishers—some overcome with emotion—as they tried to make their way out of the club.

At the coffee shop, Barbara and her two-man cheering section relived every moment of that magical evening. When a young man who had been to The Lion that night walked up to their table and asked Barbara for her autograph, she was clearly thrilled. She took a paper napkin and signed it.

She had just signed her first autograph for her first fan, but Barbara was already thinking of ways to improve her image. She announced to Dennen and Leong that she had decided to drop the second *a* in her name. From this moment on, she proclaimed as she scrawled her new name on yet another napkin, she was not Barbara but Barbra—Barbra Streisand.

At that moment, Barbra had no way of knowing that—with or without the *a*—the Streisand legend was already building in New York's influential gay community. Those lucky enough to have seen her perform that first night told anyone they could about the skinny, slightly quirky-looking girl with the off-center personality and a wardrobe to match. But the voice . . .

Trying to describe Streisand's voice was a challenge in itself. The power, the clarity, the phrasing—Barbra, who had never had a singing lesson in her life—used them all like the natural virtuoso that she was. Like Ethel Merman and the other great Broadway

belters, she had the vocal equipment to project to the balcony seats and beyond. But Barbra chose instead to follow in the footsteps of the great stylists like Judy Garland and Frank Sinatra, caressing and spinning and savoring each lyric for full dramatic effect. Even now, at the brink of a career that would stretch well into the next century, Barbra fully understood that this approach to *every* song—coupled with the singular quality of her voice—would prove to be the key to her phenomenal success. "Every song," she would ask rhetorically, "is like a three-act play, right?"

Over the next three weeks, the crowd waiting to hear the kooky kid from Brooklyn vanquish all comers—including a weird, ukelele-playing falsetto who billed himself as Tiny Tim—spilled out onto the steamy sidewalks of Ninth Street and Sixth Avenue. Inside, she huddled by the piano for some numbers and wandered, microphone in hand, among the tables for others. Her tone would be crisp and ebullient one moment, tinged with wistful melancholy the next—by turns pleading and defiant, vulnerable and triumphant, hopeful and sardonic, tragic and joyful.

Whatever material she chose to sing—whatever the nature of that evening's particular ride on Barbra's emotional Tilt-a-Whirl—the reaction was always the same: pandemonium. Every night they whistled, stomped, screamed their approval, and begged for more.

One of those who came to see her was a friend she had met in acting class. His name was Dustin Hoffman. "She was sitting on a stool, and before she sang her first song, she took a wad of chewing gum out of her mouth and put it under the seat. I thought: 'What a smart girl.' It was a seemingly natural act, but it had a method to its madness. It was quite provoking, and suddenly, out of this amiable anteater, came this *magic* . . . She did what a fighter does—she was feinting with her left when she put the gum under the seat. Then she knocked you out with her right when she sang."

Barbra's love life was also looking up, or so it seemed. Not long before her debut at The Lion, she and Dennen had, after several abortive attempts, consummated their relationship. She was unaware that Dennen, the son of a wealthy California businessman, was also grappling with the growing realization that he preferred sex with men.

The awkwardness of their lovemaking only served to fuel what

Dennen—and everyone else who would get to know Barbra, for that matter—knew was gnawing self-doubt about the way she looked. When she asked him if he thought she was pretty, Dennen marched Barbra to the Brooklyn Museum to see a bust of the fourteenth century B.C. Egyptian queen Nefertiti. The message—that both women possessed a regal if unconventional beauty—backfired. Sizing up the famous statue, Barbra recoiled in horror. "Just get a load of that *schnoz!*" she said before asking Barry if she shouldn't get a nose job.

"No!" Dennen shot back. "Don't even *think* about changing your nose." She might never be considered "pretty," but the day would come when people called her beautiful. Barbra was, her friend and lover told her, the "Nefertiti of Brooklyn."

Not everyone shared Dennen's glowing opinion of Barbra's countenance—certainly not her emotionally distant mother Diana, or Diana's abusive husband, the callous stepfather whose belittling remarks would fuel both Barbra's gnawing self-doubt about her looks and her burning desire to succeed. Nor could she forget the sneers of her classmates or the humiliating nickname they saddled her with: "Big Beak."

Things would have been different, Barbra fantasized even then, if her real father had lived. Though she would never know him, Emanuel Streisand was, by all accounts, a remarkable man. So, too, was Barbra's paternal grandfather Isaac, a tailor who had grown up in Brzezany, a tiny village in the impoverished Polish province of Galicia. Only 10 percent of the population in Galicia was Jewish, and Isaac Streisand lived under the perpetual threat of violence from his Catholic neighbors. In 1898, at the age of seventeen, Isaac boarded the SS *Meier* in the German port city of Bremen. Three weeks later, after disease had claimed the lives of several of his fellow passengers in steerage, Isaac Streisand arrived at Ellis Island.

For the next nine years, Isaac hauled a sewing machine around on his back as he struggled to eke out a meager existence as a tailor among the teeming immigrant masses that clogged the avenues and alleyways of New York's Lower East Side. In 1907 he married another refugee from Galicia, sixteen-year-old Annie Kesten, and within nine months Annie gave birth to Emanuel (followed by Murray, Hy, Philip, Daisy, and Molly).

When Manny was eleven, the family moved from their cramped, two-room tenement apartment on East Seventh Street to marginally more spacious quarters in Brooklyn. There Papa embarked on a new career—as the owner of a fish store on Sumner Avenue in the borough's Williamsburg district.

Barbra's grandfather Isaac, who continued to converse almost exclusively in Yiddish or German, got up at 2:30 A.M. several times a week and boarded the train that would take him over the Williamsburg Bridge to the Fulton Fish Market. There he would pick out the fish he wanted to buy, haggle with the brokers, and then arrange to have the fish he purchased transported by truck to his store.

As the eldest child, Manny helped out whenever he could, unloading the crates full of fish packed in ice, cleaning the fish and then wrapping them in newspaper. Yet Manny never let his responsibilities to his father interfere with his education. Graduating from Boys High School in 1924, he enrolled at the College of the City of New York and supplemented his small scholarship with a variety of odd jobs. At various times, he worked as a lifeguard, drove a Good Humor truck, and worked as a file clerk at the Brooklyn offices of AT&T.

Darkly handsome—he combed his black hair straight back and sported a pencil-thin Adolph Menjou mustache—Manny threw himself into a number of school activities. He was active in the debating, math, chess, and drama clubs. He fenced. He boxed. He played handball and tennis. He swam. He made Phi Beta Kappa. No sooner did he graduate in 1928 than he was offered a job teaching at a public elementary school in Manhattan. Yet he continued his own education, working toward his master's degree in education by taking night courses at CCNY and summer courses at Hunter College, Cornell, and Columbia University.

Despite his hectic schedule, Manny still made time for dating. From the age of fifteen, Molly Streisand recalled, her brother was pursued by the opposite sex. None of these relationships proved serious, however—until he met Diana Rosen at a Purim celebration at the home of a mutual friend in 1928. Whatever his initial feelings were for the vivacious, blue-eyed nineteen-year-old, Diana had no doubts whatsoever. "It was love at first sight, oh, boy!" she later said of that first meeting.

They had much in common. Diana was also the child of immigrant Jews; like Isaac Streisand, her father, Louis, had been trained as a tailor. And like Isaac, Louis, along with his wife, Ida, had fled the pogroms of their native Russia to build a new life in America, ultimately settling in Brooklyn. He paid the bills working as a garment cutter in Manhattan, but it was while fulfilling his duties as part-time cantor at his local synagogue that Louis Rosen seemed happiest.

Barbra's mother was actually born Ida Rosen on December 10, 1908 (she would adopt the more modern- and alluring-sounding Diana in her early teens), the third of Louis and Ida Rosen's four children. Yiddish was the first language spoken in the Rosen home, but Diana and her siblings, anxious to fully assimilate into American culture, implored their parents to speak to them only in English. Diana's early musical influences were also from the old country; Louis Rosen, clad in his prayer shawl, walked around their small apartment singing prayers and Yiddish folk songs every day.

For her part, Diana tried whenever she could to escape into the world of opera; she spent hours listening to the recordings of such artists as Caruso and Lily Pons on the Victrola in the family's front parlor. Diana would later say that while her father's vocal deficiencies prevented him from becoming a great cantor, any future signs of musical talent in the family could be traced back to Louis Rosen. "I inherited it from him," she later said, "and Barbra inherited it from me."

Diana, a soprano, possessed the sort of sweet voice that might have been suited to light opera. At seventeen, she and a girlfriend took the train into Manhattan and, on a lark, auditioned for the Metropolitan Opera Chorus. Both girls were turned down, and for the time being that signaled an end to Diana's show-business aspirations.

Diana was not particularly interested in pursuing her education beyond high school, either. Like most women of her generation, she focused on finding a husband and starting a family of her own. After a rocky two-year courtship, she and Manny were married by a rabbi in the living room of the Streisands' apartment on Christmas Eve, 1930.

It had been just a little more than a year since the stock-market crash of 1929 triggered the Great Depression, so instead of a costly honeymoon, the bride and groom opted for a Broadway show and a

night in a nice hotel. Driving back to Brooklyn in his sputtering Model T, Manny was tailgating the car in front of him when traffic came to a sudden halt. In an instant, the Streisands' car slammed into the other car, and Manny flew headfirst into the windshield. Diana sustained cuts to her leg that would soon heal, but for her husband the accident would have longer-lasting effects. From this point on, Manny would suffer bouts of dizziness and severe headaches that he would treat with massive doses of aspirin.

The Streisands, like nearly everyone else in the country, struggled to make ends meet. When Manny got an offer to teach troubled youths at the Elmira Reformatory in upstate New York, he seized the opportunity. It was not a move his wife was eager to make. As anxious as her husband was upbeat and reassuring, Diana did not want to leave the only home she'd known. She was also afraid that her husband, whose headaches and dizzy spells persisted, was simply working too hard. Still, the offer was just too lucrative to pass up, and in 1932 they packed their bags and left Brooklyn.

While living in Elmira, Diana gave birth to the Streisands' first child, Sheldon Jay, in 1935. Not long after, Manny suffered a seizure and was diagnosed with epilepsy. Physicians in Elmira speculated that the head trauma Manny had suffered as a result of his car crash was probably the root cause of his condition. The prognosis was anything but encouraging; there were no drugs to treat epilepsy at the time, and no way of predicting if and when another seizure might strike.

Convinced that stress from his job at the reformatory was at least partly to blame, Diana convinced Manny to return to Brooklyn and take a less demanding job as an English teacher at the High School for Specialty Trades. The students there, mostly delinquents for whom the high school offered a final opportunity before dropping out altogether, were only slightly more manageable than the ones he taught at Elmira.

Over the next seven years, Manny earned the respect and admiration of his pupils by treating them with compassion—something most of the students, nearly all of whom had grown up in New York's toughest, most hardscrabble neighborhoods, were entirely unaccustomed to. He was no less revered by his fellow teachers, and in 1942 was included among the hundreds of influential educators

nationwide listed in the who's who of his profession, *Leaders in Education*.

By this time, the Streisands had moved into a two-bedroom apartment in an upscale building on Schenectady Avenue in Flatbush. While Manny devoted nights and weekends to studying for his doctorate in education at Columbia University Teachers College, Diana supplemented her husband's $2,000-a-year salary by working as a file clerk. "We worked hard in those days," she later said, "but who didn't? Everyone did what they had to do to survive—first the Depression, and then, of course, the war . . ."

Mom, was I pretty as a baby?

All babies are pretty.

No, I mean me: Was I pretty?

What's pretty, anyway?
Look at what good it did your sister.

Barbara Joan Streisand arrived—nearly three weeks late—in the middle of an air-raid drill at 5:04 on the morning of April 24, 1942. After ten days at the Jewish Hospital of Brooklyn, mother and daughter returned to the Streisand family apartment just as Manny was mailing out the birth announcements. "Mr. and Mrs. Emanuel Streisand," the card read, "take much pleasure in announcing the rather expected and hoped-for arrival of BARBARA JOAN (a cute little trick if they must say so, weighing 7 lbs. 5 ozs. net)." Barbara Joan had taken up residence, the announcement continued, "with her proud parents and her especially proud brother, Sheldon Jay."

Blue-eyed and bald—family lore had it that not a hair grew on the child's head until she was two—Barbara was a standout even then. She was, her mother would recall, an "easy baby" who seldom cried and, from the very beginning, "seemed to notice everything that was going on around her."

While the rest of the world seemed to be collapsing around them—both sides of the family knew of relatives who would perish in Nazi concentration camps—Manny and Diana counted their blessings. After twelve years of marriage they had the family they had always wanted—a boy and a girl—and now Manny was more determined than ever to earn the doctorate in education that would afford them an even brighter financial future.

For the moment, however, they would have to economize. With Diana staying home to care for the children full-time, Manny made whatever extra money he could tutoring in his off-hours. In the summer of 1943, another teacher at the High School for Specialty Trades, Nate Spiro, approached Manny with a proposition. Spiro had just taken over Camp Cascade, a small summer camp in the Catskills, and needed someone to work alongside him as head counselor. Spiro invited Manny to bring his entire family along; it would be a chance for the Streisands to spend their first summer together in the country.

Again, Manny leaped at the chance—not only to make the extra cash, but to escape Brooklyn's stifling summer heat. Their apartment was the proverbial oven, and Camp Cascade boasted a swimming hole *and* a waterfall. Still, Diana was apprehensive. "I don't feel good about this, Manny," she told her husband. "I don't know why . . ."

With fourteen-month-old Barbara and big brother "Shelly" in tow, Manny and Diana arrived at Camp Cascade in Highmount, New York, toward the end of June and moved into a cabin with no heat and no hot water. It quickly became clear that this would not be the working vacation Manny had originally envisioned. They had been at Camp Cascade only ten days when two of the other counselors, overwhelmed by the task of supervising 150 unruly boys and girls, abruptly quit, leaving Manny and Nate to fill the void. Soon Manny was working from dawn to midnight, teaching the kids to swim, leading them on long hikes through the wilderness, umpiring their baseball games, and reading them scary ghost stories over the campfire at night.

On a particularly scorching August morning, Manny, the camp counselor's all-important whistle hanging from a chord around his neck, presided over a swim meet before returning to his cabin with

a migraine. He was feeling nauseous, he told Diana, but would be fine if he could just take a short nap. "Come get me in an hour," he instructed her.

When Diana returned, she tried to wake her husband, but couldn't. Frantic, she ran to Nate Spiro for help. Within moments, Nate was at the wheel of a car speeding toward the nearest hospital in Margaretville, nine miles away. Manny, still unconscious, lay on the backseat, his head in Diana's lap. Barbara was left behind with Spiro's teenage daughter, Helene, who cradled the infant as the car sped away from the camp. It was then that Barbara, the baby who never cried, began to wail inconsolably.

Shortly after arriving at the hospital, Manny suffered a seizure. One of the doctors in the emergency room, following what was then accepted procedure for dealing with seizures, injected morphine directly into Manny's neck. The result was catastrophic. Almost immediately, Manny went into respiratory arrest—either because the dose was too high or because he was allergic. At 2:45 P.M. on August 4, 1943—less than twenty-four hours after he was admitted to the hospital—Manny was pronounced dead. He was just thirty-five.

Diana sat in the waiting room in stunned disbelief. "He was such a healthy, strapping man—an athlete," she said. "He had everything to look forward to." Since Manny had to be buried within twenty-four hours in accordance with Jewish tradition, Diana called her grieving father-in-law in Brooklyn and asked him to make the necessary arrangements. Then, with Barbara perched on one hip and Shelly holding on tight to her hand, Diana boarded the train that would carry her husband's body home. The next day, Manny was buried at Mount Hebron Cemetery in Queens. When his tombstone was completed weeks later, it would bear a carving of his Phi Beta Kappa key and the words BELOVED TEACHER AND SCHOLAR.

"Now you're the man of the family," Diana whispered to her son. Certainly this moment would have a profound impact on the life of Sheldon Streisand; at the age of eight, he was old enough to have collected enough memories of his father to last throughout his life. But Barbara was barely a toddler—too young to know the man whose loss would be the pivotal event in her life.

The circumstances of Manny Streisand's death would remain

shrouded in mystery for decades. Believing, as so many of her generation did, that epilepsy was somehow a shameful disease, Diana told her children only that their father died of a cerebral hemorrhage brought on by overwork. "I thought," Barbra later said, "that I might die of overwork, too."

Following her father's death, Barbara returned to Brooklyn and an uncertain future. Manny had been a decent enough provider, but at his comparatively young age he had not given much thought to providing for his family in the event of his death. There was no life insurance, and whatever money they had been able to save had gone to pay for Manny's tuition at Columbia.

No longer able to afford the apartment on Schenectady Avenue, Diana moved into her parents' cramped, three-room apartment on Pulaski Street. Barbara's grandparents had one room to themselves, Barbara and Diana shared another, and Sheldon slept on a cot in the dining room. "We weren't *poor* poor, we just didn't have anything," Barbra would later say of that period in her life. "We never had a sitting room, and we never had a couch. Couches to me were, like, what rich people had."

At first, Barbara waited at the window for Daddy to come home. Eventually, he faded from memory entirely. There was almost nothing to remind Barbara of her father—not a single photograph of them together, only his books gathering dust in the basement. Decades later, when Barbra asked her mother why she never spoke of her father, Diana replied, "I didn't want you to get upset. I didn't want you to miss him."

As a result, Barbra later said, "I always felt I never had a father." In fact, she grew to resent the fact that he had made her "the only kid on the block without a father." To make matters worse, Manny's young widow was in no state to comfort her children. There was no way to escape her mother's overwhelming grief. With Barbara trying to sleep in the bed they shared, Diana wept for hours every night until she was finally overcome by exhaustion.

Shortly after the war, Diana finally pulled herself together enough to take a job in downtown Brooklyn as a bookkeeper. That left the Streisand children to be raised by their stern, oddly dispassionate old-world grandparents. Sheldon would call them "decent" and "hardworking," but he also readily conceded "there was no

love in that house." More likely to dispense discipline than affection, they confined their conversations with the children to issuing orders and reprimands. An asthmatic who also suffered frequent headaches, "Bubbe" Rosen made no secret of the fact that she felt too old to be saddled with caring for rambunctious young children. Her husband, whom the children called "Zayde" (the Yiddish word for "grandfather"), still wandered about the apartment in yarmulke and prayer shawl reciting prayers—an exotic, rather theatrical ritual that Barbara found fascinating.

Still, whenever either child was too loud or unruly, it was Zayde who brandished a leather strap. At those times, Barbara and her brother scrambled under the apartment's huge dining-room table to avoid being beaten.

Not that little Barbara was easy to handle. One day Bubbe Rosen walked into her room to see her two-year-old granddaughter standing on her dresser, staring at herself in the mirror. Barbara had taken a tube of Diana's fire-engine-red lipstick and, using the edge of her grandmother's favorite wool blanket, proceeded to streak the lipstick over her cheeks, mouth, and forehead. Despite the inevitable scoldings, it was a scene that would be repeated over and over again; when she couldn't get access to her mother's makeup, Barbara made do with Sheldon's crayons, smearing them over her face until she achieved the desired effect.

Her grandparents later claimed that she was more than just a handful. At times, Manny's little girl seemed to be everywhere—rummaging through her mother's closet and trying on whatever she could pull down from the hangers, climbing up onto tabletops and chairs, careening about the tiny apartment with Shelley as they played cowboys and Indians. Bubbe Rosen called her *farbrent*—Yiddish for "on fire"—because, Barbra would later concede, "I just couldn't accept no for an answer."

Yet Barbara's bravado could not entirely conceal the fear and apprehension of a little girl whose father had, for all intents and purposes, simply vanished. She waited eagerly for her mother to return from work each day, and if Diana was late by even a few minutes, Barbara could work herself into a panic. It didn't help that her mother, exhausted from working ten-hour days and still grieving for her dead husband, offered nothing in the way of solace or

encouragement. "Go play" was the usual response when Barbara approached her for affection. But go play with what? "I didn't have anything to play *with*," Barbra later recalled. Her only toy: "A hot-water bottle with a little sweater on it. That was my doll."

In truth, Barbra, whose lifelong need to portray herself as a victim, did have toys—stuffed animals, books, jacks, tops that spun around the floor of the apartment, annoying the adults. And, in her desperate need for something warm and comforting to cling to when no one else would offer affection, Barbara did grow attached to a hot-water bottle. By way of giving the hot-water bottle something of a personality, Diana simply sewed one of Barbara's baby sweaters onto it.

Even with Sheldon attending grammar school, it soon became apparent that Diana's elderly parents were not up to the task of keeping Barbara out of mischief. In the autumn of 1946, Diana enrolled the four-year-old Barbara in nursery school. In the summer months, both Streisand children were shipped off to their aunt's farm in Connecticut while their mother worked. Barbara may not have received any encouragement or tenderness from her mother, but she was warned repeatedly of the dangers she faced in the outside world. "I was raised," Barbra said, "to be frightened of *everything*."

She was warned never to cross the street unless she was holding the hand of an adult. She was warned never to talk to strangers—there were kidnappers out there waiting to steal children just like her. When visiting her aunt in Connecticut, she was warned not to go near the water, not to get too close to any strange animals, not to run with scissors, not to . . .

Diana also admonished her daughter that no one liked a skinny girl, that she would get sick if she didn't gain weight, that people would say her family didn't love her because she wasn't being fed properly. "I was this skinny kid," she remembered, "and my mother was always trying to fatten me up." None of it worked. Despite the calorie-laden egg creams, the cakes, cookies, and puddings—some of which Diana literally ladled into her daughter's mouth with a giant spoon—Barbara remained stick thin. She wanted love from her mother, but instead, Barbra would always remember, "she gave me food."

The following year, Barbara was enrolled in kindergarten at the

local yeshiva where Manny had once taught remedial classes to earn some extra money. Although she was obviously a bright child, she was also something of a discipline problem from the start. She demanded to be heard, waving her hands to get the teachers' attention and, when that attention was not forthcoming, blurting out whatever thought or question popped into her inquisitive mind. Barbara "had questions: why, why, why? It didn't go over well."

Nor did some of her other attention-grabbing antics. When the rabbi left the classroom, she liked to blurt out the one word that she knew they didn't want to hear in a yeshiva: "Christmas!"

In fact, at the age of six, Barbara found certain aspects of Christianity fascinating. By this time she had befriended two girls on the block—Rosalyn Arenstein, who was an atheist, and Joanne Micelli, a Catholic. "I was the Jew," remembered Barbara, who nonetheless harbored "this fascination about wanting to be Catholic—the nuns, the fathers, the costumes, the whole thing . . ." She curtsied and said "Hello, Father" whenever she encountered a priest. The fact that she did not have a father had a great deal to do with the appeal of Catholicism and its trappings. "To have a father, that there was a guy *named* Father," she later mused. "I thought it was great."

Yet she never forgot who she was, or how she fit into Brooklyn's religious and cultural mosaic. When Joanne Micelli insisted that "the Jews killed Christ," Barbara angrily shouted back, "No, they didn't!"

Rosalyn Arenstein and Joanne Micelli aside, Barbara really did not fit in with the other children at the yeshiva—and not because she secretly wanted to be a part of the mystery and ceremony surrounding the Catholic Church. She had inherited her father's looks—a sizable nose with a slight bump, a wandering left eye that sometimes strayed toward her nose, giving her the appearance of being slightly cross-eyed. She was skinny, with an oversize head and knobby knees.

"I was a homely kid—the kind who looked just ridiculous with a bow in her hair," she would admit. Other children teased her, and the girls were worst of all. "Sometimes," she said, "the girls would gang up on me in my neighborhood, make a circle around me, make fun of me, and I'd start to cry and then run away." She would always

think it was more than the way she looked, that there was something in her that threatened the others. "What did I do? What did I vibrate? What made them angry at me?"

Soon, rather than shrink from the taunts, Barbara simply ignored them. Her detached, imperious manner only convinced her peers at the yeshiva that they were right in their assessment of the scrawny, odd-looking *mieskeit*. On top of everything else, she was *stuck-up*, though no one could imagine why.

Barbara did have one good friend at school—Irving Borokow, who also happened to live on the first floor of the Streisands' apartment building on Pulaski Street. Yet it was Irving's mother, a zaftig, kind-faced woman named Toby Wander Borokow, who provided far more than friendship. Sensing a sadness in Barbara, Toby lavished affection on the little girl, trying to fill the void with hugs, kisses, and words of encouragement and praise. In the afternoons, Barbara rushed to the Borokow apartment, where Toby cooked or knitted while the children watched Laurel and Hardy comedies on a tiny television—one of the few in the neighborhood. They watched the screen through a large magnifying glass set up in front of it—a standard setup in television's infancy—but Barbara didn't mind. It was the window to the outside world—a world to which Barbara soon yearned to escape.

But not quite yet. After Barbara completed first grade, Diana shipped her off to what was then known as a "health camp." There, presumably, Barbara would benefit from fresh air, exercise, and chowing down in front of the campfire with her newfound friends.

Streisand later labeled the two summers she spent at the health camp "the most horrible experiences of my life," and with reason. Barbara said she was treated like a prisoner from the moment she entered the camp. She was stripped, tossed in a bathtub, and then deloused before being issued a drab camp uniform. Missing Toby Borokow more than her mother, Barbara refused to eat and cried herself to sleep every night. Again subjected to the unremitting taunts of the other children, she blasted back, "I'm *not* crying. I have a loose tear duct that just runs."

Once back in the warm embrace of Toby Borokow, Barbara felt secure enough to indulge her fantasies of becoming somebody . . . special. She would lie in her bed and stare at the ceiling, thinking all

the while that she was "chosen . . . I could feel people's minds, like I knew the truth. I could see the truth."

Barbara also loved to sing, whether there were people around to hear her or not. The acoustics in the stairwell and the high-ceilinged hallways of her apartment building "were quite good," she later remembered. "There was the echo. I thought my voice sounded pretty."

Shortly after she turned seven in 1949, Barbara made her singing debut before an audience of parents at the yeshiva's annual PTA talent show. Suffering from a cold, she put on the new dress that she had made her mother purchase for the occasion and performed anyway. When she asked her mother how she'd done, Diana replied only that her arms were too thin for the sleeveless dress she was wearing. It was enough for Barbara that the people seemed to like her singing. Their applause sounded like love to Manny's little girl.

That summer, however, Barbara was back at health camp, and more forlorn than ever. Now her anxiety about being away from Toby Borokow was triggering psychosomatic asthma attacks that, over the course of the next two decades, would strike her whenever she ventured into the countryside.

Homesickness wasn't the only cause of Barbara's emotional distress. By now she was well aware that she had been sent away from home during the summer months so that her mother would be free to resume dating. Barbara viewed her mother's suitors with a mixture of fear, anger, and dread. Understandably, her greatest fear was that her mother, now forty and worried that she might wind up spending the rest of her life alone, would leave with one of these strange men for an evening out—and simply never return. So Barbara shrieked and cried and begged her mother not to go every time Diana went out on a date. The reason, Barbara later explained, was simple: "I hated those men."

None more than the dapper, charming-to-a-fault landlord-cum-used-car-salesman her mother began dating in the summer of 1949 while Barbara was away at camp. Russian-born Louis Kind, fifty-five and an Orthodox Jew, was separated from his wife, Ida, the mother of their three children.

When Diana wrote to say she would be visiting Barbara at camp and bringing her new friend Mr. Kind along, Barbara was frantic.

Obviously this was a sign that Kind occupied a more important place in her mother's life than any of the other men. When Diana introduced her new boyfriend to Barbara, the little girl ignored him completely. Instead, she launched into a litany of complaints about the camp, how awful the food was, how mean the counselors were, how she was shunned and teased by her fellow campers. Sobbing and pleading and stamping her feet, she demanded that her mother take her home. Diana insisted that Barbara must be exaggerating, and Kind simply watched as the little girl grew more and more insistent. "You are not leaving without me," she demanded. "I am *not* staying here any longer."

Diana caved in to her daughter's demands. As Lou Kind looked on disapprovingly, she packed up Barbara's things and loaded them into Kind's car. It was the defining moment in the relationship between Barbara and this new man in her mother's life. On the drive back to Brooklyn, all three sat in total, sullen silence. "He hated me," Barbara later said, ". . . until he died."

Unfortunately for Kind, things only got worse. In the coming weeks, Barbara threw a tantrum every time he came by the apartment to pick up her mother. As Diana headed for the front door, Barbara literally tugged on the hem of her mother's dress, begging her to stay. "Please, Mommy, don't go," she would cry. "Don't go with *him*. Stay with me, PLEASE, MOMMY."

Diana tried to explain that Barbara was simply afraid of anyone she viewed as a rival for her mother's affections. Kind claimed he understood, but in reality he resented what he saw as Barbara's blatant and selfish attempt to manipulate her mother. Sadly, these mutual feelings of suspicion and acrimony would only grow over time.

At first, Barbara need not have worried about Lou's intentions toward her mother. He had just been through a particularly painful divorce and had no interest in rushing to the altar anytime soon. Nor did he find the notion of committing himself to a widow and her two children—one of whom he already viewed as a spoiled, self-absorbed brat—particularly appealing.

Kind was anything but understanding when, in April of 1950, Diana informed him that she was pregnant. At the time, the stigma attached to having a child out of wedlock was so overwhelming that it drove some women to suicide. To compound Diana's shame, Kind

was still technically married to another woman—his divorce had not yet gone through. Diana, aware that her condition would bring unimaginable disgrace on the Rosens' Orthodox household, worried about what her own father might do.

The months dragged on, and when Diana could no longer conceal her pregnancy from the family, her father flew into a rage and threatened to kick her—and the children—out. At this point, Kind reluctantly agreed to rent a small, one-bedroom apartment for Diana and the kids in Vanderveer Estates, a massive, working-class housing project in Flatbush. Barbara was devastated, partly because she would now be living with the dreaded Lou Kind, and partly because she missed the true mother figure in her life, Toby Borokow.

Whatever physical closeness Barbara shared with her mother stemmed from the simple fact that they slept together in the same bed. But under the new living arrangements, Kind and Diana occupied the bedroom, Sheldon continued sleeping on a cot in the dining room, and Barbara was left to sleep on a sofa in the living room. "I lived with my mother in Brooklyn until I left high school," she later said, "and in all that time I never had a room of my own. I slept on a couch. Ever sleep on a couch night after night? All you think about is, 'How can I get a room of my own?' You get to the point where you *have* to make good!"

That first night in the new apartment, Barbara cried herself to sleep. She awoke the next morning to an odd clicking sound in her head. Her mother showed little interest, telling her to stop complaining and sleep with a hot-water bottle against her head if the strange sounds bothered her.

The sounds would continue, and before long would be replaced by a permanent high-pitched wail—the classic symptoms of what would ultimately be diagnosed as tinnitus, a persistent and incurable condition that affects the inner ear. To try to stop the strange noise Barbara wrapped a scarf around her head like a turban. It didn't work, and the odd headgear only made her seem that much stranger to the other kids in the neighborhood.

Not long after, Barbara would come upon a pamphlet that listed nine symptoms of cancer and was immediately convinced she had every one of them. "I thought I had cancer," recalled Streisand, who would experience numerous psychosomatic illnesses over the

years. "There were two or three years of my life based on dying. I thought I'd have about six months to live . . ."

Two days before Christmas 1950—on the eve of what would have been Diana and Manny's twentieth wedding anniversary—Louis Kind finally married Diana in a civil ceremony. Their daughter, Rosalind, was born less than three weeks later.

Now Barbara, who had spent her life craving attention from her emotionally inaccessible mother, had to compete with an adorable baby sister. Louis was as resentful toward Barbara as he was smitten with her cute, round-faced, even-featured half sister, Rosalind (later Roslyn). From this point on, Kind did not hesitate to heap verbal abuse on his stepdaughter. When she asked him a question, he behaved as if she wasn't in the room. He would make a point of treating kids in the neighborhood to ice-cream cones, and then, in front of everyone, refuse to buy one for Barbara because she was "too ugly for ice cream."

"Louis Kind was very cruel," Toby Borokow later told a friend. "He would tease Barbara and tell her she wasn't pretty and that she would never amount to anything." Concurred Sheldon Streisand, who in 1952 left Brooklyn to enroll at City College of New York: "Louis was really mean to Barbara. He taunted her continually, telling her how plain she was compared to Rosalind . . ." Kind's sadistic streak extended to his pet names for the little girls: "Beauty" and "The Beast."

Barbara's stepfather did not abuse her physically, although neighbors complained that the sound of yelling, slamming doors, and even breaking glass in the Kind household reverberated through the corridors of their apartment building. Barbara would cower under the dining-room table or hide in a stairwell during several of the more heated rows. Whenever anyone asked why there was such turmoil in apartment 4G, Diana said nothing of her husband's penchant for spending days at a time in the company of other women. Instead, she blamed any tension in her marriage on her children. Lou was, she often said, simply "allergic to kids."

Now enrolled at P.S. 89, which was conveniently located across the street from Vanderveer Estates, Barbara counted Ed Frankel and another neighbor, Maxine Eddelson, among her few friends. A straight-A student and a member of the school chorus, Barbara

nonetheless found it no easier to fit in than she had at the yeshiva. "I was kind of a loner, a real ugly kid, the kind who looks ridiculous with a ribbon in her hair," she later said. Once again, she was "Big Beak," and the constant teasing—coupled with the emotional and physical mistreatment she suffered at the hands of Lou Kind—only served to fuel Barbara's lifelong determination to "show them all." Her drive to succeed academically—Streisand kept to herself and studied compulsively—earned her a new nickname among her peers at school: "Crazy Barbara."

The students weren't the only ones who viewed Barbara as an oddity. "Her nose preceded her by half a block, her eyes peered at each other, and her ears came to points," said her eighth-grade science teacher, Edward Isseks. "She was skinny as a rail and a little awkward, but she was also very smart and had an obvious hunger to learn. I remember her for her intelligence and her spirit more than anything else." At the age of ten, she was also starting to look very unhealthy—perhaps the result of her puffing away on Pall Mall cigarettes while she practiced her singing on the roof of her apartment house. "She had smoker's cough, dark circles under her eyes, and pale skin," said family friend Dora Rosen, who noted that Barbara did not hesitate to inhale deeply. "Not a pretty sight." (Around this time, Barbra would later say, "I taught my mother to smoke.")

Ironically, Louis Kind, who never seemed to notice that his stepdaughter was filching his cigarettes, also unknowingly supplied Barbara with the only antidote to his cruelty: the family's first television set. Soon Barbara would lose herself in the glowing little box that occupied the spot once reserved for the radio. During the afternoons, she could lose herself in family-friendly shows like *Art Linkletter's House Party* and the weepy *Queen for a Day*. Prime time belonged to Lucy, Sid Caesar, Milton Berle, and *The Honeymooners,* and variety shows hosted by the lovable likes of Dinah Shore, Perry Como, and Bob Hope. But none could compare to CBS's Ed Sullivan, whose weekly lineup of legendary performers—interspersed with circus acts, ventriloquists, and the occasional aria or pas de deux—was unparalleled. Barbara sat transfixed with the rest of America as every great star from Ethel Merman, Ella Fitzgerald, and Judy Garland to Frank Sinatra and Elvis paraded across Sullivan's stage.

Even the commercials fired Barbara's young imagination; she

would borrow her mother's lipstick and her brother's art supplies to create her own stage makeup, then act out commercials for toothpaste, cigarettes, and countless other products in front of the bathroom mirror. One moment she was mimicking Dinah Shore's signature "See the USA in your Chevrolet" line, the next she was Chiquita Banana with an imaginary fruit basket balanced on her head.

Barbara's fascination with television even figured in "Crack the Safe," a game she later played with her cousin Lowell. They would call people randomly selected from the phone book and offer a $1,000 prize for answering a few questions correctly. During the call, Barbara would break in to do a "commercial" for Fab laundry detergent. Later, they sent the "winner" fake money in the mail.

While she would admit that she wanted to be an actress from the time she was in second grade, Barbara was also keenly aware of her own vocal talents. Her favorite singers were Peggy Lee, Johnny Mathis, and Joni James, who had scored hits with "Why Don't You Believe Me?" and "Have You Heard?" Now, with her friends Ed Frankel and Maxine Eddelson backing her up, she belted out pop songs and show tunes in the stairwell during the cold winter months and on the front step in the sweltering heat of summer. Even Louis Kind recognized her talent. Barbara's voice was "even then remarkably true" and the songs she sang were "delivered with great feeling," he remembered. Then, Kind went on, the neighbors would stick their heads out their windows, "clap loudly and yell, 'More, Barbara. Give us more!' "

Conversely, Diana did nothing to encourage her daughter. She told Barbara that her voice was "too thin," that she could never make it in show business because "actresses are pretty." She "couldn't fathom why Barbara wanted to be famous, but she did. I was worried she wouldn't succeed and that she would be hurt, so I tried not to encourage her." No matter how hard she tried to shatter Barbara's dreams, Diana said, "I couldn't break up her ideas and her thinking."

Diana's resistance only fanned the flames of Barbara's nascent ambition. "She was critical of me and never believed in me," Barbara recalled. "My mother never said to me, 'You're smart, you're pretty—you can do what you want.' She never told me anything like that." Instead, her mother was always telling her daughter she

didn't want her to get a "swelled head," to think that she was any-
thing other than ordinary—at best. "I was always trying to prove to
her that I was worthwhile," Barbara said, "that I wasn't just a skinny
little *marink*."

Unfortunately, Barbara's teachers at P.S. 89 seemed to share Di-
ana's assessment of her daughter's talent. When Barbara asked to be
part of the school's big folk-dance festival, teacher Seymour
Lebenger told her point-blank: "You can't sing a note or dance a
step. You just don't have the talent." She shrugged off such com-
ments, and when her mother forbade her to act out scenes in front
of the bathroom mirror, Barbara merely snuck up to the roof.

As part of her preparation toward becoming the personality she
knew she was destined to be, Barbara hounded her mother to sign
her up for ballet lessons. No sooner did her dance teacher move out
of Brooklyn—thus abruptly ending Barbara's dreams of becoming
another Ginger Rogers or Cyd Charisse—Barbara insisted her
mother take her for auditions at MGM's Steve Allen recording stu-
dios in Manhattan.

Standing at a microphone in a glass booth, Barbara got her orders
from a sweaty man visible just a few feet away in the control room.
"All right, kid, sing!" the sweaty man commanded, and Barbara
obediently launched into an a cappella rendition of Joni James's up-
tempo hit "Have You Heard?" Bounding out in her blue dress with
white collar and cuffs, she expected to be offered a contract on the
spot. She wasn't.

Now and then there were people, however, who sat up and took
notice when the little girl with the skinny legs, huge blue eyes, and
sizable nose burst into song. After Barbara graduated from middle
school, Diana took her daughters for a weekend in the Catskills sans
Lou, who had once again taken off with one of his mistresses.
When Barbara easily won a talent contest at the hotel where they
were staying, two guests approached her with offers to sing at their
weddings—paying jobs, she was quick to point out to her mother.

That September, thirteen-year-old Barbara enrolled at the presti-
gious Erasmus Hall High School, the crown jewel of New York
City's public-school system. The Dutch Reform Church estab-
lished Erasmus Hall as an all-boys private preparatory school in

1786, and its early patrons included Alexander Hamilton and Aaron Burr. By the time Barbara arrived, Erasmus Hall was more famous for producing a number of Westinghouse science winners and movie stars like Mae West, Barbara Stanwyck, Jeff Chandler, and Susan Hayward.

From the start, Barbara was intimidated by Erasmus Hall's vaunted academic reputation, its imposing neo-Gothic architecture, and its sheer size; when she arrived, the school boasted a total student body of over six thousand. She had never really fit in with the rest of the kids at her yeshiva or at P.S. 89, and she was convinced the same fate would befall her in high school.

Not that she didn't try. Still convinced that she was fundamentally unattractive, Barbara went to great lengths to compensate for what she believed nature had failed to provide. She was meticulous about her clothes, which conformed to the teenage fashions of the day—sweater sets worn with a single strand of fake pearls or a neckerchief, long skirts, white stockings, saddle shoes. She wore her hair up, and she spent an hour or more every morning working on her makeup—especially the eyes, which she showcased with mascara and blue eye shadow. "She had the most incredible eyes—just beautiful," said a classmate, Norman Schimmel. "And she was always very skinny." As for Streisand's prominent nose: "We *all* had Jewish noses," said Barbara's friend and classmate Diane Silverstein Lemm. "We all talked about getting nose jobs, all of us."

There were those classmates who insisted Barbara was nothing like the weirdly dressed "kook" she later made herself out to be. "All of us thought she was good-looking. There was *never* any pity," Lemm said. "Barbara did *not* look bizarre. I won't buy that. Not in high school."

Norman Schimmel, who was arguably her closest male friend at Erasmus, agreed that Barbara was "by no means ostracized. She was not part of the 'in' group because that was her choice. She knew what she wanted from the beginning, and that's where her focus was. She walked her own path." But Schimmel also conceded that her appearance raised eyebrows. "These were the days when girls wore poodle skirts and the guys were either jocks or rock and rollers. Barbara was something different. She would show up wearing some

strange outfit she found at a thrift store. She was just very . . . bohemian."

Of special significance were her fingernails—long and elegant and painted fire-engine red. Diana had demanded that her daughter take typing lessons on the grounds that they would prepare her for a "real" job as a clerk or a secretary. By growing her nails long and keeping them that way, Barbara could argue with some conviction that typing wasn't an option for her. The manicured nails were part of what made Barbara feel glamorous, but they were also a symbol of defiance in the face of her mother's continued insistence that she was "nothing special."

On rare occasions, Diana indulged her elder daughter's dreams of stardom. On a tip from the pianist who had accompanied Barbara during the talent show in the Catskills, mother and daughter went to the Nola Studios on Manhattan's West Fifty-seventh Street to cut a demo record. The pianist, recognizing the special quality of Barbara's voice, offered to go along. The total cost for studio time and a recording engineer: four dollars.

Diana, intrigued by the idea of recording her own singing voice, went first with the schmaltzy light-opera standard "One Kiss." Unfortunately, the piano player overpowered her with endless, elaborate refrains. When Barbara launched into Judy Garland's up-tempo hit "Zing Went the Strings of My Heart," the accompanist started to do the same thing. "NO, NO," the thirteen-year-old barked. "We'll just do a *little* interlude and then I'll come back in." Duly chastened, the piano player delivered a subdued accompaniment. For her second number, Barbara picked a ballad, "You'll Never Know." This time it was Barbara who got carried away at the end of the song, adding a few extra syllables and trills. "I guess it was my first musical improvisation," said Barbara, who a half century later was still holding on to that first recording. Once she got home and heard her improvisational take on the Alice Faye standard, Barbara asked herself, "Who was that? Where did that come from? It was like *The Exorcist.*"

At school, Barbara's talents—and her personality—remained largely hidden from view. Unsure of whom to talk to, not quite fitting into any of the school's varied cliques, she simply kept to herself. While her peers congregated in the hallways between classes,

she invariably stood off to one side clutching her books, alone and apart. With the exception of the school chorus, she shied away from extracurricular activities and stuck to her studies. She was an exceptional student, even by Erasmus Hall standards. In her freshman year she earned a 93.5 percent grade-point average—a level of academic performance she maintained throughout high school.

Not surprisingly, the other students misinterpreted Barbara's fundamental lack of confidence as haughtiness. It did not help that Barbara, still lacking in social skills, made no effort to mask her astonishment when another student didn't know something or failed to answer a question correctly. "You mean," she would blurt out contemptuously, "you didn't know *that*?"

For the most part, Barbara went unnoticed by her classmates at Erasmus Hall. Most of those who did notice her remembered only a cold, aloof loner. "I was this absolute misfit," she later conceded. "A real outsider."

Accordingly, she did not attend either her junior or senior prom, and was never asked out on a date. There was one boy she had a crush on, however—another loner in the class behind hers, someone who also seemed in a world of his own. His name was Bobby Fisher. Every day she had lunch with Fisher, who wore a hat with earflaps and laughed hysterically as he read *Mad* magazine. "Bobby was always much, much farther out there than Barbara," Schimmel said. "He was just very odd—bizarre, really—even then."

Already a chess champion, Fisher was indeed "always alone and very peculiar," Streisand agreed. "But I found him very sexy."

The few friends Barbara did have—they gave her the nickname "Colorful" because of her striking blue eye makeup, red fingernails, and pastel wardrobe—smoked with her off campus and accompanied her on the occasional shoplifting spree. Barbara lifted candy— Cinnamon Hots and Jujubes were particular favorites—and cosmetics. But she was also more ambitious than her fellow thieves. She would search a department store for receipts that had been tossed into a trash can or thrown on the floor, find the items that matched the receipt, and then turn them in for a full cash refund.

These few friends also knew Barbara could sing—not pop tunes but, ironically enough, the carols that were performed by Erasmus's mostly Jewish freshman chorus at the school's popular

Christmas concerts. "Back then," said Lemm, "Hanukkah wasn't even discussed . . ."

Not everyone at school was that impressed with Barbara's vocal talent. Although she was admitted into Erasmus Hall's Choral Club, the school's musical director, Cosimo De Pietto, placed her in the back-row alto section. Like most of the other girls in Choral Club, Barbara had a crush on the swarthy De Pietto—all of which made it that more hurtful when he overlooked her for solos. Those always went to Trudy Wallace, the attractive blond soprano everyone at Erasmus predicted would become the next Deanna Durbin.

In 1956, Louis Kind went out for the proverbial pack of cigarettes and never came back. As pleased as Barbara was to be finally rid of her abusive stepfather, Kind's permanent departure meant that the family would have to struggle that much harder to make ends meet. Now that she was confronted on a daily basis with "Cashmeres"—the cashmere-sweater-wearing Jewish girls who commuted to Erasmus Hall from their homes in the upscale enclaves of Long Island—Barbara wanted out of gritty, smelly, noisy Brooklyn more than ever.

It didn't help that Barbara was spending every Saturday afternoon at Loew's Kings Theater on Flatbush Avenue. "I always loved the smell of that theater," she said. "The cooled refrigeration and the hot buttered popcorn . . . they had the best ice cream." Inside, Barbara said, "I was the character in the movie, not the actress. I was not Vivien Leigh, I was Scarlett O'Hara, and I loved being the most beautiful woman being kissed by the beautiful man." When she saw *Guys and Dolls,* she instantly fell in love—not with Frank Sinatra, but the musical's other male star, Marlon Brando. "I thought, 'What a *gorgeous* man!'"

"Life was so beautiful in the movies," Barbara said. "How beautiful it all looked, how perfect it all looked, until I stepped one foot out of the theater and it all seemed so depressing."

Shortly after her fourteenth birthday, Barbara went along with several school friends to audition for a radio show. She chose a speech from George Bernard Shaw's *Saint Joan* and, as she knew she would be, was promptly turned down for the part. Not long after, she read that famed Hollywood director Otto Preminger was in

New York searching for an unknown young actress to play the title role in his screen version of *Saint Joan*. Convinced that this was some sort of sign from above, Barbara took the subway into Manhattan, went straight to Preminger's offices at United Artists, and was promptly told she was too young for the part. (The role would eventually go to seventeen-year-old blond beauty Jean Seberg.)

Like everyone else at the time, Barbara was desperate to see Rex Harrison and Julie Andrews in the original Broadway production of *My Fair Lady*. But there was no way Diana could afford what were then the highest ticket prices for a show in Broadway history. Instead, Barbara opted for matinee tickets to another, more affordable hit, *The Diary of Anne Frank* at the Cort Theater. When the curtain rose on the set, Barbara, sitting in the last row of the balcony, was "awfully disappointed, looking at the dreary setting." But as the inspiring true story of the feisty Jewish girl whose family hid from the Nazis in an attic unfolded, it slowly dawned on Barbara that the title character was very much like her—and that because she could identify with Anne Frank, she could easily play her. In fact, Barbara felt that there was no part in the play that was beyond her reach as an actor. "I remember thinking that I could go onstage and play any role without any trouble at all."

In the summer of 1957, Barbara was once again badgering her mother—this time for the money to pay for an apprenticeship at the Malden Bridge Playhouse near Albany, New York. Unbeknownst to Barbara, she actually had the money—$150 her grandfather had left her when he died earlier that year. But Diana wanted to use the money to fix Barbara's teeth, which became infected when two of her baby bicuspids refused to make room for her adult teeth. The dentist extracted the baby teeth, leaving two gaping holes on either side of her mouth that for the next year Barbara would fill in with Aspergum. "It was," she explained, "the closest color I could get to real teeth."

Barbara, still the *farbrent* ("on fire") child who refused to take no for an answer, hounded her mother until Diana finally agreed to use what was left of her daughter's small inheritance to send her to Malden Bridge. She had to lie about her age to get in; the fifteen-year-old managed to convince them that she was seventeen.

It would be a turning point for Barbara. At the playhouse, which

catered largely to New Yorkers vacationing in the Adirondacks, she played a Japanese child in *Teahouse of the August Moon,* a flirtatious secretary in *The Desk Set* ("Can't you just see me at fifteen—coming on the stage, sitting down on a desk, swinging my leg, and playing sexy?"), and Millie, the teenage tomboy in William Inge's *Picnic.*

Not all of her fellow apprentices appreciated Barbara's in-your-face attitude. While everyone else waited patiently in line for their turn to use the bathroom, Barbara simply shoved past them. In the dining hall, she cut in line or elbowed her fellow apprentices out of the way. She was, said fellow-actress-in-training Ingrid Meighan, "very overbearing and unpopular—a little Brooklyn brat."

Barbara would later credit—or blame—her family for what she acknowledges is her obvious lack of social skills. "I wasn't taught manners," she admitted. "My family never had meals together. We never had conversations. I would eat over a pot. I would sit with my leg up at the table . . ."

But no one doubted Barbara's drive to succeed. For the first time in her life, she was receiving encouragement from her director, her fellow actors, and local newspaper reporters who went out of their way to praise the brash young newcomer even when the parts she played were minuscule. "The girl who plays the office vamp is very sexy," read her first review, "and her name is Barbara Streisand. *Down boys!*"

When she returned home to Brooklyn, however, Barbara discovered that nothing had changed on the home front. Diana had hoped that Barbara's stint in summer stock would "get it out of her system" and that she would now focus on getting the typing skills needed for an office job.

Again, Barbara turned to a neighbor for reassurance. When Diana decided to get a job selling women's lingerie door-to-door—a move necessitated by the now-departed Louis Kind's increasing unwillingness to support his family—Barbara went to work babysitting for a neighbor, Muriel Choy. The Choys owned a Chinese restaurant nearby, and while Muriel and her husband, Jimmy, were at work, Barbara often looked after their two small daughters. Recognizing that Barbara was something of a whiz at math, they put her to work in the restaurant, first as a cashier. She also took take-out

orders over the phone and occasionally functioned as hostess, showing customers to their tables.

Like Toby Borokow before her, the warm, openly affectionate Muriel Choy became something of a surrogate mother to the lonely girl from apartment 4G. She was also the person who taught Barbara "about love and life and sex . . . I would ask her things that my mother never told me. Just about being a woman."

At one point, Muriel Choy began talking to the wide-eyed girl about sexual positions. "Is the man always on top?" Barbara asked.

"Not necessarily," Choy replied.

"What?!" Barbara responded. It was an exchange Streisand would remember for the rest of her life.

For the moment, Barbara was less interested in the opposite sex than she was in pursuing her dreams of stardom. Incredibly, the fifteen-year-old persuaded her mother to let her take the subway into Manhattan several nights a week and on weekends so she could work as an unpaid apprentice at the Cherry Lane Theater in Greenwich Village. This time, Barbara was primarily a gofer; when she wasn't sweeping the stage or acting as script girl, she was fetching food for the cast from the local delicatessen.

Eventually she caught the eye of Anita Miller, who played the part of Avril in the Cherry Lane production of Sean O'Casey's *Purple Dust*. Miller told her husband, the acting teacher Allan Miller, about the strange, stagestruck girl who never stopped asking questions. Allan, keenly aware of the sacrifices demanded by the acting profession, resisted the notion of taking a fifteen-year-old high-school junior under his wing. "I'm not going to encourage someone that young to go into the theater. It's a tough, tough business, and I just won't do it. It's too hard." But his wife was convinced there was "just *something* about her. I can't put my finger on it, I don't know what it is," she told him, "but you have just got to see her."

Since she was unable to persuade her husband to see Barbara, Anita Miller agreed to help the wide-eyed apprentice prepare for an audition at the Actors Studio. Barbara again lied about her age—the Actors Studio accepted no one under the age of eighteen—but to no avail. She was turned down. Despite what Anita thought was a strong performance in a scene from N. Richard Nash's *The Young and Fair,* Barbara was rejected.

Determined to help Barbara out, Anita simply brought her home, unannounced, for dinner. His wife and "The Creature," as Allan Miller referred to Barbara, had prepared another audition scene. It was "the worst, most disjointed and embarrassingly bad thing I have ever seen," Miller said. "She couldn't act her way out of a paper bag." But it hardly mattered. He was as impressed as his wife had been with Barbara's "ferocity, her rawness . . . She was so *desiring*. She was so full of this young, raw eagerness." On the spot, he offered to let her enroll in his acting workshop at the Theater Studio of New York on West Forty-sixth Street. In exchange, she offered to babysit the Millers' two sons.

By this point Barbara, whose previous reading had consisted almost entirely of Nancy Drew mysteries, was besotted with the theater. Now she rushed to the New York Public Library to devour books about Sarah Bernhardt and Duse, as well as the works they performed—Shakespeare, Greek tragedies, Russian plays, and Russian novels adapted for the stage. Tolstoy's *Anna Karenina,* she later proclaimed, "changed my life." What she wanted more than anything, she gushed to anyone who would listen, was to become a "great actress."

By way of hedging her bets, Barbara, who secretly suspected her voice might end up being her passport to stardom, also spent hours at the main library on Forty-second Street listening to recordings by the likes of Billie Holiday, Ella Fitzgerald, and Sarah Vaughn. She wanted to learn about phrasing and vocal techniques, what songs they chose to sing, and whom they picked to do the orchestrations. As much as she wanted to learn everything there was to learn about acting, Barbara wanted to know what went into making a truly great singer.

It would be weeks before Miller offered her a speaking part at his acting workshop—a scene in Tennessee Williams's steamy *The Rose Tattoo.* Barbara took the script home to read, then called Miller the next morning to tell him that she couldn't bring herself to do it. The scene called for her to play a teenager trying to seduce her boyfriend, who resists because he has vowed to her mother that he won't take advantage of her.

Barbara hemmed and hawed, but it soon became clear to Miller that she felt awkward playing the role. Since she was still a virgin,

she felt she had no real life experience to draw on for the role. Miller urged her to think about how she could make the part work by removing the sexual component entirely—by acting as if it had nothing to do with sex at all.

Barbara rehearsed the part for over a week, but when the time came for the actual performance in front of the rest of the class, she startled the boy she was acting with by standing on his feet, tickling, nuzzling, and jabbing him—and at one particularly startling point, jumping on his back. When it was over, her fellow students cheered wildly.

There was method to her madness. "I gave myself the image of being on fire and the boy was ice," she recalled. "But that came out a little too passionate and painful. So I changed to a very technical thing . . . I tried to touch every part of his body with every part of my body without ever touching the same part twice." The result was a touchingly poignant portrayal of pent-up adolescent sexuality. "It was awkward, it was sad, it was funny, it was—I think—right."

Barbara's own sexual awakening was not far behind. Another of Allan Miller's students, twenty-three-year-old Roy Scott, was intrigued by the kid from Brooklyn. Boyishly handsome and the workshop's resident ladykiller, Scott was fascinated by the "very plain" girl with the huge blue eyes, the flame-red fingernails, and the quirky personality. She impressed him as shy, vulnerable, "wondrous in her own way." Scott became her first lover, taking up where Muriel Choy left off when it came to answering any questions Barbara had about sex.

Now, when she wasn't staying over at the Millers' West Fifty-fourth Street apartment on the pretext of babysitting for them, she was spending nights six blocks away with Scott in his small room at a residential hotel for actors. Diana Kind was understandably upset—and angry that so many people had seemingly conspired to lure her daughter away from home. Barbara was, after all, still just a sixteen-year-old high-school student.

Diana regularly phoned the Millers and screamed at them for corrupting her daughter. When she learned that Barbara had lost her virginity to Scott and was spending nights with him, she went over the edge. "Diana was a real piece of work. She accused us of being white slavers, among other things," Allan Miller recalled.

"Her main concern seemed to be that we were costing her money. Barbara was a source of income for the family, and Diana didn't like the idea that we might be taking that away from her. I mean, with a mother like that, you could understand why Barbara ended up being so penurious. There was always this fear of running out of money."

When the Millers failed to intercede in the matter of Barbara's amorous actor friend, Diana phoned Scott's apartment in a panic and demanded that he end their relationship and send her home. Worried that her mother might call the police, Barbara fled Scott's room in tears and returned to Brooklyn.

The Barbara who returned to Erasmus Hall for her senior year was no longer called "Colorful." She dressed head to toe in black. "I used to look like a real beatnik," said Barbara, who now seemed to embrace her reputation for being cold, aloof, even arrogant. Her new best friend, Susan Dworkowitz, wore "white makeup and kooky clothes," Barbara said. "I used to call her 'Pasty-Face.' I liked her immediately."

Barbara took only one acting class in high school, but made no further effort to display her talents by trying out for a school play. "Why go out for an amateurish high-school production," she asked, "when you can do the real thing?" Eager to get back to "the real thing" in New York, Barbara piled on the extra courses needed to graduate six months early.

Before she graduated, Barbara was actually able to snag a professional role, as Lorna in Maurice Tei Dunn's eminently forgettable drama *Driftwood*. The production was staged at the "Garrett Theater," more accurately the attic space above Dunn's grimy fifth-floor walk-up. The unheated "theater" could accommodate an audience of twenty people at most.

One of the other cast members was Joan Molinsky, an aspiring actress and stand-up comic who would soon change her name to Joan Rivers. Her first recollection of Streisand was of "a skinny high-school girl with a large nose and a pin that said 'Go Erasmus.'" Barbara, though a good decade younger than nearly everyone else, took the initiative and introduced herself to Rivers at the first rehearsal. "She was just this bouncy Brooklyn kid—very friendly and not at all shy."

Rehearsals were held in Dunn's living room, and the cast kibitzed about acting over coffee in the cramped kitchen. "I liked her right away. She told these terrible jokes, but she was funny anyway," Rivers said. "We clicked right away. She was still sweet and not above getting her feelings hurt, but she was also pretty damn tough. You knew she was going to do whatever it took to make it."

In *Driftwood,* Barbara played Lorna, a thirtysomething barfly. Rivers assayed the role of a knife-wielding prude. The potboiler was, predictably, dismissed by the one critic who showed up as so badly written that the actors' performances could not be critiqued. When Rivers told Barbara that the play was closing after six weeks, Streisand seemed relieved. "It's just as well," she said. "I got midterms."

By the time she graduated at the age of sixteen in January 1959, the straight-A student ranked fourth in her class. Not surprisingly, few of her fellow students or teachers missed her. During graduation ceremonies that June, "Class Actress" honors went to Harriet Mersel. Trudy Wallace, the soprano who'd gotten all the solos, was named "Class Singer." Decades after she had achieved stardom, this still annoyed Barbra. "They had this other girl, an opera singer," she recalled. "*She* was going to be a big star, they said."

That February, Barbara and her pale-faced friend Susan Dworkowitz moved into a studio apartment on West Forty-eighth Street. Not wanting Miller to know she had also signed up for acting classes with another noted acting teacher, Eli Rill, Barbara decided to enroll under a name she plucked from the Manhattan telephone directory: Angelina Scarangella. It would come in handy during auditions as well, when she felt producers might be looking for a more Mediterranean type.

Barbara had no serious interest in actually changing her name, however. "I wanted all the people I knew when I was younger," she would say, "to know it was me when I became a star."

Rill quickly learned that the skinny girl who padded her bra with socks and occasionally showed up with dyed red hair had no interest in pursuing her natural gifts as a comedienne. "She was curious when the other students laughed at her mannerisms onstage," Rill said. "She did not like being laughed at. I kept telling her she had to develop what she had and not try to be somebody else. She would make it clear that my role was to make her into a tragic muse."

Armed with an inflated résumé and plenty of attitude, Barbara pounded the pavement in search of an acting job. Weeks of auditioning without any success took their toll. She did not take rejection well, and rejection was all she experienced.

Barbara often couldn't even get past the receptionist. Borrowing a page from her friend Susan, she wore Kabuki-white makeup, black tights, and a black trench coat. "People looked at me," she remembered, "as though I was nuts."

When she did get past the front desk, she was invariably rejected out of hand—without even being given the opportunity to do a reading—ostensibly because she lacked experience.

"What have you done?" someone in the shadows would ask.

"Nothing. Wanna hear me read? Look, you better sign me up. I'm terrific!"

"Sorry," came the terse reply. "NEXT!"

"How do I get experience," she invariably pleaded, "if no one will hire me?"

More often than not, the real reason for her not being allowed to audition had less to do with her lack of experience than with her appearance. On the rare occasions when she was permitted to read for a part, casting directors would wait for her to leave the room before discussing whether she was "too ugly" to put in their production. It did not help that Barbara was battling teenage acne, and would go for extended periods without washing her hair, leaving her long dark hair stringy and at times matted. She had developed, she confided to one of her fellow acting students, something of a phobia about putting her head under water.

Barbara found the audition process degrading, humiliating. "It was their opportunity to say, 'You sit in the corner there, you wait in line there' . . . It was so depressing," she added. "I cried in practically every office."

Before long, frustration turned to anger. "You'll be sorry," she would tell startled directors and casting agents. "You'll come after me. I'm not going to come after you. I'm not going to bang on your door and say 'Hire me.' That's *your* problem. Screw you! I ain't coming back and asking you for no work!"

As a result, Barbara knew she was crossing some of the very

people on whom her life in the theater would depend. "I made terrible enemies," she later conceded. But after months of rejection, Barbara concluded that she would no longer subject herself to the proverbial Broadway "cattle calls," as open auditions are known. "I decided I was not gonna come back and knock on their doors and tell them that they've got to hire me," she said. "My pride as a person was more important to me than a job."

In fact, she already had a job, as the only switchboard operator at a small Manhattan printing company called Michael Press. After a little more than seven months, she was abruptly fired—in part, ironically enough, because her coworkers found Barbara Streisand's habit of humming on the job "irritating."

No matter. For a while she lived on handouts from friends and her $32.50 in weekly unemployment benefits—until someone with the labor department discovered Barbara had violated the rules by looking for work not as a switchboard operator but as an actress. "The penalty was standing in line for five weeks before I could receive another check," she remembered. "How could I do that? What a waste of time."

Now Barbara focused on her acting, dividing her time between acting coaches Rill (he still knew her as "Angelina Scarangella"), Curt Conway, and Allan Miller. At Miller's Theater Studio, students were asked to portray an inanimate object of their choosing. Barbara picked a chocolate chip cookie. "I was stuck into a sticky batter, put into an oven, where I swelled and started to melt and burn," she said. "I was taken out of the oven, where the air congealed my outer layer, leaving my insides mushy. My head started to droop when somebody ate me. Chocolate chip cookies have never tasted the same . . ." Marilyn Fried, who had just replaced Susan Dworkowitz as Barbara's roommate, witnessed the performance. "After that day," Fried said, "I knew Barbara was going to be a great artist."

It was at Miller's Theater Studio that Barbara also first encountered another struggling, headstrong, far-from-conventionally-attractive young actor with a sizable nose and both ego and talent to match. Dustin Hoffman was making his share of enemies by lashing out at directors and casting agents.

Hoffman was instantly impressed by the "funny-looking girl," by her talent—and her ambition. "Did you ever see those pictures of a mother bird with the worm and there's a bunch of baby birds with their mouths open?" Hoffman asked. "Somehow there's one that's trying more than any other to get that worm from their mother. That would be Barbara." (Years later, Hoffman would run afoul of his old friend by claiming they both "cleaned toilets" to pay for their acting lessons. "You were the janitor that cleaned the toilets," she told him. "I would never clean a toilet. I was babysitting to pay for my lessons. Don't tell people I cleaned toilets with you! I didn't.")

Even after she had been rejected by the Actors Studio, Barbara's faith in her own abilities as an actress remained unshakable. "It was their tough luck," she said, "if they couldn't recognize talent when it was right there, staring them right in the face." Oddly, Barbara still harbored grave reservations about the quality of her voice. "I really don't know if I can sing," she would say. "Now, Joni James, *she* can sing."

It was at the Curt Conway Studio where Barbara met Cis Corman, another surrogate parent who would turn out to be her lifelong best friend. Barbara was fifteen when they both acted in a class production of Christopher Fry's *The Lady's Not for Burning*. "We became her surrogate family," said Cis, who was married to psychiatrist Harvey Corman. "I had four kids. I had roots. I had a refrigerator full of food."

While she looked for acting jobs Barbara had reluctantly taken a job as an usher at the Lunt-Fontanne Theater, where Mary Martin was making history as Maria in Rodgers and Hammerstein's *The Sound of Music*. Still completely convinced of her own future stardom, Barbara left no doubt that she felt the job was beneath her; determined that no one would ever know that the Great Streisand had once worked as an usher, she kept her head turned away from theatergoers even as she led them to their seats.

The job would wind up having a profound effect on Streisand, however. As she stood in the back of the theater, clutching her programs and her flashlight, Barbara studied every line of dialogue, every lyric, every nuance of every performance. More important, she came

to the realization that, like *The Diary of Anne Frank, The Sound of Music* offered its own important—albeit decidedly less harrowing—take on the rise of Nazism. Musicals were not all froth; they could tackle the most serious topics, deliver significant, rather sophisticated social commentary, *and* offer any actress who could sing an opportunity to deliver a serious dramatic performance as well.

When she learned that producers were auditioning cast members for several road-show companies of *The Sound of Music,* Barbara mailed off her résumé and the only eight-by-ten glossy she had—a portrait taken of her in costume by a student photographer. The picture, which in essence was her payment for sitting as a model, depicted Barbara as some sort of exotic character draped in flowing robes, scarves, and veils, her hair piled on her head, her eyes ringed with heavy mascara, her lips smeared with dark lipstick.

The show's casting director, Eddie Blum, shook his head in disbelief when he saw the bizarre photo of the homely seventeen-year-old straining to look fifty. He had no intention of considering her for the role of Liesl, which she was aiming for, or even for a place in the show's chorus. Her appearance, he would later say, was "too off-putting." Still, there was something compelling about the strange-looking creature in the photograph. It would be months before Blum summoned her to the Rodgers and Hammerstein casting offices. "He wanted to see," she told a friend, "what kind of a kook would send out that weird picture."

In the meantime, Barbara, rather than stoop to singing in a nightclub ("I thought singers were kind of . . . well, I didn't want to be one"), went ahead with her plans to play a bug in an embarrassing production of a very bad Czechoslovakian play. "*That's* how bad I wanted to be a serious actress," she said.

A handful of Barbara's fellow unemployed thespians got together to form what they called the "Actors' Co-op." By virtue of the fact that no one was likely to pay to see them, the out-of-work actors called themselves a "nonprofit group" and set out to put on small productions with whatever meager backing they could find. Their first—and, not surprisingly, last—production was *The Insect Comedy* by Karel and Josef Čapek. The play, which was subtitled "The

World We Live In," had featured an endless parade of actors dressed as moths, butterflies, crickets, ants, snails, and beetles skittering, hopping, and flitting across the stage when it was first presented on Broadway in 1922.

Boasting a huge cast and eye-popping sets, *The Insect Comedy* had been a huge hit thirty-eight years earlier. By contrast, the Actors' Co-op production featured a cast of only thirteen and was staged in the Jan Hus Playhouse Theater, actually the auditorium of the Czech National Hall on East Seventy-third Street. Barbara was cast as a butterfly and a moth. It was during rehearsals that she met Barre Dennen, cast as Felix the "poet butterfly." The first time he saw Barbara, Dennen recalled, "she was madly running around an empty theater stage, desperately and ditzily flapping a pair of butterfly wings stuck to her shoulders."

Twenty-two-year-old Dennen (he would later change his first name to the less pretentious-sounding "Barry") took an instant liking to the quirky, quick-witted Miss Streisand. He admired her spunk, her sense of humor, and her sense of style—already guided in part by the aspiring artist and designer Terry Leong. Soon Dennen was tagging along as Barbara and Leong, who had been introduced to her by Marilyn Fried, trawled New York's thrift shops and low-end antiques stores in search of hidden treasures.

Dennen already knew that his strange new misfit friend had the makings of an actress, but he had no idea she could sing. When Barbara told him that Eddie Blum had finally responded to her bizarre photograph and summoned her to his offices for an audition, Dennen could only feign enthusiasm. Even if she could sing, which he seriously doubted, it was impossible to imagine Barbara onstage among the nuns and the Nazis who backed up the irrepressibly bubbly Mary Martin.

Blum, however, turned out to be considerably more perceptive than the other casting directors Barbara had encountered. After he heard her sing "Do-Re-Mi" and "My Favorite Things" from *The Sound of Music* score, Blum was so intrigued that he invited her to lunch. For the next nine hours as lunch dragged into dinner and beyond, he quizzed her on everything from her life growing up in Brooklyn to her stint behind the cash register at Choy's to her dreams of becoming another Sarah Bernhardt.

In the end, as Barry Dennen predicted, Blum told Barbara there was no way he could hire her for *The Sound of Music*. She did not look the part—the Austrian Von Trapps were even more Aryan-looking than the Nazis who pursued them over the Alps—and her voice was simply too distinctive, too overpowering, to blend into the background as part of the chorus.

Although he did not hire her, Blum gave Barbara something that was every bit as important: encouragement from a professional, someone who clearly knew what he was talking about. "For heaven's sake," he told her, "use that voice. Get yourself a job singing in a nightclub or something."

Even praise from a man like Eddie Blum was not enough to make Barbara put aside her dreams of becoming an important actress, even momentarily. Dismissive of her talent as a singer, she described her performance for Blum—he would later admit that her rendition of songs he had heard a thousand times nearly moved him to tears—as "just a lot of screaming." (At this point, her disdain for singing and singers was such that Barbara routinely referred to it as "screaming" or "yelling.")

Dennen had no reason to doubt Barbara's own unsparing assessment of her vocal talents. So he was understandably taken by surprise when she showed up at his Greenwich Village apartment with Carl Esser, a friend from one of her acting classes. Esser had brought his guitar with him. Barbara asked to use Dennen's Ampex stereo equipment. Blum had asked her, she explained, to make a tape of her singing. Dennen thought to himself that Barbara was desperate to break into show business in any way she could, and that she had the "chutzpah, the unmitigated gall, to present herself as a singer."

"This is exciting!" Barbara said as she looked up from her music. Dennen, thinking only of how not to hurt her feelings, fiddled nervously with the controls of the tape recorder. Moments later, after she had sung the first few phrases of a Sammy Cahn standard made famous by Frank Sinatra, "Day by Day," Dennen blinked. "And then something like a cold electric shock ran right up my spine from my heels to my head." Dennen thought he was losing his mind. "My heart started to pound faster. Imagine hearing Barbra sing for the very first time!" Dennen would later say this was the

precise moment when "this nutty little kook," he thought he knew began to morph from "Barbara" to "Barbra."

Once the song was over, Dennen had to catch his breath before he could even look at her. When he finally blurted out that her voice was "incredible . . . amazing," Barbara seemed surprised, though far from overjoyed. When Dennen begged her to enter the weekly talent competition at The Lion, she balked. It could be the first step toward a bona fide nightclub act—an act he volunteered to help her put together.

No dice, Barbara replied. "I don't wanna sing in a nightclub," she protested. "I don't like air-conditioning, and drinking, and all that cigarette smoke. I wanna *act*!"

Dennen told Barbara that singing—good singing—*was* acting, and played one of Edith Piaf's melancholy recordings to prove it to her. Barbara wavered, but only a little.

Later that night, Barbara dropped in on her friends the Cormans. "Y'know," she announced in their kitchen, "I'm gonna enter a contest for singing."

"Why would you do that?" asked Cis Corman, who in two years had never even heard Barbara hum. "You don't know how to sing."

"Yeah, I do," Barbara replied.

"Well, sing for us," Cis said. Later, she would be struck by how "silly" it was for her to have issued such a command.

"I'm too embarrassed," Barbara said, hesitating. "You can't look at me . . . Look, I'll sit on the table and look toward the wall. Promise not to laugh . . ." With that, she sat on the table and began to sing "A Sleepin' Bee."

When she was finished, Barbara waited for a moment, fearing the worst. There was an awkward silence. Barbra squirmed on the table. "Hey, guys, you okay?" she asked, still facing the wall. "It was terrible, wasn't it?"

Then she took a deep breath and turned to see Cis and Harvey looking at her as if they were seeing her—really seeing her—for the first time. Tears were streaming down their faces.

"No, Barbara," said Cis, wiping her eye with the back of her hand. "It was beautiful. Absolutely . . . beautiful."

I'm not a singer. I'm an actress who sings.

She carries her own spotlight.

—Jule Styne, composer of *Funny Girl*

Rumors about her abounded. She was temperamental, she was unpredictable, she was foul-mouthed, she was nuts. She was also one hulluva singer.

—Mel Tormé

She was a real bully. As soon as she sensed fear in anyone she went for the throat.

—Bob Mersey, producer of Barbra's *People* album

Marriage to her is like a bath of lava.

—Elliott Gould

3

The Summer of 1960

I want a steak and a baked potato," Barbra said.

Ernie Sgroi, owner of the Bon Soir, looked at her quizzically. She was wearing a four-dollar black dress, a two-dollar Persian vest, and old white satin shoes with large silver buckles that she'd picked up at a thrift shop for fifty cents. "A steak *and* a baked potato?" Sgroi asked.

"Yeah," his new singer said flatly. "With sour cream and chives. And I'll get some eight-by-ten glossies, and I want them out front. I want one of them at the top, and one at the bottom."

Sgroi paused for a moment. "Well," he said calmly, "the other people that perform here are also very talented and they only get one photo."

"Take it or leave it," Barbra replied without missing a beat. "I want those eight-by-tens, and I want a steak and baked potato every night. That's the deal."

After eight weeks of packing them in at The Lion, Barbra was ready to make the move around the corner and light-years away to the Bon Soir, at the time the most chic of all the Greenwich Village clubs. With no experience prior to her amateur nights at The Lion, she was in no position to ask for more than the $125 per week offered to every entry-level act at the Bon Soir. Her only bargaining chip, she reasoned, was food—though she later admitted to Barry Dennen that she'd balked at pressing for a shrimp cocktail and

dessert. "Food was love," she later explained. "It was important that they be willing to feed me . . . I've made lots of deals based on a meal."

Despite her success at The Lion—and a rave endorsement from The Lion's manager, Burke McHugh—Barbra had still had to audition for the job at the Bon Soir. Watching from the wings was the club's headliner at the time, the comedian Larry Storch. "Kid," he said, pulling her aside when she was finished, "you're gonna be a star."

Barbra had no doubt of that. Since her engagement at the Bon Soir didn't actually begin until after Labor Day, she had four weeks to work on putting together a new, more sophisticated act. In the meantime, she landed the part of the French maid in a summer-stock production of *The Boy Friend* in Fishkill, New York. With Dennen helping her nail down a passable French accent, Barbra practiced her one song, "It's Nicer in Nice," for hours at a time in front of a mirror. She stopped the show.

Theatrical attorney Si Litvinoff, whose list of clients included Beatrice Arthur, Andy Warhol, and Joel Grey, was among those who remembered being "completely mesmerized by this odd-looking creature—especially by the way she used her hands. I'd never seen anything quite like her before."

Litvinoff rushed backstage after the performance and told Barbra he wanted to manage her. When she returned to New York, she met with him on several occasions, but in the end declined his offer. "It's a good thing," Litvinoff said decades later, "because I'd probably be dead by now . . . But I am very fond of her."

Barry Dennen continued to play Pygmalion to Barbra's Galatea. After she returned to Manhattan in late August, the two would spend hours in Dennen's apartment listening to his extensive record collection. With Dennen as her guide, Barbra was introduced to the diverse likes of Helen Morgan, Edith Piaf, Ruth Etting, Mabel Mercer, and Gertrude Lawrence. He coached her on what songs would be ideally suited to her, where they should be placed in her act to create a dramatic arc, what gestures she should use to hold the audience's attention. The one thing he did not do was teach Streisand how to approach a song. Her vocal technique, her exquisite phrasing, her uncanny ability to put her own, distinct stamp on songs that

had been around for decades—these were the hallmarks of what Barbra called her "natural talent."

It was little more than a cramped, dimly lit basement, but few nightclubs in the country had the cachet of the Bon Soir. Since opening its doors in 1949, it had featured some of the biggest names in show business. Barbra had felt right at home when she walked into the club for the first time. "She had the attitude of 'I belong here,'" recalled Tiger Haynes, leader of the club's house group, the Three Flames. The first day he saw her, she was wearing a black velveteen dress that "looked like she got it at a thrift shop. First, you looked at the nose. Then you looked at the dress. Then you heard the voice—and that was it." Haynes's girlfriend, Bea, sidled up to the young singer. "Kid," she said, "you got dollar signs written all over you."

Barbra's first gig at the Bon Soir was to open for the hottest new female stand-up comic of the time, Phyllis Diller. The dressing room the two women shared was "dinky—about the size of a pea pod," Diller recalled. "You know, four chairs, a mirror, and a nail to hang your clothes on. Most of the time you could smell the fear in there. But not Barbra. From the beginning, she was totally calm." Beyond that, however, Diller's first impression was that Barbra was little more than "this kooky kid . . . she was *so* young." According to Diller, Barbra actually "came in pretending to be a princess from some exotic country. But with her accent, we knew she wasn't *that*.

"Barbra told me her shoes were antique and they cost her thirty-five cents. But then she went out and did her number, and when she hit about the third note, every hair on my body stood up. It was unbelievable—the total control she had over that voice . . . It was scary."

It was also, from Diller's point of view, "refreshing as hell. I worked with a lot of pretty young singers and they all looked the same and dressed the same and sang the same kinds of songs—all about the pain of lost love, and of course it was just ridiculous. What does anyone that young know about the pain of lost love? Then along comes someone who looks so completely different and who sings 'Who's Afraid of the Big Bad Wolf?' I thought, 'Wow, the chick has *brains*.'"

Although Streisand claimed to have never seen Disney's famous

Three Little Pigs or heard its "Who's Afraid of the Big Bad Wolf?" theme, Dennen persuaded her to open with it. "Oh my God," Diller thought to herself, "what a fabulous choice." Audiences—and critics—agreed.

For Barbra, it was sweet vindication for a life spent, she felt, in the shadows. "In life I felt that people didn't pay any attention to me," she said. "You know, when I would talk it came out so enthusiastically that they would disregard it. On the stage, singing, I could say what I felt—and I was listened to."

Barbra and Diller became "instant buddies. I wanted to be her friend," Diller said, "because I was so impressed with her. I wanted to help her any way I could." That meant spending an entire week searching for "the perfect little black nightclub singer dress." They found it at the popular discount dress shop Klein's. "Klein's was sort of an institution," Diller said. "You could find designer clothes marked way, way down. Once we found the dress, I think we paid twenty dollars for it."

Despite the way she was being lauded for her vocal talent, Streisand made it clear to her new friend that she really didn't want to be a singer. "She kept saying, 'Everybody keeps calling me a singer, and I know I can do that, but I am really an actress . . .'" She was, in fact, already behaving like the star she would soon become. "Barbra was a teenage diva," Diller recalled. "She didn't *need* diva lessons. She made everyone else wait for *her*. But it's what made Barbra. She was just so . . . different." Even with the $125 a week and the free meals, Barbra was just scraping by. Unable even to afford sheet music, she would call up publishers pretending to be Vaughn Monroe's secretary and ask them to send over whatever new material they had for the schmaltzy crooner to consider. Still, she had her coterie of friends and admirers willing to design her clothes, do her makeup, and help her choose her material—gratis.

Barbra had moved into Dennen's apartment by this time, and she whispered to their mutual friend Bob Schulenberg that they were "talking about getting married. I was shocked. No one else our age at the time—nobody I knew anyway—was talking about marriage. It just seemed inconceivable to me. But Barbra obviously wanted it."

In truth, Barbra wondered if Dennen wasn't gay. When she began to quiz him on the subject, he told her that indeed his interest

wasn't confined to women only, and admitted to being, at the very least, "confused."

None of which seemed to bother Barbra very much—or at least that is what she told Dennen. She might have been in love with him, but not to the point where she paid much attention to his career—or for that matter to anyone's but her own.

When Dennen appeared in a Shakespeare in the Park production of *Henry V,* he was eager for Barbra to see him in what was his first major appearance on the New York stage. Two house seats were reserved for the closing night, but when Barbra and Schulenberg showed up only moments before the curtain went up, they discovered their seats had been given away. They had arrived at the last minute because Schulenberg had spent hours doing Streisand's makeup. Later, when Dennen asked his friends what they thought of his performance, they told him they had missed it. Barbra and Schulenberg were both so excited by her new, sophisticated look that they were taken aback when Dennen then flew into a rage.

Barbra wasn't selfish so much as self-involved, Dennen eventually concluded. "Barbra lived her life as if it were a movie constantly unspooling inside her head," he later observed. "Supporting players came and went."

One of those players, her Bon Soir costar Phyllis Diller, took Barbra under her wing. Diller was a middle-aged housewife with five kids when she began her career as a comic. By poking fun at herself—onstage she typically wore a fright wig, a psychedelic print smock, white plastic boots, and dangling glitter-ball earrings the size of tennis balls—Diller won over audiences like no other female comic had before. But she also knew what it meant to be unattractive in the conventional sense, and that at some point Barbra would be asked to have plastic surgery.

"I knew lousy, insensitive agents would come along and say, 'Hey, baby, do this, do that,'" Diller said. So on their final night together at the Bon Soir, Diller approached Barbra. "I know it's bold to say this," she told the newcomer, "but don't you *ever* cut your nose." Ironically, Diller herself would undergo extensive plastic surgery over the years, and turn that experience into material for her act.

Diana Kind showed up on her daughter's second night at the

Bon Soir to chip away at Barbra's self-esteem. The flimsy Victorian white lace top she wore made her look like she was "singing in a nightgown" and her arms were "too skinny," Kind told Barbra. As for the voice—it was, she said, "very thin. You need eggs in your milk to make your voice stronger." One of the comics who waited in the wings was also far from bowled over by Barbra; he was so absorbed with going over his own material that he did not even notice the young singer. His name was Woody Allen.

One member of the audience who did take notice was personal manager Ted Rozar, who was there with his most important client at the time, Orson Bean. After the show, the tall, impeccably dressed Rozar approached Barbra backstage and planted a kiss on her lips. "I love you," he declared before offering to become her manager.

Moments later, Barbra called Dennen from the kitchen of the Bon Soir and asked him to rush down to the club to meet the blond, blue-eyed Rozar. She was excited by Rozar's professional interest in her, but she had reservations. "He's such a *goy*," she said.

No matter. A few days later, she signed a three-year contract with Rozar, giving him a flat 20 percent commission. Not long after, she also landed an agent. Irvin Arthur would later say he got her "by default" because every other agent in town had turned her down. They were, he said, "kind of turned off by her appearance."

Within days, Rozar booked Barbra for a one-night stand at a shabby Catskills resort, where she shared the bill with three aging female impersonators. The resort's geriatric audience was so rude—talking and laughing and clanking their silverware while Barbra struggled to be heard—that an exasperated Dennen sprang to his feet, grabbed the microphone, and yelled at them to "just shut up!" He then told the stunned diners that they would someday brag to their grandchildren that they'd heard Barbra Streisand sing before she was famous. No sooner did he return to his seat than the crowd picked up where it had left off, drowning out every note. Afterward, Dennen rushed backstage to comfort Barbra, only to find her doubled over, convulsed with laughter.

At the Bon Soir, Barbra continued to refine her act. She still started off every night with the same sight gag—only now just pretending to take her gum out of her mouth, she stuck the imaginary wad on her microphone instead of under her stool. Bored with

having to do the same four or five songs every night, Streisand re-
lied more and more on her own free-form patter. She made up wild
stories about herself, crossed her eyes, waved her arms wildly, gig-
gled, mugged shamelessly, and delivered every syllable with her dis-
tinctive Brooklyn intonation. All was counterpoint to the celestial
voice, the exquisite phrasing, the command of both words and mu-
sic that belied her nineteen years.

It was around this time that Barry Dennen stepped into the ele-
vator in his building and overheard another tenant, the comedienne
and actress Kaye Ballard, talking about how much she wanted to
play Fanny Brice in a new musical being planned by producer Ray
Stark. When he rushed to tell Barbra, she made a face. "Fanny *who*?"
she asked.

Once he'd gotten over his initial shock, Dennen dove into his
record collection and pulled out his extensive collection of Brice
records—from "Second Hand Rose" and "I'd Rather Be Blue" to
the stirring and tearful ballad "My Man." At one point, according
to Dennen, Barbra blurted out, "*Listen* to her! How can she get *away*
with that? Singing in a Yiddish accent!" Then she answered her
own question, "Hey, I guess when you're a star, you can get away
with anything."

As Barbra's act at the Bon Soir rolled on into its fourth month,
Dennen decided he could take the time to visit his ailing father in
Beverly Hills. One week later, Barbra stocked up on such New York
staples as bagels, lox, cream cheese, and cheesecake to celebrate Den-
nen's homecoming. She set the table with silverware, fresh-cut
flowers, and candles. But when she returned to their apartment
from the club that night, there was no Barry in sight.

What Dennen had neglected to tell Barbra was that he was simply
enjoying himself too much in California. He extended his stay a few
days, then an entire week. Each night, Barbra came home to an empty
apartment, gradually finishing off the food she had bought and won-
dering aloud to Bob Schulenberg if Dennen was ever coming back.

When he finally did return home, Barbra treated him with thinly
veiled contempt. She did not tell him what trouble she had gone to
to celebrate his homecoming, or how she had wrung her hands
night after night wondering if he had simply disappeared from her
life forever.

It was the beginning of the end of their relationship. In the coming days, Dennen would later recall, "we began to argue violently, explosions of vitriol and sarcastic criticism . . . flew back and forth."

The turning point, according to Barbra, came on New Year's Eve. While the rest of New York ushered in 1961, Barbra returned home from the Bon Soir in hopes of celebrating with Barry. She walked into the apartment and, to her surprise, encountered a strange black man in their bathroom. "I thought for some reason that maybe I could change you," she admitted to Dennen decades later. She believed strongly that they could "have a future together . . . But when I found you with a black guy, I thought, 'holy shit,' and I moved out."

Barbra left Dennen in early February, armed with a huge ring of keys—the keys to friends' apartments around the city. Eventually, she would become so accustomed to crashing at other people's apartments that she trooped to Whelan's drugstore and spent $12.95 on a fold-up cot that she tucked under her arm and carried everywhere with her. She had a standard response for anyone who asked about her collection of keys: "I sleep around."

In mid-February, Irvin Arthur booked his new client on a modest tour that would take her by train to Detroit, Cleveland, and St. Louis. Her pay: an underwhelming $150 per week. Barbra was chronically late and unwilling to accept any suggestions from the house musicians.

"It was in the days before hippies, but that's essentially what she looked like," said Matt Michaels, the pianist in the back room of Detroit's tony Caucus Club. "Her clothes were pretty awful. She would show up in something ratty and say, 'Oh, this is from an old slipcover I found at the Salvation Army store.' She was wearing *upholstery*. But in her defense, she was just dirt-poor. She didn't have anything—certainly no wardrobe to speak of."

Nor did she have much of a repertoire. "Barbra arrived with four or five Broadway numbers—that was it," Michaels said. "We had to do three shows a night, so I sat down with her right away and began teaching her. Some singers can get a song after hearing it once or twice, but it takes Barbra Streisand a long time to learn a song. And she had to learn it until it's burned in her brain because she is inca-

pable of improvising. But she makes up for all that by working harder than anyone I've ever seen."

Michaels, who wrote arrangements that Barbra would use for the next forty years, quickly learned that she was "very particular about what she would and would not do. Barbra didn't read music, and she was quite adamant that she *not* be taught to read it," Michaels said. "She was afraid it would ruin her natural talent. Obviously, her instincts were correct."

From the beginning, Michaels was impressed with Barbra's "incredible acting ability. She always rehearsed in front of a mirror. I mean for *hours*. Her voice was magnificent, but there were other singers with great voices. It was Barbra's ability to act out the lyrics that set her apart."

The nineteen-year-old kid from Brooklyn was also the most ambitious performer Michaels had ever seen. "She had her own agenda from the beginning. Barbra was self-centered, very focused on getting where she wanted to be," he said. "She was not easy to get along with, and she was very demanding. She was always changing things, over and over and over again, until everyone went nuts. It wasn't that she knew what she wanted—she didn't. She would just say, 'I don't like the ending,' or 'I don't like that note.' She had no idea *why* she didn't like something, she just didn't. Basically, Barbra was tremendously insecure—full of fear, really—and *everybody* paid for it."

Contrary to popular belief, Streisand was not immune to occasionally singing off-key. When he paid her forty-seven dollars to do a commercial for Edgewater Park, a local amusement park, Michaels said "Barbra sang so loud and so far out of tune that I wound up using her voice for the screams of people riding on the roller coaster."

Perhaps Barbra's biggest shortcoming was that she was chronically late—so frequently tardy that she often ran from the street straight to the stage and did the first set of her nightclub act still wearing her coat. Musicians who were kept waiting each night grew to resent the brash, gum-snapping upstart. According to Michaels, one night a bass player "really chewed her out for being late. After she did the set, Barbra walked off the stage and sobbed. It was the only time I ever saw her cry. But she got over it quick."

Audiences did not fare much better than the musicians who

worked with Barbra; more than once she stormed off the stage because she felt patrons weren't paying close enough attention to her. "She got angry at the audience all the time," recalled Michaels. "She wanted people to be quiet when she sang, and if they weren't, she was perfectly capable of stopping in the middle of a song and shouting, 'Shut up!' She was not polite about it. Barbra was just so aggressive—a very tough lady even then."

Barbra was already miffed with Rozar, who had declined to accompany her on the tour. "She needed someone to be there holding her hand," he said. "But I told her I wasn't that kind of manager. I figured she was a big girl and could handle herself. My life was—is—too important for me to give it over to somebody else. The fact that I had a wife and family—a life of my own, other people who depended on me—this didn't matter to her one bit. Even at the beginning, when she was really a nobody, Barbra saw everyone else in the world as existing to do her bidding. If you couldn't do something for her, you didn't exist."

She was also upset with Rozar for offering to pay for the surgery if she decided she wanted to have her nose fixed. "No!" Streisand shot back. "I like my nose."

Rozar was partly responsible, however, for convincing Orson Bean, who had been impressed by the newcomer's act at the Bon Soir, to book Barbra on the NBC *Tonight Show* when Bean substituted for host Jack Paar. Caucus Club owner Lester Gruber was so excited by the prospect of Streisand plugging his establishment on national television that he convinced several patrons to pitch in and pay for her airfare back to New York.

On Wednesday night, April 5, 1961, a national audience got its first look at Barbra. "She's never been, to the best of my knowledge, on network television before," Bean said in his introduction. "She has the most charming manner and the most charming voice. She's flown in from Detroit to be with us tonight . . . and her name is Barbra Streisand."

Bean recalled that at first Barbra was "a nervous wreck. But when she started singing "A Sleepin' Bee" it was like God singing through her. She got a standing ovation, which doesn't happen on TV. It was an incredible moment."

During a commercial break, she changed into a sophisticated

black cocktail dress to sing "When the Sun Comes Out." Then she tentatively walked over to the couch and plopped next to her friend Phyllis Diller. To Diller's left were fellow guests Gore Vidal and actor Albert Dekker, as well as Paar's loyal sidekick, Hugh Downs. "This is *so* exciting," she gushed to Bean, looking every bit the fresh-faced Brooklyn gamin. "I just can't tell you! All these people, and the cameras and the lights and people! Oh!"

As she had done with Dennen and Diller and would do with countless others, Barbra asked Bean if she should succumb to pressure and have her nose fixed—"y'know, like Doris Day. Only I'm kind of afraid that it'll ruin my voice . . ." And, like all the others, Bean pleaded with her not to have the surgery. "You're beautiful," he told her. "Don't do it. God has given you this voice and this nose. You can't have one without the other."

Around the same time, Ben Bagley, a producer of musical reviews, suggested that if she had her nose fixed, Barbra might wind up "looking like Florence Henderson." Pretty, sweet-voiced Henderson, who had already been tapped by Richard Rodgers to sing in *Oklahoma!* and *The Sound of Music,* would go on to achieve fame as the matriarch of television's *The Brady Bunch.* "What's worse," Bagley went on, "you'll *sound* like Florence Henderson." That prospect, Bagley said, "terrified her."

Barbra knew all about the perils of plastic surgery, particularly as they applied to the quality of her voice. But, understandably, she never tired of hearing other people tell her she was beautiful.

When she returned in triumph to Detroit, Les Gruber gave her a fifty-dollar-a-week raise and asked her to extend her stay from two weeks to two months. Determined to get Barry Dennen out of her mind, Barbra took up residence at the Henrose Hotel, flirted with some of the club's wealthier patrons, and accepted any social invitations that came her way. "There are some singers who hang around with the band," said her Caucus Club accompanist Matt Michaels. "Barbra was not one of those singers. She had her own agenda. She was a climber, and she socialized with a very wealthy Jewish crowd in Detroit. There was a guy who owned a steel company who was very fond of Barbra, and she spent a lot of time with him." After a lifetime of riding buses and subways, Barbra wanted the freedom that came with being behind the wheel. With a little help from one

of her new friends, veteran newspaperman Arno Hirsch, she took her driver's test and obtained her first license—issued not by New York but the state of Michigan. To make herself seem more interesting, she had told Hirsch and other journalists that she had actually been born in Turkey.

At the Crystal Palace in St. Louis, she made more than a friend out of Tommy Smothers, the endearingly dim-witted half of the Smothers Brothers comedy team. Their affair lasted only as long as her brief engagement at the club and failed to erase Barbra's heartache over her breakup with Barry Dennen.

That May, Barbra returned to New York and the Bon Soir. By now, she had incorporated a new number into her act—"Cry Me a River," the torch song made famous by Julie London. Barbra had transformed London's sultry, melancholy song about spurning an ex-lover into an angry anthem of revenge. Whenever she sang the song, Barbra thought about Dennen. "I tried," she admitted, "to re-create in my mind the details of his face."

One night after her first set at the Bon Soir, Barbra was standing in the kitchen pouring herself a cup of coffee when a stocky, blunt-speaking man in a rumpled suit walked up and began heaping praise on her. "You are wonderful," Bronx-born Marty Erlichman told her. "The first time out of the box you are going to win every award this business has to offer—the Tony, the Emmy, the Grammy, the Oscar."

"The Oscar?" she asked.

"That's going to be the biggest one," Erlichman said, "because you are going to be the biggest movie star of them all."

Barbra smiled. "I think," she agreed, "that I'm going to be a star, too."

Erlichman wanted to manage her, and unlike Ted Rozar, he insisted she not change a thing—not her name (people had suggested she become either "Barbra Sands" or "Barbra Strand"), not her nose, not her songs, not her clothes. Erlichman wanted to manage Barbra so badly that he offered to do it for free for the first year. Barbra had taken a liking to Erlichman even before he offered to work for her gratis. But before she could sign with him, he would have to find a way to get her out of her contract with Rozar.

Streisand was, in fact, becoming increasingly impatient with both

her manager and her agent. After her stint at the Bon Soir ended in June, Barbra had expected to be flooded with offers to perform in nightclubs. None materialized, however, and she was forced to retreat to her mother's apartment in Brooklyn—until Diana's nagging drove her to grab the folding cot and head back to Manhattan.

Now completely broke, Barbra was forced to seek part-time employment. Her brother, Sheldon, who had just become a new father, was gainfully employed in the art department of a leading Manhattan ad agency, Ben Sakheim. Occasionally he took his little sister to lunch, although he was so embarrassed by her tattered thrift-shop wardrobe that he made her walk three feet behind him. "She had these horrible rips in the backs of her stockings," he recalled. "I offered to buy her a new pair. She said, 'They're not ripped in front and I don't see them in back, so they don't bother me.'"

Eventually, he arranged for his sister to man the agency's switchboard while the agency's receptionist went on vacation for two weeks—provided she show up wearing clothes with no visible holes or rips. Having already had a taste of stardom, Barbra did not take her new job seriously. She tried out various accents whenever she answered the phone—French, Russian, Spanish, Yiddish, German—and made very little effort to actually take accurate messages or even put calls through. "It was like that scene in *Auntie Mame* where Rosalind Russell takes a job as a switchboard operator and gets all the lines crossed," Bob Schulenberg recalled. "That was Barbra. She was always disconnecting people, and they'd call back and scream at her. Then she'd disconnect them again."

Finally, Rozar and her agent Irvin Arthur did manage to book her into a club in Winnipeg, Canada. But Auby Galpern, who owned Winnipeg's Town & Country Club, regretted his decision as soon as she arrived in town. Unable to afford dry cleaning, she appeared onstage in dresses that were stained and wrinkled. She routinely berated the club's audience for not paying enough attention and one night, halfway through her act, simply stormed off the stage cursing. Galpern had had enough; he axed her on the spot—the first and, as it turned out, only time Barbra was ever fired.

From Winnipeg, she returned to Detroit and the Caucus Club. This time, the decidedly more worldly Barbra was letting male admirers buy her drinks and on occasion come up to her room. "For

someone as odd-looking as she supposedly was," said one of the Caucus Club musicians, "she had an awful lot of guys sniffing around." But she was not yet entirely over Dennen; her renditions of "Cry Me a River" were more bitter-sounding than ever.

Barbra was not exactly enamored of Ted Rozar, either. She borrowed $700 from Irvin Arthur's agency to buy out her contract with Rozar and took Marty Erlichman up on his offer to manage her career. Erlichman, who managed an Irish folksinging group called the Clancy Brothers, genuinely believed in Barbra's star potential. "Barbra is the girl the guys never look at twice," Erlichman said. "And when she sings about that—about being an invisible woman—people break their necks trying to protect her."

Within days of signing her up, Erlichman wrangled Barbra an audition for one of Manhattan's most chic uptown clubs, the Blue Angel. Over the years, such legendary performers as Johnny Mathis, Harry Belafonte, Pearl Bailey, Carol Burnett, and Eartha Kitt had graced the Blue Angel's tiny stage. Barbra had, in fact, tried out for a spot at the club with little success. This time, however, Erlichman persuaded the club's owners that the homely girl from Brooklyn with the bombastic personality would appeal to the Blue Angel's jaded clientele. She was something new, fresh, *different*. Barbra was hired, but her engagement would not start for another three months. She would open for the comic Pat Harrington, later best known as the T-shirt-clad janitor in the long-running sitcom *One Day at a Time*.

What continued to distinguish Barbra from her contemporaries as well as those who had gone before her was the unique quality of her voice, her cockeyed look, and her equally off-center persona. Keenly aware of the importance of television exposure, she hounded producers of talk shows on a more or less continuous basis. Local TV personality Joe Franklin grudgingly agreed to have her appear on his show. "I thought she was pretty darn ugly back then, frankly," he said. "And this *is* a visual medium. But, boy, could she sing." Not everyone, however, appreciated her talent. Twice she appeared on Franklin's show with 1920s singing idol Rudy Vallee, and both times Vallee gleefully informed her and the TV audience that she was too ugly and not talented enough to make it in show business.

Mike Wallace did not have to be convinced that this brash neo-phyte was, in fact, perfect for television. Wallace, who decades later would become best known as *60 Minutes*'s most relentless inter-rogator, invited Barbra to appear on his regional talk show *PM East* in the summer of 1961.

Having already appeared on *The Tonight Show,* Barbra viewed *PM East* as this "crummy local show . . . What's the big deal? I should go out and buy a dress special for this show? It's not even one of those fancy network shows." She admitted that she went on Wal-lace's program "like I didn't give a damn. I'd look uglier than I was."

When she perched on a grand piano and sang "A Sleepin' Bee," Wallace was "floored. She understood the lyrics and she cared about the lyrics. It made me shiver." The two instantly hit it off in an odd, semiadversarial way. Over the course of more than a dozen appear-ances on *PM East,* Streisand became the program's resident loose cannon. On one show she told fellow guest Mickey Rooney that she loved him "in all those pictures with Judy Garland" and then sang a duet with him—"I Wish I Were in Love Again." When Eartha Kitt asked what indeed happens when "a sleeping bee lies in the palm of your hand," Barbra snapped back, "He stings you dead."

Barbra felt free to expound on anything that struck her fancy, and Wallace encouraged her to do so. She railed against Zen Buddhism, fallout shelters, smoked foods, and milk. On a show that also fea-tured Rod Serling and Anthony Quinn, producer and TV talk-show host David Susskind told Barbra she was hardly a "master of coher-ence." She responded by pointing out that he had once been an agent who refused to see her. "None of your people would even let me read anything," she said as Susskind squirmed. "That's why I decided to give up theater, rather than go through that stuff."

"Probably, at the switchboard, they had difficulty understanding what you wanted," Susskind replied.

"No," she replied with a straight face. "I talked in sign language and spoke Italian . . ." Turning serious, she accused Susskind of squelching new talent. While Susskind sat openmouthed, she con-tinued, "I scare you, don't I? I'm so far-out, I'm in."

On another show, Burt Lancaster stormed off after Wallace's per-sistent questioning about his infamous temper. While the other

guests commiserated with Wallace, Barbra blurted out, "Well, I don't blame him. You kept asking him about his temper, so he showed you he had it."

Wallace clashed with all of his guests at one time or another, and Barbra was no exception. "I like the fact that you're provoking," she told Wallace. "Just don't provoke *me*."

In the beginning, Wallace enjoyed the verbal sparring with the brash, opinionated Miss Streisand—not to mention the fact that his show's ratings spiked every time she was on. After a year, however, he grew tired of her "overbearing" behavior. "Without having achieved it, she displayed a great deal of the temperament of a star," Wallace said. "At first I loved it because she was so offbeat and interesting. But then, if she didn't get enough attention, she was simply difficult."

Barbra now had a manager working free of charge—not to mention friends like Bob Schulenberg, Terry Leong, and even Barry Dennen. Also working gratis, they continued to help her out with songs, arrangements, costumes, and makeup whenever they could.

Next she approached *PM East*'s publicists, brothers John and Donald Softness, to work as her press agents—for free, of course. "She just said, 'You're gonna do this for me,'" Don Softness said. "That's how she operated. She wasn't shy about it at all. These were orders, and for some reason, you obeyed."

Despite her declaration to David Susskind that her days of auditioning for the theater were over, she still yearned to be on the legitimate stage. "My voice is from God," she told Don Softness. "It was given to me—I did nothing to earn it. But comedy and drama—these are higher arts than music, and they're something I have to work at."

Between auditions, Barbra showed up at a variety of small clubs around New York. Occasionally, she was accompanied by her friend Neil Wolfe, who had been a pianist in the front room at Detroit's Caucus Club before moving to Manhattan. At Gatsby's, a midtown club where Wolfe played the piano, Barbra would perch next to him on the bench and sing. "She had to sit next to me," Wolfe said, "because if you stood up and sang, then you were legally doing cabaret, and Gatsby's didn't have a cabaret license. There were bars all

around town where they didn't have a cabaret license, and she would do the same thing in every one of them—just slide onto the bench next to the guy who was playing the piano."

Barbra occasionally stayed at Wolfe's apartment ("My place basically served as Streisand's office back then"), and the two frequently went out together. "She was just so much fun—a ball to be with," said Wolfe, who remembered that at the time she was "obsessed with Marlon Brando. We went to see Brando in the movie *One-Eyed Jacks* and she just kept talking about how beautiful he was." According to Wolfe, she was also eager to experiment with a variety of musical forms. "We'd go to coffeehouses in the Village," he said, "and she would sit on the floor and sing 'Black Is the Color of My True Love's Hair.' It didn't matter what style she sang, she always knocked 'em dead."

Wolfe also knew from his experience with her at the Caucus Club in Detroit that Barbra had her detractors. "So she can be difficult—whatever that means. So what? The negative stuff she might do is dwarfed by her colossal talent," Wolfe said. "You know, Picasso was a bastard. Who cares?"

Barbra was still determined to make it as an actress. After another humiliating round of rejections, she finally landed a part in *Another Evening with Harry Stoones,* a musical spoof of the *An Evening with . . . (Judy Garland, Marlene Dietrich, Maurice Chevalier, Ella Fitzgerald,* etc.) format that proliferated in the early 1960s.

With the exception of Diana Sands, the beautiful black actress who had scored a huge success on Broadway in *A Raisin in the Sun,* the cast of *Harry Stoones* consisted of other lovable, talented misfits, including the portly comic actor Dom DeLuise. Presaging the enormous success of television's *Laugh-In* seven years later, the show was a collection of skits and musical numbers that showcased the talents of its stars. In one, Barbra plays a skinny wallflower who listens to the other high-school girls talk about their boyfriends while, in the boys' locker room across the hall, her nerdy male counterpart remains silent and withdrawn as the jocks brag about their sexual conquests. At the end of the skit, the two nerds meet in the hallway and Barbra utters her one line. "Barry," she says, "I'm pregnant."

That one line won Barbra a huge laugh, though she got an even bigger one without uttering any words at all. In this particular

sketch, she played a secretary taking dictation for boss Dom DeLuise
late at night. When it finally dawns on DeLuise that there's an at-
traction between them, he asks her to stand up and take off her
glasses. She does—and her skirt falls to the floor.

In another sketch, she played a clumsy Wendy in a takeoff of *Pe-
ter Pan,* and in yet another, she sang—to the accompaniment of
jungle drums—about launching an expedition to rescue her
boyfriend, who has moved to the wilds of New Jersey. In one of the
routines where she had a chance to sing, Barbra belted out "I've Got
the Blues" dozens of different ways for three minutes. Then, look-
ing satisfied with herself, she sighed and said, "Now I feel better."

The four weeks of rehearsals were agony for the cast and direc-
tor Glenn Jordan, in large part because Barbra seemed incapable of
repeating each performance in precisely the same way. This meant
the other actors could not anticipate how to respond from one per-
formance to the next. "Consistency is key in the theater," Jordan
said. "The rest of the cast absolutely relies on it." She was also ha-
bitually late and thought nothing of keeping the rest of the com-
pany waiting.

"Barbra was a great girl," said the show's manager, Paul Libin.
"But she didn't waste time watching anyone else's performance.
When she wasn't onstage, she was always hustling on the pay phone
in the lobby, talking to agents and producers."

The show's conductor, Abba Bogin, found Barbra "frustrating . . .
she simply had no theatrical discipline at all. She was only a kid, in-
experienced, and already Barbra had this huge ego. She was an ab-
solute pain in the ass to work with."

Indeed, Barbra was not exactly a casting director's dream, and the
show's creative team worried about how audiences would react to
her. "She was limited," Bogin said. "She was a little bit ugly, cross-
eyed, with a big nose. She wasn't sweet or even remotely sexy. But
she *was* a born comedienne. She was wild. She knew exactly and in-
stinctively what was funny. Her body language, her reactions, her
timing—all perfect, and she constantly broke everyone up." As for
her looks: "Fortunately, years later they were able to pretty her up
for the movies," Bogin said, "but back then, she was . . . well, she
was no Julie Andrews or Florence Henderson."

When *Harry Stoones* opened at the Gramercy Arts Theater, the

playbill contained an autobiographical description of Barbra that was imaginative, to say the least. It began "Born in Rangoon, Burma" and ended with "in January [she] will go to New Orleans, Miami and Chicago to work—although she thinks she's going there to ride horses."

The critics praised Barbra, but slammed the show itself. After two weeks of previews, *An Evening with Harry Stoones* opened and closed on the same night.

It was just as well. On November 19, 1961, Barbra was to start her engagement at the Blue Angel. Once again, she would garner standing ovations with her take on songs like "Have I Stayed Too Long at the Fair?," "Moon River," "Lover Come Back to Me," and "Ding Dong the Witch Is Dead" from *The Wizard of Oz*.

But her opening night at the Blue Angel would not be as significant as what happened to her earlier that day. Following weeks of failed auditions, Barbra tried out for a part in a new musical called *I Can Get It for You Wholesale*. Based on a novel by Jerome Weidman, *Wholesale* tells the story of Harry Bogen, an unscrupulous Sammy Glick character who claws his way to the top of New York's garment industry.

Weidman, who also wrote the book for the musical, was sitting in the audience with *Wholesale*'s composer Harold Rome and director Arthur Laurents when Barbra made her dramatic—and calculated—entrance, stumbling onto the stage of the St. James Theater in an oversize, honey-colored karakul coat with fox trim (which she'd purchased at a thrift shop for ten dollars) and dirty sneakers. Clutching a bright red plastic briefcase, she hurled it atop the piano, sending pages of sheet music sliding toward the startled accompanist.

"My name's Barbra Streisand," she declared. "With only two *a*'s. In the name, I mean. I figure that third *a* in the middle, who needs it? What would you like me to do?"

There was only silence. Beyond the footlights, Rome, Laurents, and the others who were present were doubled over with laughter. "What are ya—dead or somethin'?" Barbra said, squinting in their direction but unable to see them. "I said what would you like me to do?"

"Can you sing?" asked Laurents. Although this was his first time directing, his writing credits included *Gypsy* and *West Side Story*.

"Can I sing? If I couldn't sing, would I have the nerve to come here in a thing like this coat?"

"Okay," Laurents replied. "Sing!"

"Sing!?" she said. "Even a jukebox you don't just say sing, you gotta first punch a button with the name of a song on it. What should I sing?"

Laurents was already exasperated. "Anything you want," he said.

"Anything?"

"Anything."

Without hesitating, Barbra turned to Peter Daniels, the pianist, and said, "Play the one on top." Then she asked if she could sing sitting down because she had been up late the night before and was "real tired." With that, she sat down, pulled off her sneakers, and, to further establish herself as a memorable kook, stuck her imaginary wad of gum under the chair.

If it hadn't come from *Harry Stoones,* the song she chose to sing—"Value"—might easily have been one of the numbers in *Wholesale.* In "Value," Barbra tries to decide whether she's in love with Arnie Fleisher or Harold Mengert by comparing the size of their cars and their bank accounts. Her rendition of the song threw Rome, Laurents, and the rest into hysterics.

When she was finished, Laurents pulled himself together and asked, "Do you have a ballad?"

"Ooh, have I got a ballad!" she answered. "Wait till you *hear!*" With that, she sang "Have I Stayed Too Long at the Fair?" and the very same veterans of the theater who had just been shrieking with laughter were reduced to tears. "Emerging through the voice and personality of this strange child," Weidman recalled, "we were getting more than music and words. We were experiencing what one gets only from great art: a moment of revealed truth . . . This, you gasped as you wiped away your tears, was what people meant when they spoke of the X quality that makes a star."

When she was done, Barbra ran around the stage yelling her phone number. "Wow!" she said. "Will somebody call me, please? Even if I don't get the part, just call! I just got my first phone, and I'm dying to get a call on it."

She was to open that night at the Blue Angel, but Barbra agreed to come back at four P.M. to audition again—this time for the

show's legendary producer, David Merrick. The mustachioed, saucer-eyed, flamboyantly temperamental Merrick found the "strange child" too strange. He did not want her in his show. But Laurents and Rome did want her—for the role of Miss Marmelstein, a frustrated, spinsterish garment-district secretary. Eventually, they won over Merrick, and she got the part.

That night, Barbra's phone rang. "You said you wanted to get calls, so I called," said *I Can Get It for You Wholesale* leading man Elliott Gould. "You were brilliant." Without waiting for her to utter a word in response, Gould then hung up.

Rome and Weidman instantly went to work expanding Barbra's role. "You let a kid like that out on a stage and things are going to happen," Rome said. "They're going to be watching her and expecting her to do something." They gave her plenty to do, giving her the lead in three songs in addition to her solo, "Miss Marmelstein."

Yet for all their efforts to make the best use of Barbra's talents, hers was still a minor role. Cast as the scheming Harry Bogen was twenty-three-year-old Elliott Gould, whose main credit up until this point was dancing in the chorus of *Irma La Douce*. Lillian Roth, the torch singer whose own struggles with alcoholism had been chronicled in the blockbuster book and movie *I'll Cry Tomorrow*, played Bogen's mother, while Sheree North was cast in the role of his mistress.

From the first day of rehearsal, Barbra made it clear that she was not going to be easy to work with. While the other actors were busy listening to their director and taking notes, Barbra was scribbling a new biographical sketch for the show's playbill. "Born in Madagascar and raised in Rangoon," it began.

When the producers objected to her taking such license with the truth, Barbra explained that it was a surefire way to seize the reader's attention. Besides, she whined, "I'm so sick and tired of being born in Brooklyn, I could plotz . . . I hapna' *love* Brooklyn, but what's that got to do with it? I mean, what are we here for? Every day the same thing? No change? No variety? Why get born? I've had nineteen years Barbara with three *a*'s and all my life born in Brooklyn. Enough is enough. Don't you understand that?"

Barbra had other ways of getting attention—and of setting herself apart from the rest of the crowd. At the start of the second week

of rehearsals, she was in the lobby of the theater when the stage manager's whistle signaled the end of a ten-minute break. While the rest of the cast rushed back to rehearsal, Barbra calmly ducked into a phone booth.

After a few minutes, the stage manager stuck his head into the lobby and shouted, "Barbra! For God's sake, onstage!"

"Be right there!" she answered as she hung up the phone. Then she proceeded to dial the operator and ask for Los Angeles. When she finally joined the rest of the cast, Laurents berated her mercilessly. Barbra just sat, head down, her elegant hands fidgeting in her lap. It was only the first of several times the willful Miss Streisand would be chewed out in front of the entire cast, and each time she would react the same way.

At one point Weidman, full of sympathy for Barbra, approached her to discover that there was a pad in her lap, and that her hands were not twitching nervously, but sketching the layout of her new apartment over Oscar's Salt of the Sea Restaurant at Sixty-seventh and Third. "Listen, Jerry," she said to Weidman as if she had not heard a word the director had said. "The damn fireplace, it's all the way over here on *this* wall, so where the hell would *you* put the studio couch, huh?"

"Where's Barbra?" would become one of the production's most oft-uttered questions. In the course of the rehearsals, previews in Philadelphia, and the Broadway run, she was officially marked down as having been late thirty-eight times ("She had no regard whatsoever for her fellow actors," Merrick complained to Actors' Equity). It did not help that, more than once, she had had the audacity to keep Merrick himself waiting. "On that score," Laurents said, "Merrick was right. Her behavior was inexcusable."

Compulsive tardiness wasn't the only thing that landed Barbra in hot water. From the very beginning, she wanted to sing her solo not standing as scripted, but sitting down in an office chair. Not just sitting, but careening and twirling on casters from one end of the stage to the other as she complained about being an overlooked office wallflower.

The director, who would clash openly and frequently with the troublesome Miss Streisand, was just as adamant that she stand while singing the song. Choreographer Herb Ross, who staged all the

musical numbers for the show, tried to stay out of the line of fire. "I wanna do it *this* way," Barbra would demand. "Why *can't* I use the chair? Secretaries sit in these chairs all day long. It's natural, and I dunno, it just works . . ."

But Laurents wouldn't budge. When she relented and gave a lackluster performance while standing, he blasted her in front of the entire company. "You were no good, just lousy. And you were lousy on purpose."

Although their affair was long over, Barbra turned to the one person whose opinion she still seemed to value above all others—Barry Dennen. Not only did Dennen tell her she should stick to her guns, but he urged her to have a stagehand give her a shove from the wings so she could make her entrance sliding across the stage in the chair. He told her that once the chair landed center stage, she should stay hunched over for a moment like a marionette, then slowly raise her face to the audience before starting to sing.

Barbra followed her former lover's advice at tryouts in Philadelphia and stopped the show. Laurents grudgingly conceded that she had been right all along. "Do it," he said, "in your goddamned chair."

Not that Laurents stopped yelling at her. The next night, and every night thereafter, Barbra altered her performance—and every night the director railed at her for not following his blueprint *precisely*. "I find it very difficult to do anything twice in exactly the same way," she explained.

Although she drove Laurents crazy, he recognized Barbra's talent and sprang to her defense whenever Merrick insisted that the "crazy-looking, ugly thing" be fired. Nor did the producer find her at all amusing. She was, Merrick declared, "a skinny flibbertigibbet with no discipline and no technique." All she had, he would later concede, "was this enormous talent . . ."

During out-of-town tryouts in Philadelphia, Merrick also wanted to dismiss the curly-haired, six-foot-three-inch-tall star of the show. He considered Elliott Gould (real name: Elliott Goldstein) to be a "lousy actor," and Barbra's equal in the looks department. Moreover, Gould sweated so profusely—*"buckets,"* Gould recalled— that he had to be toweled off by cast and crew at every available opportunity. Merrick went so far as to audition other actors to replace

Gould. But, as they had done for Barbra, Laurents, Rome, and Weidman stood their ground and insisted that Gould stay in the show.

The two newcomers did, in fact, have much in common. Both hailed from working-class families in Brooklyn, both had grown up feeling self-conscious ("I was convinced I had a fat ass," Gould said), and both coped with a family dynamic that was stress inducing, to say the least. The entire Goldstein family was crammed into a two-room apartment, and Elliott was forced to sleep in the same room with his parents until he was twelve. As a result, he said, "I didn't feel abnormal, but I certainly didn't feel normal."

In contrast to Diana Kind, Lucille Goldstein was a classic stage mother, doting on her little boy and forcing him to take singing, dancing, and acting lessons at Charlie Lowe's Broadway Show Business School for Children. At age ten, he was singing and tap-dancing on local television programs. At about this time, a producer suggested he shorten his name from Goldstein to Gold. Lucille thought Gold was too obvious, and instead chose the name of then-popular orchestra leader Morton Gould. After graduating from Professional Children's School in Manhattan, Elliott did summer stock and, at eighteen, landed his first Broadway job dancing in the chorus of the short-lived musical *Rumple.*

The first real face-to-face encounter between Barbra and Gould occurred the first day of rehearsals for *Wholesale,* when, according to Elliott, she walked onstage looking like "a fantastic freak—the weirdo of all times" in her thirty-five-cent shoes, torn black nylons, and wearing her hair in an oversize bun—a style her old friend Bob Schulenberg called "the Cheese Danish." Gould responded by handing her a cigar. She took it, and they shared a smoke. "He was like a little kid," said Barbra, whose initial impression was simply that he was "funny-looking."

Gould began walking her to the subway, and soon they were sharing their mutual passions for arcade games, Chinese food, catching late-night horror movies, and coffee ice cream. More outgoing than Barbra, "Elly" would go up to strangers on the street and tell them jokes, climb in one side of an occupied cab and out the other while it was stopped at an intersection, or suddenly burst into song. "He did crazy things," she recalled. "I liked him. He wasn't normal."

At one point that winter, they were strolling around the Rocke-

feller Center skating rink at two A.M. when Gould started chasing her and the two had a spirited snowball fight. "I very delicately washed her face with snow," he said, "and then kind of touched her lips. It wasn't very demonstrative. She's desperately insecure. She always thought of herself as an ugly duckling, and she made herself up to be weird as a defense. She liked me. I was the first person who liked her back."

Not exactly, but Barbra was feeling something for Gould that she had not felt since her affair with Barry Dennen. "He never held me or anything," she said of their romantic snowball fight, "but he put snow on my face and kissed me, very lightly. It sounds so hokey, but it was great, like out of a movie."

While the other members of the cast and crew agreed that Barbra had already set her sights on landing the leading man, Gould saw Barbra as someone who "needs to be protected. She's a very fragile little girl. She doesn't commit easily. I found her absolutely *exquisite*. As conventional beatniks go, she's different-looking. I had this desire to make her feel secure." She was, he believed at the time, anything but calculating. "She was the most innocent thing I'd ever seen, like a beautiful flower that hadn't blossomed yet. But she was so strange that I was afraid."

Not Barbra. On opening night in Philadelphia, she sent him a single red rose with a note: "From Barbra, to my clandestine lover." Despite his having dated several girls in the chorus of the show, Gould was still a virgin—and he wrongly made the assumption about nineteen-year-old Barbra.

That night at the Bellevue Stratford Hotel, Elliott set out to consummate their relationship. "She was the one I chose," he recalled. "I was excited, but I was frightened."

To further complicate matters, no sooner had Gould gotten Barbra into bed than friends of his began banging on the door of their hotel room. "I was trying to become a man, and these guys were pounding on the door. I wouldn't open it. This was my moment, and I wasn't about to let anyone take it from me."

It was actually only the first of many moments during the run of *Wholesale*. While basically behaving like children during the day— Barbra and Elliott liked to throw food at each other in restaurants or chase each other through the hallways of their hotel—they spent

every night after the show in his room. Their lovemaking was so raucous that fellow cast member Wilma Curley, who occupied the hotel room next door, complained that the sound of their headboard banging against the wall for what seemed like hours on end was keeping her awake. She also heard them laughing, at other times yelling at each other—and once Curley peered into the hallway to see Barbra, completely nude, pounding on the door and demanding that Elliott let her back in.

I Can Get It for You Wholesale opened at the Schubert Theater on March 22, 1962, to tepid reviews. Elliott was singled out for special criticism, most notably by Richard Watts Jr. of the *New York Post.* Gould was the show's primary flaw, Watts wrote, because the actor was "so uninteresting and unattractive. Yet he is apparently supposed to have a charm that was not visible to me last night."

Conversely, *Wholesale* was nothing less than a career-making triumph for Barbra. After her performance, Leonard Bernstein led the audience in a three-minute standing ovation. Despite her small part in the production, she was held up in every review as the show's main saving grace. She took special delight in *New York World-Telegram* critic Norman Nadel's suggestion that "Erasmus Hall High School call a half-day holiday to celebrate the success of its spectacular alumna, nineteen-year-old Barbra Streisand."

One member of the opening-night audience who did not share the critics' collective enthusiasm for Barbra Streisand was her own mother. Diana Kind left the theater that night saying she felt her daughter would be more secure working as "a *real* secretary."

"I don't think she knew what I was trying to do in it," Barbra said of her mother's characteristically negative reaction to her performance. "Why should she? The things that interest her about me are whether I'm eating enough and whether I am warmly enough dressed. She's a very simple, nonintellectual, nontheatrical person who lives and breathes."

Whether her mother appreciated it or not, Barbra was an instant sensation. *The New Yorker, Life, Mademoiselle,* and *Time* all ran features on Broadway's hottest new star. "Even with a banal song," *Time* observed, "she can hush a room as if she really had something worth saying."

She was welcomed back by Mike Wallace on *PM East,* and by

John Chancellor on the *Today* show. Every night there were bravos and standing ovations—so many and such effusive ones that she told Gould and others that she was "embarrassed by it. I didn't feel I deserved that much attention."

If she had any misgivings at all about hogging the limelight, they stemmed from her affection for Elliott. She felt "guilty," she claimed, for stopping the show every night. "I had very mixed feelings. On the one hand, I loved it. On the other hand, I hated it, because I didn't want Elliott to be hurt."

In truth, with the possible exception of Sheree North, whom Barbra befriended, Gould was probably the only member of the cast who was truly happy about Barbra's success. "I was the most hated girl on Broadway," she conceded. "There were people who resented me . . ."

Her fellow actors did indeed resent Barbra, and not merely for being chronically late and wantonly breaking into their dressing rooms to "borrow" their makeup. "She had a mean streak," said one member of the cast. At one point, Barbra's understudy, Elly Stone, asked if she could be relieved of her duties so she could do a concert downtown at Cooper Union. "Barbra had never missed a performance," she said, "so the producers said it was fine." Then, the morning of Stone's concert, Gould called to say Barbra was sick. Stone was told she would have to cancel her concert and go on in the role of Miss Marmelstein. "I knew it was all a game to her," Stone said. "But there was nothing I could do." Then, just minutes before the curtain, Barbra showed up smiling. "It wreaked havoc on my stomach," Stone recalled. "It was very upsetting to me. Why would anyone be so cruel? Why put another person through that?"

"Barbra was a pain in the ass," said Wilma Curley, who eventually replaced Sheree North in a role that was actually much bigger than Streisand's. "She was completely inconsiderate of others. If she wanted something—makeup, a part, a man—she took it. Nothing stood in her way." Certainly not another actress. Although she'd cozied up to Sheree North, an important Hollywood star in the late 1950s, Barbra wasted no time making friends with other cast members. On several occasions, she went so far as to approach Laurents and demand that she be given the lead female role, then played by Marilyn Cooper. Laurents, astonished by her chutzpah, told her she

should be satisfied with her showstopping "Miss Marmelstein" number.

Even Jerome Weidman, who along with Harold Rome and Laurents had battled David Merrick to keep her in the cast, was growing tired of the abrasive upstart. Pointing out that he had dealt with plenty of "revolting people" in both the garment business, where he had started out, and in the theater, Weidman was upset with Streisand's demanding behavior because she "had not earned the right to act that way."

One of the many industry insiders who learned all about Barbra's temperament was Jule Styne. A musical prodigy, Styne abandoned a career as a concert pianist when he was told his hands were too small. Instead, he switched to popular music, teaming up with Sammy Cahn to write such standards as "I've Heard That Song Before," "Let It Snow! Let It Snow! Let It Snow!," and the Oscar-winning "Three Coins in the Fountain." Turning to Broadway, Styne wrote *Gentlemen Prefer Blondes* (which included "Diamonds Are a Girl's Best Friend") and paired with Stephen Sondheim to write what many believe to be the greatest Broadway musical of all time, *Gypsy*.

Now Styne had been asked to write *Funny Girl,* the highly anticipated musical based on the life of singer-comedienne Fanny Brice. Born on New York's Lower East Side, the homely Fanny Borach parlayed a natural flair for dialects (particularly Yiddish) and physical comedy into a career as an unlikely Ziegfeld headliner, a radio personality (her most famous character was "Baby Snooks"), and a movie star.

Bucking all odds, Fanny achieved phenomenal success professionally, but her personal life was a disaster. Her marriage to the dashing gambler Nick Arnstein produced two children—Frances and William—and before it was over, Fanny had spent a fortune trying, unsuccessfully, to keep Nick out of prison. Eventually, Arnstein was convicted of embezzlement and served time in Sing Sing and Leavenworth. Brice would go on to marry and divorce another larger-than-life character, Broadway producer Billy Rose.

After Fanny died of a stroke in 1951, Norman Katkov penned a biography that was so upsetting to her daughter, Fran, that Fran's husband, hard-driving Hollywood agent Ray Stark, paid $50,000 to

purchase the rights and have the plates destroyed. Then Stark set out on his own to turn Brice's poignant life story into a film. Meeting resistance from producers who thought the project was not commercially viable, Stark approached David Merrick to turn it into a musical. Merrick, in turn, signed up the creators of *Gypsy*, Styne and Sondheim. Jerome Robbins was hired to direct.

First, the eternally pert Mary Martin expressed interest in the starring role. "You've gotta have a Jewish girl!" Sondheim objected. "And if she's not Jewish, at least she has to have a *nose!*"

Styne didn't think they could find someone in either category. "C'mon, Steve," he said, "we're not going to find any girl with a nose."

Before long, Martin herself realized she was ill-suited for the part and withdrew. She was promptly followed by Sondheim, who had his own misgivings about the wisdom of trying to top *Gypsy* with its similar backstage themes.

Lyricist Bob Merrill, who had written such 1950s pop classics as "(How Much Is) That Doggie in the Window?" and "Mambo Italiano" as well as the hit Broadway musicals *Take Me Along* and *Carnival,* was signed to replace Sondheim. Stark, meanwhile, found a new leading lady—Anne Bancroft, fresh from winning an Academy Award for the role she created onstage in *The Miracle Worker.* Merrick and Styne thought this was the wrong choice from the beginning, but Stark insisted that a major star was needed to carry the project.

Styne, however, had other plans. When he saw *I Can Get It for You Wholesale* for the first time, he was intrigued enough to ask Barbra out to dinner that same night. They sat at a front table in Sardi's— she said she needed to sit in front "so everybody will see me"—and chatted for two hours. They talked about music, producers, acting— everything *except* the Fanny Brice musical.

As written by Isobel Lennart, who based the book of the musical on her own screenplay, *Funny Girl* was a lush, sweeping love story— not at all suited, in other words, to the overtly neurotic, highly idiosyncratic, disarmingly callow, and decidedly unglamorous Miss Streisand.

Marty Erlichman thought otherwise. When she wasn't on the Broadway stage in *Wholesale,* Barbra was still doing the late show at

the Bon Soir. At Erlichman's urging, Merrick and Styne went to catch her act. It was there that both men realized that they had found their star. For the next month, Styne sat in the audience at the Bon Soir, studying Barbra's technique, her phrasing, the vocal strengths he could play to. During that period, he wrote the score of *Funny Girl* specifically for Barbra.

When Styne played several of the songs for Anne Bancroft, she instantly recognized that they suited someone else, but certainly not her. Bancroft went further after hearing "I'm the Greatest Star" and the bombastic "Don't Rain on My Parade." "You won't get *anyone* to sing those songs," she predicted.

At this point, Styne hauled Stark down to the Bon Soir to see the woman the songs *were* suited for. But before he did, Styne warned Barbra to ditch the thrift-shop couture for something simple and elegant, and to stick to singing. No jokes. No shtick. Nothing, in other words, to distract from her natural elegance and the beauty of her voice.

Stark was duly impressed and, without telling Styne, came back with his wife. This time, Barbra dressed and acted as she normally would at the Bon Soir—outrageously. There was lots of snappy patter, and the kind of adolescent mugging that betrayed the fact that she had only been out of high school for three years. "That woman," Fran Stark told her husband in no uncertain terms, "will *never* play my mother."

Barbra got one more shot after Jerome Robbins caught her act at the Bon Soir. Seeing what Styne saw in the awkward yet curiously elegant Miss Streisand, Robbins convinced Stark to let her come in for an audition. But when she showed up, Styne was shocked at "how horrible she looked . . . She wore a Cossack-uniform kind of thing . . ." Worse yet, at first she seemed reluctant to follow Robbins's direction. Eventually, Robbins would call her back to read for the part seven times—but Stark remained unconvinced.

In the coming months, the project would bounce from one potential leading lady to another: Kay Ballard, whose elevator chitchat was the reason Barbra had even heard of Fanny Brice, was still in the running. So were the ever-wholesome Mitzi Gaynor (who seemed about as logical a candidate as Mary Martin) and one of Columbia

Records's biggest stars, Eydie Gorme. And for a time it looked as if the role would go to another rubber-faced pro with a window-rattling voice—Carol Burnett.

Her sudden fame notwithstanding, Barbra was still scraping by financially. She barely earned enough to afford her own sixty-two-dollar-a-month, one-bedroom, third-floor walk-up railroad flat. Located directly above Oscar's Salt of the Sea restaurant, the place always stank of fish—no problem, it seemed, for the granddaughter of a fishmonger. Beyond that, there was a fun-house quality to the place. The only window looked out on a brick wall that had been painted black. There was no air-conditioning, of course, and the bathtub sat in the middle of the kitchen. The floor was so uneven that Barbra would place a marble at one side of the apartment and watch it roll across the living-room floor to the opposite wall.

Empty picture frames hung on the wall; Barbra claimed she couldn't afford to put anything in them. Alongside the frames: a toilet seat. As for the actual bathroom, the walls were covered with a collage of newspaper stories, print ads, and photos Barbra had picked out. During one of her many thrift-shop safaris, she had unearthed a dentist's cabinet that she placed in the bedroom and filled with costume jewelry. There was no bed, only a narrow cot on which Barbra and Elliott—who by now had moved in—somehow managed to sleep.

Meals—usually frozen TV dinners (Swanson's fried chicken was Barbra's favorite)—were eaten off a Singer sewing-machine cabinet that served as a dining-room table of sorts. Bathing was even more problematic. Most of the time, a sheet of plywood that covered the tub was heaped with dirty dishes. Whenever they wanted to take a bath, the couple had to remove the plywood and then fill up several pots with hot water from the kitchen sink. The pots, in turn, were poured into the tub.

Barbra and Elliott were not alone. One night, Gould recalled, they were awakened by a "gruesome squealing and scratching. It sounded like a rat the size of an elephant. I looked under the tub and I saw a tail about a yard long with notches on it, probably to

keep score of all the people it had bitten." He retreated to the bedroom and called the fire department. Unable to rid themselves of the rodent, they simply decided to live with it. From that point on, they alternately referred to it as Gonzola or, in honor of the restaurant two floors below them, Oscar.

These squalid living conditions did nothing to dampen their ardor. The couple invited friends over to play board games, or stayed home alone reading to each other or watching old movies on their battered black-and-white TV. This would be their happiest time together. "I look back to Third Avenue," Gould mused, "with sublime affection." They had pet names for each other as well. They were "Hansel" and "Gretel," living in their old blissful gingerbread house while the cold, cruel world lurked just outside their door.

Not that they didn't have their moments. Barbra did not hesitate to tell Elliott when his performance was subpar, or when he hit a sour note. Elliott did not take such criticism well. She simply ignored him when he flirted with other cast members to get even, which only made Elliott angrier. The constant, twenty-four-hour-a-day exposure to each other took its toll. There were scenes in restaurants, screaming matches in cabs and on the street; she locked him out of the apartment at least three times, and once she stormed out in the rain, only to show up dripping wet and—in true Hollywood fashion—fall into her lover's waiting arms. "We were very young," Gould recalled. "It was all very romantic."

Tensions between Barbra and the rest of the cast mounted when she alone was singled out for a Tony nomination, for Best Featured or Supporting Actress in a Musical. She had already won the New York Drama Critics Circle Award (tied with Sandy Dennis for *A Thousand Clowns*) and fully expected to win the Tony. The other nominees were Barbara Harris, for *From the Second City;* Elizabeth Allen, in *The Gay Life;* and Phyllis Newman, in another David Merrick musical, Jule Styne's *Subways Are for Sleeping.*

On April 29, 1962, Barbra sat in the ballroom of the Waldorf-Astoria Hotel and managed a wan smile as the Tony went to Phyllis Newman. When she returned with Elliott to their dive on Third Avenue, she agonized over the loss, asking Elliott over and over again what it could have been that she was doing wrong. "I mean,

Elly," she wailed. "I lost to *Phyllis Newman*?" It bothered her even more that Merrick had played favorites by choosing to sit with Newman rather than his showstopping *Wholesale* star.

Barbra had, in fact, felt her only real competition came from one of the other nominated actresses. Ever since Elliott began raving to Barbra about how Barbara Harris had generously offered to coach him before taking on the lead in *Wholesale,* Streisand paid close attention to the winsome actress. "Well, Barbara Harris can act," she would say to Gould, her voice dripping with sarcasm. "Barbara Harris can sing. Barbara Harris can do *anything*."

Not that Barbra was being ignored. At a midnight twentieth-birthday bash thrown for Barbra at the Lichee Tree Restaurant in Greenwich Village, the casts of half the shows on Broadway showed up. The gift table was heaped with offerings from such notables as Ethel Merman, Mike Nichols, Richard Rodgers, and Leonard Bernstein. In the eight weeks since *Wholesale* had opened, Barry Dennen observed, Barbra "seemed to have formed intimate friendships with every talented, famous, or powerful person in New York."

At the center of the swirling celebrity cyclone was Barbra. But whenever Dennen or Schulenberg tried to approach her, she either turned her back or had Marty Erlichman make sure they never got near her. Schulenberg would eventually call this treatment at the hands of their old friend "The Big Kiss-off," and it left Dennen feeling nothing less than "heartbroken."

"Barbra was always a master of sucking up to anybody who could help her," Ted Rozar said. "She couldn't be sweeter if she thought you were important. But if you were of no value to her, that little switch went off in her head and she treated you like shit."

For all the critical praise and the standing ovations she was getting as Miss Marmelstein, Barbra began to worry that she was being perceived more as a clown than a serious singer. As hard as she tried for laughs, she still wanted to be taken seriously as an artist. To bolster her reputation as a singer, she returned to the Bon Soir. Each night after the curtain had gone down on *Wholesale* and she had taken her last bow, she sprinted for a cab that would take her straight downtown. At one point, she stopped the show and asked the crew, "Am I out of the spotlight?" Before anyone could say a word, she answered

her own question. "I'll never," she said wryly, "be out of the spot-light."

A few days later, she grabbed the national spotlight when she appeared on the highly rated prime-time CBS variety program *The Garry Moore Show*. Each week the show featured a segment called "The Wonderful Year," and the year chosen for Barbra was 1929. She was handed the bouncy, upbeat song "Happy Days Are Here Again," which was actually published just before the stock-market crash that triggered the Great Depression, but later became FDR's hopeful campaign anthem. During rehearsals, the song's tempo was slowed down by the show's musical director, Ken Welch, until it morphed into something quite different—a wrenching, sardonic, powerfully moving ballad. When Barbra, decked out like a Park Avenue matron who has just lost all her money in the crash, sang it this way for the first time on the show, cast members like Moore and Carol Burnett stood awestruck in the wings.

By the summer of 1962, Barbra had come to the realization that she really didn't like performing on Broadway. As she repeatedly pointed out to her frustrated director, she lacked the ability—and the desire—to do the same thing every night in precisely the same way. She was bored, and she made no attempt to conceal her boredom from her fellow actors. Her performances in *Wholesale* became increasingly uneven—though the audiences never seemed to notice, or care—and when she wasn't onstage she retreated to her dressing room to rehearse new material for her nightclub act.

Her return to the Blue Angel in July 1962—this time as the headliner—provided yet another opportunity for New York critics to gush about the phenomenon named Barbra Streisand. Just as important in the wake of her funny, but far from vocally challenging role in *Wholesale,* this cabaret appearance showcased Barbra's talents as a singer. With her newfound fame and a decidedly more sophisticated audience, Barbra was now aiming at the next big prize: a recording contract.

It was not going to be easy. In fact, Marty Erlichman, who was so fiercely loyal to Barbra that he often upbraided even the most important critics and industry executives for making rude references to the size of her nose, had spent more than a year trying in vain to persuade a record label to sign her. Rather than send audi-

tion tapes, he insisted that she audition in person so that executives could experience the full power of her voice and her unique personality.

The voice, everyone seemed to agree, was exceptional. But when it came to selling records, that was only part of the equation—and perhaps not even the most important part. According to the record executives, she was either too unattractive, too flamboyant, too quirky, or—in perhaps the most frequently made comment—"too Jewish." At a time when top female recording stars ran the narrow gamut from Leslie Gore and Brenda Lee to Annette Funicello and Connie Francis, Barbra seemed too sophisticated for *American Bandstand* and too offbeat for radio listeners who couldn't seem to get enough of Andy Williams singing "Moon River."

At the top of Erlichman's list was Columbia, at the time the Rolls-Royce of record labels. But after being approached to sign Barbra on at least three separate occasions—twice by Erlichman and once by Arthur Laurents—Columbia's president, Goddard Lieberson, said no. "God," as the legendary Lieberson was known throughout the recording industry, had no choice but to allow her into his studio when she showed up with the rest of the cast to record the soundtrack for *I Can Get It for You Wholesale.* Even during that brief encounter, she caused a stir by abruptly stopping in the middle of her session and complaining about the orchestration.

Not surprisingly, when Harold Rome had wanted Barbra to perform on a Columbia album marking the twenty-fifth anniversary of his landmark garment-industry musical *Pins and Needles,* Lieberson objected. When Rome threatened to cancel the whole project if Barbra wasn't hired, Lieberson acquiesced. Rome had fought so hard for Barbra not just because of her voice, but because she possessed an almost eerie understanding of material that dated back to the 1930s. She did not tell Rome that she had taken Barry Dennen to lunch at Sardi's and debriefed him on the period, Rome's songs, and how to sing them.

Columbia's *Wholesale* and *Pins and Needles* albums were selling well, but Lieberson would not budge on the issue of signing Streisand to an exclusive contract. That did not stop Marty Erlichman. Even though he had now gotten Atlantic and Capitol interested, Barbra's manager knew that Columbia, with its long history

of producing smash albums, offered his client her best shot at becoming a major recording artist.

That summer of 1962, Barbra's name seemed to be on everyone's lips—stopping the show eight times a week at the Schubert, wowing audiences at the Blue Angel, being welcomed onto NBC's *Tonight Show* by guest host Groucho Marx. Even the sublimely sarcastic Groucho, brandishing his ever-present cigar, was taken aback by her boldness. Turning Groucho into her straight man, Barbra got all the laughs. When he began complimenting her on being a "big success," she interrupted: "Well, if I'm such a big success, how come your announcer just called me 'Streesand.' My name is Barbra *Streisand!*"

GROUCHO: Now, Barbra, you're twenty years old and you're a big success. I hear about you on the coast from many people.

BARBRA: Nothing they can prove, right?

GROUCHO: I had dinner with Jule Styne and he says they're talking about you for the Fanny Brice story—it's between you and Carol Burnett and [Anne] Bancroft . . . That's pretty big-league company. I'd say that if they're considering you against those two others, then you have arrived.

BARBRA: I dunno, it's been good, I guess . . . Y'know, I go to department stores and they still don't wait on me . . .

In August, Lieberson bowed to mounting pressure from inside Columbia—most notably from artists and repertoire chief David Kapralik (by now a self-described "Streisand groupie")—and caught Barbra's final performance at the Blue Angel.

A few days later Lieberson called Erlichman. "It takes a big man to admit a mistake, and I made a mistake," Lieberson said. "I would like to record Barbra." Although he had been impressed by the almost hypnotic power she had over her audience, this was not the reason he finally relented. "We knew Capitol had made an offer," a Columbia executive said, "and we did not want the competition to get her."

Barbra was not going to make it easy. Even after fighting so hard to land a contract with Columbia, she made it clear she wanted it

only on her terms. There would be more than two months of wrangling before Barbra got what she wanted. In exchange for a significantly smaller advance (only $20,000) than the other record companies had been willing to pay, she was given full creative control—everything from what she would record to the title of the album and the cover art. Moreover, under the terms of the contract, Columbia agreed to release two Barbra Streisand albums in the first year alone, the first within six months of signing.

On October 1, 1962, Barbra, wearing a black dress and a simple strand of pearls, arrived early at Columbia's corporate offices so she could be tended to by the company's hair and makeup artists. Then, with Goddard Lieberson standing to her right and A&R director Kapralik on her left, Barbra Streisand signed her first record contract while Columbia's photographers snapped away. In the photo, Kapralik said, "Barbra has a wonderful cocky grin on her face. It's as if she were saying, 'You bastards, you made me wait a long time for this moment. Now . . . you're going to be waiting on me.'"

Three days later, she scored another first: After months of trying to land a guest spot on *The Tonight Show* with its hot new permanent host Johnny Carson, Barbra received the coveted invitation. Carson was so impressed that he invited her back every month for the next five months.

Unfortunately, the rank and file at Columbia did not share Carson's high opinion of their new star. At a time when the label was pushing the likes of Anita Bryant, Robert Goulet, and Eydie Gorme, Barbra did not fit its squeaky-clean image. Streisand had a particularly powerful enemy in Columbia sales chief Bill Gallagher, who was second only to "God" Lieberson at the company. Appropriately, Gallagher was known as "The Pope."

There were those in the Columbia hierarchy who viewed Barbra with disdain. They believed that, like Judy Garland, her appeal was to gays and that she had no future as a mainstream artist. Mitch Miller, who had produced every major artist from Tony Bennett and Frank Sinatra to Rosemary Clooney, refused to take on the assignment of producing her first record because he had already heard she was difficult. He was accustomed to cranking out hits in less than an hour; Barbra's reputation as someone who insisted on multiple takes had preceded her.

Finally, a young producer named Mike Berniker agreed to oversee Barbra Streisand's first record. On October 16, 1962, Barbra, backed by a full orchestra instead of her usual nightclub trio, recorded "Happy Days Are Here Again" as a single, with "When the Sun Comes Out" on the B side. Two weeks later, the 45 was released. "The Pope," Bill Gallagher, made sure it would fail, ordering that only five hundred copies be manufactured, that no radio stations be sent the record, and that no money be spent on promoting Streisand.

Not that she'd made it easy. The brass at Columbia wanted her to tone down the shrill, plaintive note at the end of "Happy Days Are Here Again," but Barbra, exercising her creative control, had said no. For her follow-up single, the company urged her to record a new song by hit makers Barry Mann and Cynthia Weill that sought to capitalize on the popularity of a hot new Brazilian dance. She refused, insisting that a dance record was beneath her. In a matter of months, fellow Columbia newcomer Eydie Gorme scored one of the year's biggest hits with the song Barbra turned down, "Blame It on the Bossa Nova."

Gallagher had had enough. Without telling Barbra that three other versions of the song were about to be released, he pushed for her to record "My Coloring Book," a sweeping Kander and Ebb ballad that had all the dramatic elements that appealed to Barbra.

It was during the recording session for "My Coloring Book" that another issue arose. Long before she signed a recording contract, there had been considerable talk about Barbra's personal hygiene— or lack of it. A number of nightclub owners, casting directors, and other industry people she'd come in contact with up until this point commented not only on the fact that her clothes were often soiled, but that her hair often appeared stringy and dirty. A few wondered if she bathed.

When she showed up at Columbia's Seventh Avenue recording studios on November 9, Barbra was still, according to arranger-conductor Bob Mersey, "a rag-bag lady." It was unseasonably warm that day, and the studio was not air-conditioned. "She's standing in front of the fan," Mersey remembered, "and the brass players were downwind from her; as they played they started to grimace because the smell was so bad."

Barry Dennen would later insist that such stories were apocryphal, and that Barbra was always extremely conscientious when it came to bathing and wearing clean clothes. Still, these accounts emerged from a wide range of sources. Equally important, there was a wide perception at Columbia that Barbra was not only selfish, fiercely ambitious, and temperamental, but that she was also so antisocial that she did not bother to bathe. "They ridiculed her constantly," Columbia publicity chief John Kurland told writer Shaun Considine. They would say, "Why doesn't someone give her a bath, wash her hair, buy her a dress?"

With no support from her record company, Barbra's version of "My Coloring Book," with "Lover Come Back to Me" on the flip side, sank from sight. Barbra was convinced that, while she might not be adept at cranking out hit singles like Gorme or Gore, her style was perfectly suited to an LP format. Erlichman agreed; a well-crafted live album was, they determined, the best way to showcase her talents.

A recording crew was sent to the Bon Soir, where over the course of a week Barbra recorded the album before an invitation-only audience. But *Barbra Streisand at the Bon Soir* was never released. Unhappy with the results, she scrapped the project entirely.

On December 9, *I Can Get It for You Wholesale* closed after three hundred performances. Barbra, who had spent the last few months sleepwalking through the role of Miss Marmelstein, was jubilant. As soon as the curtain came down, she ignored her fellow actors, some of whom were weeping, and ran off the stage shouting "I'm free! I'm free!"

Composer Harold Rome, who had given her her first Broadway musical, would be discarded like so many others who had helped her in the beginning. After *Wholesale* closed, he remarked, "She never sang a song of mine. I sent her a whole batch when she later emerged as a top recording star and she didn't even acknowledge getting them. I called up and a very fake secretarial voice answered and asked, 'Harold who?' I hung up . . . She runs away from the past and tries to put that period out of her mind."

One week after *Wholesale* closed, Barbra made her first appearance on the hugely popular *Ed Sullivan Show* singing "My Coloring Book" and "Lover Come Back to Me." As had already happened

with Elvis and would later happen with the Beatles and the Rolling Stones, her appearance on *Ed Sullivan* would prove to be a defining moment in her career.

Soon she was back at the Blue Angel, where her opening act would be the husband-wife comedy team of Jerry Stiller and Ann Meara. (In a curious twist of fate, more than forty years later their son, Ben Stiller, would cast Barbra in the biggest-grossing film of her career, 2004's *Meet the Fockers*.)

At the same time, she got to work on the studio album she was confident would make her a star. This time, she recorded eleven songs in three days—all that Columbia's $18,000 budget for the project would allow. Arranged and conducted by Peter Matz, who had worked with Noël Coward and Marlene Dietrich, the studio album began with "Cry Me a River," then rambled along with such Streisand nightclub standbys as "Who's Afraid of the Big Bad Wolf?," "Keepin' Out of Mischief Now," and "Soon It's Gonna Rain."

"She was so young—just twenty years old—that of course she had all the misgivings and insecurities that anyone that age would have," said Mike Berniker. "At the same time, she had this unbelievable, utter self-confidence."

As she would do throughout her career, Barbra sought to control every detail. When she realized studio technicians had decided to "clean up" the album by removing her breaths between phrases, she insisted the breaths be reinstated. "Don't *clean* so good. You're cleaning up what is natural, what is right." As for the title, she nixed all attempts at being clever (*From Brooklyn to Broadway, Sweet and Saucy Streisand*) and insisted on simply calling it *The Barbra Streisand Album*. Even the cover art was problematic. She approved the photo, but when she saw the album design, she was outraged that a retoucher had removed the bump on her nose. "If I wanted my nose fixed," she said, instructing the designers to go back to the original, "I would have gone to a doctor."

Musically, observed Mike Beniker, "what set her apart was this remarkable clarity—clarity I never saw before and have never seen since. How could she possibly know all she knew about these great standards by Harold Arlen and Richard Rodgers and the Gershwins? That was the point." Still, she had her detractors at Columbia.

"She was an unknown quantity," said Berniker, who would go on to produce her next two albums as well. "Nobody else was doing what she was doing. It wasn't like 'Oh boy, we're off to the races.' People kept asking; 'Why is she singing so *loud*?' For me, I could identify with what she was trying to do."

Harold Arlen, the celebrated composer of such standards as "Over the Rainbow" and "Stormy Weather," had been smitten with Barbra ever since he first heard her sing his "A Sleepin' Bee." He volunteered to write the liner notes for the album. "Did you ever hear Helen Morgan sing?" Arlen gushed. "Were you ever at the theater when Fanny Brice clowned in her classic comedic way—or when Beatrice Lillie deliciously poked fun at all the sham and pomp: Have you ever heard our top vocalists 'belt,' 'whisper,' or sing with that steady, urgent beat behind them? Have you ever seen a painting by Modigliani? . . . I advise you to watch Barbra Streisand's career. This young lady has . . . a stunning future."

Barbra read over Arlen's tribute and winced. "Is that *it*?" she whined. "So many *dead people*."

Streisand's first album was released on February 1, 1963, and she immediately embarked on a national tour to promote it. After a five-night gig at a Boston-area nightclub called The Frolic, she flew to snowy Cleveland to appear at a club called the Chateau and, most important, to cohost *The Mike Douglas Show* for the entire week of February 11. The show, which was a staple of daytime viewing throughout the 1960s and 1970s, introduced Barbra to a national audience of housewives—precisely the audience Columbia executives were convinced she could never win over.

For five days running, she did skits—in one she played Jeanette MacDonald to Douglas's Canadian Mountie—interviewed guests, sang all the songs on her album, and generally clowned and kidded around with Douglas. "She was magnificent," Douglas remembered. "Great fun, game for everything, a total pro. She even got down on her hands and knees and showed me how to play tiddly-winks using bottle caps." Before the show, Barbra would refuse to speak with anyone, responding even to Douglas's questions by pointing to her throat and smiling. "It took me a while to figure it out," he said. "She was saving her voice for the show. She wanted to sound perfect, and she did."

While in Cleveland, Marty Erlichman quickly discovered that Columbia's lack of interest in Barbra was once again threatening to torpedo her chances of having a hit record. There were, he angrily told the label's sales executives, no albums in Cleveland's record stores; based on the low sales forecasts, only a small number had been shipped. Largely because of Barbra's five straight days on *The Mike Douglas Show,* the albums had sold out within twenty-four hours.

"How dare you do this?!" Erlichman screamed at Bill Gallagher. "After we went out on a limb, taking less money, building a following, and you guys don't have records out there?"

At last, Columbia swung into action, shipping thousands of copies to stores around the country. Barbra returned home to New York, where she made two more appearances with Johnny Carson on *The Tonight Show.* On March 5, Johnny, who justifiably felt he had given her valuable exposure early in her career, trumpeted her success. "You're really going, aren't you?" he crowed, while Barbra giggled in response. "That's the nice thing . . . that you show up here," he continued. "I suppose when you get to be a really big star, we'll never see you again."

"No," Barbra replied instantly. "Never, never. I will never come here again."

The audience laughed, but Carson believed her. "She really means it, too." He was right. Streisand never came back. (In 1975, Barbra was scheduled to be on the program, but canceled the day of the taping. Carson was furious. "It's been twelve years since she was last on the program," he said during the show's monologue, "and it will be another twelve years before she's invited back." The next night, actress Madlyn Rhue showed up in a Streisand wig and lip-synched "People." Carson went up to her and said, "Thanks, we don't need you," and the ersatz Streisand slunk back behind the curtain.)

While her album finally began churning up the charts, Barbra flew to Miami to appear before what she called the "rocks and lox" crowd of affluent Jewish retirees at the Eden Roc Hotel. It did not go well. Even though she shared the bill with the Italian crooner Sergio Franchi, Streisand wound up playing to an empty room. She

did, however, still receive a standing ovation—from the waiters and busboys, some of whom were so excited they leaped up onto tables to whoop and holler their approval.

Barbra flew back to Manhattan to do *The Ed Sullivan Show* for a second time, exposing her again to tens of millions of viewers who would later recall her *Ed Sullivan* appearances as the first time they ever saw Barbra Streisand perform. She also auditioned for the lead in yet another Broadway show—Martin Charnin's *Hot Spot.* Charnin, who would go on to write the Broadway smash *Annie,* had called Erlichman and invited Barbra to try out for the lead. She showed up at the Majestic Theater and learned two of the songs from the show and three of the scenes—all while sucking on a peach pit. "She was dazzling," Charnin said. "I mean she was just staggering."

When Barbra was finished, the producers of the show gave her the standard "Thank you and we'll be in touch" brush-off. "I could see how deflated she was," said Charnin, who apologized to Barbra for his colleagues' "mind-bogglingly rude behavior" and then returned to confront them.

"Are you guys *nuts*?" he screamed. "Have you not just seen the most extraordinary human being that the musical theater has ever produced?"

"No one," one of them said bluntly, "will ever believe that anybody could fall in love with that face." The others nodded in agreement.

"We are making," Charnin replied, "the biggest mistake in the history of this business."

Dejected, Barbra returned to the Eden Roc to complete her dismal run there, then jetted off to San Francisco. In stark contrast to the chilly reception she had received in Miami, Barbra created a sensation when she performed at San Francisco's most famous nightclub, the hungry i. Just to make certain his client's arrival in town got noticed, Marty Erlichman called the fire department claiming that the crowd mobbing the club on opening night—which included no small number of gay men—was creating a fire hazard. The mayhem that ensued was duly reported in the next day's *San Francisco Chronicle,* the *San Francisco Examiner,* and the *News-Call Bulletin.*

The club's eccentric owner, Enrico Banducci, had actually met Barbra the year before in the office of her agent Irvin Arthur. Told that Banducci had passed on hiring her at her going rate of $350 a week, she called him a "moron in a beret" for passing on the opportunity to "grab me now while I'm cheaper." Banducci should have listened. By the time she started her four-week stint at the hungry i on March 27, 1963, her salary had jumped to $2,500 a week.

It was during Barbra's record-smashing run in San Francisco that Columbia re-released "Happy Days" in order to get the album more radio airtime. Within a week, the album jumped onto the *Billboard* charts and began its climb into the top ten. *The Barbra Streisand Album* would remain on the charts for an astounding 101 weeks, catapulting her into the top tier of recording artists—male or female.

Inevitably, the focus on Barbra was not confined to her career. Repeatedly quizzed about her love life, she broke down at one point and told a reporter from the *San Francisco Chronicle* that she and Elliott Gould were married. In the coming months, she would shore up that misconception by periodically referring to herself in the press as "a married woman."

Buoyed by her success, Barbra appeared on singer Dinah Shore's popular NBC talk show on May 12 and caught the eye of an unexpected viewer—President John F. Kennedy, who asked that Barbra sing at the annual White House correspondents' dinner later that month. The day after her Dinah Shore show appearance, Barbra opened for "King of Swing" Benny Goodman at New York's Basin Street East. His stature in the business notwithstanding, the crowds that flocked to Basin Street East that May were there to see Barbra—not the legendary bandleader—and they let him know it. On several occasions, Goodman was booed by Streisand partisans who wanted him to finish up and make room for Barbra. Never acknowledging that he had been heckled, Goodman later said that Barbra's fans reminded him of his own raucous fans from his heyday in the 1930s and 1940s. "Well," allowed Goodman, who had reduced more than one top female vocalist to tears with his criticism, "Barbra *is* very good."

The owners of Basin Street East offered Barbra an exclusive con-

tract at $2,500 a week, but she declined. She did ask for—and was granted—a break in her engagement to entertain at the White House correspondents' dinner. Merv Griffin, who served as host of the stellar affair, had turned Barbra down as a guest on his popular television talk show several times. He also doubted that she was right for the dinner—she certainly did not seem like JFK's type; the President was partial to Hollywood sex symbols in the Marilyn Monroe mold.

On May 23, 1963, Barbra, wearing a cleavage-bearing satin gown, sang "Happy Days Are Here Again" at the Washington correspondents' dinner without ever taking her eyes off the handsome, charismatic JFK. "Washington's power structure sat mesmerized," the once-skeptical Griffin said, "as the little girl from Brooklyn stunned them right out of their minds. When she finished, an awesome pause filled the room; then applause thundered toward the stage. Everyone in the room—even me—knew they were looking at a girl on the way to becoming a major star."

When it came time to stand in the receiving line and meet the President, Griffin warned Barbra that the White House expressly forbade anyone from asking for JFK's autograph—it would simply take too much of his time. Moments later, Griffin introduced Kennedy to Streisand, and she curtsied. "How long have you been singing?" he asked her.

"About as long as you've been president," she shot back without hesitation. The President laughed. Then she stuck a program and a pen in Kennedy's face and said, "Mr. President, my mother in Brooklyn is a big fan of yours, and if I don't get your autograph she'll kill me."

Barbra's old friend and accompanist Peter Daniels turned and offered his back as a writing surface, and the President good-naturedly complied as Griffin looked on disdainfully. "Thanks, Mr. President," Barbra said. "You're a doll."

Over breakfast the next morning, Barbra was still ecstatic over her brief encounter with the President. "I mean, he actually *glowed*," she said, marveling. "It was like he walked around with a halo over his head."

But Griffin was still upset over what he saw as an unforgivable

faux pas on Barbra's part. "You were just fabulous last night," he told her. "You just floored everybody. But for God's sake, Barbra, did you *have* to ask for his autograph?"

"I wanted it," she replied.

"Well, I know," Griffin persisted, "but they specifically asked us not to stop the President."

"But I wanted his autograph, Merv," she explained. "How many times would I get the chance to have the President sign an autograph?"

Defeated, Merv moved on. "Well, did he write an inscription?"

"Yes," Barbra answered with a straight face. "'Fuck you. The President.'"

Of course, the President had actually written "Best Wishes, John F. Kennedy," and Barbra had absolutely no intention of giving the program with Kennedy's signature to her mother. What she did not tell Griffin was that, in the course of the evening, she had misplaced the autographed program. "I put it right down my dress and lost it," she later said. "I couldn't believe it."

As much as she admired the President, the whole point of asking for his autograph became clear to Griffin when he picked up the next morning's papers. Across the country, people awoke to the image of President Kennedy signing an autograph on someone's back while Barbra, hair up and dressed in a dramatic Empire-waisted gown, looked on gratefully.

Unfortunately, Elliott was not around to share in Barbra's success. The day after closing at Basin Street East, Barbra flew to London to be in the audience when Gould made his debut playing a goofy sailor in a West End revival of *On the Town*. The London critics were no more impressed than the New York critics had been, and Barbra, still too self-absorbed to focus on her lover's professional woes, flew home to New York the next day.

The couple would stay in touch by phone, scheduling regular times when they could talk—usually around midnight London time, after Elliott had presumably returned home from the theater. As it turned out, Gould was often not in his hotel room to take Barbra's call, which led her to suspect that he was out with other women. She did not suspect the truth—that he had resumed the

gambling habit that had begun during his teenage years. "It's my way," he explained, "of handling stress."

With her career at full throttle, Barbra went from Basin Street to recording sessions for her next album to yet another appearance on *Ed Sullivan* (where she awed the show's famously cadaverous host with her roof-raising rendition of "When the Sun Comes Out") to a three-week engagement at Mr. Kelly's in Chicago.

When Liberace invited Barbra to open for him at the Riviera in Las Vegas, Marty Erlichman jumped at the chance. Not only would she get $7,500 a week for being Liberace's "extra added attraction," but she would be handed a golden opportunity to conquer the town where the Rat Pack still reigned supreme.

Unfortunately, Liberace's audiences—mostly older ladies who dragged their reluctant husbands to see the sequined showman and his candelabra-topped white piano—"did not get her at all," he admitted. For three nights running, Barbra's half-hour set earned only a smattering of polite applause. The *Hollywood Reporter* seemed to echo the audience's sentiments: "Her make-up made her look like something that just climbed off a broom but when she sang, it was like the wailing of a banshee bouncing up and down on marionette strings . . . Her outrageous grooming almost nullifies her talent." Alarmed, management was poised to fire her. At this point Liberace, who was effusive in his praise of the newcomer, took matters into his own hands. First, "Lee," as Liberace was known to his friends and colleagues, suggested that she replace her drab gray wardrobe with a flashy gold lamé dress and dangling earrings. "This is *Vegas,* baby," he explained, "you gotta sparkle!" The fourth night, he started the show off, then after fifteen minutes breathlessly introduced "my new discovery, this very talented young gal, Barbra Streisand!" Liberace's scheme worked; this time when Barbra finished, she got a thunderous ovation.

At one point during Barbra's run at the Riviera, Jule Styne and Ray Stark came backstage to see her. By this time, she was no longer hell-bent on playing Fanny Brice onstage. She had already turned down an offer to star in the new Sondheim musical *Anyone Can Whistle* (which, with Lee Remick and Angela Lansbury heading the cast, fizzled). Styne played a few of the new numbers he had

written for *Funny Girl* anyway, but stopped short of offering her the part. Barbra was equally noncommittal.

Two weeks later, after Carol Burnett turned down the part on the grounds that it was better suited to a Jewish actress, Ray Stark finally made up his mind. "We go with the kid," he told Styne and his director, Jerome Robbins. On July 25, 1963, Stark announced to the press that Barbra Streisand had been signed to play the part of Fanny Brice in *Funny Girl.* "We're very much alike," Barbra told a reporter. The script, she went on, "is like me talking. Like Miss Brice, I find it hard to take advice from anyone. Fanny Brice was a woman who refused to heed her mother, or Florenz Ziegfeld."

The same record executives who had once written her off as appealing only to "fags" were now scrambling to cash in on the Streisand phenomenon. Five days after the announcement that Barbra would star in *Funny Girl,* her second album was released. The aptly named *The Second Barbra Streisand Album* contained standards like "Any Place I Hang My Hat Is Home," "Down with Love," and the poignant "Have I Stayed Too Long at the Fair?" There was also a new, manic-staccato number composer-arranger Peter Matz had written expressly to suit Barbra's restless personality, "Gotta Move." *The Second Barbra Streisand Album* was an immediate hit, and would remain on the charts for seventy-four weeks.

Mike Berniker would call it quits after producing *Barbra Streisand: The Third Album,* which would make it to number five on the strength of Streisand's renditions of "Melancholy Baby," "Just in Time," "As Time Goes By," and other standards.

"I stopped working with Barbra by choice because she had just become too domineering," Berniker explained. "For her to *dictate* to me, the producer, was simply unacceptable. And that was definitely her M.O. Barbra's whole approach is 'You don't exist until I finish *telling you* what to do.' She's a great talent, but when you work with Barbra you have to put up with a lot of shit. I wasn't willing to do that, but of course there were plenty of people who were."

With royalties rolling in and club dates lined up for months at $10,000 a week and up, it was time to bid good-bye to her live-in rat Gonzola and move out of her apartment over Oscar's Salt of the Sea. For the then-hefty sum of $450 a month, Barbra and Elliott—now back from London—rented a twentieth-floor duplex on

Central Park West that had once been the home of the celebrated songwriter Lorenz Hart. The apartment featured wraparound terraces, chandeliers, ten-foot-high ceilings, and a winding staircase that led to the upstairs master bedroom—an architectural detail Barbra found especially appealing. "I can make an entrance," she said. "You know what I mean?"

The bedroom was dominated by a Brobdingnagian carved wood French canopy bed; beside it, Barbra had a small refrigerator installed so she could snack on bricks of her favorite Breyers coffee ice cream while watching old movies on television. She covered the walls of the kitchen in red patent leather and stocked the refrigerator with gefilte fish, kosher salami, pickled beets, corn fritters, cottage cheese, grapefruit wedges, caviar, and her favorite— Swanson's frozen chicken TV dinners.

She would soon have two dozen gardenia plants delivered and placed throughout the apartment—in the kitchen, the dining room, the bathrooms, in a wooden bucket next to her bed. "A garden is a free spirit," she explained to a visitor. "Its fragrance cannot be captured. It's like it doesn't want to be tied down and destroyed by all the sterility of modern times."

Barbra would have little time to enjoy her glamorous new pied-à-terre. No sooner had she and Elliott moved in than she boarded a plane headed for Los Angeles and what would become a history-making two-week engagement at the Cocoanut Grove.

Located at the Ambassador Hotel on Wilshire Boulevard, the Cocoanut Grove was easily the best-known nightclub in Hollywood. The club's decor featured ceiling-scraping potted palms—said to be props from Rudolph Valentino's silent classic *The Sheik*—with stuffed monkeys hanging from them, red and green chairs, and a brilliant blue ceiling painted with twinkling stars. And while top-of-the-line acts performed there—among them Frank Sinatra, Sammy Davis Jr., Judy Garland, Ella Fitzgerald, Duke Ellington, Bob Hope, Peggy Lee, and Bing Crosby, to name just a few—the star-packed audience was often the real star of the show.

August 21, 1963—Barbra's opening night—would be exceptional even by the Cocoanut Grove's lofty standards. Five years earlier, Judy Garland had made history there with her comeback performance. Now Natalie Wood, Kirk Douglas, Danny Thomas,

Edward G. Robinson, Ray Milland, and Henry Fonda were among the twelve hundred entertainment-industry movers and shakers who had come to see if the woman could possibly live up to the hype.

Terrified, Barbra decided to approach the evening with a sense of humor. Since the other big Hollywood story was the pending release of *The Sound of Music* with Julie Andrews in the starring role, Barbra thought she would pay homage to the film with a puff-sleeved pink gingham gown of her own design.

Not one to change her ways—not even for this stellar crowd—Barbra kept the audience waiting a full hour before she made her appearance. She would recall years later that, as she made her way to the stage in her pink gingham outfit, she heard a woman dripping in diamonds murmur, "And I've had to wait all this time to hear some *facochtek* [Yiddish for "fouled up"] country singer?"

She made her belated entrance from the back of the room, a spotlight following her as she moved through the audience toward the stage. First, she apologized for being late, then, gazing out at all the famous faces, acknowledged that she was the only one in the room she didn't recognize. She also noted that the audience surrounded the stage. "This is a strange room. So wide," she mused. "If I'd known you were going to be on both sides of me I'd have gotten my nose fixed."

Within minutes, the audience was hooked. "Henry Fonda even stood up and applauded after one song," she said. "Henry Fonda." Also in the audience at the Cocoanut Grove that night was Fran Stark, now completely sold on the idea of Barbra playing her mother in *Funny Girl*.

Three weeks later, on closing night, Judy Garland showed up to see why everyone was calling this cabaret singer from New York "the next Garland." After the first song, Judy nudged the person next to her. "I'm never," she whispered, "going to open my mouth again." That night, in fact, Garland invited Barbra to be a guest on her new CBS variety show. So did Bob Hope, who wanted her for one of his upcoming hour-long NBC comedy specials. She accepted these, but passed on similar offers from Bing Crosby, Red Skelton, and Danny Thomas; there simply wasn't time in her rapidly filling schedule.

Barbra's Cocoanut Grove stint gave her time to hobnob with stars

and producers, and to shop around for a new agent. Barbra had out-grown Irvin Arthur, and now needed an agency with strong ties to the major studios. She found what she was looking for in Freddie Fields and David Begelman, whose new Creative Management Associates (later International Creative Management—ICM) represented Judy Garland, among others. Fields and Begelman, who would eventually kill himself after being charged with embezzlement in one of Hollywood's most sensational scandals, courted Barbra aggressively. Once her contract with Arthur's Talent Associates Agency expired, she signed with CMA for one reason: Unlike her old agency, CMA had a separate division devoted expressly to placing its clients in motion pictures. As evidence of their clout, Fields and Begelman put Barbra together with Samuel Goldwyn Jr., who offered her the lead in his new movie, *The Young Lovers*. Streisand, set to start rehearsals for *Funny Girl* at the end of the year, demurred.

Still, Barbra was far from satisfied. In her sprawling suite at the Ambassador Hotel, she called the housekeeping department to complain that her shoes were missing (she eventually found them tangled up in her bedclothes) and lashed out at critics for failing to appreciate her exotic beauty. "No one writes about me in terms of looking good," she scolded one reporter. "They just say, 'This is the girl that's ugly, but very talented.' "

Her stay at the Ambassador also gave Barbra a chance to bask in her newfound celebrity status. Early on, she appeared at the front desk and loudly proclaimed that her room would have to be guarded because she kept her jewelry there. Why not put them in the hotel safe? "Everybody *knows* that you can't trust hotel safes," she added with a flourish. Whenever she had a spare moment, Barbra would join Elliott for a stroll through the lobby, talking animatedly and hoping to be recognized. "It was all still new and exciting," Gould said. "We were still kids."

The day after she closed at the Cocoanut Grove, Barbra and Elliott headed north to Harrah's casino resort at Lake Tahoe, where once again headliner Liberace introduced her, more proudly than ever, as his "discovery." Flamboyant, hard-drinking, womanizing casino owner Bill Harrah, who would number among his six wives country singer Bobbie Gentry, was one of those who viewed Barbra as "an acquired taste. I've got to admit that her kooky looks

threw me at first. She waved her hands around a lot and seemed almost hysterical when she sang. But that voice . . ."

Harrah, a perfectionist, sat in the audience on opening night as he always did, and at one point Liberace pointed him out to the audience. "That's my boss," he said, giggling, while Barbra rolled her eyes backstage. After the show, Harrah told Liberace that the next time Barbra was coming back to his casino, it would be as the headliner. Bill Harrah was not the only Nevada casino owner who was offering Barbra a hefty sum to perform at his establishment; she had already signed a contract with the Riviera to perform there as often as she'd like at a salary of $10,000 a week. It would be seven years, however, before she could find the time in her schedule to fulfill her contractual obligation.

Barbra was about to take on a far more important contractual obligation—to Elliott. While the public was under the impression that they were already married, Streisand and Gould had been thrusting and parrying for months over the question of marriage. At one point, she was the aggressor, pushing for matrimony while he resisted on the grounds that he did not want to become just another sycophant in her swelling entourage.

On other occasions, it was Elliott who seemed to be shoving them both toward the altar. But that backfired when she told him bluntly, "I really can't stay with you. I have to sow my oats. What if I was with you and I wanted to be with Marlon Brando?"

By the time they landed together at Lake Tahoe, Barbra and Elliott agreed that they had reached a pivotal moment in their relationship—either they would call it off completely or get married. "It was like we shook on it," Gould recalled. "Let's get married—glop! So we did."

On September 13, 1963—a Friday—Barbra and Elliott drove twenty-five miles to Carson City, Nevada. The decision to marry in Nevada, and not over the state line in California, may have been a strategic one; unlike California, Nevada did not have a community-property law. Whatever she earned in the marriage, then, would remain hers, and not have to be shared with Gould in the event of a divorce. In the days before prenuptial agreements, this would have been a prudent move.

With no press present—after all, the world had been under the

impression for six months that they were already married—
Streisand and Gould were wed before Justice of the Peace Pete Su-
pera, with Barbra's two Martys—Erlichman and Bregman, her new
business manager—as witnesses. The bride, who signed the mar-
riage license Barbara Joan Streisand, wore a cotton suit and a benign
smile. Ever the control freak, she wanted the vows changed. Instead
of promising to "love, honor, and obey," she pledged to "love,
honor, and feed." Food, after all, had always meant a great deal to
Barbra. "I mean food, nourishment, that's a very important exchange
between people," she said. "It's as important as sex, you know?"

As his gift to the newlyweds, Bill Harrah put them up for the re-
mainder of their stay at one of his sprawling glass-and-stone houses
on Lake Tahoe. Now cast in the real-life role of wife, Barbra de-
cided to make a show of her newfound domestic prowess by throw-
ing a birthday party for Liberace's stage manager. After the candles
were blown out and the guests dug in, Liberace complained that the
frosting was "tough."

"Oh, yeah, well, I guess that's because I had a little problem," she
said. "I ran out of confectioners' sugar, so I used flour instead." Ac-
cording to Liberace, Barbra's cake made "a great doorstop."

From Tahoe, the Goulds returned to Los Angeles and checked
into the Beverly Hills Hotel for what was to amount to a busman's
honeymoon. While Barbra met with her various representatives,
did interviews, and prepped for her appearances on the Bob Hope
special and Judy Garland's new series, Elliott bided his time in the
wings. When the two found time to cavort in the hotel pool, it
was for the benefit of magazine photographer Bob Willoughby,
whose shot of Barbra perched on Elliott's shoulders, her hand
completely obscuring his face, would speak volumes about their
relationship.

Whenever she could, Barbra waxed poetic about the man she had
chosen to marry. "To me, he is a mixture of Bogart, the Michelan-
gelo statue of David, and—Jean-Paul Belmondo."

During the taping of *The Bob Hope Comedy Special,* Barbra
gamely hoked it up with Hope and Dean Martin, strumming a
washboard as part of a gap-toothed hillbilly trio. "Bob was a huge
fan of Barbra's from the very first moment he heard her sing,"
Hope's wife, Dolores, said. "Even when everyone else failed to see

it, Bob kept saying, 'She's gonna be big—another Garland, I'm not kiddin'. Just wait.'"

The real Judy Garland felt the same way, and when Barbra showed up at CBS's L.A. studios on October 4, 1963, to tape Garland's new show, the excitement was palpable. Not one to be outdone by a newcomer, Judy, who customarily arrived in the morning bleary-eyed from a night of barbiturates and drinking, showed up early looking rested and "ready to knock 'em dead," said the show's pianist, Jack Elliott. Conversely, Elliott remembered that Streisand walked in looking "dirty, scruffy, and barefoot, with stringy hair." But once she opened her mouth, Elliott said, "who gave a damn what she looked like?"

In fact, by the time she stepped onstage for the taping, Barbra, whose geometric shoulder-length hairstyle was already being copied by women around the country, looked young and chic in a skirt and sailor top. Judy introduced her during her regular "Be My Guest" segment, proclaiming, "You can have anything you want, dear."

"Can I replace you?" Barbra shot back, waiting for Judy's scripted double take.

"Well, yes, dear," Garland replied with a straight face, "but not right now."

Later on, after Streisand had sung "Bewitched, Bothered, and Bewildered" and "Down with Love," Garland gushed, "You're thrilling. So absolutely *thrilling*! You're so good that I *hate* you!"

"Oh, Judy, that is so sweet of you, thank you," Barbra said sunnily. "You're so great I've been hating you for years. In fact, it's my ambition to be great enough to be hated by as many singers as you."

Mel Tormé had been brought in to compose and arrange special material for the show, and Garland went to him with the idea of combining her hit "Get Happy" with Barbra's "Happy Days Are Here Again." Afraid of offending the notoriously prickly Miss Streisand, Garland told Tormé to approach her with the idea as if it were his own. The resulting duet would go down in history as one of television's greatest musical performances.

But there was more. Halfway through their scripted "Tea Time" chat segment, Ethel Merman bounded onstage and the three sang Merman's signature song, "There's No Business Like Show Busi-

ness." Neither Garland nor Streisand could compete with the undisputed Queen of the Broadway Belters, and at one point Barbra, straining to be heard over Merman's caterwauling, rolled her eyes in mock exasperation.

Later, Judy and Barbra teamed together for a "Hooray for Love" medley of their respective hits, and at one moment during Streisand's frenzied version of "Lover Come Back," Garland burst out in spontaneous laughter.

Not ready to hand over her crown quite yet, Judy ended the show with one of her biggest hits, the Oscar-winning "Trolley Song." Barbra led the studio audience in a standing ovation.

If Barbra was nervous about working with the legendary Garland, she did not show it. Throughout the taping of the show, she was confident, unflappable, in complete control. Judy, on the other hand, was extremely open, vulnerable, and more than a little nervous about Streisand.

"She was kind, sweet, frightened, clutching my hands, holding on to me," Barbra said. "My heart went out to her. She was holding on to me, tight. She was scared. Somehow you get more scared as you get older, maybe. When you're young, you have nothing to lose." At the time, Garland was all of forty-two years old.

CBS founder William Paley had flown out from New York expressly to watch the Garland–Streisand taping. "Watching those two—the legend and the legend-in-the-making—really sent a chill down everyone's spine. It was Barbra's moment, but it was Judy's, too. She was in top form." Paley was so impressed that he ordered that the show be edited quickly and moved up on the schedule so that it would air just two nights later.

The show also marked a reunion for Barbra and her former lover Tommy Smothers, who with his brother, Dick (and newcomer Jerry Van Dyke), provided the show's comedy relief. "Elliott knew that Barbra was sexually restless and he was very jealous when she was around other men," said a friend from the Bon Soir days. "He had no idea she had slept with Tommy Smothers. If he had, he would have gone crazy about the two of them working on *The Judy Garland Show* together." Was there any reason for Gould to be concerned? "Barbra thought Tommy Smothers was very sexy in a way that Elliott just wasn't. She was very coy about the whole

thing . . . Everybody was paying so much attention to how she and Judy were getting along, nobody saw the chemistry between Barbra and Tommy."

Indeed, it was the chemistry between the two women that brought Judy and Barbra Emmy nominations for Best Variety Performance—in Streisand's case, the first time a one-shot guest had been nominated for an Emmy. Publicly, Barbra claimed to be embarrassed to be vying with Garland for the same award; privately, she was, Gould said, "absolutely delighted—are you kidding?"

Barbra's first manager, Ted Rozar, was not at all surprised that the two women had hit it off. "First, Barbra was wonderful to powerful, important, famous people. They were rungs up the ladder to her. And of course, Judy loved being kowtowed to," Rozar said. "They were so similar: Judy was an animal, Barbra was an animal. Singers like Ella Fitzgerald and Eydie Gorme and Peggy Lee and Rosemary Clooney—those were people. Garland and Streisand were animals."

The day after the Garland taping, Judy caused another sensation when she appeared at the Hollywood Bowl with Sammy Davis Jr. But one event in the fall of 1963 would overshadow all the events in Barbra's life—and everyone else's, for that matter. On November 22, Barbra was back home in Manhattan and indulging in her favorite pastime—shopping for antiques—when the news came over the store radio that President Kennedy had been assassinated in Dallas.

"It just can't be true," Barbra said, suggesting that perhaps it was just some sort of radio hoax like the one Orson Welles pulled off in 1938. At the time, Welles's realistic "War of the Worlds" broadcast sent off a worldwide panic among listeners convinced the earth was being attacked by Martians.

Barbra was in a cab headed home when she spotted Elliott in a taxi going in the opposite direction. Both ordered their cabs to stop, jumped out, and fell into each other's arms. Like the rest of America, the Goulds and everyone around them were in a state of shock. "You've got to remember," said Marty Bregman, who rushed to be with Barbra at her Central Park West apartment, "she worshiped JFK even *before* she met him. Like a lot of young people, she felt he spoke for her generation. She got pretty emotional whenever she talked about Jack Kennedy."

That afternoon, Barbra went ahead as planned with a rehearsal at New York's St. Regis Hotel, where she was scheduled to perform that night at a charity event. With a full orchestra behind her and her friend Peter Daniels conducting, Barbra managed to soldier through—until she began to sing "Happy Days Are Here Again," the song she had sung for Kennedy just six months earlier in Washington. After the first few bars, she broke down. It would be the first and last time Barbra Streisand lost control onstage.

For the next two weeks, Barbra careened from one high-paying one-night engagement to another, culminating in a whirlwind tour of California that took her by rental car from San Francisco to San Jose to Sacramento and back to Los Angeles. At a time when air-conditioning was not a standard feature in most American automobiles, she sweltered in the backseat while poring over the script to *Funny Girl*. She learned her songs and her lines while the California countryside whizzed by—only to discover once she got to her hotel that pages of revisions were waiting for her.

The script wasn't the only thing about *Funny Girl* that had changed while Barbra was busy becoming a star. Bob Fosse had signed on as director, then quit when Ray Stark questioned his competence. Stark then talked to his old friends in Hollywood, persuading Sidney Lumet, director of such films as *Twelve Angry Men* and *Long Day's Journey into Night,* to take the job—until Lumet took one look at the script and deemed it "too messy."

Exit Jerome Robbins (over "differences with the producer"). Enter Garson Kanin, a screenwriter and sometime film director who, along with his actress wife Ruth Gordon, had written the scripts for the Katharine Hepburn–Spencer Tracy classics *Pat and Mike* and *Adam's Rib*. Soon Kanin was told that he was to deal exclusively with Stark; David Merrick, at odds with his coproducer from the beginning, had also bowed out of the show.

All of which put Barbra in the proverbial catbird seat. The show had essentially been built around her, but her contract was technically with Merrick, not Stark. If *Funny Girl* was to make it to Broadway with Barbra Streisand as its star, Stark would have to negotiate a new contract with her new agents. In the end, Barbra walked away with more money—at $5,000 a week, nearly four times the salary she had been promised in her contract with

Merrick. For now Stark, whom Barbra would come to regard as something of a father figure, felt betrayed. "Ray Stark was a very proud man, and someone who did not like to be taken advantage of," Kanin said. "You got the definite feeling that he felt this little girl he was making into a great big Broadway star had taken him for a ride."

Rehearsals began on December 6, 1963, with Charlie Chaplin's dashing thirty-eight-year-old son Sydney playing Nick Arnstein and veteran actress Kay Medford cast as Fanny's mother, Rose. From the first day, Barbra was struggling with the material. "She was a natural singer and a presence—a star—but acting," Kanin observed, "is more than that. She had no technique, no ability to inhabit the character and then get that across to the people in the audience." Chimed in the ever-wise Ruth Gordon: "Barbra is great, but she is not yet *good*."

Almost immediately she clashed with Jule Styne over two songs that she did not want to sing: "People" and "Don't Rain on My Parade." Styne was furious. "Barbra," he told her point-blank, "if you don't sing 'People,' you don't sing my score."

Floundering, Barbra asked Marty Erlichman to call up her old acting teacher Allan Miller for advice. Miller, who had played such an important part in nurturing her career back when she was trying to escape her mother and Brooklyn, agreed to drop everything and coach her. But when he asked to be paid for his efforts, Barbra balked. "You're like my father," she protested. "It's like paying my father."

"Well, Barbra," Miller replied, "even daddies have to eat."

Grudgingly, Streisand agreed to pay Miller as long as he coached her in secret and introduced himself to everyone as her "lawyer cousin from California." Over the next thirteen weeks, Miller would work closely with Barbra, shaping every line and every gesture—even restaging entire scenes. Since Miller was incognito, these suggestions had to come not from him but direct from Barbra, as if they were her ideas.

Kanin's directorial style, which was to "create an atmosphere and then let the actors *be,*" simply did not work for Barbra; she had no

great reservoir of acting experience to draw on. Even projecting her
voice became a problem. "I never played to the balcony," she con-
ceded. "I always played to the best seat in the theater. I always
played to my own reality." To rectify the problem, a microphone
was tucked in her cleavage, and the battery pack was taped to her
backside.

From the first out-of-town tryouts at the Schubert Theater in
Boston, it was painfully evident that Barbra would be needing all
the help she could get. Starting late because of a blizzard, the show
did not end until two A.M.—and by then half the audience had van-
ished. It did not help that in the middle of one song Barbra's
microphone began picking up police calls that could be clearly
heard in the first few rows.

In its then-present incarnation, *Funny Girl* was anything but. Not
only was the show an hour too long, but most of the songs were
forgettable (not even "People" seemed to elicit a response), the
story was weak and unfocused, the dialogue bland. It did not matter
to the theater audience that they were watching one of the newest
stars in the show-business firmament. "Barbra was in real trouble,
and she knew it," Miller said. "She was just behaving like a rank
amateur up there onstage. It was appalling."

It was at this point that Stark actually considered firing Barbra
and replacing her with another actress. Carol Burnett was ap-
proached yet again, as was Eydie Gorme. Barbra's understudy and
fellow Erasmus alumna, Lainie Kazan, was also told to get ready to
audition for the lead.

At first Kazan, who had already had small roles on Broadway and
a blossoming nightclub career of her own, was not interested in tak-
ing the job. "I'm not the understudy type," she told Ray Stark. But
Stark, who had just broken his leg in a skiing accident, had her
driven in a Bentley to his suite at the Navarro on Central Park
South. There he offered her a seven-year movie contract and fifty-
dollars a week to understudy Barbra and play the role of Vera, a
Ziegfeld showgirl. She accepted—"mainly for the fifty dollars a
week. That was a fortune to me then."

Later, when Jerome Robbins returned to the production and saw
the sultry Kazan for the first time, he shook his head. "Oh, Christ,
she can't be Fanny Brice!" he said. "She's too damn attractive."

Now determined to keep her job, Kazan asked for ten minutes to audition for him. "Robbins just sat there, stone-faced," she recalled. "But later he sent me a bottle of champagne."

Barbra desperately needed her old acting coach to turn things around. Miller employed a variety of techniques and some outright trickery to make her come alive onstage as Fanny Brice. When Jerome Robbins complained that she lacked maturity, Miller pointed to a copy of an old-master painting that hung on Barbra's wall. The painting was of a young girl hoisting up her skirt to dip her toe in a stream. "Look at her face," he said to Barbra. "What's the girl doing? What's her expression?"

"Nothing," Barbra said with a shrug.

"That's right," Miller replied. "She isn't *kvelling*. She isn't registering any emotion on her face. She's just doing what is necessary. Try just doing what is necessary."

From that moment on, Miller had her practice only doing what was necessary. "Barbra cut out the unnecessary gestures, the expressions—she calmed down," he said. "Then Elliott walked in and said, 'Barbra, you seem different.'"

"How?" Barbra asked.

"I dunno," he said. "You seem older."

A particularly tough challenge was getting Barbra to cry on cue. Years earlier, when she was acting in one of his drama-school productions, Miller had solved the problem by tapping into her near obsession with food. He asked her to imagine what it would be like if she cut him a piece of her birthday cake, only to have him intentionally drop it on the floor. "She became quite upset at the thought of someone doing something so mean," Miller said. During rehearsals for the play, he hired a stagehand to stand in the wings so that Barbra could see him and, at precisely the right moment, dig into a large piece of cake. "She sobbed like a baby," Miller said. "That's how powerfully she felt about food—and about someone else enjoying something that she wanted."

Frustrated that he had to coach Barbra in secret, Miller nonetheless grabbed her and Sydney Chaplin for an impromptu rehearsal in the ladies' room while Chaplin's strikingly beautiful wife, Noelle, kept watch outside the door. Ironically, Barbra, who had been married to Elliott Gould for a little over three months, was already in

the throes of an affair with her leading man. At one point during the Boston run, Chaplin, who had already romanced the likes of Judy Holliday, Joan Collins, and Kay Kendall, was entwined with Barbra on the sofa of her dressing room when a friend bounded in. "Like lovers caught in the act," Streisand and Chaplin scrambled to disentangle themselves.

Although Barbra never complained about the physical toll all the stress was taking, she was now throwing up offstage with disturbing regularity. To keep food down, she began taking the prescription medication Donnatal. At various times, Barbra lashed out at Kanin ("I gotta get this fucking thing right. Just tell me what to do!"), at Stark ("Do you want a goddamned hit or not?"), and at the conductor, whom she repeatedly called "that fucking asshole in the pit."

Jule Styne, meanwhile, was, by his own admission, "having a small nervous breakdown" over the possibility that the song "People" might be cut from the show. In a last-ditch effort to save the ballad, Barbra agreed to go into the studio and record it as a single. But since Capitol Records, not Columbia, was to record the cast album, Columbia executives were reluctant to do anything to promote *Funny Girl*. In the end, they agreed to release the single only if "People" was on the B side of the record. Columbia would do little to promote the song, instead focusing their efforts on the A side, "I Am Woman."

By the time *Funny Girl* opened in Philadelphia on February 4, 1963, "People" was already a hit, at least in the City of Brotherly Love. It would not be cut from the show.

The battles continued. Stark, Kanin, Styne, the writers Isobel Lennart and John Patrick, the choreographer Carol Haney—all fought constantly over the direction the show was taking. "Garson Kanin was so wonderful," Lainie Kazan said. "Ruth Gordon was always there, whispering in her husband's ear—so bizarre. But in the end the major problem was that Kanin and Barbra just didn't get along."

Finally, in desperation, Stark fired Kanin and brought Jerome Robbins back. When Kanin refused to give up his credit, Robbins agreed to a "production supervised by" credit—and the then-staggering fee of $1,000 a day.

At the epicenter of the chaos—Kazan would describe the production as being "in complete turmoil all of the time"—was Barbra.

"She was in total control of everything," Kazan said, "only she didn't know exactly what she was controlling. Barbra was just so determined to succeed. She was like a steamroller."

Streisand argued bitterly, loudly, and often with both Stark and Kanin. "Barbra may not have ulcers," the embattled director said, "but she's definitely a carrier."

One of the biggest rows was triggered by Barbra's failure ever to do anything the same way twice. After giving what Stark deemed to be a flawless performance one night, she did something altogether different the next. Stark stormed into her dressing room. "You goddamned fucking little bitch! . . . You'll never work in the theater again!"

Barbra appeared shell-shocked—until Stark made the mistake of ordering her to do it his way or else. "I *own* you," he shouted.

"You do not own me!" Barbra blasted back. "Fuck *you!*"

"You can't say that to me!"

"This is my dressing room," she screamed so that her voice could be heard out the door and down the hall, "and I am telling you to get out. *Fuck you* and get the hell out!"

Furious, Stark stomped out. "Do you think," Barbra asked Allan Miller, "that I should call the others in and say 'fuck you' to them, too?"

When the "goddamned asshole in the pit," conductor Milton Rosenstock, appeared in her dressing room to complain that her improvisational riffs were confusing to him and the orchestra, she informed him in no uncertain terms that it was his job to follow her lead, not the other way around. Sweating profusely, Rosenstock literally backed out of the dressing room. Fearing for his job, the middle-aged Rosenstock returned to Barbra's dressing room to genuflect and tell her she had been "right all along."

Perversely, Barbra, who made a point of eating Chinese food every night before she went onstage, would claim she thrived on the confusion. "The more they changed the scenes, the more I liked it," she insisted. "The more I had different songs to try out, the more I loved it. We had forty-one different last scenes, the last one being frozen only on opening night. Forty-one versions of a last scene! That was always exciting, stimulating . . . I work best under battle conditions." In fact, just one hour before the curtain was to go up,

Barbra and Chaplin were still rehearsing the latest version of their final scene.

Barbra's lover and leading man had no illusions about his own importance. "Just stand there and *be*," Chaplin was told. "She'll do the rest." As it stood now, in fact, Barbra was on stage for 111 of *Funny Girl*'s 131 minutes.

Chaplin's role was dramatically cut to give Barbra more time, and he knew clearly where he stood vis-à-vis La Streisand. "I'm sort of nobody, a straight man for Barbra Streisand," he admitted. "I'm a guy in white tails, a snob. The audience doesn't root for me. And you can't write a good part when the character doesn't *want* something. What can you hope for Arnstein, that he doesn't ruffle his white shirt?" The glory—and the burden to make the whole production work—was all Barbra's.

Indeed, journalist Ray Kennedy would describe *Funny Girl* as "the most fussed-over, reworked, overmanaged, multidirected Broadway production ever—imposing expectations on its star that would have broken someone who lacked her will."

Before the show arrived on Broadway, Allan Miller visited Barbra at her Philadelphia hotel room and tried to get her to relax by rubbing her shoulders. Miller asked his student if she would be inviting her mother to the opening. Reluctantly, she said yes. How about her sister, her brother? They were also invited, she replied. "What about your father?" he asked.

"Oh, Allan . . ." Barbra said.

"I was wondering," Miller continued, "what it might be like to dedicate the entire opening night performance to your father."

Barbra burst into tears. "She just bawled and bawled," Miller said. "Her connection with her dead father—her longing for him—was just always there, right beneath the surface."

After five postponements, *Funny Girl* opened at the Winter Garden Theater on March 26, 1964. Even before she sang a note—from the moment she stood staring into a mirror and uttered the musical's classic opening line, "Hello, Gorgeous"—Barbra carried the entire show on her own slender shoulders. Her paean to self-esteem, "I'm the Greatest Star," her hilarious pregnant-bride "His Love Makes Me Beautiful" bit, her touching rendition of "People," her dreamy "The Music That Makes Me Dance," her roof-raising

anthem of defiance, "Don't Rain on My Parade"—each met with thunderous applause and, when it was all over, a standing ovation that seemed to go on forever. That night, there would be no fewer than twenty-three curtain calls.

The mayhem did not end there. Trying to make her way to her dressing room, she was shoved and pulled in every direction. Leading the pack was Ethel Merman, who elbowed her way into the room to boom her congratulations to the shell-shocked star. "It was the most gorgeous, transcendent performance," Miller said. "And it was all because she was really giving it for her father. Only she and I knew that." When Miller walked into her dressing room, he watched as "Ray Stark, and Robbins and the rest of them literally bowed down to her."

When the others had left, Miller remembered, "Barbra looked at me and I looked at her, and she said, 'Wow!' "

"Yeah," Miller replied. "Wow." Her moment of triumph over, Barbra then asked Miller to share his notes on what she could have done better. "I thought maybe she would want to savor the moment for a while, but no, she was all business." (Unable to sustain the level of emotion she'd summoned in her father's memory, Barbra faltered the second night. After the curtain came down that evening, an angry Stark burst into her dressing room and bellowed, "I want last night's performance back again!")

While Barbra was already fretting about imperfections in her performance, everyone else involved in the production was understandably in the mood to celebrate. "There were rave reviews, and we were in the biggest show with the biggest star on Broadway," Kazan remembered. "I didn't even care that I had to walk up the five floors to the chorus dressing rooms. We were living the high life."

The pandemonium that had begun backstage at the Winter Garden continued at the art deco Rainbow Room atop the RCA Building, where Ray and Fran Stark hosted the opening-night party. When Barbra made her entrance with her husband and Marty Erlichman, the room erupted in applause. Angela Lansbury, Sophie Tucker, Leonard Bernstein, and Bette Davis were among those who came to pay homage. Even Fanny Brice's second husband, Billy Rose, was there. "I understand I was married to you once," she said. "So how was I?"

"Great"—he smiled—"for the first five years."

Barbra was also surprised to see her kid sister, Roslyn, who at fourteen and standing just five foot two inches tall weighed nearly two hundred pounds. "Jeez," said Barbra, who hadn't seen her in nine months, "you really look like a *big girl* now!"

The comment, clearly intended to wound, did just that. It hit, Roslyn Kind would say years later, "right in the heart." From that moment on, Roslyn would idolize Barbra to an extent that bordered on obsession. She sat through fifty straight matinees of *Funny Girl,* then waited outside the stage door with the rest of the cheering fans to catch a fleeting glimpse of the star. The shy, chubby teen saw her own sister as unapproachable, and Barbra did nothing to make her feel differently. Whenever she spotted Roslyn in the crowd, Barbra simply pretended not to notice her. "Oh, there was no way she could have missed her sister standing out there," said one of the regulars who waited outside. "Barbra looked right through Roslyn as if she wasn't there."

Incredibly, opening night of *Funny Girl* was, claimed Elliott, "a disaster for Barbra. People were pawing her, sticking mikes down her bosom, telling her things she couldn't believe . . . it was almost depressing."

Streisand would later concede that the whole experience—the praise, the hysteria—left her drained, confused. "What does it mean when people applaud?" she asked. "I don't know how to respond. Should I give 'em money? Say thank you? Lift my dress. The *lack* of applause—that I can respond to. It tears me up!"

Barbra was equally suspicious of the praise she received from critics, and the critics gave her plenty to be suspicious about the morning after *Funny Girl* opened. With few exceptions, they stumbled over one another reaching for superlatives. "Some stars merely brighten up a marquee," *Time* proclaimed. "Barbra Streisand sets an entire theater ablaze . . ." *New York Times* critic Howard Taubman called Barbra's portrayal "splendid . . . she goes as far as any performer can toward realizing the laughter and joy that were Fanny Brice." *Cue*'s reviewer could scarcely contain himself: "Magnificent, sublime, radiant, extraordinary, electric—what puny little adjectives to describe Barbra Streisand."

The most influential critic of the time, the *New York Herald*

Tribune's Walter Kerr, was almost blasé about the inevitable, spectacular arrival of Barbra on the Great White Way. "Everybody knew that Barbra Streisand would be a star," Kerr wrote, "and so she is."

Barbra dismissed them all—the good ones, anyway. "Good reviews? I don't remember them," she said. "I only remember the bad."

One week later, she was on the cover of *Time* magazine—at twenty-one, the youngest *Time* cover subject since Shirley Temple. "Her impact was instant and stunning," raved reporter Ray Kennedy. "When she is onstage, singing, mugging, dancing, loving, shouting, wiggling, grinding, wheedling, she turns the air around her into a cloud of tired ions. Her voice has all the colors, bright and subtle, that a musical play could ask for, and power too. It pushes the walls out, and it pulls them in."

The *Time* story would also make a valiant attempt to describe Barbra's offbeat sex appeal. "The nose is a shrine. It starts at the summit of her hive-piled hair and ends where a trombone hits the D below middle C. The face it divides is long and sad, and the look in repose is the essence of hound . . ." Ultimately, Kennedy went on, "she touches the heart with her awkwardness, her lunging humor, and a bravery that is all the more winning because she seems so vulnerable. People start to nudge one another and say, 'This girl is beautiful.' "

The cover portrait of Barbra, an impressionistic yet dignified study in reds, oranges, and greens by Henry Koerner, was the result of three separate sittings in the Goulds' Central Park West apartment. After the story ran, she asked if she could have the portrait, but was told that was impossible. By order of Time Inc. founder Henry Luce, all original artwork was kept for the company archives. "That's okay," she blithely informed them. "It was shit anyway. I was gonna burn it."

Not one to pass up any opportunity to plug the show—and, more important, herself—Barbra appeared that same week trying to fool the blindfolded panelists as the mystery guest on CBS's wildly popular *What's My Line*. Two weeks later, she was on yet another magazine cover. This time it was *Time*'s sister publication, *Life*. And the image was a photograph, not a portrait.

"When Barbra opened on Broadway," Shana Alexander wrote,

"the entire gorgeous, rattletrap show business Establishment blew sky-high. Overnight critics began raving, photographers flipping, flacks yakking and columnists flocking." The American public, she went on, "has now worked itself into a perfect star-is-born swivet."

Alexander, whose songwriter father Milton Ager had, coincidentally, written "Happy Days Are Here Again," went on to marvel at the rags-to-riches quality of Barbra's personal story. She also pointed out that young women across the country were now copying the perennial ugly duckling's "proto-Cleopatra" eyeliner, her modified Beatle coif, and her studied thrift-shop couture.

As famous and as idolized as she was, Barbra was still haunted by the demons of her childhood. One night she injured her eye, and Lainie Kazan was set to go on in her place when someone handed her a dish of candy from an older gentleman in the audience. It was her stepfather, Louis Kind, whom she hadn't seen since he'd walked out on the family when she was fourteen. She went on anyway, despite the searing pain in her eye, and gave what she would later say was "the greatest performance" of her life. Then she waited backstage for him to come and congratulate her. He never came.

Mama was not much better. She never praised Barbra's performance in *Funny Girl,* or acknowledged her daughter's emergence as a bona fide star. "I wish," Barbra said wistfully, "that I could convince my mother that I'm a success."

Certainly no one else needed convincing. By any measure, Barbra was the most electrifying personality to come along, said *Cashbox* magazine, "since Elvis."

Now that she had achieved the stardom she had always craved, Barbra bemoaned her lack of anonymity. She barely seemed to tolerate the celebrities who came backstage to see her—Audrey Hepburn, Elizabeth Taylor and her then-husband Richard Burton, Ava Gardner, Carol Burnett, Lauren Bacall, Julie Andrews, and Frank Sinatra among them—and was thrown into a panic by the "crazies" who waited for her, autograph books in hand, outside by the stage door. "Out of my way, out of my way!" she announced. "Don't you people have anything better to do? Jesus!"

She was upset when strangers fawned over her or made grand

gestures. Once, a secretary at Columbia came up to her and said, "I love you."

"You don't love me," Barbra said contemptuously. "You don't even *know* me."

When a young man spotted her trying to hail a cab in the drenching rain, he raced up and threw his coat down so she wouldn't have to step in a puddle.

"Don't do that for me!" she yelled. "Please, please pick up your coat . . . You shouldn't do that for anyone."

Although she joked that her newfound fame meant she would have to give up a favorite pastime—shoplifting—she was most upset with people who bothered her in restaurants. In a scene that would be repeated countless times in her life, Barbra was eating at Mama Leone's in New York when a woman came up to her.

"Listen," the woman said, "I hate to bother you, but may I have your autograph?"

Barbra put down her utensils and looked up. " 'I hate to bother you'?" Barbra said. " *'I hate to bother you'?* Then why do you? If you really hated to bother me, then you wouldn't. Why don't you just admit that you're bothering me and you don't care?" Later, she would reflect on the "pure rudeness of it, the lack of any consideration, especially when you're trying to eat." Besides, she added, "they even come up to you when your hands are dripping with barbecue sauce! Do they really want an autograph covered in barbecue sauce? Do they?"

With *Funny Girl* sold out for months, *The Third Album* creeping up to number five on the *Billboard* chart, her single of "People" climbing also into the top five, and the cast album of *Funny Girl* selling 400,000 copies—the fastest-selling Capitol record to date—Barbra was not about to relinquish center stage, not even for a moment.

Barbra had boasted to writer Pete Hamill that she would win the Grammy, the Tony, the Emmy, and the Oscar. On May 12, 1964, she showed up at the Grammy Awards and picked up two—the Best Female Vocal Performance for "Happy Days Are Here Again," and the biggest prize of the evening, Best Album for *The Barbra Streisand Album.*

She did not fare quite so well at the Tony Awards twelve days

later, however. She was in the main ballroom of the New York Hilton when the nominees for Best Actress in a Musical were read aloud: Streisand, Carol Channing for *Hello, Dolly!*, Beatrice Lillie for *High Spirits*, and Inga Swenson for *110 in the Shade*. Channing won, and Barbra was devastated—though she managed to conceal her disappointment. (Barbra's was one of eight nominations *Funny Girl* received. The show's sole winner was Kay Medford in the Best Supporting Actress category.)

The next day, Streisand lost the Emmy—not to Judy Garland, but to Danny Kaye for *The Danny Kaye Show*. After the back-to-back losses, she was more insecure than ever. "All right, what is it?" she whined to a nonplussed magazine writer. "Am I great or am I lousy? Huh? I need to know."

Barbra assuaged her pain the only way she knew how—by spending money, and lots of it. Indulging her twin passions for antiques and interior design, she splurged on art, furnishings, and fabric for the Goulds' Central Park aerie. As with everything in life, Barbra took the assignment seriously, carefully studying all the various schools of architecture and design from Bauhaus to Frank Lloyd Wright to Belle Époque, art deco, art moderne, Mission, and the Arts and Crafts movement. The knowledge she was now acquiring— as well as the furnishings and artwork—would form the basis for several impressive collections of art and antiques.

"I wanted Louis, Louis, Louis—as much as I could lay my hands on," she said, referring to her obsession with French antiques. "And I got it: bronzes, porcelains, satin, moiré. Later I became far more sophisticated." The reason for this buying binge, she would later suggest, came from a desire *not* to be Jewish. "I wanted to be Gentile. I wanted to have the things that all Gentiles have—like great art. I always thought that having French furniture and art was Gentile."

By the time she was finished, the apartment boasted no fewer than six chandeliers—including one in the master bathroom. To tend to all this—and to the star herself—Barbra hired a maid, a cook, a personal secretary, and a uniformed chauffeur to drive her around in the Goulds' off-white Bentley.

Barbra's dressing room was also given the Streisand treatment. Soon it would more closely resemble Madame Recamier's salon, with an eighteenth-century daybed and paisley-print wallpaper.

Furs were tossed over chairs, champagne chilled in a silver cooler, and there seemed to be flowers everywhere. Fanny Brice would have been proud.

The famous continued to flock backstage, and Barbra, who detested small talk, found it harder than ever to connect with them. Sophia Loren, Richard Rodgers, Joe Namath, Marcello Mastroiani, Ginger Rogers, Cary Grant, and Vice President Elect Hubert Humphrey were among those who made the pilgrimage backstage to see Barbra as *Funny Girl* rolled on. "I hate it," she said. "I just hate it. I don't know what to say to these people. Suddenly like I'm a star and they're stars and we're all supposed to have something in common, but what?"

During one of the charity events she was able to squeeze in, someone came up from behind and began nuzzling her neck. She spun around, and looked straight into the eyes of Marlon Brando. Ever since she was a little girl, Barbra had always felt they were kindred spirits. "I wanted to say to him, 'I understand you. You are just like me.'" But when she saw him in the flesh that night, he seemed like all the others.

"I'm letting you off easy," Brando said as he continued stroking her shoulders.

"Whaddya mean easy?" she joked. "This is the best part!" Then, she recalled, there was silence. "What was there to say? It was kind of sad, because he wasn't like me at all."

Nevertheless, Barbra geared herself up for performances when she was told there was someone famous in the audience. The rest of the time she was, by her own admission, "trying to find ways from getting completely bored out there."

Now that the show was on automatic pilot, Barbra turned her attention to other projects. On June 22, she signed a $5 million, ten-year deal with CBS. Three weeks later, she performed before fifteen thousand people in an outdoor concert at Forest Hills Tennis Stadium in Queens. Forest Hills was home to all the "rich girls" she had known and envied during her Brooklyn childhood, and she seized upon this chance to lord it over them.

But the weather did not cooperate. There had been torrential rains throughout the day, but Barbra showed up anyway rather than cancel and risk disappointing her fans. With lightning flashing over-

head and her pastel blue-green gown blowing in the high winds, Barbra tried out some of the material for her new album on the crowd.

There was considerable distance between Barbra and her audience—a wide swath of lawn separated the singer from the first row—and cries of "Come closer!" went up from the crowd.

Technicians told her it was too dangerous; given the soaking rain that had been coming down earlier, there was a good chance that she might receive an electrical shock. "How can I come closer?" she yelled back. "If I walk on the wet grass I might electrocute myself!"

But she did anyway, and the audience went wild. "That's brave," said one of the electricians looking on. "Stupid, but brave."

Pleased by the crowd's response to her songs, Barbra went into the Columbia studios a few weeks later and began recording her fourth album, *People*. Released that September, it would rocket up the charts, replacing the Beatles' *A Hard Day's Night* in the top spot. *People* would also win Barbra a Best Female Artist Grammy for the second year in a row.

All the while, her husband's career floundered. He had wanted the role of Nick Arnstein from the beginning, but she had done nothing to make that happen. So Elliott agreed instead to star in a low-budget movie with Ginger Rogers that was so bad it was not released for seven years.

The same month Barbra signed her $5 million deal with CBS, Gould played the prince in the TV version of the Broadway musical *Once Upon a Mattress*. But again he was eclipsed by his leading lady, in this case Carol Burnett.

"I hated Barbra supporting me," he insisted, but that didn't stop him from throwing her money away gambling on football games, boxing matches, and horse races. Ironically, Elliott and Barbra were living the scenario she was acting out on the Winter Garden stage eight times a week—that of rising star and her gambling-addict husband.

Barbra was much too busy to really focus on Elliott's problems. Bored by the routine, constantly second-guessing herself, resentful of her fellow cast members and even the cheering audiences, she began to see her run in *Funny Girl* as "a living nightmare . . . I felt like I was locked up in prison." She began seeing a psychoanalyst.

To cope with the pressure, she began doing three separate versions of the show—one in which her time spent singing onstage was cut dramatically.

Lainie Kazan would gladly have done any of the three versions of the show had Streisand not made it clear that she was not interested in boosting the careers of other young actresses. Even in her small role as the *Ziegfeld Follies* girl Vera, the strikingly attractive Kazan was instructed to wear the character's oversize hats down at an angle so that they essentially covered her face. "Barbra," explained Kazan, "was not eager to compete with anyone for the audience's attention."

After six months, Kazan was informed that Barbra would be taking a two-week vacation. "I had never done the whole performance before," Kazan said, "so I ran through it onstage. I was later told that Barbra and her friend Cis Corman were sitting in the back row, watching me. The next thing I knew, Barbra wasn't going to take a vacation, after all."

Barbra's interest in stifling competition apparently extended beyond the show. When Kazan was asked to sing "People" on the *Bell Telephone Hour,* she received a call at NBC's studios ordering her to drop everything and return to the theater. "Barbra suddenly had stomach pains and a headache," Kazan said. "I told them I wasn't coming back. I was doing the *Bell Telephone Hour,* period." Miraculously, Streisand's aches and pains cleared up quickly, and she went on that night as usual.

As determined as she was not to let anyone share in her *Funny Girl* glory, Barbra still needed the extra time between performances to work on her first TV special and to field whatever other worthwhile offers happened to come her way. On January 18, 1965, she flew to Washington to join a star-studded gala on the eve of Lyndon Baines Johnson's inauguration as president. After succeeding Jack Kennedy, LBJ had been elected to the White House in his own right. Now Barbra was to be part of a celebration at the National Armory that included the varied likes of Julie Andrews, Carol Burnett, Woody Allen, Harry Belafonte, Carol Channing, Rudolf Nureyev, Alfred Hitchcock, Ann-Margret, Bobby Darin, and Johnny Carson.

Barbra had no doubt she would be the standout act of the eve-

ning. But when a lighting technician missed an important cue, leaving her in darkness for a few crucial moments as she began to sing "People," she was rattled. Afterward, she chewed out the director of the show, Richard Adler, and demanded that whoever was responsible for the mix-up be sacked. Carol Channing, not Barbra, would end up stealing the show with her wide-eyed, breathless rendition of "Hello, Lyndon."

"I sang for Kennedy because I loved him," Barbra said. "But when I sang at Johnson's inauguration, it was the most depressing evening I ever had. Kennedy was dead and this man was there because he was dead and it was just awful."

After being upstaged by Channing, Barbra was not about to take a backseat again—and certainly not on her home turf. Not long after the inaugural-gala debacle, she came down with laryngitis. The first Tuesday in February 1965, she was forced to inform the producers that, for the first time, she would not be able to go on. Manning the phones with a girlfriend, Lainie Kazan ("I kept a list of who to contact—just in case") had within a matter of hours informed all the major news organizations and columnists in New York that she would be going on in Barbra's place. By this time, she had been with the show for fourteen months without ever having substituted for the star. "Of course, I wanted to go on," Kazan said. "I had career ambitions of my own, and I was determined to get a little publicity for myself."

At the theater, Kazan was preparing to go onstage for the first time with the rest of the principal cast—until this point she had rehearsed the part only with understudies. "I was being schlepped around the stage, and I was terrified. But I was exhilarated, too. I wanted to go on. Badly.

"Now you have to understand that Barbra was always late," Kazan continued. "She was never on time—*never*. She would just run in off the street and right onto the stage without makeup and start singing. I had never seen anything like it.

"I swear, *ten minutes* before the show, Barbra walks in. I was completely devastated. I walked up the five flights to my dressing room and cried and cried. Then, of course, I had to go on that night in my little part as Vera."

Kazan got the message, and so did the press. SHOW GOES ON, BUT

LAINIE DOESN'T was the headline in one paper the next morning; another blared IT AIN'T FUNNY, GIRL on its front page.

Streisand did the usual long version of the show, and just to make it clear to the press in attendance that no one could take her place, pushed herself to the limit to give one of her best performances to date. In the process, she strained her voice even more.

The next day, Barbra had no choice but to stay home. Since it was Wednesday, this time Kazan was able to fill in for both the matinee and evening performances. Instructed not to tell anyone that she was going on, Kazan asked, "Well, can I at least call my mother? So of course, my mother called everyone anyway." Kazan's mother probably didn't have to; the backstage drama had only heightened interest, and every major critic was there to see if there was another actress capable of filling Streisand's shoes.

As might have been expected, the audience that had shown up to see Streisand was not happy that the star would not be appearing that day. A number of people got out of their seats and headed for the door, but paused at the back of the theater long enough to hear Kazan belt out "I'm the Greatest Star." Impressed, nearly everyone returned to their seats. "To see the people filtering back down the aisles was just so wonderful," Kazan remembered. "That Wednesday matinee was the single most thrilling performance I've ever done."

The reviews were solid enough to land Kazan a lucrative record deal and a nightclub contract virtually overnight. Streisand was mightily irked, but she might have let the upstart understudy stay if Kazan hadn't already been romantically involved with Barbra's musical director and *Funny Girl*'s assistant conductor, Peter Daniels.

Kazan had met Daniels during the show's rehearsals in New York. "He was British, much older than I was, and on the surface not really my type," Kazan recalled. "But my father had just died, and he was so kind, such a nice man. He was very solicitous of me, always there for me. We just gradually fell in love." Kazan had no idea that the relationship would upset Barbra. "Maybe I was just unbelievably naive, or just dumb," she said, "but I honestly never considered that this could be a problem for anyone else, and especially not for Barbra."

But it was. Now that Daniels's first loyalty was to Kazan (the two

would later marry), Barbra felt betrayed by both of them. Kazan believed that the rift between Daniels and Streisand had begun much earlier. "They had other issues that had nothing to do with me," she said. "I don't know if she was crawling her way to the top and Peter wasn't happy with the way he was being treated. He had been such a big part of her early success . . . but their relationship was strained before I arrived on the scene. They were not getting along."

After Kazan substituted for Streisand onstage, the situation was "just too unpleasant for me to stick around," Kazan said. "It was pretty clear Barbra was never going to get sick again, so I gave them my notice. People have said that I was fired, and I'd be the first to say it if I was, but the producers actually begged me to stay."

Kazan was replaced by Linda Gerard, and this time the understudy's contract specifically prohibited her from contacting the press in the unlikely event that she went on for the star.

As with so many people whose paths would cross with Streisand's over the decades, Kazan felt Barbra had a profound impact on the course of her life. While merely being cast as Streisand's understudy in *Funny Girl* had made her a national celebrity overnight, it also meant that she would spend years trying to emerge from Barbra's looming shadow. "For five years after I left the show, I was *always* introduced as 'Barbra Streisand's understudy.' I did anything and everything I could to shake that and establish myself as my own person in the public eye—including posing nude for *Playboy*," said Kazan.

Even more important, said Kazan, "I changed as a person during the run of *Funny Girl*. I started out this open, warm, playful young woman, and that experience really threw me for a loop. It affected my entire life. To see how Barbra was manipulated, and how she in turn manipulated others—it just made me cynical and depressed about the business. It really took me years to get over it . . ."

Although she would eventually achieve success in her own right as a singer and actress, Kazan's seven-year movie contract with Stark more or less "evaporated." Did she believe Barbra had something to do with that? "Who knows?" Kazan said with a shrug. "All I know is that nothing ever happened, and to this day I wonder why . . ."

Another *Funny Girl* casualty was Peter Daniels, who joined the growing list of friends and colleagues—many of whom played an important part in her career—jettisoned by Barbra during this period. Among them were Terry Leong and Bob Schulenberg, who created her trendsetting look; Elaine Sobel and Rick Sommers, among the dozen or so struggling actors who fed, housed, and encouraged Barbra when she was homeless and carting her portable cot around Manhattan; Burke McHugh, who helped her land her first nightclub gig at The Lion and then persuaded the owners of the Bon Soir to hire her; Carl Esser, who played guitar—for free—on the very first tape she ever recorded; her first manager, Ted Rozar; brothers Don and John Softness, who worked free of charge as her first publicists; and composer Harold Rome, who fought hard for her to get hired for her first Broadway role in his *I Can Get It for You Wholesale* and then fought even harder to keep her from being fired from the production.

Barbra was especially brutal in her treatment of acting teacher Allan Miller, who with his wife, Anita, had taken her in as a teenager and nurtured her talent. After he played an instrumental role in helping shape her interpretation of Fanny Brice on stage—a job Streisand paid him for only reluctantly—Miller was again abruptly dropped. The only time he would hear from her again was when he ran a small ad in the trades for his struggling acting school, accurately describing himself as "recent coach to Barbra Streisand in *Funny Girl*."

"Why, Allan?" she yelled. "Why would you *do* such a goddamned terrible thing to me? I want you to pull that *thing* out of the paper, *now*! Do you understand?"

Miller, stunned by the savageness of Barbra's verbal assault, hung up.

The most egregious victim of Barbra's ingratitude was Barry Dennen. Two weeks after Lainie Kazan's highly publicized appearance in Barbra's stead, Dennen received an out-of-the-blue call from Barbra inviting him to see the show and then visit her backstage. When Elliott Gould finally did welcome him into Barbra's dressing room, she was ranting about "that jerk who calls himself a conductor" and threatening to walk offstage if her orders weren't carried out to the letter.

It quickly became clear to Dennen why, after she had not spoken to him for years, Barbra had reached out to him. "I want those tapes," she demanded.

The tapes he had made for her at his apartment when she was just starting out, early recordings of Barbara Streisand doing the material he had selected for her to sing at the Bon Soir—she wanted them. And if he didn't hand them over, Barbra said, she would sue to get them back.

Stunned and insulted that she feared he might try to release the recordings they had made before she became a star, Dennen refused point-blank to return them. The phone then rang, and Elliott interrupted to say that Barbra's mother was on the phone.

"Tell her to go fuck herself!" Barbra screamed without missing a beat. She then resumed her attack on Dennen.

It was then that Dennen, speaking for those Streisand had left behind, accused her of being an ingrate, a user, and someone who had no intention of ever even acknowledging—much less paying back—the people who had made her success possible. Before Barbra could say a thing, he stormed out of her dressing room, and, yet again, out of her life. "Did Barry have reason to be bitter about the way he was treated?" asked Schulenberg. "Yes, absolutely. His contribution to what she became was just incalculable."

If Barbra had little regard for the people in her past, she wasn't much nicer to those in her present. Her tirades against the conductor, the musicians, technicians, and fellow cast members continued. She made copious, highly critical notes and, rather than give them to the director so he could pass them on as his suggestions, handed them directly to the actor, musician, or stagehand in question. Her concerns extended to even the most minute detail, said a publicist for the show, like why there was "dust on the plastic flowers or why the blue light failed on cue 82."

She would not make eye contact with her fellow actors either onstage or off (leading man and real-life lover Sydney Chaplin said she looked over his shoulder during their scenes together), seldom acknowledged anyone in the hallways or backstage, and froze if anyone tried to hug her. "All the hugging in this business," she said, "and by people who don't even *know* me. I hate it, it's so fucking phony!"

Not surprisingly, Barbra was viewed as arrogant, cold, and self-absorbed by nearly everyone else working on the production. "She was always aloof," Kazan said. "But in retrospect, I understand why. It was such an enormous responsibility for such a young girl to be carrying. She was so concentrated on just getting the job done. As a result, the rest of the cast didn't like her very much. But it was also pretty obvious that she didn't *care* if they liked her or if they didn't like her."

(According to Kazan, the only cast member who liked Streisand was veteran actress Kay Medford, who played Fanny's mother both onstage and in the subsequent film version of *Funny Girl*. "It was so weird—I think Kay Medford actually believed she was Barbra's mother," Kazan said. "We'd always been very friendly, but when Barbra got sick and I eventually went on for her, Kay stopped speaking to me. She didn't like the idea that I'd replaced her 'daughter.' ")

By way of trying to bridge the gap between the leading lady and her coworkers, Elliott organized a twenty-third birthday party for Barbra at Manhattan's Spindletop restaurant. The press, told that the party was being thrown in Barbra's honor by the cast of *Funny Girl*, showed up en masse. The highlight of the event came when Barbra was handed a white poodle puppy. She instantly assumed it was a birthday present from her fellow actors. In truth, the rest of the company was more irked with her than ever, and no one felt compelled to buy her a present. The dog happened to be a gift from the owner of the Spindletop, who was understandably overjoyed at the amount of publicity he was getting from the event. Barbra named the poodle pup "Sadie," as in "Sadie, Sadie, Married Lady."

Barbra's growing sense of entitlement extended to total strangers on the streets of Manhattan. The city abounded with tales of New Yorkers who claimed to have hailed a taxi, pulled open the cab door, and been brushed aside as Barbra Streisand simply got in. In one of these instances, the victim was her fellow cast member in *I Can Get It for You Wholesale* Wilma Curley. Struggling with Christmas presents outside the Fifth Avenue toy store FAO Schwarz on a blustery day, Curley was just about to get into her cab when Barbra whizzed right past her and into the taxi. When Curley, still standing

at the curb, ordered her out, Barbra looked up, said she wanted the cab, slammed the door—and sped away.

It was also a snowy day in 1965 when Barry Dennen stood shivering at a bus stop on Central Park West. Suddenly a gleaming Bentley drove up and stopped at the light. In the back sat Barbra, stroking her poodle, Sadie. When Streisand turned and recognized Dennen, he smiled. It was freezing, the bus was late, and now he would be getting a lift in a warm limousine. Instead, Barbra smiled at Dennen, held Sadie up to the window, and waved her paw in his direction. The Bentley sped off, hitting a puddle and splashing Dennen in the process.

Dennen had been concentrating on the backseat, and failed to notice who was driving the Bentley. Behind the wheel, wearing a pearl-gray chauffeur's cap and a dour expression, sat the man who, more than anyone else, knew what it was like to live in the shadow of a supernova: Mr. Barbra Streisand, Elliott Gould.

Her tantrums are torrential.

—Michel Legrand, composer and friend

I'm not a person who needs people.

*I think her biggest problem is that she wants to be a woman
and she wants to be beautiful and she is neither.*

—Omar Sharif, Barbra's former lover and leading man
in *Funny Girl*

You know, you're the only woman who has ever intimidated me.

—Elvis Presley to Barbra in 1975

**It's a very unkind, mean word, bitch. I resent it deeply. . . .
Maybe I'm rude without being aware of it—that's possible.**

4

You are such a fucking selfish bitch, you really are."

Barbra was shocked. It was the most tender moment of the show, when Fanny Brice turns to Nick Arnstein and sings "People" to him directly. But leading man Sydney Chaplin, his back to the audience and facing Barbra, was mumbling terrible things to her, things that she feared might actually be heard in the audience. She had no choice, however, but to proceed as if nothing unusual was happening.

With two people, two very special people . . .

"You realize, of course, that everyone in the cast really despises you," Chaplin continued, talking under his breath even as Barbra continued to sing.

People who need people . . .

"God, you *are* an ugly girl. That nose! I mean, really, *do* something about it, for Christ's sake . . ."

Barbra had abruptly broken off their affair, and Chaplin, more accustomed to dumping than being dumped, took it hard. He also resented the notes that she made on a more or less regular basis critiquing his performance. Like the other old pros whose roles had been drastically cut so that Barbra's could be expanded, Chaplin resented being told how to do his job—especially by a twenty-three-year-old newcomer.

For months now there had been pitched battles, Chaplin and Streisand shouting obscenities at each other at the top of their lungs, slamming doors, throwing things—never once concerned about making a scene. "It was really nasty stuff," said a stagehand who witnessed several such confrontations. "He had a really filthy mouth to begin with, and he called her everything in the book. But Streisand swore like a sailor, too, and she gave as good as she got."

"There was great hostility between them," Lainie Kazan remembered. "At that point she wouldn't talk to him, and when they were onstage taking their bows and smiling, they'd be saying 'Fuck you' to each other. It was pretty amazing."

Chaplin discovered that there was one four-letter word that hit Barbra particularly hard, preying on her deepest insecurities from childhood. During their most tender moments onstage, he would whisper "nose" in her ear. Between scenes, Barbra would retreat to her dressing room, vowing not to go back onstage.

Eventually, she felt her only recourse was to file a formal complaint with Actors' Equity. Only this time, she accused him of repeatedly using another four-letter word—one that began with *c*—that even a stevedore would hesitate before using. During the hearing that ensued, however, the urbane, smooth-talking Chaplin simply charmed the Equity committee members, all of whom were veteran actors he had known for years. Conversely, they viewed his accuser as abrasive and shrill.

Barbra took matters into her own hands. Once, when he whispered "nose" in her ear one too many times, she bit him on the neck. Reeling back, Chaplin hit his head on a piece of scenery and wound up with a concussion.

Even that was not enough to deter Chaplin. He continued mumbling insults and doing whatever he could to throw off her concentration onstage. Fed up, Streisand demanded that Stark fire her leading man. The producer protested that his hands were tied; Chaplin had a run-of-the-play contract. Barbra's scorned lover would leave in June of 1965, however, but only so long as Stark agreed to pay him his $2,500 a week plus 1 percent of the gross until the play closed.

The rest of the cast was sorry to see Chaplin go. "Sydney had

such a dirty mouth," Lainie Kazan recalled, laughing. "Every other word he said was a four-letter word. But he was really such a sweet, charming, kind man. Everyone loved Sydney. Everyone, I guess, but Barbra. Whatever was between them, I don't know. But obviously it must have been very intense."

So intense in fact, that, according to Chaplin's third wife Margaret, he "packed up his family and moved to France and didn't come back for a long time. So you know his experience with Barbra—the shabby way she treated him—well, the situation must have been pretty nasty. It was a very upsetting period for Sydney. He was *angry* at her, and from what I understand, with good reason."

Chaplin was replaced by former 1940s big-band singer Johnny Desmond. While Barbra also peppered the new Nicky Arnstein with notes about his performance, the easygoing Desmond made it clear to her from the outset that he regarded *Funny Girl* as her show and that he had no illusions about competing with her for attention.

In the meantime, Barbra had racked up another triumph—this time as the star of her own one-woman television special *My Name Is Barbra*. She eschewed guest stars ("That idle, silly talk you have to indulge in on television shows. It doesn't interest me"), opting instead to devote the entire hour to showcasing her voice. The show began with Barbra frantically running around a set singing "I'm Late" (from Disney's *Alice in Wonderland*), moved on to a playground scene where she was suddenly a kindergartner, and then segued into what was the most memorable part of the show—a fantasy shopping sequence at Bergdorf Goodman's department store on Fifth Avenue. Alone, she sang and frolicked about the store in a variety of furs, from a $15,000 Somali leopard coat to a long evening suit of white broadtail mink to white mink knickers.

When CBS executives first previewed the show, they panicked, predicting that it would destroy her career overnight. When they suggested last-minute changes—like bringing in Frank Sinatra or Dean Martin to join her in a duet—Barbra refused. And because she had complete control, there was nothing CBS could do but go ahead and air the show as planned.

To hype the show, Barbra made a return "mystery guest" appearance on *What's My Line,* signing in on the show's famous blackboard with "My Name Is Barbra." Then she sat back and, while the brass at CBS predicted a savaging by the critics and the lowest ratings in the history of prime-time television, waited to see if the American viewing public was willing to spend an entire hour watching her and no one else.

Not only were the reviews ecstatic when the show was broadcast on April 28, 1965—just four days after her twenty-third birthday—but *My Name Is Barbra* racked up a huge 35.6 share, making it the number one show for the week and one of the most-watched programs of the year. That September, *My Name Is Barbra* picked up five Emmys, including the top prizes for Best Entertainment Program and Best Individual Performance. "I think I have a run in my stocking," she said after bounding onto the podium to accept her award. "Of all nights!" She went on to say that when she was growing up her favorite shows had always been the Oscars and Emmys. "I didn't care who won, just how they looked. Television is a marvelous business. This is my first experience with it. I figured out that I would have to work fifty-eight years in *Funny Girl* to reach as many people as I did in this one show." She also pointed out that a ten-year-old fan of *My Name Is Barbra* had written her saying that "of all the people in your show, I liked you best."

Elliott had dared not ask for even a cameo part in *My Name Is Barbra*—he knew all too well what the answer would have been. "Barbra's favorite subject is Barbra," he snarled. "It bugs me a lot, and I get bored by it sometimes. Here is a girl who is a major star, who makes a fortune, but who is unhappy. It is a pain to hear her complain constantly."

Unable to find work as an actor for over a year, Gould fretted that his wife was fast losing respect for him. Certainly she did not want to hear him complain. "I used to be apologetic and feel guilty about expressing my problems in front of Barbra," he said. "I thought it showed a weakness in my sex and in me." But, he added, "The woman should understand and not hit the nerve of the man's problem to keep him off balance . . ."

By way of announcing to the world—and each other—that they were still very much a team, the Goulds followed the lead of Desi

Arnaz and Lucille Ball's Desilu productions in naming their own television production company. When neither would relinquish top billing, however, they wound up forming two companies: Barbell Productions and Ellbar Productions. It scarcely mattered what they were called. Barbra only worked solo, and no network would consider employing Elliott if his spouse wasn't along for the ride.

Finally, Elliott was handed what looked like his own shot at Broadway stardom acting opposite newcomer Lesley Ann Warren in a new musical called *Drat! The Cat!* It closed after just six days. Crushed by yet another humiliating failure ("I cried for a week"), Gould followed his wife onto the psychoanalyst's couch. "I lacked confidence, and I subordinated myself to Barbra because I always felt, what did I have to offer her?" But there was still love there—at least on his part. "To say I love Barbra—that's obvious," he protested. "Otherwise, I couldn't have stood it."

Ironically, Barbra, who seemed to transform everything she touched into gold, even managed to make *Drat! The Cat!* work for her. In the show, Gould sang a simple, moving ballad called "She Touched Me." Barbra recorded it as "He Touched Me," and it became one of her trademark hits.

Barbra had always held the balance of power in the marriage—so much so that when Elliott asked half-jokingly if the rumors about her affair with Sydney Chaplin were true, she matter-of-factly acknowledged that they were. Nor did it help when, after axing her musical director Peter Daniels because of his affair with Lainie Kazan, Barbra began working with the handsome, suave French composer Michel Legrand.

In late 1965, Legrand, whose score for *The Umbrellas of Cherbourg* had been nominated for that year's Academy Award, began meeting Barbra in her dressing room at the Winter Garden after the curtain went down on *Funny Girl.* They would walk out onto the stage, ostensibly to work out their ideas at the theater's rehearsal piano, and in the process ended up falling in love—or something close to it.

"She was prodigiously happy," the very married, thirty-four-year-old Legrand recalled of that "euphoric" time. "Some nights we laughed so much together . . ." So much that at times Barbra did not return to Elliott until dawn.

According to Legrand, he and Barbra became "inseparable. I

didn't have time—nor did she, evidently—to understand what was happening all of sudden to us." Unfortunately, Elliott understood perfectly, and the relationship with Barbra that Legrand himself described as "intimate" would be just one more flash point in the Goulds' problematic marriage.

On and off over the next nine months, Barbra and Legrand would work on her first foreign-language album, *Je m'appelle Barbra*. Whenever Elliott dropped in to spy on them, Legrand made little effort to conceal his contempt for the man he referred to as "this gawky, bearlike ninny . . . Nothing must be more boring, for a bear, than the sight of two birds constantly occupied with singing the same tune."

That collaboration, predictably, led to the sort of bitter rows that would come to characterize nearly all of Barbra's personal and professional partnerships. During rehearsals for their album, Legrand learned that Streisand could instantly become "seized with fury and capable of the most foul vocabulary—the epitome of charm and politeness on one side and on the other a sort of Brooklyn nag, aggressive, intolerant, enraged."

As 1965 came to a close, Barbra felt more trapped than ever in the role that had made her a Broadway star. "I feel like a prisoner. I am trapped. I am suffocating," she complained to anyone who would listen. *"Isn't anyone listening to what the fuck I am saying?"*

Now that she had played the role to perfection for twenty-one months, she began to imagine the audience was lying in wait for her, hoping to catch a botched line of dialogue or a sour note. "What do people expect of me?" she demanded. "They haven't seen me, but they've heard of me . . ." Maybe, she thought, she could never live up to their expectations. "It makes me feel that they're the monster," she now said of her adoring audiences, "and I'm the victim."

The physical symptoms intensified—the nausea gripped her earlier now, three hours before the curtain went up. There was speculation that Barbra, who had put on a few pounds, was pregnant. That only made her more frustrated and upset. "I had a big calendar," she later remembered. "I would cross off the days. After eighteen months, all I wanted was out, out, out."

Finally, Ray Stark agreed to let her out of the Broadway run of

Funny Girl—on the condition that she play the part in the London production the following April. Barbra had a condition of her own. "Marty," she told her agent Marty Erlichman, "tell Ray that I'll do it—if he promises me the movie."

"Forget it," Stark replied, pointing to the casting of Audrey Hepburn instead of Julie Andrews as Eliza Doolittle in the film version of *My Fair Lady*. Although Andrews had created the role on Broadway, Hollywood insisted on a bankable movie star for the part.

Erlichman warned Barbra that Stark did not like ultimatums. If she pressed the issue, Stark was perfectly capable of punishing her by giving the film role to someone else. "Look," Erlichman told her, "if you're prepared to lose the movie . . ." But Barbra wasn't willing to risk angering Stark. She backed down, and reluctantly agreed to star in the London production whether she got the movie or not.

As it turned out, Stark was merely testing the young actress he came to view as his creation. *My Name Is Barbra* had proven beyond all doubt that Streisand not only had genuine screen presence but could, with proper lighting and camera angles, be made to look as sexy and appealing as any more conventionally pretty movie actress. He told her he would give her the part so long as she signed a four-picture deal with him. Barbra balked at first, but it quickly became clear she had no choice.

Not that Stark didn't have to work hard to convince executives at Columbia Pictures that she was right for the movie. All the usual objections were raised: She was too unattractive for the part, too Jewish, too outlandish to be accepted by the moviegoing public. They wanted a proven movie star. They wanted Shirley MacLaine. But Stark prevailed, and on December 17, 1965, Columbia announced that Barbra Streisand would reprise her role in the studio's film version of *Funny Girl*. Then, the day after Christmas, Barbra gave her final, emotional performance on the stage of the Winter Garden Theater. It would, in fact, be her final appearance on Broadway.

While singing "People," Barbra experienced an epiphany of sorts. She felt she was understanding the meaning of Bob Merrill's touching lyrics for the first time. Streisand deliberately looked out into the audience as she sang—something she had been far too frightened to do in the past. But this time "it was like a farewell,"

she later said, "and I sang the song to them." Overcome with emotion, she broke down in the middle of the song.

"I did it for Ray, because he loved it," she would say. "And I did it for Fanny Brice, for when all was said and done, it was still her song."

As she took her final bows that night, the theater exploded in stomping, whistles, cheers, screams, and bravos. Once she managed to quiet the audience down, she pointed out that she was standing on the same stage where Fanny Brice had given her last performance in a Broadway show. Although Brice's signature number, "My Man," had not been included in the stage version of *Funny Girl* because Stark could not secure the rights for it, Barbra now paid tribute to Brice by singing the song. Streisand's version of "My Man" was, according to one critic sitting in the audience that night, nothing short of "sublime."

By the time she sang the last soaring note, most of the crowd was in tears. They then joined hands and sang "Auld Lang Syne" while Barbra cried, waved, and blew kisses into the audience. For one fleeting moment, she loved them as much as they loved her—or so she said.

A few weeks later, she felt differently about the live audience of Barbra Streisand Fan Club members assembled to cheer and applaud the finale of her *Color Me Barbra* television special. Back to resenting even her most die-hard fans, she fled to her dressing room and slammed the door. "Tell them to go away!" Barbra allegedly screamed at Marty Erlichman. "I hate them!"

To be sure, expectations were again running high. At a time when only a small fraction of American households even had color TV sets, the mere fact that Barbra's second special for CBS was being broadcast in color made it seem like a daring undertaking. This time, Barbra flitted around the Philadelphia Art Museum instead of Bergdorf's, and worked several thirty-hour days in a row to tape an elaborate circus fantasy that at one point involved nine takes and three hours to get less than a minute of Barbra bouncing up and down on a trampoline.

The animals brought in for the circus scene made Streisand nervous. At one point, an elephant named Champagne lifted up its trunk and roared, spooking a llama that, in the words of reporter

Rex Reed, "did a somersault." At another point, a lion got away from its handler, and at yet another, a horse bolted as Barbra sang "Funny Face." The hot lights were too much for some of the animals brought onto the set; a penguin simply dropped dead on the spot. The only playful moment came when Barbra touched noses with an aardvark named Izzy. "He must be Jewish," she said.

To further complicate matters, more than twenty reporters and photographers were called in to witness the taping for features in a variety of publications including *Newsweek, Life, Look,* and *TV Guide.* At one point, after she had kept the press waiting for three and a half hours, Barbra plopped down for a press conference. "Okay," she said, tearing into a fruit basket and taking a bite of a green banana, "you've got twenty minutes."

What's the new show like? "Like the old one . . . What do I know from TV? I hire the best people in the business, then I let them do everything for me . . . I'm paying the bill, it's my problem, right? I coulda got some big-name stars to clown around like everybody else does on their specials, but who needs it? I got complete creative control here, so I do it my way, right?"

As the taping in the Philadelphia Museum dragged on into the early morning hours, a few fans showed up outside with chicken soup for the star, asking only that she wave in their direction. Appropriately dressed in a silver-and-lavender Marie Antoinette costume complete with powdered wig and purple ostrich plumes, Barbra shook her head and snapped her gum. "Get rid of them," she snarled. "They follow me everywhere."

Thus, when it came time to shoot her final concert scene in front of the audience filled with wildly applauding fan-club members, Barbra felt she had been pushed to the limit. After screaming that she wanted them gone—and that she hated them—Barbra walked back out to the unsuspecting, ever-loyal fans, sang two songs, and made her exit.

For all the chaos, *Color Me Barbra* was another huge critical and ratings success when it aired on March 30, 1966. By that time, Barbra was already in London with Elliott, preparing to re-create her role on the stage of the very theater where her husband had bombed two years before in *On the Town.*

That February, Barbra was also named one of the ten best-dressed

women in America, an honor that coincided with her highly publicized tour of the great fashion houses of Paris. With a reporter and a photographer for *Life* in tow, she hit Cardin, Saint-Laurent, Dior, Madame Grès, and Chanel, where the legendary Coco Chanel agreed to meet with America's newest fashion icon.

To mark her newfound status as a haute couture darling, Barbra—who only two years before had been traipsing around New York in torn stockings and secondhand *schmatas*—posed for the cover of *Vogue*. Modeling Dior and Madame Grès, she was not at all impressed that Richard Avedon had been assigned to take the photographs. "Capture me correctly," she instructed him.

Before they actually arrived in London, Barbra had arranged for Elliott to be offered the part of Nicky Arnstein. He refused, out of pride and the realization that Barbra really did not want him to take her up on the offer. "Barbra mistrusts anyone," he rightly observed, "who needs anything from her."

Besides, he had another ambitious scheme up his sleeve. As Barbra dealt with mounting problems at the Prince of Wales Theatre—foremost of which was what she regarded as the "incompetence" of the conductor, whom she promptly sacked—Elliott moved them into a suite at London's swank Savoy Hotel and mapped out a plan to get his wife pregnant.

"A baby can be a solidifying thing for a marriage," mused Elliott, who also believed his harried, frantic wife needed a child to bring "her mind back down to life." It was also, he reasoned, something that only he as her husband could give her—and something that, in turn, would restore his pride. "The best thing I could give her," he said, "was a child."

According to Elliott, the couple had not been intimate for well over a month, and when Barbra finally arrived at the Savoy, Gould found himself having to do everything he could to soothe her nerves. "I talked her all the way down," he later said, "through the whole encounter." He was so successful at getting her to relax that he even convinced her to have sex without contraception.

Later, when Barbra's doctor phoned with the news that she was pregnant, Elliott told him not to tell her until after her London opening. "She's got too much on her mind right now," he said. "Let's wait . . ."

Notwithstanding the natural reserve of the British audiences—
"What's the matter with them? Why aren't they *laughing*?"—Barbra
turned out to be a huge hit in the West End. What would come to
bother the girl from Brooklyn most, however, occurred when mem-
bers of the Royal Family showed up; their presence, and the suffo-
cating sense of decorum that prevailed, only served to dampen the
audience's spirits. When Princess Margaret came backstage to meet
the cast one night after a command performance, Barbra told her,
"You should come back some night when you're not here." The
Queen's younger sister, a huge Streisand fan, later said she was
"confused" by the oddly hostile-sounding remark.

That was nothing, of course, compared to her reaction when, af-
ter she delivered her opening-night performance before an audi-
ence that included Peter Sellers, Rex Harrison, and Warren Beatty,
Elliott told her she was pregnant. "What? No, I *can't* be pregnant,
not *now*," she protested. Indeed, Elliott had failed to take into ac-
count that Barbra was already planning a third CBS special with a
high-fashion theme, and that she had signed a $1 million, twenty-
six-city U.S. concert tour as soon as the West End run was over.

When it was pointed out that her fee for the tour put her on a par
with the Beatles, Streisand shot back, "*I'm* paid more. I get as much
for me, one person, as all four of the Beatles." The promoters of the
concert series, comedian Alan King and Walter A. Hyman, were also
expected to foot the bill for Barbra's thirty-five-member orchestra,
and to give her complete control of the ticket prices and concert
venues. The perks, which included a hefty weekly budget for fresh-
cut flowers, chartered jets, and dressing rooms decorated to her pre-
cise specifications, were also to be paid for out of the promoters'
pockets.

On top of these looming commitments, there was the sheer phys-
ical exertion involved in performing in *Funny Girl* eight days a
week—couldn't the strain harm the baby, or cause her to miscarry?
And what about morning sickness? What if she was onstage in the
middle of singing "Don't Rain on My Parade" and she suddenly
had to throw up?

Elliott spent days trying to calm Barbra down. She could do the
short version of the show, he reassured her, and some of the dance
routines could be reworked. As for the tour, she could simply cut

the number of cities in half. (Eventually, instead of twenty-six con-
certs, she would do only four.)

Gradually, Barbra warmed to the idea of becoming a mother.
"This pregnancy is like a God-given thing," she said, "and the tim-
ing couldn't have been better. I was beginning to feel like a slave to
a schedule." They moved into a town-house flat at 48 Ennismor
Gardens in London (the previous tenant had been Cary Grant), and
for a short time Barbra even took up knitting—specifically, a "wild"
baby blanket "in all kinds of pink." That lasted for a week. Barbra
handed the blanket over to her dresser, who finished it in the wings
while her mistress performed onstage. "I think," Barbra said as she
put down her knitting needles, "I'll just have the baby and be done
with it."

News of Barbra's pregnancy made headlines on both sides of the
Atlantic. BARBRA AWAITS MILLION $ BABY screamed the full front-
page story in the New York *Daily News,* an allusion to her all-but-
canceled million-dollar concert tour.

"Why do they say that?" she objected. "I mean, why must they
measure everything in money? The most important thing is not
what got canceled but that a healthy baby is born." She would make
certain, however, that she would be paid a quarter-million dollars
for the few concerts she was still willing to do and that the promot-
ers stuck to the terms of the original contract. "She was tough, all
right," King said. "She broke our balls on that one."

Nevertheless, King and Hyman would not be disappointed with
the outcome. Barbra ended her London run on July 16, 1966, and
returned to New York the next day. On July 21, she electrified the
Columbia Records sales convention at the Sahara Hotel in Las Ve-
gas with a surprise appearance, singing a few numbers of her up-
coming *Color Me Barbra* album.

Nine days later, a visibly pregnant Barbra boarded a chartered jet
christened *Barbra's Second Hand Rose* and headed for the first stop on
her abbreviated *An Evening with Barbra Streisand* tour—the Newport
Music Festival in Newport, Rhode Island. In addition to the regular
members of her entourage—Elliott, her hairdresser Fred Glaser,
Marty Erlichman, and Sadie the poodle—Barbra's old friend from
Allan Miller's acting class, Cis Corman, and Corman's psychoana-
lyst husband Harvey came along for the ride.

At this and the other tour cities—Philadelphia, Atlanta, and Chicago—Barbra followed basically the same routine: She rehearsed with the full orchestra for two hours, personally checked all 143 light cues, then napped for an hour before Elliott told her it was time to dress for the performance. And at each city, she ignored the fact that her audiences were wilting in the summer heat and sang a moving (not to mention wholly unexpected) rendition of "Silent Night." She was not going to let the soaring July temperatures or her current status as the most famous Jew in show business stand in the way of plugging her forthcoming Christmas album.

Once the record-breaking concert tour had ended, the Goulds moved into a rented house on Long Island and spent the remaining few weeks of the summer strolling the island's broad beaches, hunting for antiques, and pondering what to name the baby. "You've got to think of the personality of your child," she mused. " 'Samantha' has possibilities. If she turns out to be a tomboy, her friends can call her Sam. You've got to think of things like that. Or she can be Samantha, exotic or dignified as the case may be."

And if it was a boy? Barbra considered Gideon, but worried that he might be given the nickname Giddy. So she and Elliott settled on Jason Emanuel, after their artist friend Jason Monet and Barbra's father.

This brief period awaiting the arrival of their child would be, Barbra later said, the most blissful, relaxed period of her life. "I always thought that having babies was for other people," she told Gloria Steinem, "but not for me . . . What's growing inside me, it's a miracle, the height of creativity for any woman."

Whatever the baby's sex, Barbra was determined that the littlest Gould not be spoiled with "toys from FAO Schwarz. Kids like simple things to play with—a piece of paper, a walnut shell." When someone asked if it was strange to think of her child having a privileged early life so unlike her own, Barbra replied, "Well, I can't suddenly get poor for her, or him, can I?"

That September, Barbra returned to the studio to finish *Je m'appelle Barbra,* the French-language album on which she and Michel Legrand had been working on and off for a year. After driving both Legrand and noted arranger Warren Vincent to the brink of a nervous breakdown ("The list of changes she wanted was so long you'd

have to write them on a roll of toilet paper," Vincent said before he quit in despair), the album came out in October of 1966.

Now Barbra focused on two things: the impending birth of her baby, and whether or not she would have her nose fixed before filming started on the screen version of *Funny Girl*. Television was one thing, but the idea of seeing her nose looming thirty feet high on the big screen was . . . unnerving. She asked a number of friends whether they thought she should have work done. "I would have liked to look like Catherine Deneuve," she said, pointing to the classically beautiful French actress as her personal ideal. "If I could do it myself with a mirror," she went on, "I would straighten my nose and take off that little piece of cartilage from the tip." Just as Schulenberg and Barry Dennen and the Millers had done years before, her new set of friends and confidants begged her not to touch her nose.

Still not quite convinced, Barbra consulted plastic surgeons in New York and in Los Angeles. There was unanimous consensus that any work done on her nose could change the unique quality of her voice. That, in the end, would be the deciding factor—and the nagging feeling that she would somehow be betraying who she *was* if she changed her nose. "I don't think," she told Elliott, "I'd like myself very much. This is my father's nose. It's who I am."

On December 28, 1966, Barbra checked into New York's Mount Sinai Hospital under her tried-and-true alias Angelina Scarangella. She and Elliott had been very outspoken about wanting to experience natural childbirth. "I can't understand how some women can just say, 'Give me an injection, I don't want to know a thing about it,' " Barbra complained. "I mean, I really wonder about people like that." But once doctors realized this was going to be a breech birth—that the baby was going to be born feetfirst—natural childbirth was out of the question.

The next day at three P.M., after nine hours of difficult labor, Jason Emanuel Gould arrived via cesarean section. Weighing in at seven pounds twelve ounces, the baby had Elliott's dark hair and his mother's dazzling blue eyes. The blue-tinted birth announcement that went out to relatives and friends from "Barbra and Elliot Gould" showed a stork holding a bright-eyed baby declaring, "Well, here I am." It also offered a one-word assessment of Jason

Emanuel borrowed, at least in part, from Barbra's opening line in *Funny Girl:* "Gorgeous!"

"It's a whole new me," Barbra said of this new chapter in her personal life. "A normal me." Becoming a mother was, she hoped, "the only thing that's going to give me roots again." For the next two months, Barbra holed up with baby Jason in the Goulds' opulent Central Park West apartment and tackled the part the way she would any other project—ferociously. She claimed that she alone bottle-fed Jason, bathed him, burped him, and put him to sleep— though there were those who wondered how she could possibly accomplish this with her long, exquisitely manicured fingernails. She took his picture every Thursday on the weekly anniversary of his birth to document his development, and tape-recorded his gurgling and giggling. She even recorded his burps. "Isn't he a gas?" she liked to say whenever that happened.

Like most other stars—and despite her own oft-proclaimed craving for privacy—Barbra was certainly not above exploiting her new bundle of joy for publicity purposes. As was the case in nearly every other aspect of her life, even the interviews that she gave to publications like the *Christian Science Monitor, Look,* and the *New York Times* had less to do with the baby than it had to do with what the baby's effect was on his celebrated mother, especially on her psyche and her career. At one point, Barbra, who must have still been somewhat under the influence of the British after completing her role in the London production of *Funny Girl,* compared herself to Anne Boleyn. "If I were a queen, they would never find fault," she announced. "I produced an heir."

It was only a matter of three months before the responsibility for the care and feeding of young Jason was turned over to a full-time, live-in nanny. By that time, Mommy had her eye on yet another project. She may never have thought of herself as a mother, but she had always thought of herself as a movie star—and that is precisely what her next big project would make her.

"I could *feel* my unwelcomeness," Barbra said of her arrival in Los Angeles on May 10, 1967, to begin work on *Funny Girl.* It was not just because the film establishment already widely regarded Barbra as a presumptuous, brash-to-the-point-of-crude, supremely arrogant upstart. The same week she landed in town, it was announced

that Streisand would be playing the part of Dolly Levi in the screen version of *Hello, Dolly!*—and not the much-admired Carol Channing, who created the role on Broadway. Instantly, Barbra became the woman to hate in Hollywood—or at least that was how it felt to her.

No one had had the heart to tell Channing, who was playing Dolly in Montreal; she had to read about it in the papers. "Well, of course I felt suicidal; I felt like jumping out a window," Channing later said. "I felt like someone had kidnapped my part." Determined to take the high road, she immediately sent Barbra a dozen roses with a handwritten note that read, "So happy for you and Dolly! Congratulations and good luck. Carol Channing."

At first, Streisand was thrilled—until she realized that the contents of the note had already been released to the press. She decided not to return the favor by thanking Channing. In fact, Barbra, well aware of the hostility toward her in Hollywood, wasted no time firing off a series of one-liners that only made the situation worse. "I wouldn't want to raise my son here," she said, "in a town where people are judged by the size of their swimming pools." By way of rubbing salt into the wound, she made a point of letting everyone know that she had rented a Beverly Hills mansion that had once been the home of the reclusive Greta Garbo. "It has class, style," she said, "something very unusual for Hollywood."

None of which prevented Ray and Fran Stark from pulling out the stops to make Barbra Streisand's landing in Hollywood seem like the second coming. The Starks pitched a tent on the grounds of their sprawling Holmby Hills estate and, while an all-female orchestra performed music from *Funny Girl,* played host to such screen legends as Jimmy Stewart, John Wayne, Gregory Peck, Marlon Brando, Rosalind Russell, Steve McQueen, Ginger Rogers, Natalie Wood, and Robert Mitchum.

The guest of honor was ninety minutes late. Barbra would later say it was "sheer nerves. I kept thinking, 'How can a little Brooklyn girl go into this room full of movie stars?' I changed my dress three times that night out of nerves. But from that night on everyone decided I must be a rude bitch."

One of the guests made it clear she certainly thought so. "Everybody was waiting for a glimpse of this amazing creature they'd all

been hearing about," Ginger Rogers recalled. "We waited and waited and waited. I mean, forget about me and Jimmy Stewart. Can you imagine this kid keeping *John Wayne* waiting?"

When she finally arrived, Barbra stepped into the Starks' foyer just as the sun was about to set. "What's the idea, Ray," she said, "of starting me out in this lighting?" Within moments, she retreated to the Starks' study, where she granted what amounted to a series of private audiences to the crème de la crème of the movie industry.

Friends theorized that Barbra was not guilty of arrogance so much as overcompensation. She hid her massive insecurity behind an imperious facade only because, as she herself would later claim, she was intimidated by all the luminaries who had come to size her up. But Ginger Rogers did not see it that way. "She did not seem shy or reticent *at all*," she observed. "Miss Streisand struck me as someone who had quite a high opinion of herself. What was she then, twenty-four? Twenty-five? And she'd never even made a picture? Why, I had made *thirty-five* pictures by the time I was her age. Anyway, I am a great believer in manners. I think everybody should have them."

William Wyler, who replaced Sidney Lumet as director of *Funny Girl* after Lumet had a falling-out with Stark, would eventually discover just how highly his leading lady thought of herself. Sixty-five years old and deaf in one ear, Wyler was one of the industry's true titans. In the process of making sixty-eight pictures, he had earned twelve Academy Award nominations for Best Director and won three (for *Mrs. Miniver, The Best Years of Our Lives,* and *Ben-Hur*). All in all, Wyler's films, which also included such classics as *Wuthering Heights, The Letter, The Little Foxes, The Heiress,* and *Roman Holiday,* had raked in a total of forty Oscars.

Still, Columbia and Stark had their doubts. In addition to being partially deaf, Wyler had never directed a musical before. Stark suggested bringing in Herb Ross, who had worked on *I Can Get It for You Wholesale,* to stage the musical numbers. To pull this off without looking as if Barbra and her cohorts were insulting the esteemed Mr. Wyler, they would have to make it look like it was his idea. In exchange for allowing Ross to sign on as what amounted to his codirector, Wyler insisted that he remain the movie's sole director, that he be given time to finish his current picture, *Patton* with

George C. Scott, and that when the credits rolled, they would refer to *Funny Girl* as a "William Wyler–Ray Stark production."

From the beginning, it was understood that whoever played the role of Nicky Arnstein in the film would have to pass muster with Barbra. She wanted either Brando or Gregory Peck for the part, but both actors declined. Sean Connery was considered, as were Frank Sinatra and David Janssen, star of the hugely popular television series *The Fugitive.*

After Wyler ran into Omar Sharif in the studio commissary, he suggested the swarthy Egyptian actor for the role opposite Streisand. Sharif, who had already appeared in *Lawrence of Arabia* and *Dr. Zhivago,* did a screen test with Barbra, and the chemistry between them was palpable. At the time, the fact that Sharif was Egyptian was of little concern to Stark and the studio. They were more than satisfied that, in every other way, he seemed the perfect fit for the part of the Jewish Arnstein. Not only was he suave and sexy and comfortable in a tuxedo, but Sharif also liked to gamble. An expert cardplayer, he would, in fact, go on to write several books and a syndicated newspaper column on the subject.

The first week in June 1967—just days after it was announced that Omar Sharif had been added to the *Funny Girl* cast—Arab and Israeli forces clashed in the Middle East. In this charged atmosphere, photos of Barbra and Omar locked in a passionate embrace during rehearsals hit papers around the world.

The pictures triggered anger on both sides of the Arab-Israeli issue. Sharif was denounced in the Arab world for betraying his people, and there was even a movement launched in his native country to revoke the actor's Egyptian citizenship.

"You think the Egyptians are angry?" Barbra told a reporter. "You should see the letter I got from my aunt Rose." Diana Kind, meanwhile, publicly announced that her daughter was "not going to work with any Egyptian!"

In Hollywood, where support for Israel had always been strong, Columbia executives told Stark they wanted Sharif off the picture. Barbra remained silent on the subject at first, wary of a backlash from her fans if she stepped in to defend Sharif. But Wyler, who was also Jewish, hesitated not at all. "We're in America, the land of freedom, and you're ready to make yourselves guilty of the same things

we're against?" he asked angrily. "Not hiring an actor because he's Egyptian is outrageous." With that, Wyler threatened to walk off the picture if his friend Omar wasn't in it. Now that the beloved William Wyler had taken the lead, Barbra felt comfortable making the same pledge to quit.

Not that she left any doubt about where she stood. Even before the Six Day War was over, she had given $400,000 to the Emergency Campaign for Israel. A week later, she sang at a "Rally for Israeli Survival" at the Hollywood Bowl. Her outspoken support of Israel, and her on-screen intimacy with Sharif, would result in Barbra's films being banned in all Arab countries for decades.

International politics aside, Barbra never strayed far from the task of bringing *Funny Girl* to the screen. She rehearsed her musical numbers with Ross for the next eleven weeks, pushing herself to the point of exhaustion. At the same time, she worked at the Goldwyn Studios prerecording all the songs for the film, which Barbra and the other actors would lip-synch during filming. Ever the perfectionist, Barbra worked with musical director Walter Scharf twelve hours at a time, doing take after take after take, until she was satisfied—and even then she would return weeks later to redo a number yet again.

Even with Elliott on hand during this period to smooth relations between Barbra and her colleagues on the film, Barbra and Scharf quarreled frequently. She was, Scharf allowed, "temperamental and stubborn," and their relationship "wasn't always easy or peaceful." In the end, however, Scharf had "nothing but complete respect" for Barbra's tenacity—and her choices. "She cares, that's the main thing. She's difficult, demanding, sure. But it's never over anything trivial—or at least not to her."

But when Elliott was offered his first major movie role in *The Night They Raided Minsky's,* he did not hesitate to accept. The film comedy was being shot in New York, which meant he and Barbra would be apart for weeks. Needing him close at hand for moral support—and to continue to serve as a buffer between her and the people she did not wish to be bothered with—Barbra begged her husband not to go. But Elliott was not about to pass up this rare opportunity to at last crawl out from under his wife's shadow.

Barbra took only one weekend off from the film—not to relax,

but to film her next television special. A little after nine P.M. on Saturday, June 16, Barbra was about to appear in Central Park's Sheep's Meadow before 135,000 people—the biggest crowd ever gathered to see a single performer. Seven CBS television cameras were positioned around and on the Plexiglas stage with its "invisible steps" that gave the impression that she was walking on air. The cameras were there to record the much-ballyhooed *A Happening in Central Park,* billed as both Barbra's homecoming and a way of paying back her loyal hometown fans. The free concert, sponsored by Rheingold beer, would pay off handsomely for Streisand, producing not only a prime-time special but also a top-selling album. Timed to air just three days before *Funny Girl's* premiere over a year later, *A Happening in Central Park* would become one of the movie's most important marketing tools.

As she stood in the wings waiting to go on that night, her pink chiffon gown billowing in the wind, Barbra was paralyzed with fear. Only three hours earlier, someone had phoned in a death threat, promising to kill the "Jew Streisand" for her support of Israel. It was less than two weeks after the Six Day War, but that was not the only reason Barbra feared for her life. Never before had the political situation in America seemed more chaotic—or more dangerous. The Vietnam War was raging, racial tensions simmered, and in less than a year Martin Luther King and Robert Kennedy would be shot dead.

"She was *terrified,*" said *Happening* director Bob Scheerer, "that the spotlights would make her a target for a crazy in the audience." Indeed, Barbra stood, frozen, at the edge of the stage. She was convinced that an assassin was lying in wait for her. Others involved in the production were even more concerned that Barbra's fans, who by now had been waiting for hours to see her, might surge onto the stage and rip her to pieces à la *The Day of the Locust.*

It took a shove from Scheerer's wife to propel her out onto the stage, arms outstretched. Stunned by the deafening roar that rose up from the crowd the moment she stepped into view, Barbra recoiled. "I didn't *do* nuthin' yet!" she cracked, glancing over to the right of the stage where Elliott, her mother, her sister Roslyn, and friends like Calvin Klein, Andy Warhol, and Congresswoman Bella Abzug were seated.

Then Barbra launched into "Any Place I Hang My Hat Is Home," followed by a hushed rendition of "The Nearness of You." She walked about the stage as she sang, shifting her position and waving her arms. When edited for television, the movements would look perfectly natural. But at the time, Barbra was thinking of how she could make it difficult for anyone to get a clear shot at her. "It's harder to hit a moving target," she later said. "I was afraid that somebody might take a shot at me during the concert. So I started walking around the stage fast."

Barbra was so preoccupied that she forgot some of the words to songs she'd been singing for years. "An actor's nightmare," she recalled. "And that frightened me—that absolute lack of control."

After the first act, she climbed into a limousine that took her to a trailer on the edge of the park and changed into another chiffon gown. She was dissatisfied with her performance thus far, and especially upset at having to stop in the middle of a song and ask her conductor for help because she had forgotten lyrics. As usual, she took it out on those around her. "I was not cute," she later admitted.

"Get the fuck out of my way!" she shrieked at a hapless stage-hand who'd lingered too long in the vicinity. She complained to Marty Erlichman about a missing light and quizzed him about one of the camera angles. "Now what am I going to wear?" she asked, holding up a flowered pink Brooks and a sequined Galanos. "What about the pink?" she asked no one in particular. A technician spoke up hesitantly, telling her that he had taken a poll and eight out of ten working on the show didn't like it. Without warning, she exploded at the hapless crew member. "You know what?" she yelled. "I'll tell you what. You guys don't understand fashion!" She ordered her dresser to help her into the pink flowered dress, another billowy, diaphanous number that would, of course, turn out to have been precisely the right choice.

After showering everyone in the vicinity with withering epithets, only her hairdresser, Fred Glaser, remained to put the finishing touches on her towering hairdo.

"She continued to rant and rave," said Glaser as they returned to the stage together in a golf cart. She noticed that, during the break, the audience had inched up to the edge of the stage. "Too close, too close!" she said. "Push them back. Push them BACK!"

The second half of the show went far more smoothly, and by the time Barbra finished singing "Happy Days Are Here Again" at 11:53 that night, the crowd was on its feet, cheering wildly and begging for an encore. *The Happening in Central Park* was indeed that—not just a resounding critical and ratings success, but a kind of milestone event in live entertainment.

With the exception of her blistering tantrum during intermission, Barbra was for the most part the very model of civility. Scheerer found her to be entirely cooperative, open to suggestions, and even congenial. "She was," he declared, "a doll."

A month later, Barbra was back onstage at the Hollywood Palladium, performing at another fund-raiser for Israel. This time, security caught sight of a man in the audience wielding a .45-caliber pistol. He was immediately apprehended and spirited away without Barbra ever noticing. When she was told of the incident after the concert, however, Barbra came unglued. "I was really scared," she said, "and who wouldn't be?" From that point on, Streisand would harbor a deep-seated terror of performing in public—a paralyzing fear that she would never entirely come to terms with.

The next day, Barbra flew back to New York to film her first scenes for *Funny Girl*—most notably her stirring "Don't Rain on My Parade" number in the bow of a tug plying New York Harbor. Barbra whined to Herb Ross about the physical demands of the part, threatened to sue Ray Stark if she became injured running down a pier with a suitcase, and reduced her personal hairstylist on the film, Gertrude Wheeler, to tears. She also reportedly made it clear to the film's designer, Irene Sharaff, that she "hated" all the costumes for the film. The two makeup artists assigned to her were also upset—not because she told them what to do, but because of what she told them *not* to do. Barbra did all her own makeup, and the two men were basically relegated to holding her cosmetics case.

William Wyler's own passion for perfection had earned him the sobriquet "Forty-Take Wyler"; working with him was so exasperating and exhausting that few actors made more than one or two pictures with him. A notable exception was Bette Davis, who starred in such Wyler films as *Jezebel, The Letter,* and *Little Foxes,* and for a time was the director's lover.

But even before the cameras began rolling, Wyler realized that he

had met his match in Barbra Streisand. At first, he conceded that his young star "frightened me to death." He had been warned that she would inundate him with notes and suggestions, that she would try to wrest control of the picture from him, and that if *Funny Girl* was to be any good, he must not let that happen.

"She's got ideas," Wyler said with a shrug. "Some are good. Some are not good." No detail was too small to escape her attention. "She fusses over things, she's terribly concerned about how she looks, with the photography, the camera, the makeup, the wardrobe, the way she moves, reads a line . . . She even checked with me about the color of her nail polish!"

Wyler conceded that her powers of observation were second to none. "She'd tell the cameraman that one of the lights was out, way up on the scaffold. If the light that was supposed to be on her was out, *she* saw it." The film's Oscar-winning cinematographer, Harry Stradling, concurred. Even though they clashed often about how she was to be lit for the film, Stradling came to feel a grudging admiration for Barbra. "Sure, she's tough," he said, "but she has an unerring eye."

Wyler learned to pick and choose, and more often than not, Barbra's ideas—on everything from lighting to camera angles to makeup, costumes, dialogue, and even casting—made it into the picture. At first Wyler thought he would simply humor her, and then go ahead in the end and shoot the scene the way he originally intended to shoot it. "You can run it and do it her way and then change the lighting or whatever," he said. "But my God, she was right! Where she got the knowledge, I don't know."

At times, Wyler was genuinely convinced by Barbra's arguments that a scene should be shot a certain way. Just as often, however, she would overwhelm him with so much talk about her character's motivation that he simply threw up his hands and let her do it her way. "I had sense enough," he later admitted, "not to argue."

Wyler came to view Barbra as nothing less than the consummate professional, and she in turn trusted him to protect her. "She was a bit obstreperous in the beginning," Wyler admitted. "But things were ironed out when she discovered some of us knew what we are doing." Waving off criticism in the press that she treated him like "a butler," Wyler acknowledged that "she's not

easy, but she's difficult in the best sense of the word. The same way I'm difficult."

Once Barbra realized that Wyler was a kindred spirit—and that she could manipulate him—she gradually warmed to her director, and vice versa. Not that there still weren't heated disagreements between the two. Pitched battles were the order of the day, and soon the standard joke around the set was that Wyler should start taking it easy with his young star because, after all, it was the first picture she had ever directed.

"Mr. Wyler was tough," said his onetime paramour Bette Davis. "He knew exactly what he wanted and how to get it. No one could *make* him do anything he didn't want to do. But that doesn't mean he wouldn't change his mind if the right argument was made."

Barbra was determined from the outset that no one would outshine her on-screen. The most egregious victim in this regard was veteran screen actress Anne Francis, who had starred in such classics as *Bad Day at Black Rock* with Spencer Tracy and *The Blackboard Jungle*. The thirty-seven-year-old Francis, a shapely blonde perhaps best known for her sultry gaze and beauty mark, was cast as Georgia, an aging Ziegfeld girl and Fanny's close friend and confidante. Having just ended a successful run in her own ABC series, *Honey West,* Francis took the meaty part—originally described as the second female lead—because she felt it afforded her a clear shot for an Academy Award nomination in the Best Supporting Actress category.

Had the movie version of *Funny Girl* followed the original script, Francis might well have landed that nomination. In addition to being the featured singer in several numbers with the other Ziegfeld girls and singing "Sadie, Sadie" with Barbra, Francis provided the movie with one of its most emotionally wrenching scenes when Georgia drinks herself into a stupor.

Virtually all of Francis's performance wound up on the cutting room floor. "Every day, Barbra would see the rushes, and the next day my part was cut or something else was cut," Francis said. "Barbra ran the whole show—Ray Stark, Willie Wyler, Herb Ross. She had the Ziegfeld girls' scenes changed—one day she told Wyler to move a girl standing next to her because she was too pretty, and the girl wound up in the background."

Elaine Joyce was one of the actresses who believed she was cut

out of several scenes because Streisand was insecure about her own looks. Working on *Funny Girl,* she said, "was torture. It was really just diabolical what went on . . . I never wanted to work with her again. There must be legions of people like that."

According to Vivien Walker, chief hairstylist on the movie, another actress was treated even more harshly. Walker was sitting directly in front of Wyler and Streisand one evening as they watched the rushes, and Barbra turned to Wyler. "You see that girl?" she asked the director.

"Yes?"

"Fire her. She's too pretty."

The girl, according to Walker, was let go the next day. "What I saw her do to other people angered me so much," Walker said, "that I couldn't tolerate her."

Although Francis claimed she had only one "unpleasant" meeting with Streisand during the five months of working on the film, she also described her treatment at the hands of Barbra and Wyler as "a nightmare . . . It was all like an experience out of *Gaslight.* There was an unreality about it." More than anything else, she found the experience degrading. "You can understand the humiliation," she later said, "when each day a note would be slipped under my dressing-room door, 'omit scene so and so.' The scene would always be the one I was called in to do that day."

Before the film's release, Francis would ask Stark to have her name taken off the credits. What had originally been conceived of as a major role in the film was now little more than a cameo. "My scenes," she said, "were whittled down to two minutes of voice-over in a New Jersey railroad station." Even when she did appear with Barbra, the star made it clear who was in charge. After a scene in which Francis lightly touched her arm, Barbra whipped around and declared, "Don't touch me." At Streisand's insistence, the scene was reshot.

Nor was Francis allowed to look as attractive as she might have. Streisand reportedly vetoed costumes and hairstyles for Francis that she deemed too flattering. Wyler acquiesced to Barbra's wishes because he knew the movie would succeed only as a vehicle for her. "My principal job," Wyler said, "was to present her in the most advantageous manner possible." As for the rest of the cast: "No one

mattered even remotely as much as Barbra. There were no illusions about that."

Thirty-five years later, Francis would claim that her complaints about Streisand's control of the film actually originated with her longtime friend and publicist Peggy McNaught. "It has gnawed at me for years that you have believed that I blamed you for cutting most of my scenes from *Funny Girl,*" Francis wrote in a 2002 "Open Letter to Barbra Streisand." Francis went on to write, "I have the greatest respect for your talent and what you have made of yourself, Barbra. You are a brilliant woman and I have always wished you the very best. One more time, it is important for me before I leave this planet to say, I have never accused you of having the role of Georgia cut to the quick."

Still, with few exceptions, Barbra's coworkers on the set resented her for being self-centered, self-aggrandizing, and aloof. She did nothing to correct the lingering impression among cast and crew members that, aside from whatever part they played in supporting *her,* they really did not exist in her eyes. "The world is divided into two categories," her former manager Ted Rozar observed, "and Barbra was, is, and will always be a taker."

"She doesn't go out of her way," Wyler acknowledged. "It's not in her manner to be especially gracious." That, observed assistant director Jack Roe, was a gross understatement. "She was downright *rude,*" he said. "Rude, rude, rude. To everyone."

These stories eventually made their way into the mainstream press. In a *New York* magazine article titled "Barbra Streisand Directing Her First Movie," influential Hollywood columnist Joyce Haber asked if Streisand was simply a bore or "a monster." Barbra "might have opted to be a bore," Haber mused. "There is evidence she has talent in that direction." Instead, Haber concluded, she was working "quite energetically" at "becoming a monster."

Streisand took it all in stride. When she arrived in Hollywood, she said, "everybody thought, oh, she's got to be a bitch and have temper tantrums, be demanding and nasty. I had no intention of being that. But it's funny. Circumstances *make* you behave like they expect you to sometimes."

For example: "On the morning of a scene, my dress isn't here yet, my hair isn't fixed properly, and they want me to go out anyway

and film it." Streisand neglected to mention that her chronic lateness—"She never showed up on time for *anything* and kept everybody waiting," Sharif said—wreaked havoc on the film's shooting schedule.

That fall of 1967, however, Barbra scarcely seemed bothered by what others were saying about her. Six months after it was taped in New York, her next TV special, *The Belle of 14th Street,* finally aired on October 11. Conceived as a tribute to vaudeville, the show, which costarred Jason Robards, was both a critical and commercial disappointment—Barbra's first bona fide flop.

Just as she had done with her onstage Nicky Arnstein, Streisand found solace in the arms of her new leading man. Already a notorious womanizer, Omar Sharif had by this point been married for thirteen years to the Egyptian actress Faten Hamama. The Sharifs' marriage was an open one, however, and Omar felt free to pursue romances with his leading ladies, including Julie Christie, Sophia Loren, and Anouk Aimée. "The truth is," he explained, "I worship women." *Women,* yes. "I have so many women," Sharif liked to say, "because I don't have *one.*" What made him so irresistible to the opposite sex? "I make women happy, with the tenderness, love, and thrills I give them. I get any woman I want because I give all of myself."

When Sharif first set eyes on Barbra, however, he was not at all sure he wanted her; he thought she was not merely unattractive but "ugly." He phoned his agent and asked, " 'How is this girl going to be a leading lady?' The next day, I looked at her again and I found her not bad. I thought she looked quite nice from certain angles. The third day of rehearsals I started to find her more and more attractive. About a week from the moment I met her, I was madly in love with her."

As shooting progressed on *Funny Girl,* Sharif made his move. By now he thought she was "the most gorgeous woman I had ever seen in my life. I was *lusting* after her."

With Elliott still back in New York—and baby Jason at her rented Beverly Hills house being taken care of by a nurse *and* a nanny—Barbra felt free to reciprocate. Their trysts began at Sharif's suite at the Beverly Wilshire Hotel and moved to Barbra's eighteen-room house.

"We led the very simple life of people in love," he said. They watched television, ate frozen TV dinners, or just talked. He taught her how to play cards, and in return she gave him tips on singing his one solo number, "Pink Velvet Jail." The song would later be dropped from the movie.

They rarely ventured out, and when they attended a fashion show together and then went to dinner at a restaurant called The Factory, they wound up wishing they hadn't. Elliott called in a rage, demanding to know what she and Sharif were up to. She complained that if she hadn't gone to the fashion show with her Egyptian costar, she would have had to pay for the $250 ticket out of her own pocket. "She's cheap," Elliott said of his wife, and "Sharif was somebody to pick up the tab . . . Actors dress for effect," he went on. "Actors date for effect. It all suddenly becomes real to them and they're affected."

Oddly, Streisand contradicted her husband's public insistence that she had merely spent an innocent—if somewhat suspicious-looking—evening out with her leading man. "I know Elliott thinks it's just another Hollywood fantasy," she told one writer, "but it's not. Omar has told me many times that he loves me."

Barbra went on to publicly state that she was "gaga" over Sharif—that she was "hopelessly, madly in love" with her leading man. It was, she said, "like the old Hollywood story—a B-movie script—but it actually happened. And I don't care who knows it." But she also claimed Omar was "too much of a gentleman to make a play for a married woman"—even as their affair was in full swing.

At this point, with Barbra both proclaiming their mutual love and falsely stating that Sharif was too much of a gentleman to do anything about it, the press could only speculate about the seriousness of the relationship. While the set buzzed with rumors that they were about to leave their respective spouses and marry each other, Wyler coyly observed, "If all Jews and Arabs got on like Barbra and Sharif, there would never be a war." For his part, Omar was even telling friends that he was seriously considering getting circumcised for her.

Later, as the stories about her megalomaniacal behavior during the filming of *Funny Girl* multiplied, Sharif rose to her defense. "She had a terrible background," he explained. "She didn't just

think she was plain—she thought she was ugly. So no wonder that insecurity. No wonder . . ."

Shooting had already ended and Sharif was packing his things to return home when Barbra summoned him back to the studio. She had viewed the rushes and was unhappy with the climactic final scene in which she sings the song most closely identified with Fanny Brice, "My Man." It had been shot two months earlier, but now she felt it seemed "I dunno, not gritty enough. Kinda *limp*."

Wyler agreed to let her sing the song live, something unheard of in the world of prerecorded movie musicals. Sharif, still professing his love for Barbra, rushed to the studio. Alone in the wings, Barbra and Omar acted out the final, poignant moments between Fanny and Nick Arnstein. Then, racked with emotion, she stepped before the cameras and sang "My Man" in front of a black curtain that left only her head and hands visible. By the time she was done, the script girl and several burly crew members were wiping away tears. Still dissatisfied, Barbra shot the scene a dozen more times.

Sharif was also moved, and touched that Barbra had called him to help her summon up the emotions she needed to deliver a perfect performance. What he did not know was that they were not merely acting out a good-bye scene between their characters; Barbra was dumping him for real, and drawing upon the pain of that to make herself more believable on-screen.

While the cast and crew mingled during the wrap party, Barbra ("I HATE making idle cocktail-party chitchat. It's so phony, I just can't make myself do it") stood off to one side and sipped champagne. She brightened, however, when Wyler presented her with an orchestra conductor's baton and a director's megaphone. The running joke continued with Stark, who gave her a trailer for the movie with a credit that read "produced and directed by Barbra Streisand." She, in turn, gave Wyler an antique gold pocket watch. On the back was the inscription, "to make up for lost time."

Sharif, who had been one of Barbra's chief defenders in the press, was less charitable when he realized that he had been dismissed as summarily as she had dismissed Sydney Chaplin. "She is a monster," he said, "but a fascinating monster."

I've been accused of being ruthless. My problem is, I'm not ruthless enough.

I found Barbra very sexy—a terrific girl.
But I think she used me.

—Ryan O'Neal

Barbra is like Marie Antoinette. It's the danger of believing you're
larger than life. Nobody is larger than life.

—Elliott Gould

Her cruelty to coworkers, her director and writers
is unforgivable. It's sad.

—Actress Estelle Parsons

I cry a lot. . . . I get so wiped out sometimes that I think,
it's not worth it.

5

—

Who the hell does she think she is?" Walter Matthau boomed at the top of his lungs as Gene Kelly tried to pull him away from Barbra. "I've been in thirty movies, and this is only her second—the first one hasn't even come out yet—and she thinks she's *directing*! Why don't you let *him* direct," he added, pointing to Kelly. "Barbra, stop directing the fucking picture! You don't have to be great *all the time*!"

It was a miserably hot June day on location in Garrison, New York, and Kelly had just marked his second full month directing Matthau and Streisand in the film version of *Hello, Dolly!* Matthau's character, Horace Vandergelder, and Barbra's Dolly Levi were about to exchange quips outside Vandergelder's feed store overlooking the Hudson River when Streisand once again offered up her own ideas about how the scene should be shot. It was too much for Matthau, and he launched into what he admitted was a "wild, furious, incoherent tirade about her."

Barbra was on the verge of crying, but she didn't want to give her *Hello, Dolly!* costar the satisfaction. "Why don't you learn your lines?" she fired back. "You're just jealous because you're not as good as I am!"

Kelly took his fuming stars inside the feed-store set, where the battle resumed. "The rest of the cast and crew were standing around outside," recalled makeup artist Don Cash Jr., who would eventually work with Barbra on a total of five films. "You could hear them yelling bloody murder at each other. It was pretty amazing."

Fresh from winning an Academy Award as Best Supporting Actor

in *The Fortune Cookie,* Matthau was not about to listen to the opinions of less experienced actors—least of all Streisand. "Cool it, baby. Listen you pipsqueak, you might be the singer in this picture," he bellowed, "but *I'm* the actor. You haven't got the talent of a butterfly's fart!"

Finally, Barbra burst into tears. "I couldn't believe it. I had no defense," she recalled. "I stood there and I was so humiliated I started to cry, and then I ran away."

Matthau, who had had a major heart attack the year before and now suffered from stomach problems and migraines, delivered the coup de grâce as she fled. "Everybody in this company hates you!" he boomed. "Go ahead, babe, walk off! Just remember, Betty Hutton thought she was indispensable, too. And *she* just filed for bankruptcy!"

Barbra dashed to her dressing room and called the movie's producer, Ernest Lehman. Shooting stopped completely while she cried for over two hours. It took the combined efforts of Lehman and Kelly to convince her to return to the set. "Barbra cried," the director said, "for a *long* time."

Coming just one day after the assassination of Robert F. Kennedy on the night of his presidential primary win in California, the verbal brawl between Streisand and Matthau might have been chalked up to grief and frustration. Both actors were staunch Democrats who opposed the war in Vietnam, and Barbra had actually performed at a "Broadway for Peace" rally at Lincoln Center earlier that year. At the urging of her friends, the husband-and-wife songwriting team of Alan and Marilyn Bergman, she had formally endorsed Minnesota senator Eugene McCarthy. But Barbra made it clear that had Bobby Kennedy secured the Democratic nomination, she would have campaigned on his behalf to defeat the presumptive Republican candidate Richard Nixon. "Anything," she said, "to defeat that son of a bitch."

There would be no peace on the set of *Hello, Dolly!;* the war between Streisand and Matthau raged on. From the outset, Barbra had known there would be trouble—and not just because Carol Channing had been unceremoniously shoved aside so she could have the plum role that originated in Thornton Wilder's 1954 play *The Matchmaker.* "I am too young to play this part," she told Lehman and Marty Erlichman and Gene Kelly and Elliott and anyone else

who would listen. "They should get someone like Elizabeth Taylor to play it."

Barbra had a point. Dolly Levi was, after all, a widow, and it had always seemed logical that she be played by an actress of a certain age. Ruth Gordon was in her fifties when she created the role on Broadway in *The Matchmaker;* Shirley Booth was sixty when she played Dolly in the 1958 movie version. In addition to Channing, older actresses like Ethel Merman, Ginger Rogers, and Pearl Bailey had all assayed the role onstage. Elizabeth Taylor had actually been considered for the part, and even after Streisand had been hired, the studio considered replacing her with Doris Day as Dolly.

Eventually, Barbra convinced herself that, at twenty-six, she could simply play the character as a woman whose much-older husband had passed away. "That happens all the time," she said with a shrug. "Right?"

Gene Kelly had doubts about Barbra, but they had nothing to do with her age. The legendary movie star hoofer, who'd codirected *Singin' in the Rain* and *On the Town* with Stanley Donen, had "heard she was a difficult lady." As soon as he agreed to direct *Hello, Dolly!,* he flew to New York and had lunch with Barbra and Marty Erlichman at the Oak Room of the Plaza Hotel.

"Barbra," he asked, "are there any truths to all these stories that . . . you're difficult?"

"Me?" she answered, incredulous. "I'm a nervous *chalaylya* maybe, but I'm not difficult."

Kelly would quickly discover that she was anything but nervous about trying to assert control of everything from changes in dialogue to wardrobe, lighting, camera angles—and of course the musical numbers. Unfortunately, what she did need from Kelly—a coherent view of the story and her character, never materialized. Left as she was to improvise, Kelly admitted that she wound up being "Mae West one minute, Fanny Brice the other, and Barbra Streisand the next. Her accent varied as much as her mannerisms . . ." In the process of trying and failing to get it right, Kelly said, "she became terribly neurotic and insecure."

"Barbra and Gene." Lehman sighed ruefully. "They were just not meant to communicate on this earth. "Kelly didn't like her. She didn't like him."

Matthau had no trouble communicating his distaste for his costar, which he had actually harbored for years. He had already heard plenty of unflattering stories from her jilted lover Sydney Chaplin by the time he met Barbra for the first time at a 1965 revival of Tennessee Williams's *The Glass Menagerie*. Streisand and Matthau were both visiting the play's star, Piper Laurie, backstage when he turned to Barbra and said, "You must be Barbara Harris. Better do something about that nose."

When he signed up to do the picture, Matthau later said, he "just knew" he was going to "blow up at her." Principal photography was only days away when she appeared at the Academy Awards to present the Oscar for Best Song. Sammy Davis Jr. accepted the award on behalf of Anthony Newley and Leslie Bricusse, for their song "Talk to the Animals" from *Dr. Doolittle*. Afterward, Matthau asked if her elaborate hairdo was "meant to be funny."

"Why are you so cruel?" she told Matthau as he tried to contain himself. "You are a very hostile person."

Even after the June 6 fireworks in front of Horace Vandergelder's feed store, the battle raged on. Matthau told her she was no actress, but "a freak attraction—like the boa constrictor at the circus." She called him "Old Sewer Mouth"; he called her "Miss Ptomaine."

One day Barbra asked, "How's your ulcer?"

"I don't have an ulcer," he replied.

"My maid said she heard on the radio that I was giving you an ulcer."

"You may be giving me another heart attack, darling," he said, "but not an ulcer."

"You never knew what she was going to do next and were afraid she'd do it," Matthau later said. "I was appalled at every move she made."

To get even, Matthau ambushed her with an inappropriate remark whenever he could. After going for a run in sweatclothes, he leaned over to her and whispered, "I don't have anything on under this. Doesn't that excite you?"

Matthau seemed to take special joy in torturing his nemesis when the nanny brought her son on the set to watch Mommy in action. At eighteen months, Jason Gould stood on the sidelines wearing parts of his mother's costume—a feather boa and an elaborate Vic-

torian-era feathered hat. In fact, that would be his first word—not
dada or *mama,* but *hat.* While Barbra filmed the upbeat "Sunday
Clothes" number, Jason giddily mimicked her dance steps.

Once, while Barbra found a spare moment to spend with Jason,
Matthau rushed up and began teasing the child with baby talk.
"The only way to bring up kids," he told her, "is to talk baby talk to
'em and beat 'em." Scooping up her little boy, she told the nanny
that she wanted to take him for a ride. "Gonna make poo-poo in
the car, Jason?" Matthau hollered after them.

"Matthau was a grouchy guy on camera and off," said makeup
artist Don Cash. "He had this sarcastic humor and sometimes you
never knew if he was being serious or just joking around. But
where Barbra was concerned, it was always obvious that he really
hated her."

Despite the fact that his well-aimed barbs seemed to be having
their desired effect, Matthau became increasingly bitter. "Once I
heard her tell Lennie Hayton, our musical director, that the flutes
were coming in too soon, and that the first violins were too fast,"
Matthau said. "Then she started telling Gene how she thought I
should feed her lines." She also, unbeknownst to Matthau, de-
manded more close-ups of herself. "The poor girl was corrupted by
power," Walter grumped, "in her second movie!"

Barbra was not about to simply sit idly by while the dyspeptic
Mr. Matthau vented his spleen. "*I* am the star of this fucking pic-
ture!" she shouted at Matthau when he became too much to bear.
"So shut the hell up and get out of my face!"

At one point, Matthau went to studio head Richard Zanuck to
complain. "She steps on your head and your tail," Matthau griped.
"She's gotta wave her goddamn feathers across your balls and in
your eyes, otherwise she's not happy."

Zanuck took a deep breath. "I'd love to help you out," the studio
chief replied. "But the movie isn't called, *Hello, Walter!*"

By the time it was finished, *Hello, Dolly!* wound up costing Fox
$24 million, making it far and away the most expensive movie mu-
sical of all time. Lehman marveled at how "terrible" the whole ex-
perience had been. "The intrigues, the bitterness, the backbiting,
the deceits, the misery, the gloom. Most unpleasant."

Barbra could not have agreed more. Physically and emotionally

drained, she returned to Manhattan to await the release of *Funny Girl*—the project on which the fate of her career as a film actress hinged.

In the meantime, she had to face the fact that her marriage was coming unglued. Elliott was awaiting the release of *The Night They Raided Minsky's,* praying that it would prove to be his launchpad to stardom—or at least restore some of his self-respect. He would later say that going out in pubic was "devastating . . . I didn't want to be there. I wanted to go someplace as *me*. And yet I felt an obligation to attend to my wife, no matter who the fuck people thought I was."

That obligation extended to protecting her from the paparazzi. In late October 1968, Barbra and Elliott were leaving an advance screening of the new Steve McQueen film *Bullitt* when photographer Tony Rizzo came toward them and began taking pictures. "Stop, stop!" Barbra shouted as Rizzo's camera continued to flash in her face.

Finally, Elliott went after Rizzo. "I'll break your camera, you son of a bitch!" he shouted as he shoved the photographer. Claiming that Elliott had "willfully and violently" attacked him, Rizzo filed a $200,000 lawsuit against Gould that languished in the courts for over two years. In June of 1971, a judge would dismiss the assault charges but acknowledge that Gould had "manhandled" the photographer. He was ordered to pay Rizzo $6,500.

In truth, Elliott had lashed out at the photographer in part out of a need to prove to his wife that she needed him—as a bodyguard if nothing else. Barbra was grateful and flattered that Elliott had been gallant enough to come to her defense when she felt threatened. But she was also embarrassed that the contretemps had once again landed her in the papers in a less than favorable light.

By this time, Elliott had come to realize that being eclipsed by his famous wife was only part of the problem. He felt emotionally abandoned by her. "She was so in love with her work and the image of herself she was creating," he later observed, "there was no time for me."

Gould also blamed the early death of her biological father, and her strained relationship with her stepfather, for what he thought was Barbra's fundamental distrust of men. "One side of Barbra needed me," he said. "The other was disdainful of men—and com-

petitive toward them." In the end, he thought that Barbra wanted to be desired by the opposite sex, but felt "men are no good and can't be trusted."

Elliott also came to the realization that the more he loved her, the less she loved him. "My adoration of her caused her to lose respect for me," he said, "to think less of me. She wondered how I could like her when she didn't really like herself." Eventually, he would claim that she used her insecurities as a trap to charm men into thinking she needed them, but that she was far from vulnerable. Instead, Elliott saw her as "cold, smart . . . the most miserable human being I have ever known."

To cope with his ego-deflating "Mr. Streisand" status, Elliott gambled more than ever. While his wife received critical praise for her starring role in *Funny Girl* and the film played to packed houses, Elliott lost $50,000—a staggering amount in 1968 dollars—betting on football alone.

Gould had also become a heavy marijuana smoker, frequently popped amphetamines, and on occasion took to the open highway while under the influence of powerful hallucinogenic drugs. He also suffered bouts of paranoia, at one point imagining there was a monster in the backseat of his car. "I scared the shit out of myself," he said.

As for the child that Elliott had hoped would bring them closer together, Barbra's description of herself as "a typical Jewish mother" was only partly accurate. She did fuss and worry whenever she was around Jason, but Streisand would eventually concede that those mother-son moments were comparatively few and far between. For the most part, Jason was watched over by employees—his nanny, Barbara Howden; Barbra's dresser, Gracie Davidson; and the cook, Grace Maddrell.

Barbra was simply fed up, and after a series of knock-down, drag-out arguments, she and Elliott separated on February 13, 1969. "We are separating not to destroy our marriage," Barbra explained to the press, "but to save it."

Elliott harbored no such illusions. "We're no longer"—he sighed—"trying to save our marriage."

Neither would waste much time pursuing other relationships. Elliott had already been publicly linked to a number of aspiring ac-

tresses, and Barbra would soon embark on a brief affair with Charles Evans, wealthy brother of Paramount's flamboyant production chief Robert Evans. She would also date screenwriter David Rayfiel.

Wherever she was and whoever she was with, her thoughts often strayed to another man—a dashing, urbane, forty-nine-year-old bachelor she had met at the London premiere of *Funny Girl* some months before. His name was Pierre Elliott Trudeau, and he was prime minister of Canada.

April 14, 1969
The Dorothy Chandler Pavilion in Los Angeles

"The winner is . . ." Ingrid Bergman said as she opened the envelope, her jaw then dropping in shock. "It's a *tie!*" Only a handful of those in the audience gathered at the Dorothy Chandler Pavilion for the forty-first annual Academy Awards had ever heard the words. The only other tie in Academy Awards history had occurred in 1932, when Wallace Beery's performance in *The Champ* tied with Fredric March's in *Dr. Jekyll and Mr. Hyde* for Best Actor honors.

Barbra went numb. She had not allowed herself to think she could win the award Marty Erlichman had predicted she would win when they'd first met at the Bon Soir just eight years before. "I can't afford to shiver and shake until the verdict is in," she had told one reporter. "But somehow I can't believe I'm going to get it. It's the Jewishness in me, I guess, the pessimism. It's so close under my skin, that old feeling, 'I can't win. Not me.'"

To be sure, the deck was stacked against her. No matter how brilliant the performance, the fact remained that the Oscar race was, above all else, a popularity contest. And by any measure, Streisand was not popular. Not only was she a New York stage actress and therefore a Hollywood outsider, but the stories that had circulated about her contentious behavior on the sets of *Funny Girl* and *Hello, Dolly!* were already fast becoming the stuff of legend.

"Everybody had heard, including little old me, that she and Willie Wyler had fought like cats and dogs," recalled Katharine Hepburn, nominated for her role as Eleanor of Aquitaine in *The Lion in Winter* and always a strong contender. "And she gave Gene Kelly a

pretty rough time of it, too. So people were wondering, who *is* this creature?"

Patricia Neal, making a comeback from a devastating stroke, was also a sympathetic favorite for her role in the movie version of Frank D. Gilroy's Pulitzer Prize–winning play *The Subject Was Roses*. Less likely to win were Joanne Woodward, nominated for *Rachel, Rachel,* a low-budget drama directed by her husband, Paul Newman, and Vanessa Redgrave, praised for her portrayal of Isadora Duncan in *Isadora*. Redgrave had little chance of winning; she had rubbed the Academy the wrong way by espousing wildly left-wing views, and trumpeted the fact that she was pregnant with the out-of-wedlock child of actor Franco Nero.

"The winners," Bergman went on after taking a moment to convince herself it was indeed a tie, "are Katharine Hepburn for *The Lion in Winter* and Barbra Streisand in *Funny Girl!*"

Barbra was riveted to her seat. In spite of their much-publicized separation, she had asked Elliott to be her escort this evening. He sat next to her, completely stoned on marijuana. It was, he tried to explain to his angry wife before they left for the ceremonies, the only way he could cope with the "stares and the whispers" in a situation that was "rife with drama." Their relationship had deteriorated to the point where Barbra's Oscar night victory left him only that much more aware of his own shortcomings. "It was," he said, "a difficult night for me, a trauma." He was not too upset, however, to forget to send out a prearranged secret signal when the TV cameras panned in his direction—two tugs on his earlobe, Carol Burnett–style, only in this case to let a friend know that he was indeed high.

At first, Barbra wasn't sure if she had actually won. "I heard one name, then another," she said. She looked at Elliott. "It's you," he assured her.

True to form, Hepburn, who would eventually win a record four Best Actress Oscars, had stayed home. While *Lion in Winter* director Anthony Harvey made his way to the stage to accept on Kate's behalf, Barbra sprang to her feet and rushed to the stage.

As she climbed up the steps, she caught her heel on the hem of her sequined Arnold Scaasi pantsuit and stumbled, then quickly regained her balance. "For two thousand dollars they can't sew the

goddamned thing," she grumbled. No matter. When he designed the playful outfit—a flimsy black net covering over nude-looking georgette crepe—Scaasi had not realized that both layers of fabric would for all intents and purposes be rendered transparent once she stepped into the glare of television lights. Now tens of millions of viewers around the world were shocked to be gazing at what appeared to be Barbra's pale and rather ample derriere.

The next day's papers would be filled with stories about the tastelessness of Barbra's attire and her apparent desire to moon the Hollywood establishment. For the moment, though, the star was blissfully unaware of the looming controversy.

"Hello, Gorgeous," she said to the statuette, using the now-famous opening line from *Funny Girl*. To the astonishment of many in the audience, her tears appeared to be genuine. "I'm very honored to be in such magnificent company as Katharine Hepburn. Gee whiz, it's kind of a wild feeling. Sitting there tonight I was thinking that the first script of *Funny Girl* was written when I was only eleven years old. Thank God it took so long to get it right, you know I would like to thank my co-producer, Ray Stark, for waiting until I grew up!" Ever the perfectionist, she carefully thanked everyone who worked on the picture.

Then she reflected on what it meant to be realizing her dream. "Somebody once said to me—asked me if I was happy, and I said, 'Are you kidding? I'd be miserable if I was happy!' And I'd like to thank all the members of the Academy," she concluded, "for making me really miserable. Thank you!"

In 1968, the coveted Best Picture award would go not to *Funny Girl* but to another musical—*Oliver!* Of the eight nominations *Funny Girl* received, Barbra was the sole winner.

At the Governors' Ball that night, an unsmiling Barbra, still wearing the controversial Scaasi pajama outfit, absentmindedly fondled her Oscar while Elliott fidgeted next to her. "Every age has its Super Lady," Barbra's nemesis Rex Reed had written when the film first premiered. "Other ages had Lillian Russell and Sarah Bernhardt and Gertrude Lawrence and Helen Morgan and Judy Garland. Well, we've got ours. Her name is Barbra and whether we like it or not, all those monstrous things she keeps doing to people out of fear and insecurity only make her more exciting on screen. When all

that talent comes to a boiling, raging, ferocious head of fireball steam, as it does in *Funny Girl,* bad publicity pales in the glow of her extraordinary genius." And now she had the Oscar to prove it.

Three days after picking up her Oscar, Barbra boarded a plane bound for New York to resume filming her third big budget musical, *On a Clear Day You Can See Forever.*

The Alan Jay Lerner–Burton Lane musical had had a respectable run on Broadway with Streisand's old nemesis Barbara Harris in the starring role as Daisy Gamble, a ditzy college student who approaches a psychology professor to cure her two-pack-a-day cigarette habit. In the process, he discovers that Daisy is not only psychic, but that she is the reincarnation of an early-nineteenth-century English-courtesan-turned-aristocrat named Melinda Tentrees. Gradually, the professor falls in love with the memory of Melinda, all the while harboring contempt for the sweet but irritatingly scatterbrained Daisy.

Barbra had agreed to do *On a Clear Day* only if producer Howard Koch gave her veto power over the entire creative team. She wanted Vincente Minnelli, who had won an Oscar for the 1958 Lerner and Loewe musical *Gigi,* to direct. There were also personal reasons for hiring the legendary director; he was the ex-husband of her idol Judy Garland and the father of her friend Liza Minnelli. And unlike the headstrong Wyler and the hypermasculine Gene Kelly, Minnelli was soft-spoken, sensitive, and reportedly bisexual.

Barbra also wanted Scaasi to create Daisy's 1960s gamin look, and famed British photographer and designer Cecil Beaton, who had won Academy Awards for *Gigi* and *My Fair Lady,* for Melinda's elaborate Regency-period costumes. Part of the film would be shot at the Royal Pavilion in Brighton, England, and Streisand trusted Beaton to come up with costumes that would be every bit as breathtaking as the onion-domed pavilion's elaborate Arabian Nights architecture.

Sixty-three-year-old Beaton, who was also gay, found Streisand to be "an ideal mannequin . . . Her face is a painting from several historical eras." In the end, he admitted that she had managed to get him to do everything she wanted "literally, like a hypnotist . . . Pleasing her was very difficult, but it got to me inwardly because I myself am extremely hard to please."

What most impressed Beaton was Barbra's seemingly unerring sense of self. "She is," he said, marveling, "a self-willed creation."

Barbra also seemed to get along with veteran French film star Yves Montand, cast in the role of Dr. Marc Chabot, the professor who falls for Daisy/Melinda. After Frank Sinatra, Richard Harris, and Gregory Peck all turned the part down, Montand applied his considerable continental charm to winning over Barbra. Accustomed to dealing with strong-willed leading ladies, Montand was married to Oscar-winning French actress Simone Signoret and had had a well-publicized affair with Marilyn Monroe during the filming of the 1960 flop *Let's Make Love*.

For comic relief, Bob Newhart played a nervous university professor and a young actor who had just made his film debut in the counterculture hit *Easy Rider* was cast as the heroine's stepbrother. The actor's name: Jack Nicholson.

Barbra still had her quirks. During one scene shot in the Brighton Pavilion's Grand Banquet Hall, she appeared wearing a stunning white turban, diamond choker, and a gem-encrusted gown with a plunging neckline. Over a sumptuous dinner, she was to seduce John Richardson, the good-looking British actor hired to play Melinda's caddish young husband, without saying a word, while her song "Love with All the Trimmings" provided the suitably sultry musical backdrop. Among other visual devices, Barbra would use her wineglass to trace the line of her cleavage—all without ever taking her eyes off Richardson.

For her close-ups, however, Barbra banished Richardson from the set. "I can't do this with him sitting there," she told Howard Koch. "He just doesn't do it for me. He's just too . . . pretty." It was not enough that Richardson not be there. A black screen was hastily thrown up in the spot where he had been sitting so that, without any distractions whatsoever, she could conjure up in her mind someone she did think was sufficiently masculine. Played solo, Barbra's seduction scene would turn out to be one of the most erotically charged of her career.

Who was she thinking of? Bond. James Bond. Or at least George Lazenby, the handsome Australian actor who had been chosen to play 007 in 1969's *On Her Majesty's Secret Service*. While Barbra was filming in Brighton, she and Lazenby began seeing each other. She

tooled around the English countryside on the back of his motorcycle, and they dined together on the town—and on room service at her hotel. Lazenby would later claim they did not get beyond the groping stage—at first because he was hesitant ("She was very disappointed") and then because she wanted an exclusive relationship.

Elliott got wind of their affair, and when they met at a party in the home of a mutual friend several months later, he flew into a jealous rage. Lazenby was surprised that, despite the Goulds' separation, "he obviously still really loved her."

Exactly one week after watching his stepdaughter win an Academy Award, Louis Kind succumbed to congestive heart failure at the age of seventy-five. Diana, who had never divorced Kind, attended the funeral with Barbra's eighteen-year-old sister, Roslyn. Barbra, still feeling the effects of her toxic childhood, did not.

If she was too busy to attend a family funeral, she made time to become the first woman since Sophie Tucker to be honored by the all-male Friars Club as Entertainer of the Year. The gala event was held on May 16, 1969, in the Grand Ballroom of the Waldorf-Astoria. Ray Stark, Ethel Merman, Ed Sullivan, Jackie Gleason, and Danny Thomas were there—and though he was unable to attend, William Wyler sent a telegram. "Congratulations. 'Entertainer of the Year' is an honor you have earned and along with it, in my opinion, 'Director of the Year.' "

As usual at events like these, "Sultan of Insult" Don Rickles got the biggest laughs. "Barbra, I say this publicly: I never liked you," he quipped. "Omar Sharif has been my whole life . . ." Turning to Barbra's mother, who was wrapped in a mink stole, Rickles grinned. "It's a hundred and ten degrees in this room, so why are you wearing mink? We all *know* you're Jewish!"

The most electrifying moment came when seven of America's greatest songwriters took to the stage to pay tribute to Barbra. Harold Arlen, Harold Rome, Burton Lane, Jerry Herman, Jule Styne, and Cy Coleman sang lyrics specially written for the occasion by Sammy Cahn. Richard Rodgers sang his own.

"Just think about the sweep of those seven careers that have given us some of America's most beautiful, moving, and enduring popular music," she said. "What an unforgettable honor."

It was also terrifying for Barbra, but she didn't let it show. Her

psychoanalyst friend Dr. Harvey Corman, also seated up front with his wife, Cis, explained to Sydney Skolsky what impressed him most about Barbra. "Her greatest talent isn't acting or singing," he told the columnist, "it's her ability to hide her fear."

Certainly she had no trepidation at all when it came to squaring off against the entrenched powers in Hollywood. A few weeks after the titans of American popular music serenaded her at the Friars Club, she teamed up with Paul Newman and Sidney Poitier to form First Artists, a production company that would allow all three stars to maintain complete creative control of their films. Within two years, Steve McQueen and Dustin Hoffman would also sign on with First Artists.

Under the terms of their agreement, the actors were to star in three films each. They would forgo a salary in return for between 25 percent and 33 percent of each film's gross.

Fear played no hand in Barbra's business dealings, clearly. It would, however, get the upper hand six weeks later when she opened at the new International Hotel in Las Vegas. Billionaire Kirk Kerkorian's 1,519-room, $60 million International Hotel was the world's biggest resort hotel and casino, and he wanted the biggest star in the world to open it.

So he went to Elvis Presley. The King's longtime manager, Colonel Tom Parker, wanted his client to make his performing comeback soon, and he wanted Elvis to make it on a Las Vegas stage. But the hotel was nowhere near completion. "It's much too risky," he said. "Let somebody else stick his neck out." Elvis agreed. "The place ain't finished yet," he said. "Let some other damn fool try to sing with guys hammerin' in the background." He would, however, be happy to follow whoever had the guts to be first.

At first, Barbra balked—until she was offered the then-unheard-of sum of $1 million in cash and hotel stock to perform for just four weeks. (Her five-year contract to perform at the International once a year would bring the total to at least $5 million.)

Gripped by stage fright, Barbra felt "hostility" coming from her opening-night audience. "All the gamblers who were there because they were important to the hotel, all the actors who resent the fact that you're doing things they think they should be doing. It's total

fear time up there. I don't enjoy performing before a bunch of strangers."

Then there was the fear that she could never live up to the audience's expectations. "All I kept thinking about was, What am I supposed to be? My God," she said, "all these people are going to watch me sing. What about what they've read in the papers and what they believe and think?"

The moment she stepped onstage, Barbra said, she was "in shock" as she looked out at the faces of, among others, Cary Grant, Natalie Wood, Peggy Lee, Rudolf Nureyev, and Tony Bennett. "It was like, What am I doing here?" The feeling "wasn't stage fright, exactly. It was a thing called *Death*."

With plaster falling from the ceiling and the entire hotel in a general state of confusion, Barbra decided to make light of the situation. Instead of wearing one of the sequined gowns created for her by Scaasi, she decided to go onstage in overalls. Then, without explanation, she sang "I Got Plenty of Nothin'." There was only a smattering of applause from the crowd, many of whom were insulted by her appearance and what they perceived as her go-to-hell attitude. Watching from the rear of the balcony, Elvis turned to an aide and offered his accurate appraisal of her opening-night performance: "Man, she sucks."

The evening had indeed proven to be an unmitigated catastrophe. The next day, Barbra went to see Peggy Lee perform in the hotel's comparatively intimate lounge. Lee was about to release "Is That All There Is?," one of the biggest hits of her career. Soignée in white satin in diamonds, her blond hair piled high in an elaborate coif, the veteran singer brought high rollers and tourists alike to their feet.

Borrowing from the master, Barbra ditched the overalls and opened her next show with "Don't Rain on My Parade." She also used her familiar blend of wisecracking Brooklyn humor and self-deprecation to win over her audience. A recurring theme: "This *facochteh* hotel. Do you believe this place? It's not even *finished* yet—I had to wear a hard hat to rehearse." Which was, in fact, true.

On her second-to-last night at the International, Barbra introduced Elvis from the audience. Like everyone else who had been at

the disastrous opening-night performance, he was impressed with how she had managed to turn things around so dramatically. Afterward, Presley, tanned and fit and on the verge of a major comeback at age thirty-four, visited Barbra in her dressing room. Before she could say a word, he shut the door, knelt down on one knee, grabbed a bottle of red nail polish from her dressing table, and started painting her nails with long, deliberate strokes. It was not the first time he had used this ploy to catch a woman off balance; Ann-Margret, with whom he had enjoyed a long and torrid affair, once told a friend Elvis enjoyed painting her toenails.

"I was . . . speechless," recalled Barbra, who soon added Elvis to her lengthening list of what she now referred to as her "flings." Later, when Elvis followed her at the International, she "stayed over a few nights," said David Kramer, who worked for the hotel under Kerkorian.

Although she seemed a far cry from the type of big-haired, toothsome, all-American beauty queens Elvis preferred, Streisand "intrigued him," said a longtime member of Presley's entourage. "She had the one thing Elvis valued above all others: a God-given ability to sing. He was in *awe* of great talent."

Elliott had made it easier for Barbra to respond to other men. Having scored the breakthrough role—that of Ted in the racy comedy *Bob & Carol & Ted & Alice*—that would make him a star in his own right and earn him his own Academy Award nomination as Best Supporting Actor, he now felt more free to speak frankly about his complicated marriage. When the scathing interview he gave to Diana Lurie of the *Ladies' Home Journal* was published, Barbra's handlers scrambled to keep her from seeing it before she went onstage.

In the *Journal* piece, Gould complained bitterly about his wife, whom he described as being spoiled, self-centered ("Barbra's favorite subject is Barbra"), and cravenly ambitious. "Barbra is really fourteen years old," he cracked. "Her problem is not only that she has been swept off her feet by phenomenal success. It is more than that . . . If Barbra conquers the world, if every last person in it says, 'Barbra Streisand, you are the most beautiful, intelligent person, the greatest,' it will be the saddest thing for her. Finally, she is going to be left with herself."

Barbra's face turned crimson as she plowed through the article.

Throwing everyone out of her dressing room except for her hair-stylist Fred Glaser, she proceeded, in Glaser's words "to tear the place apart." She tore the magazine to shreds, and wiped everything off her dressing table with one stroke. "It was not," Glaser said, "a pretty sight."

Nor, it turned out, were the sales figures on her new album, *What About Today?* Before the latter's release, she had scored another big hit for Columbia with the *Funny Girl* soundtrack; it would wind up spending an astounding 108 straight weeks on the charts. At a time when movie musicals seemed little more than a quaint vestige of a more innocent past, the *Funny Girl* soundtrack was jockeying for a spot in the top ten with albums by the Beatles, the Rolling Stones, Iron Butterfly, and Columbia's hottest new property, Janis Joplin.

But Clive Davis, who by now had taken over responsibility for running Columbia from Goddard Lieberson, warned that her records were now hopelessly out of style. The man who discovered Joplin and would go on to nurture the careers of such artists as Bruce Springsteen, Aretha Franklin, Barry Manilow, Billy Joel, Aerosmith, and Whitney Houston, urged Barbra to update her material—and change her style.

Barbra had resisted at first. History's most successful purveyor of popular-music standards by America's greatest composers was no fan of hard rock. And from a professional standpoint, she did not see how she could adapt to it. "Rock is okay, fine," she said. "But there's nothing in it for me."

But Davis persisted, and *What About Today?* was the result—an awkward pastiche of songs by old standbys Michel Legrand and Harold Arlen as well as Jimmy Webb, Paul Simon, and John Lennon and Paul McCartney. A critical and commercial disaster, the album would be her worst selling ever.

Barbra had once described herself as "an actress who sings." Now, with her recording career cooling, she wanted to be known as an actress—period. Pandemonium would ensue at the New York world premiere of *Hello, Dolly!;* Streisand feared she would be torn apart by over a thousand frenzied fans as she arrived at the theater. But despite the hoopla, the movie would fizzle. *On a Clear Day You Can See Forever* would suffer a similar fate; it would be released with virtually no publicity or studio backing, ensuring its demise. "What

the public saw," said Barbra about Paramount's decision to pare *On a Clear Day* down by nearly 30 percent, "was not the picture we envisioned. I learned a very important lesson about final control."

Barbra now wanted to make a movie where she did not sing a note. She would get that chance playing a lovable hooker who falls in love with a pretentious, self-absorbed bookstore clerk (played by George Segal) in *The Owl and the Pussycat.*

Shot in the fall of 1969, *The Owl and the Pussycat* would mark several firsts: Barbra's first nonsinging role, her first topless scene (for which she insisted on numerous retakes but wound up having cut out of the film), and the first time anyone ever uttered the words *fuck off* in a major film. Much to the consternation of her director, Herb Ross, she also demanded that she be allowed to do more than a dozen takes so she could get the inflection just right. "As if she needed the practice," Ross cracked to a crew member.

Roslyn Kind could have used some of her sister's grit. She had been president of the Barbra Streisand Fan Club and editor of its newsletter, *The Streizette,* but what she wanted was a singing career like her sister's. Toward that end, she managed to diet down from nearly two hundred pounds to under one-forty, and in late 1968 RCA released her first album, *Give Me You.* To promote the record, she did *The Ed Sullivan Show* and then embarked on a fifteen-city tour that included many of the clubs where Barbra had played, including the hungry i in San Francisco and the Eden Roc in Miami.

Despite pressure from Diana Kind—who, oddly, had encouraged Roslyn to pursue a show-business career as adamantly as she had tried to *discourage* her older sister—Barbra had done little to help Roslyn. But in January 1970, she did show up for Kind's New York debut at the Persian Room in the Plaza Hotel. Afterward, mother and daughters posed for photographers backstage.

Kind was talented, though obviously not as talented as her sister. And therein lay the problem. Although she sounded remarkably like Barbra, Roslyn came off as little more than a somewhat faded copy of the real article. Nor, by her own admission, did she have the chutzpah to carve out a distinctive style of her own and then go after success with the same ferocity as Barbra. "I don't feel comfortable pushing myself," Kind said. "I'm not bold like Barbra. I can't

go up to people and say, 'Hello, my name is Roslyn. Would you like to hear me sing?' "

There would be considerable speculation regarding the amount of help—or rather the lack of it—Barbra lent Roslyn in trying to get her career off the ground. Although she admitted there "isn't much contact between us," Roslyn tried to debunk the notion that there was a rift between them. "People would love to think that Barbra and I hate each other, that there's some kind of rivalry or that I'm completely dependent upon her, but it's not true," she said. "Barbra as a sister is just like having anyone else for a sister. No more, no less."

After years of trying and failing to obtain the recognition Barbra could give her with a snap of her well-manicured fingers, Roslyn sang a different tune. "If only Barbra would say something nice about me when she's asked," Roslyn complained. "I feel she's hurting my chances with her silence."

Barbra paid Roslyn little heed. She was too busy filming *The Owl and the Pussycat* and, between takes, pursuing a white-hot affair with one of the world's most eligible bachelors—Canadian prime minister Pierre Trudeau. More or less viewed by his countrymen and the world press as the Canadian equivalent of John F. Kennedy, the youthful, athletic, erudite, extremely popular, and very liberal Trudeau had been swept into office in 1968. He promptly began steering Canada away from U.S. influence over his nation's economy and its foreign policy.

In late 1969, Trudeau had his hands full. Among other things, he was about to break from his American allies by giving formal recognition to the People's Republic of China. He was also grappling with the separatist movement in the Canadian province of Quebec. Within months, terrorist activities by the Front de Libération du Québec—including bombings and the kidnap-murder of Canada's labor minister—would prompt Trudeau to impose martial law.

But Trudeau still made time to fly down to New York for a whirlwind weekend with America's biggest female star. After dinner at a popular Upper East Side restaurant called Casa Brasil, they were whisked by the prime minister's official limousine to Raffles, a members-only disco in the Sherry-Netherland Hotel. They spent

all of Saturday holed up in her Central Park West apartment, and on Sunday ventured out to the theater.

Trudeau seemed as smitten with Streisand as she was with him. When a reporter cornered the prime minister and asked how long he had known Barbra, he answered with a broad grin, "Not long enough." After he flew back to Canada and she returned to the West Coast to work on *The Owl and the Pussycat,* the couple burned up the phone lines between Los Angeles and Ottawa.

The press had a field day, and neither Trudeau nor Streisand did anything to discourage speculation. They were photographed smiling at each other across the table and getting out of limousines. Barbra instructed a secretary to clip these pictures out of the newspapers and save them.

Barbra wrapped up *The Owl and the Pussycat* in January 1970, and a week later flew to the Canadian capital, Ottawa. In what was tantamount to a state visit, Barbra, bedecked in furs to ward off the arctic chill, was escorted by the prime minister to one high-profile event after another.

Red-jacketed Mounties flanked the couple as they entered Canada's stately parliament buildings, and Barbra watched from the visitors' gallery as her new love deftly fielded questions from the opposition. Aware of the distracting presence of Trudeau's American visitor, opposition party member George Hees looked up at Streisand and then at Trudeau. "I should like to ask a question of the prime minister—if he can take his eyes and mind off the visitors' gallery long enough to answer it." A delighted Barbra, who might just as well have been reprising her role as haughty Melinda Tentrees in *On a Clear Day,* threw back her head and laughed. Trudeau was still meeting with members of his cabinet immediately after the session when an aide whispered in his ear that Barbra was leaving. Trudeau sprinted out of his office, down a hall, and outside to her waiting car. Graciously helping Barbra into the backseat, he then spoke with her quietly for several minutes without ever letting go of her hand—a tender moment duly captured by photographers who had been hovering outside for hours.

On January 28, the Streisand–Trudeau show moved on to the National Arts Center, where they arrived at the same time but in separate cars for Manitoba's centennial celebration. In yet another

gallant gesture, he leaped out of his limousine before it had come to a full stop, dashed over to Barbra's car, and flung open the door. She emerged looking as if she had stepped out of the pages of *Dr. Zhivago,* her hands snuggly implanted in a white mink muff that matched her mink hat and mink-trimmed evening coat. All heads turned as they walked, arm in arm, into the grand hall of the arts center. "It happened to be overwhelming," she said of the evening.

Not all of their time together was spent in the media glare. The night after their headline-making date at the National Arts Center, they dined by candlelight alone at 24 Sussex Drive, the prime minister's official residence. They were also seen cozying up in pubs and even sharing breakfast among the flannel-clad denizens at a *Northern Exposure*–style coffee shop.

Given the high-profile nature of their romance—and the adoring gazes they threw in each other's direction—there was the inevitable speculation that the relationship might end up in marriage. The idea excited some ("God knows we could use some glamour," said one member of parliament) but upset others who did not want their leader to marry either an American or an actress—much less an American actress.

Trudeau, not known for his tact in dealing with the press, bristled when a television reporter brought up the subject. "I think the public is entitled to know," the intrepid interviewer demanded, "whether you are developing a serious relationship with her."

"It's none of your business," Trudeau snarled back, "*or* the public's business." On other occasions, the prime minister handled the question by simply pointing out the reporter in question to his security detail and ordering them to "arrest that man." The line was one of Barbra's favorites.

It was all heady stuff for a Brooklyn girl. While he shared her love of Chinese food, art, and of course music, he radiated confidence and power. "I feel," she told a friend at one point, "just like Jackie Kennedy."

Even Barbra's mother got in on the act. When asked if her daughter was in love with Trudeau, Diana Kind shrugged and said, "Who knows? Barbra has a lot of interesting friends."

What Diana did not know—what no one else knew—was that Trudeau had already proposed to her. Stunned, Barbra seriously

considered what it would be like to be Canada's first lady. "Oh, yeah, I thought it would be fantastic," she later confessed. "I'd have to learn how to speak French. I would do only movies made in Canada. I had it all figured out. I would campaign for him and become totally politically involved in all the causes, abortion and whatever."

Abortion was obviously not an issue she had raised with Trudeau, who, as a devout Catholic, was unalterably opposed to it. Had she accepted his proposal, it is likely that Barbra would have had to convert to Catholicism—something she hardly seemed prepared to do—and that her status as a divorced woman would have to be dealt with. That is, once she actually divorced Elliott Gould. During their entire affair, the fact that she was still married to Gould was seldom raised.

Nor was it likely that, had they married, Trudeau could ever have remained faithful. Even while he was dating Barbra, he was spending time with the pretty nineteen-year-old daughter of a former fisheries minister, Margaret Sinclair. They had met a year earlier when Sinclair, then a student at British Columbia's Simon Fraser University, was vacationing in Tahiti.

Sinclair watched from the sidelines as journalists breathlessly described every detail of Streisand's Canadian adventure. "It was a romance," she said of the prime minister's relationship with Barbra. "Every paper carried it." The self-described "flower child" was well aware of the treatment Barbra was getting. "Pierre had a silky, warm charming manner," Maggie explained, "that eased any initial awkwardness a woman might be feeling."

For the next several days, Maggie later recalled, her "pique and jealousy" mounted. Every time he called her up to talk, Sinclair screamed, "Go back to your American actress!" before hanging up.

Barbra would later say that "certain realities" kept her from becoming Canada's first lady. And of course she would never dream of asking Trudeau to resign. His life, she said somewhat disingenuously, "is too important to a whole country, a world. I don't feel mine is that significant. It's significant in that it gives people a fantasy life or some pleasure, but it's not like being the prime minister of a country."

Since Barbra had not jumped at his proposal, Trudeau ended their

affair in March and focused on wooing the headstrong, unpredictable Maggie Sinclair. That he would pursue someone so young did not surprise Barbra. "He's a very young-minded, spirited, hip figure," she said of Pierre, "who goes to parliament in sandals."

Trudeau and Sinclair would wed in 1971. Canada's nonconformist first lady would quickly prove to be something of a loose cannon. At one point, Maggie Trudeau decided to break away from her domineering husband and the pressures of being first lady by joining the Rolling Stones on tour. As a result, the prime minister found himself in the awkward position of having to defend his young wife's erratic behavior on the floor of parliament. After six tumultuous years that produced three sons, the Trudeaus would split in 1977.

(Over the years, Barbra and Pierre remained friends. When Trudeau's youngest son, Michel, was killed in an avalanche in 1998 at the age of twenty-three, Barbra called her former lover to offer her sympathies.)

Now Barbra turned her attention to real estate, plunking down $295,000 for a rambling, whitewashed, five-bedroom, 10,500-square-foot Mediterranean-style house on Carolwood Drive in Holmby Hills. New York would be more problematic. She had wanted to stay in her building on Central Park West, so much so that she bought the apartment next door. But when the co-op board refused to let her combine the two apartments, she went looking elsewhere.

Barbra quickly found the apartment of her dreams at 1107 Fifth Avenue, but was turned down by the building's co-op board because of fears that having a celebrity of Streisand's magnitude in their midst might disrupt the daily lives of the other residents. Months later, she found a twenty-room Park Avenue apartment that took up an entire floor. Again, her generous $249,000 bid was turned down because the board found "Hollywood types" like Streisand unacceptable.

She suspected that the rejections had less to do with her celebrity than it did with the fact that she was Jewish. "It's an unbelievable experience to be discriminated against," said Barbra, whose plight led New York State Attorney General Lefkowitz to launch an investigation into anti-Semitic practices among Manhattan's tonier co-op boards.

No longer willing to risk rejection, she abandoned the idea of buying an apartment and instead bought a building all her own—a five-story brownstone off Fifth Avenue at 49 East Eightieth Street. The town house had eighteen rooms, six bathrooms, a paneled library, and a walled garden in the rear. It was, however, a shambles. She would essentially have to refurbish the entire building, right down to installing new plumbing, heating, and electrical systems.

Enter yet another influential boyfriend—Warner Bros. president John Calley. While her relationship with Calley was decidedly short-lived, it led to a friendship with an ever more powerful figure—Calley's boss Steve Ross, head of Warner Communications. When Barbra threw up her hands at the idea of remodeling the town house and put it on the market, Ross interceded.

"How much do you want for it?" he said over dinner one evening.

"Four hundred and fifty thousand."

"I'll buy it," said Ross, whose company did indeed take the property off Barbra's hands, and then resold it at a sizable profit. Over the years, Ross offered Barbra advice on business matters and showered her with hundreds of thousands of dollars' worth of expensive gifts—principally art and antiques. Barbra, in turn, was a loyal friend. Whenever the controversial Ross needed someone to say something nice about him in the press, he could count on Streisand to sing his praises. In the meantime, Barbra returned to her Central Park West apartment, which would remain her New York base of operations for the next thirty years.

Certainly few celebrities commanded the kind of media attention that Barbra did, even as early as 1970. On April 7, she handed screen legend John Wayne his one and only Oscar for his role as the aging, one-eyed gunslinger Rooster Cogburn in *True Grit*. "Beginner's luck," he whispered in her ear before he turned to the audience. "Wow! If I had known that, I would have put that eye patch on thirty-five years earlier." Two weeks later, Streisand would pick up an award of her own—a special Tony bestowed on her as "Entertainer of the Decade."

If Barbra was the quintessential performer of the 1960s, then the shaggy-maned, hangdog Elliott Gould was emerging as the proto-

typical counterculture movie actor of the 1970s. Following *Bob & Carol & Ted & Alice,* Gould racked up a string of hits with *M*A*S*H* (in which he created the role of off-center army surgeon Trapper John), *Getting Straight, Move,* and *I Love My Wife.* On the cover of its September 7, 1970, issue, *Time* proclaimed Elliott a STAR FOR AN UPTIGHT AGE. That same month, he was named Star of the Year by the National Association of Theater Owners.

Elliott reveled in his newfound success as, in *Time*'s words, "the urban Don Quixote." Bragged Gould: "I'm the hottest thing in Hollywood right now . . . I always knew there were things going on inside of me, that I had something to express."

Barbra was genuinely happy for her husband. "It was fabulous," she said of the *Time* cover story. "I was very proud of him. I wanted it very much for him and for my son." According to Elliott, it was at this point that Barbra flew to Stockholm, where he was filming *The Touch* for Ingmar Bergman, and told him she wanted to reconcile.

There was a hitch, however. By this time, Gould was already in love with someone else: Jenny Bogart, the daughter of director Paul Bogart. Beautiful, vulnerable, unassuming and only eighteen, Jenny was, said a friend, "about as far away from Barbra Streisand as you could get and still be members of the same sex." Her Stockholm mission a failure, Barbra flew back to New York. The following June, she and Elliott would file jointly for divorce in the Dominican Republic.

As amicable as their divorce had been, Elliott worried that Jason was growing up spoiled and pampered in what was essentially an all-female environment. Barbra was, in fact, besotted with her son. During her self-imposed sabbatical during the summer of 1970, she spent more time with Jason than she ever had before. He, in turn, delighted her with his precocious behavior. When fans swarmed them during a Sunday-matinee performance of the Joffrey Ballet, Jason waved them off with his program. "No autographs today!" he declared. "No autographs today!" Soon the little boy was introducing himself as "Jason Streisand."

It was around this time that Barbra began an affair with a lanky country singer-songwriter six years her senior named Kris Kristofferson. The son of an air force general, Kristofferson had played football and rugby at Pomona College in California, and as a Phi

Beta Kappa graduate studied English literature at Oxford on a Rhodes Scholarship. He quit two years later and joined the army, where he learned to pilot a helicopter. Having already tried a solo country-western singing career as "Kris Carson," he resigned his captain's commission to work as a gofer at Columbia Records in Nashville.

During the early 1970s, he would write a number of hit C&W tunes for singers like Janis Joplin ("Me and Bobby McGee"), Sammi Smith ("Help Me Make It Through the Night"), and Johnny Cash ("Sunday Mornin' Comin' Down"). During this prolific period as a gravel-voiced songwriter troubadour, Kristofferson, whose twelve-year marriage to Fran Beir was on the rocks, dated Joplin and Carly Simon before Barbra.

Barbra, Kristofferson later recalled, "was being a superstar and I was being a country shit kicker, both playing games." The game playing continued for two months, until Kristofferson moved on to the sultry backup singer who would later become his wife and a hit recording artist in her own right, Rita Coolidge.

In addition to dating Kris Kristofferson that summer of 1970, Barbra also shopped for antiques, caught up on her moviegoing, and pursued another of her hobbies—politics. Before she unloaded the town house, Barbra used it to hold a fund-raiser for the congressional campaign of her friend Bella Abzug. Loud and stout, with a fondness for big hats, Abzug had been a self-described Stalinist as a young woman, but was now merely one of the more outspoken members of the Democratic Party's far left wing. Violently opposed to the war and one of the acknowledged leaders of the blossoming women's rights movement, Abzug also shared Barbra's deep-seated hatred of the White House's current occupant, Richard Nixon. In style and substance, Barbra and Bella were perfectly suited to each other.

Barbra threw herself into Bella's attempt to unseat incumbent Democrat Leonard Farbstein. Since the town house was still empty, Streisand sent out three thousand invitations promising "There will be stars of stage, screen, and radio! Drinks, canapés—but no furniture! You must *abzuglutely* come!" After a bitter primary battle—during which Barbra climbed aboard the back of a flatbed truck to denounce the "illegal war" in Southeast Asia and speak on behalf of

her candidate—Abzug handily won the Democratic nomination. Pandemonium would break out when, two days before the general election, Barbra appeared as the star attraction at a "Broadway for Bella" concert at Madison Square Garden. With New York's most celebrated daughter backing her, there was little chance that Abzug would lose—and she didn't.

As genuine as her concerns may have been ("I have a son and I want to do what I can for peace," she told Abzug), Barbra also knew this was a way for her to connect with the young, hip counterculture audience Elliott already had in the palm of his hand. It was a following she needed to win over if she was to remain a viable commodity in the entertainment industry.

Barbra made an even more transparent attempt to look hip when she returned to Las Vegas in late November 1970. Over the course of four weeks, she would fulfill the remainder of her 1963 contract with the Riviera and then move on to the Las Vegas Hilton (formerly Kirk Kerkorian's International). Still coping with stage fright—hysterical fans had surged onto the stage and tried to drag her off during the Madison Square Garden concert for Bella Abzug just weeks before—Barbra now sought to relieve the tension in other ways. She began smoking pot—onstage.

She would begin by telling her audience about her stage fright ("I would stand in the wings, and my whole life would pass right before my eyes") and how she had always envied people like Dean Martin, who could take a drink or two to loosen up before going onstage.

Then she'd produce a cigarette case, pull out a fake joint, and pass it to a member of the audience. "Then I started lighting live joints, passing them around to the band, you know?" she later recalled. "It was *great*. It relieved all of my tensions. And I ended up with the greatest supply of grass ever. Other acts up and down the Strip heard about what I was doing—Little Anthony and the Imperials, people like that—and started sending me the best dope in the world. I never ran out. Hmm . . . I wonder if I should tell that story."

Clive Davis was perfectly happy to have her tell the story—and do anything else she could to contemporize her image. Undaunted by the failure of *What About Today?* the year before, he urged her to

go into the studio with producer Richard Perry and record songs by younger artists like Laura Nyro, Joni Mitchell, Harry Nilsson, and Randy Newman. The result would be the hugely successful platinum album *Stoney End*. Propelling the record into the top ten was the single of the same name, written by Nyro and—not at all to Barbra's liking—sung on the beat. "Stoney End," essentially a bouncy paean to suicide, would peak at number six—making it her biggest single since "People" back in 1964.

Five months later, she would release a second Perry-produced album. *Barbra Joan Streisand,* an eclectic mix of songs by John Lennon ("Mother"), Burt Bacharach and Hal David ("One Less Bell to Answer"/"A House Is Not a Home"), and her friends Michel Legrand and Marilyn and Alan Bergman ("The Summer Knows"). The album, another huge commercial and critical success, would be just one more step toward restoring Barbra to her customary place at the top of the music heap.

At the same time as "Stoney End" was dominating the airwaves, *The Owl and the Pussycat* was proving that people would flock to the theaters to see a Streisand movie—even if she didn't sing a note in it. Released in November 1970 with a soundtrack by Blood, Sweat & Tears, the raunchy comedy would cause a bit of a stir when newspapers refused to run ads showing Barbra in a negligee with hand-shaped appliqués sewn over the breasts and a heart covering her crotch. All of which, of course, served only to pique the public's curiosity. *The Owl and the Pussycat* would go on to become a huge success at the box office—the fifth biggest-grossing film of the year. But neither it nor any of the other big pictures of 1970 could come close to that year's blockbuster, one of the biggest of all time: *Love Story.*

In a town filled with strange bedfellows, they were perhaps the strangest of all: He the blond, bronzed California Golden Boy with an easy manner; she the famously insecure, temperamental, demanding Jewish girl from Brooklyn. It was precisely because they were two very different people that, when they met at a dinner party in late 1970, Ryan O'Neal and Barbra Streisand clicked instantly.

"Ryan and I had an argument on our first date," she recalled. "He won. I never felt better losing."

O'Neal's appeal was obvious. Beyond his disarming manner and surfer good looks, O'Neal was arguably the hottest actor in Hollywood. As the doomed lovers in the film adaptation of Erich Segal's weepy bestseller *Love Story,* both O'Neal and Ali MacGraw were propelled to movie stardom virtually overnight.

Not that O'Neal hadn't paid his dues. The son of actress Patricia Callaghan and writer Charles O'Neal, Ryan started out as a stuntman on TV's *Tales of the Vikings* before landing various bit parts on shows like *Dobie Gillis, Bachelor Father,* and *My Three Sons.* For five years he played the bratty scion Rodney Harrington in the prime-time television soap opera *Peyton Place.* The show, which chronicled the libidinous goings-on in a fictional New England town, paled in comparison to O'Neal's offscreen romantic life.

Divorced from actress Joanna Moore, the mother of his children Tatum (who would go on to become the youngest person ever to win an Academy Award) and Griffin, O'Neal went on to marry his *Peyton Place* costar Leigh Taylor-Young. Even before *Love Story,* O'Neal had already cut a wide romantic swath through Hollywood with the diverse likes of Ursula Andress, Anouk Aimée, Barbara Parkins (another *Peyton Place* alumnus), and Joan Collins. He would later number among his conquests Bianca Jagger, Diana Ross, and Farrah Fawcett, the mother of his son Redmond. The reason for his success with women, explained Moore, was that Ryan was simply "an incredible lover, totally devoted to giving a woman pleasure."

Almost as important to Barbra was the fact that, unlike nearly everyone she encountered, Ryan was not intimidated by her iconic status. "Ryan isn't afraid of my image," she said. "He respects my talent, but he's not in awe of my career."

At first, Ryan and Barbra kept their torrid affair hidden from the public. With good reason, since at the time Barbra had yet to obtain her quickie divorce from Elliott Gould, and Ryan was still married to Leigh Taylor-Young, the mother of his son Patrick. There was also the feeling that an extramarital affair might offend the Academy of Motion Picture Arts and Sciences' older voters, thereby hurting O'Neal's chances of nabbing an Oscar nomination.

The couple remained behind closed doors until January 1971, when they attended James Taylor's opening night at The Troubadour in Los Angeles. A few days later, they dined at the home of their mutual agent, Sue Mengers, then went to Mama Cass Elliot's concert at the Santa Monica Civic Auditorium. By way of a diversionary tactic, O'Neal's brother Kevin provided cover as Barbra's date for the evening; Ryan was reluctantly tagging along as their "chaperone."

If they were trying to avoid being noticed, however, Kevin was clearly the wrong man for the job. When photographer Peter Borsari tried to take their picture after the concert, O'Neal's brother grabbed his camera and then took a swing at him. The next morning, photos of the tussle—and of Ryan and Barbra together—landed on front pages around the world.

The unlikely coupling was instantly dismissed as a publicity stunt, and Ryan as nothing more to Barbra than a boy toy. In truth, the quick-witted O'Neal was more than a match for Barbra, and the verbal sparring that went on between the two was, said Sue Mengers, "very Tracy–Hepburn." In keeping with her love of pet names, Streisand delighted in the fact that he called her Hilda or Ceil or Sadie or Babs—but almost never Barbra.

O'Neal did land his Oscar nomination for Best Actor, but lost to George C. Scott for *Patton*. From that point on, he and Barbra felt free to be a couple in public. They prowled antiques stores together, bought his and hers gold dog tags at Cartier's in Beverly Hills, took long weekend drives up the coast, frolicked in the sand with Jason at O'Neal's Malibu beach house, and nuzzled in out-of-the-way restaurants and at the homes of friends.

Gradually, Barbra even began to look like a proper match for Ryan. She was leaner than she had ever been, the white makeup had been replaced with a healthy-looking West Coast tan, and her hair was now long, straight, and streaked with blond highlights.

Before long, Ryan drove Barbra and Jason up to Joanna Moore's San Fernando Valley ranch to spend time with Tatum and Griffin. "We both fall in love easily," Streisand said of their affair. "You wouldn't think so, would you? I've had one marriage that didn't work; he's had two. No one's in a rush . . ."

That June, O'Neal led a standing ovation after his girlfriend per-

formed at a star-studded benefit for the Motion Picture and TV Relief Fund that also featured Frank Sinatra, Pearl Bailey, and Bob Hope. A few days later, they stopped to pose for photographers on the red carpet at the world premiere of Ryan's new movie, *The Wild Rovers*.

That same month, O'Neal was called upon to comfort Barbra when a profile in *Rolling Stone* depicted her as a cold, calculating movie star trying desperately to sell herself as a hip, denim-clad, environmentally conscious, pot-smoking member of the counterculture. She stressed to writer Grover Lewis that she was tired of being "this kind of institution thing . . . But I ask you—twenty-eight, is that old? Is twenty-eight all that old?"

Resenting the fact that he was being "hustled," Lewis deftly conveyed Streisand's patronizing tone. "I wrote," he explained, "what I saw before me—a flighty, temperamental, shallow, ambitious, avaricious person."

With Ryan's help, Barbra was able to put the *Rolling Stone* piece behind her. "It's not that she ever forgets what's been said or written about her," a colleague observed. "She keeps score. She remembers *everything*. But Ryan was able to get her spirits back up after a pretty short time. Without him, it would have taken her weeks to get over a piece that was as brutal as that one was."

As accustomed as she had become to falling for her leading men, it seemed strange to Barbra that she and O'Neal had never worked together. That would change when Peter Bogdanovich, the young director of the much-acclaimed *The Last Picture Show*, approached her with a script titled *What's Up, Doc?*

The title alone was offensive to La Streisand. "Who do you think I am," she yelled at Bogdanovich, "Bugs Bunny?" In a bizarre twist of fate, *What's Up, Doc?* had actually originated with a film the ex–Mr. Streisand was set to star in called *A Glimpse of Tiger*.

Elliott had also signed to co-produce *A Glimpse of Tiger* for Warner Bros. But after the first week of shooting in February 1971, Gould—dirty, unshaven, and red-eyed—suffered what amounted to an emotional meltdown. He battled furiously with the movie's director, Anthony Harvey of *Lion in Winter* fame, before abruptly firing him. That same day, he very nearly hit his leading lady, Kim

Darby, leaving her so shaken that she returned to the set only after Warner Bros. hired armed guards to protect her.

Reports of Elliott's erratic behavior reached studio executives, who were left to conclude that Gould—one of Hollywood's biggest stars at the time—was either abusing drugs, suffering from some sort of psychosis, or both. "Sure, I smoked grass and did psychedelics a little," Gould said, "but I was *not* a druggie or a crazy."

Barbra was asked to reason with her ex-husband, which she did over the phone. Whatever she said worked, but it was only a matter of hours before the insanity resumed. Phone lines on the set were mysteriously cut. Elliott allegedly began harassing his fellow actors by blowing a whistle as they tried to film their scenes.

Fed up, Warners pulled the plug and sued Elliott. To prove to their insurance company that he was certifiably insane, they hired a number of psychiatrists to file reports saying just that. Gould, who openly smoked pot and proudly displayed a poster proclaiming FUCK YOU on the living-room wall of his Greenwich Village apartment, was suddenly persona non grata in Hollywood. It would be two years before a movie producer worked up the courage to hire him, and a full decade before he got his career fully back on track. He would, of course, never regain the leading-man status he briefly enjoyed.

In order to keep Warners from taking even stronger legal action against the father of her son, Barbra read the script and saw no reason why a woman couldn't play the lead. Like almost everyone else in the industry, she had been so impressed by *The Last Picture Show* that she agreed to do the film if Bogdanovich was hired to direct.

Bogdanovich took on the project, but quickly decided that what he really wanted to do was an updated version of the screwball comedies of the 1930s. However, when the director screened two of his favorite screwball comedies for Barbra and Ryan—*The Lady Eve* starring Henry Fonda and Barbara Stanwyck and the Katharine Hepburn–Cary Grant classic *Bringing Up Baby*—she walked out midway through.

Despite Streisand's obvious distaste for the genre, Bogdanovich pressed on. Robert Benton and David Newman wrote a first draft of *What's Up, Doc?* and later Buck Henry was called in to do a rewrite. *What's Up, Doc?* told the story of a brilliant but kooky

young woman named Judy Maxwell who disrupts the life of
Howard Bannister, a bowtie-wearing midwestern academic. The
script called for sight gags, double takes, a harrowing car chase
through the streets of San Francisco, and pratfalls aplenty.

Trouble was, Barbra hated it. Before the picture was shot, she
threatened to quit. During filming in San Francisco, where she and
Ryan shared a suite in the chic Huntington Hotel on Nob Hill, she
routinely complained that *What's Up, Doc?* just wasn't funny.
"Where are the laughs, Peter?" she demanded. "Where are the
fucking laughs? I know fun, and this is *not funny*." Bogdanovich just
laughed. "This is *terrible,* goddammit!" she shrieked in reply.

Barbra's leading man suffered most from her negativism; strug-
gling to prove himself to her and everyone else in his first comedy,
O'Neal endured Barbra's whining after every take. "We're in a
piece of shit, Ryan!" he later recalled her saying. "Why did we
agree to do this in the first place?"

True, Barbra had had such faith in Bogdanovich when she signed
on to do the movie that she had neglected to get final creative con-
trol. But she did manage to wrangle a concession she had never got-
ten before: a full 10 percent of the gross.

Barbra was also very particular about her trailer on the set. Like
her dressing room for *Hello, Dolly!,* this one was decorated with vel-
vet drapes and upholstery, crystal chandeliers, and ornate fixtures so
that it resembled a Victorian-era boudoir. When word leaked out
that she had complained to the studio that her trailer was over-the-
top, O'Neal came to her defense. "If she turns this trailer down and
asks for another, the studio knocks her for being hard to please," he
said. "If she doesn't, everyone else on the set thinks she's strutting—
she can't win."

With so many stories flying about her demands and her tantrums,
Barbra protested to one reporter that she was being unfairly por-
trayed in the press. "I'm not mean," she insisted. "I'm not a beast. I
wish I was as mean and temperamental as the press says I am. I'd get
things done a lot faster and more efficiently." Then she added some-
what disingenuously, "No one who is a bitch to the people she
works with gets to the top. It takes too much cooperation and team
effort . . . The truth is that I'm a very dull person. I'm simple and
ordinary. Really."

Negative press wasn't all she had to deal with. To add to the tension during filming, Barbra was on the set when someone called her hotel and threatened to abduct Jason if she didn't agree to meet with him. It was at times like these that she most appreciated O'Neal's take-charge attitude. The ex-boxer called the police and hotel security and assured a terrified Barbra that all was under control.

Unfortunately, Ryan's sex life was anything but under control. When blond, svelte Peggy Lipton, riding high as the star of television's *Mod Squad,* paid a visit to O'Neal on the set, Barbra blew. By way of retaliation, she began dating director Milos Forman and yet another Hollywood lothario, Steve McQueen. Ryan, in turn, rekindled his romance with Barbara Parkins, then moved on to actresses Lana Wood and Joyce Williams.

The Streisand–O'Neal Dating Wars ground to a halt when Ryan injured his back during one of the film's many chase scenes. Later, when he underwent disk surgery, it was his wife, Leigh Taylor-Young, who showed up at the hospital. The couple reconciled just in time for the release of *What's Up, Doc?*

By the time the movie wrapped and Barbra returned from a final three-week stint in Las Vegas—during which Ed Sullivan filmed a special hour-long tribute to her as "Entertainer of the Year"—she and Ryan were through. They would, however, remain friends and eventually work together again. "We were able to share a kind of shyness," he said wistfully. "If I had to marry, I mean if I was up against the wall with a rifle at my back, Babs is the girl I'd have wanted to marry."

Barbra's doubts about *What's Up, Doc?* persisted right up until its premiere—this despite the fact that it marked the memorable screen debut of Madeline Kahn as Howard's disarmingly clueless fiancée, Eunice Burns. Growing increasingly frantic, she went to another old friend, Warner chief John Calley, and bet him $10,000 the movie would not even gross a paltry $5 million. Calley declined the bet, but he did offer to sell her back her 10 percent interest in the film. She accepted the offer, and watched as *What's Up, Doc?* went on to earn critical praise and rake in a then-spectacular $70 million.

Despite her $7 million mistake, Barbra insisted *What's Up, Doc?* was "infantile" and "disappointing." She was, she said unequivocally, "embarrassed to do that film."

Perhaps. But that "infantile" film would make Streisand America's number one box-office star in 1972, a fact that apparently escaped the notice of one screen legend. At about this time, director Jerry Schatzberg was attending a party in the home of producer John Foreman when he spotted Barbra in a corner chatting with Mae West. Streisand had asked West what she thought of today's movies.

"So what did she say?" Schatzberg wanted to know.

" 'Well, honey,' " Streisand said, one hand on her hip as she imitated West, " 'today there are no *stars*.' "

"Imagine saying that to *Barbra Streisand!*" Schatzberg later said, shaking his head.

Barbra would retain her superstar status despite the dismal failure of her next project. In her novel *Up the Sandbox,* Anne Richardson Roiphe told the story of a young New York housewife and mother of two who suddenly feels trapped by the fact that she is once again pregnant. Her humdrum existence is punctuated by a series of outlandish Walter Mitty fantasies, ranging from blowing up the Statue of Liberty to attacking her bossy mother to pulling off Fidel Castro's shirt to reveal that the Cuban dictator is really a woman.

The feminist film, more than faintly reminiscent of 1970's *Diary of a Mad Housewife* (which Barbra had passed on), would also mark Jason's screen debut. During one of the scenes in which Barbra's character is shown living her real life as a Manhattan mom, the five-year-old is seen happily riding a swing at a playground on the Upper West Side.

Jason would also be along for the ride when the production shot on location in East Africa, where Barbra's character hopes the Sambura tribe will show her the secret to painless childbirth. At first, she was reluctant to go at all. "I'm a person who my whole life has been full of fear," she said. "You know, the whole Jewish-mother syndrome. I mean, I was scared to look at animals in the zoo . . . I'm not a zoo person."

But Streisand went anyway, in large part to expose five-year-old Jason to another part of the world. Since he had been showing a keen interest in anthropology, she packed some chicken bones and brought them along to bury in the African soil—just so Jason would not come up dry when he went out with his nanny on an archaeological "dig."

By the time they left Africa in early June of 1972, Barbra had grown to appreciate nature—sort of. "You realize how beautiful it all is," she conceded. "You see a giraffe and you realize that it's his land. Although if I never see another wild animal again, I think I can survive."

The people she encountered made even more of an impression. In the middle of making a film that descried the plight of the American housewife, she realized that the African women she met were not allowed to show pain. "They seem happy," she said, "but wow!" The fastidious Streisand was also taken aback by her hosts' lack of hygiene. "The people have dirt on their hands, maybe from the time they were born. They don't have any soap," she said. "I gave some women a few Wash'n Dris. But, you know, they probably didn't like it."

Even before she left for Africa, Barbra had rebounded—both personally and professionally—from her breakup with Ryan O'Neal. She was already planning her next film, about a left-wing Jewish firebrand who falls for, marries, and eventually divorces a preternaturally blond, ice-blue-eyed WASP. The Arthur Laurents script, commissioned by Ray Stark, traced the star-crossed couple's romance from the 1930s through the McCarthy era and beyond. For obvious reasons, Barbra instantly identified with the part of headstrong, passionately involved, outspoken Katie Morosky—which, oddly enough, Laurents had based on a Cornell classmate of his named Fanny Price.

From the beginning, Barbra wanted the blond-maned Robert Redford to play the part of The Way We Were's politically apathetic golden boy, Hubbell Gardiner, opposite her pamphleteering, speechifying Katie. Certainly the movie dealt with issues—redbaiting and the infamous Hollywood blacklist—that seemed particularly relevant during the Watergate era. But Redford felt the character he was asked to play was one-dimensional, the love story "overly sentimental and drippy," and that the script's political message was "bullshit knee-jerk liberalism—very arch."

Barbra then suggested Ryan O'Neal, but the general consensus was that the moviegoing public was not yet ready for another

Streisand–O'Neal pairing. Ken Howard, the tall blond TV actor of *White Shadow* fame, was considered and then rejected by Barbra on the grounds that, after they played tennis together, she realized there was no "sexual tension" between them. Another oversize blond star, Dennis Cole, was rejected for similar reasons.

He wasn't blond, but Barbra had long had her eye on another heartbreaker for the role. Beginning in March of 1972, she began spending time with Warren Beatty at El Escondido ("The Hideaway"), his sprawling suite at the Beverly Wilshire Hotel. Crammed with old newspapers, scripts, and magazines—not to mention half-eaten room-service meals—El Escondido had been Beatty's base of operations since 1966.

Shirley MacLaine's little brother had actually first met Barbra back in 1958, when they were both in summer stock. Once they got back to New York, he would drop by for pizza while she babysat her acting teacher's small children. At the time, the teenage Barbara refused his advances. "One of her convictions seemed to be that with the recent loss of my virginity," he later said, "I might be experiencing too much of a good thing."

Notorious for his womanizing even before his first film's release—he carried on simultaneous affairs with Joan Collins, Natalie Wood, and Leslie Caron while shooting *Splendor in the Grass*—Beatty went on to some rather disappointing movies (*The Roman Spring of Mrs. Stone, All Fall Down, Lilith*) and more famous ladies: Julie Christie, Michelle Phillips, Carly Simon (who supposedly wrote the song "You're So Vain" about him), Joni Mitchell, and Diane Keaton among them.

Bonnie and Clyde, an instant classic that he both produced and starred in, established Beatty as a major talent in 1968. But with the exception of Robert Altman's *McCabe and Mrs. Miller* opposite Christie, Beatty rejected juicy roles in such offerings as *The Godfather* and *The Sting* in order to have the time to raise funds for liberal presidential aspirant George McGovern.

Barbra called her affair with Beatty "one of my flings," but it differed from the others in that it was conducted almost entirely behind closed doors—and for the most part on Beatty's turf. While Beatty's longtime girlfriend Julie Christie was in England visiting her family, Barbra and Warren "were in there for a couple of days at

a time," said a hotel staffer, "but that was not unusual for Mr. Beatty. Once he got women in there, they never seemed to want to come out. Unless their boyfriend was in the lobby. Or the press . . ."

As consumed as he was with seeing George McGovern oust Richard Nixon from the White House, Beatty made it clear to Barbra that he would consider starring with her in *The Way We Were*—for a price. She would have to agree to sing at a concert for McGovern in April.

At first she balked at this quid pro quo. She did not feel that the people who would come to hear the other performers slated to appear—James Taylor, Carol King, and Quincy Jones—would particularly want to hear *her*. Jones was seriously hip, Taylor already had a youthful cult following, and King's *Tapestry* was well on its way to becoming one of the biggest-selling albums of all time.

Still, Barbra detested Nixon as much if not more than Beatty, and finally relented. If anything, she was the centerpiece of the "4 for McGovern" concert at the Forum in Los Angeles. Again, she did her marijuana routine for the audience, lighting up a joint and, as the crowd cheered, joking, "You're ahead of me tonight!" After taking a drag, she then asked, "It's still illegal?"

More than eighteen thousand fans paid up to $100 apiece—an unheard of ticket price in 1972—and once the receipts were counted, Barbra told the cheering throng that the event had poured $320,000 into the coffers of the McGovern campaign. Unfortunately, more than $300,000 in expenses would have to be subtracted from that total, leaving the candidate with less than $16,000.

Doing the concert had been the right decision for Barbra, however. She turned her part of the event into a Richard Perry–produced album—*Live at the Forum*—that would go platinum and, in the process, earn her millions.

Once she had done the concert as he asked, Beatty, who had resumed his romance with Christie, declined the part of Hubbell in *The Way We Were*. Once again, Barbra turned her attention to landing Redford. One way Redford might be convinced to take on the project, Stark figured, was if Sydney Pollack was hired to direct. Pollack had directed the actor in *This Property Is Condemned* and *Jeremiah Johnson,* and they had been buddies for over a decade.

Pollack instantly saw Redford as the lead—and the only actor

who would not be completely overshadowed by Barbra on film—
and joined her in the ongoing campaign to convince him to join
them on the picture. "He didn't like the script, he didn't like the
character, he didn't like the concept of the film, he didn't think the
politics and the love story would mix," Pollack recalled.

Redford could not be moved. "Pollack, you're crazy!" he
shouted at his friend. "What are you doing this for?"

A total of twelve writers, including Dalton Trumbo, Alvin Sar-
gent, Barbra's former escort David Rayfiel, Judith Rasco, and Fran-
cis Ford Coppola, were brought in to fashion a script that would
ultimately meet Redford's approval. When all else failed, New
York–based writers Herb Gardner and Paddy Chayevksy were asked
to weigh in with their ideas.

After several rewrites, Hubbell became a progressively darker,
more complicated figure. Still, Redford refused. Enraged, Ray Stark
delivered an ultimatum: Redford had until midnight June 8, 1972,
to make up his mind, or Ryan O'Neal would get the role. At 11:30
P.M. on June 10, Pollack informed Stark that Redford had agreed to
do the movie. "Finally," Redford said, "I just took the part on
faith."

And for a price. Redford demanded a percentage of the gross and
a $1.2 million salary. Barbra agreed to take less—a mere $1
million—if it meant assuaging her co-star's ego.

Before the ink was dry, Barbra wanted to have a casual dinner
with Redford so that they could get to know each other and discuss
their upcoming film. Redford had other ideas. He felt that actors
should not become friendly with each other before a movie; the
strangeness, he felt, contributed to the tension in the film.

After a while, however, Barbra became convinced that he was
simply avoiding her. She felt spurned. "Why *can't* I sit and talk with
Bob Redford?" she pleaded with Pollack. "Why? Is something
wrong?"

"Bob, this is crazy," the director told his friend. "You've got to
go, because she is starting to take it personally."

Redford, Streisand, and Pollack all met for dinner at Barbra's
house in Holmby Hills, and she was smitten from the start. "She was
simply mesmerized," Arthur Laurents said, "because she found him
so beautiful." So much so that it was widely suspected on the set

that Barbra, who for a time had been besotted with the Aryan charms of Ryan O'Neal, had set her sights on the then-very-much-married Redford.

"Barbra was kind of giddy about him," said her makeup artist on the film, Don Cash Jr. "She would never say it, but Barbra definitely had a crush on Redford." According to Cash, Redford and his cronies on the set had a nickname for Barbra, though they were careful never to let her hear it. "Redford would say, 'So how's Blah-Blah today?' That's what he called her all the time—*Blah-Blah*."

Nothing happened between them off camera; Redford remained almost as aloof and unapproachable as he had been before the long-postponed dinner meeting. In mid-September, shooting began at Union College in Schenectady, New York—substituting for a Depression-era Cornell—and Barbra began her usual routine of second-guessing her director, demanding retake after retake, and, in Pollack's words, "worrying everything to death."

Every night after a full day's filming, she called the director and grilled him for an hour or more, wanting to know if a certain line was being read the right way, if maybe something else could be added here or omitted there, even if a particular costume was right for a scene or if she still looked good being shot from a certain angle. "Sometimes I'd want to say," admits Pollack, " 'Will you just *relax?* ' "

She did not have the nerve to bother Redford after work, but she still peppered him with questions and observations on the set. "Barbra would talk and talk and talk and drive me nuts," he said. "And the amusing thing was that after she'd talk and talk and talk, we'd get down to doing it and she'd do just what she was going to do from the beginning."

According to Pollack, each was in awe of the other. Barbra would view the daily rushes and then ask the director "How does Bob do it? I stink, don't I?" But just as often, Redford would see the dailies and call Pollack asking, "How does she *do* it? She is just so goddamn great and I'm so goddamn *lousy*." Pollack was left having to reassure them both that they were doing a good job.

It was Stark who had landed Redford for *The Way We Were,* and he would be just as effective at keeping the story on course. He insisted that it be above all else a love story, instead of a polemic about the evils of the Communist witch hunts. Stark was opposed to

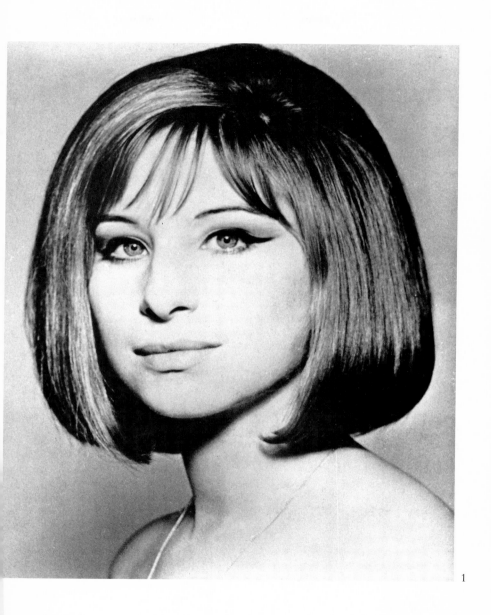

1

 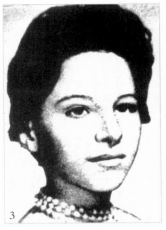 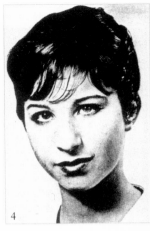

At age eight (*top left*), Barbra was used to being called "ugly" by her stepfather. The cruel taunts of her classmates continued through eighth grade (*middle*), but by the time she graduated from Erasmus Hall in January 1959, sixteen-year-old Streisand had already played in summer stock.

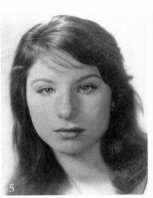 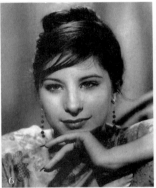

"Even at fifteen she was a difficult know-it-all terror," said New York theatrical attorney Si Litvinoff. "But once I heard her sing . . ." Barbra sent Litvinoff a handful of five-by-tens taken by a friend along with a résumé. For the first time, Streisand crossed out the second *a* in her name, transforming herself from Barbara to Barbra.

8

Inside the apartment they shared on West Ninth Street in Greenwich Village, Barry Dennen photographed an elegant and pensive eighteen-year-old Barbra before they left for Sunday brunch.

11

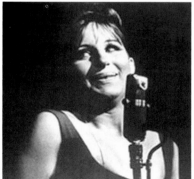

12

Barbra's sensational Broadway debut at age nineteen, as the office-chair-bound Miss Marmelstein in 1962's *I Can Get It for You Wholesale.* As soon as the curtain went down, Streisand grabbed a cab and headed for the Bon Soir, where she dazzled nightclub audiences with songs like "When Sunny Gets Blue" and an offbeat "Who's Afraid of the Big Bad Wolf?"

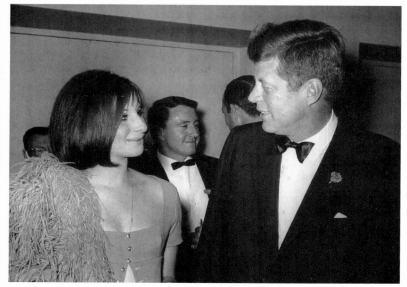

13

"You're a doll," Streisand told President John F. Kennedy when they met at a White House correspondents dinner in May 1963. Six months later, JFK was gunned down in Dallas.

Barbra married Elliott Gould on September 13, 1963, in Carson City, Nevada. What he first described as an idyllic "Hansel and Gretel" relationship would devolve, in Gould's words, into "a nightmare."

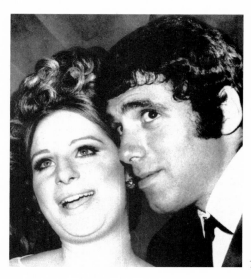

14

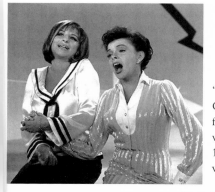

"Barbra really wanted to be as big as Judy Garland, and she surpassed her," said Streisand's former lover Barry Dennen. When the two women appeared together on Garland's show in 1964, Barbra was touched by how "small and vulnerable and frightened" Judy seemed.

16

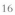

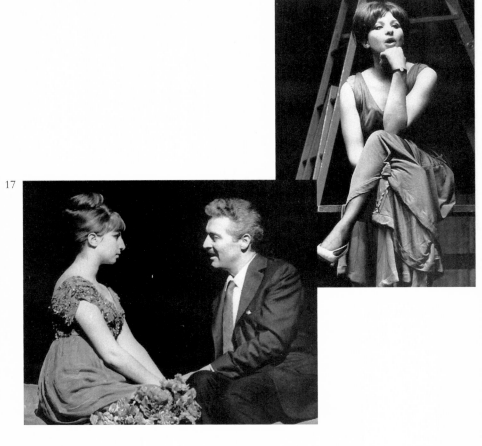

17

18

Already fast becoming a household name, Barbra perched on a ladder during rehearsals of *Funny Girl* on Broadway. Her extramarital affair with Charlie Chaplin's son Sydney, her leading man (*middle*), ended badly. At a twenty-third-birthday party thrown for Barbra by Elliott, she was given a white poodle pup. She named the dog Sadie.

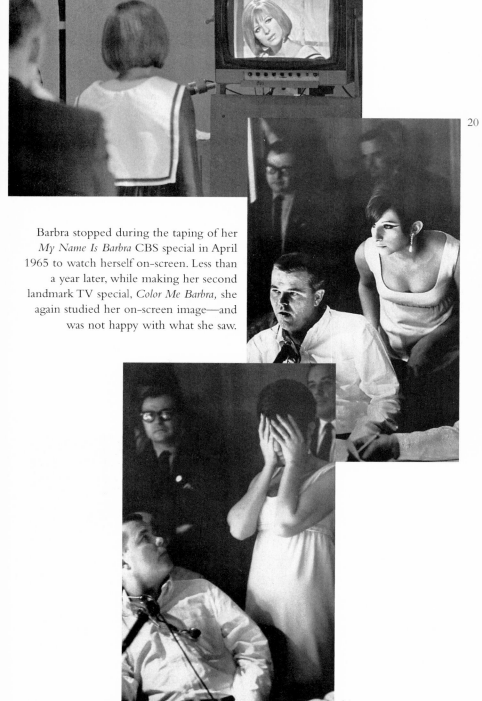

Barbra stopped during the taping of her *My Name Is Barbra* CBS special in April 1965 to watch herself on-screen. Less than a year later, while making her second landmark TV special, *Color Me Barbra,* she again studied her on-screen image—and was not happy with what she saw.

22

Columbia Records president Goddard Lieberson—"God" for short—joined Barbra in toasting the imminent arrival of her first child. Already Columbia's most important star, Barbra was preparing to launch her film career with the movie version of *Funny Girl*.

Jason Emanuel Gould arrived via caesarean section on December 29, 1966. The birth announcement borrowed from Barbra's star-making opening line in *Funny Girl:* "Gorgeous!" Six months later, the Goulds were off to New York to film scenes for the movie.

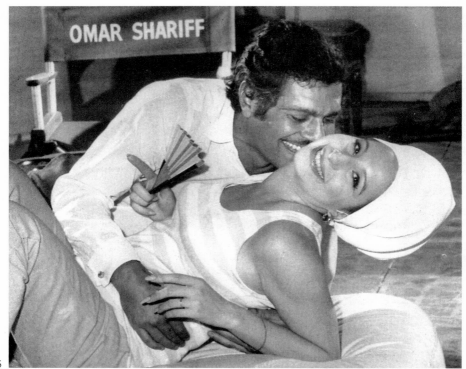

25

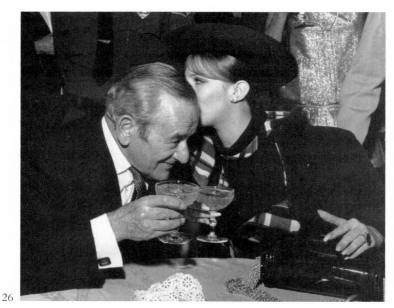

26

A photograph of *Funny Girl*'s Jewish star and her leading man, Egyptian
actor Omar Sharif, inflamed the Arab world. Aware of threats against
Barbra's life, police kept a watchful eye over the proceedings as
Streisand and director William Wyler celebrated the film's release.

Making her first foray into the turbulent world of national politics, Barbra backed Minnesota senator Eugene McCarthy for president in 1968. New York senator Robert Kennedy, who had courted her support, was not pleased.

27

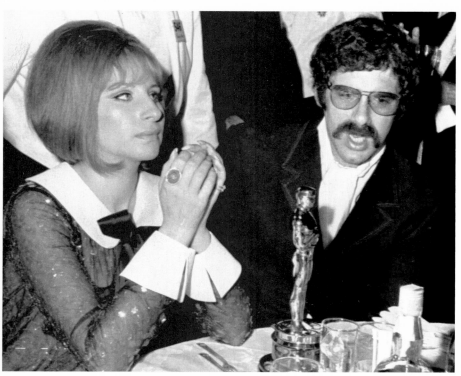

28

In an unprecedented tie with *The Lion in Winter*'s Katharine Hepburn, Barbra's 1968 *Funny Girl* performance won her an Academy Award as Best Actress. At the Oscar party that followed, Elliott Gould and his wife—wearing her famous see-through pajamas by Arnold Scaasi—looked anything but pleased.

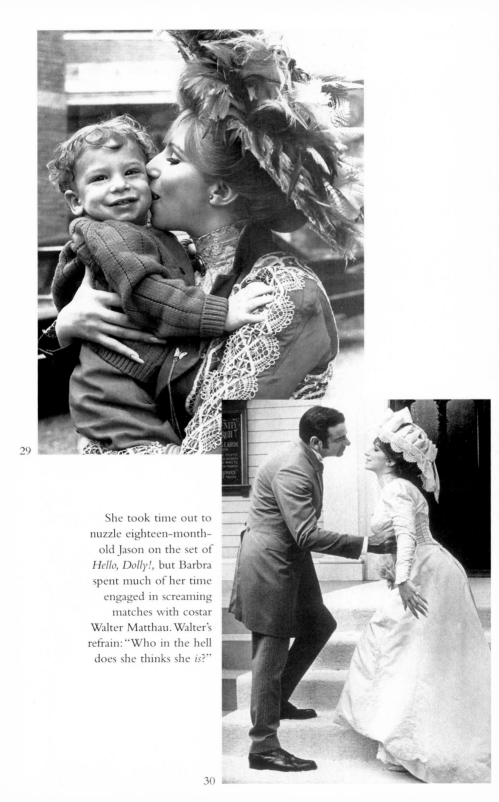

29

She took time out to nuzzle eighteen-month-old Jason on the set of *Hello, Dolly!*, but Barbra spent much of her time engaged in screaming matches with costar Walter Matthau. Walter's refrain: "Who in the hell does she thinks she *is*?"

After she opened the new International Hotel in Las Vegas in July of 1969, Barbra was visited backstage by the King himself. Awed by her talent, Elvis showed his appreciation by getting on one knee—and painting her toenails.

Barbra began an affair with Canada's flamboyant prime minister, Pierre Elliott Trudeau, in late 1969. There were marriage rumors on both sides of the border when she visited Canada as Trudeau's guest the following year.

33

As the reincarnation of
an eighteenth-century
aristocrat in 1970's *On a
Clear Day You Can See
Forever*, Barbra wore lavish
costumes by Cecil Beaton.
A few months later, what
she wore as the hooker in
The Owl and the Pussycat
caused a major stir. The
New York Times, among
other papers, refused to
publish an ad featuring
this shot.

34

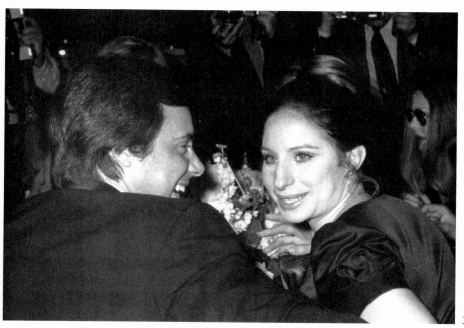

While *What's Up, Doc?* director Peter Bogdanovich and his star behaved like a couple for the paparazzi, Barbra was actually carrying on a full-throttle affair with leading man Ryan O'Neal at the time.

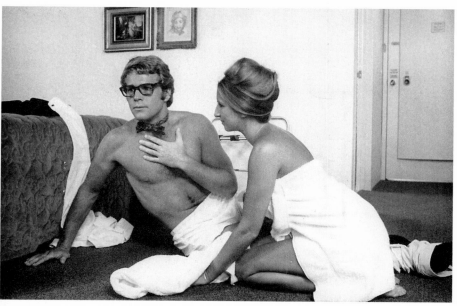

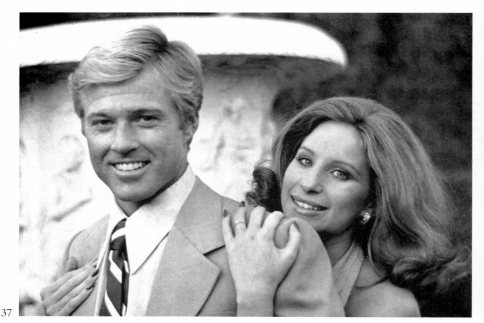

37

"Barbra had a huge crush on Redford," screenwriter Arthur Laurents said of her costar in 1973's *The Way We Were*. "There were times when she was literally trembling like a love-struck teenager around him."

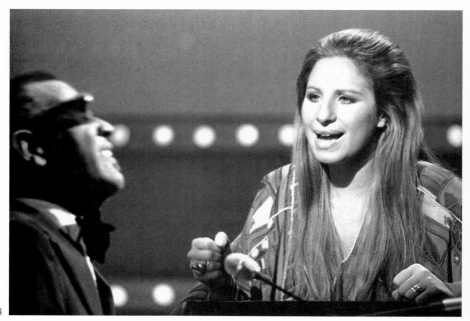

38

"She doesn't just sing notes, she sings feelings," Ray Charles said when they teamed up on "Cryin' Time" for a Streisand TV special in 1973. But their five-hour session at the piano left Charles feeling exhausted and angry. "She's a bitch," he reportedly said.

Odd Couple: After years of harboring a secret crush on Barbra ("my only pinup," he called her), Britain's Prince Charles cornered her on the set of *Funny Lady* in 1974. It was only the first of several encounters over the years. Meeting the Queen at *Funny Lady*'s London premiere as costar James Caan and Jimmy Stewart looked on, Streisand raised eyebrows by violating royal protocol.

Before filming a concert sequence before sixty thousand fans for their 1976 remake of *A Star Is Born,* Barbra offered costar Kris Kristofferson a snack. Legendary rock promoter Bill Graham, sporting a flower in his hat, looked on. Although at one another's throats during filming, Jon Peters, Barbra, and Kristofferson were all smiles at the movie's first big preview in New York.

43

No one had a greater hand in shaping Barbra's political views than flamboyant, far-left-of-center New York congresswoman Bella Abzug. In 1976, Streisand hosted one of her famous Hollywood fund-raisers for Abzug at her Beverly Hills home.

All in the Family: Roslyn Kind offers her big sister a protective hand as they cross a busy L.A. street in 1978. Barbra did little to help her sister's career. Meanwhile Diana Kind, (*below*), with her daughters, had repeatedly told Barbra she would never make it as an entertainer.

44

Barbra reunited with old flame Ryan O'Neal for their 1979 comedy hit *The Main Event*. O'Neal flirted openly with Barbra on the set, infuriating Jon Peters.

46

47

Labor of Love: Barbra co-wrote, produced, directed, and starred in 1983's *Yentl* as a tribute to her late father, Manny, who "told" her to proceed with the project during a séance.

"I love your coffee ice cream!" Barbra proclaimed when she met Baskin-Robbins heir Richard Baskin, who was eight years her junior, in 1983. Baskin would be her live-in lover, confidant, and sometime collaborator for the next four years.

In 1987, Miami Vice star Don Johnson "turned Barbra's world upside down," said a mutual friend. Streisand was stunned a year later when the much-younger Johnson returned to his former wife Melanie Griffith.

The Prince of Tides director, producer, and star talks over a camera angle with leading man Nick Nolte. Cast as her football-playing son in the 1991 film, real-life son, Jason Gould (*below*), also won critical acclaim. The movie won seven Oscar nominations, but Barbra was once again overlooked as Best Director.

Mother and son posed for photographers before lining up with Nick Nolte to meet Princess Diana at the February 1992 royal premiere of *The Prince of Tides* in London. Five years later, Dodi Fayed, who had dated Barbra in Hollywood, would perish with Diana in a Paris car crash.

52

53

54

Tennis champ Andre Agassi, who at twenty-seven was three years younger than
her son, began dating Barbra in 1992. "We're from different worlds," he said,
"but we collided."

55

Bill Clinton thanked his
number one Hollywood
fund-raiser after she
headlined his inaugural
gala in 1993. She would
soon spend a controversial
night at the White House
while Hillary was out
of town.

56

Barbra and date Peter Jennings stole the show at a 1994 White House dinner for Japanese emperor Akihito. Streisand parted company with the late ABC anchor after he took credit for helping her with a speech. After Jennings, she moved on to fellow Oscar winner Jon Voight, who traveled with her to London in 1995.

59

The Barbra Has Two Faces: After delivering her "Artist as Citizen" speech at Harvard in 1995, Streisand reacted to a question from one of the students in the audience.

60

Jeff Bridges takes Barbra for a spin—literally—on the streets of New York in another Streisand-produced, Streisand-directed epic, *The Mirror Has Two Faces*. She also wrote the 1996 film's hit love theme, "I Finally Found Someone."

61

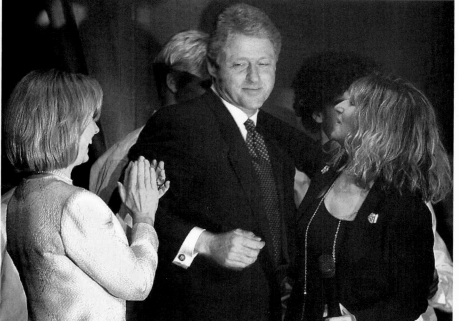

62

Bill looked less than pleased at his wife's presence when Barbra sang at a 1996 campaign fund-raiser in L.A. that raised $4 million. Although Streisand is one of Senator Clinton's most outspoken supporters, Hillary, according to one Clinton friend, "has never liked her."

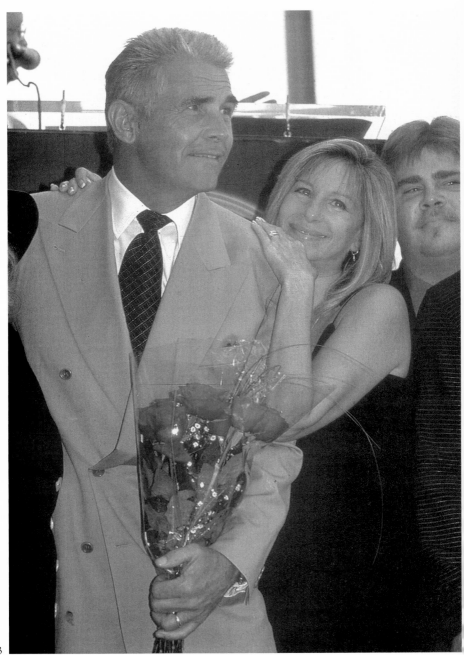

63

Two months after their July 1, 1998, wedding, Barbra beamed as husband James Brolin was given a star on the Hollywood Walk of Fame. She calls him Jim, he calls her "Beezer"—century-old American slang for, well, "schnoz."

64

Onboard a chartered yacht off the coast of Italy in 2003, Jim and Barbra Brolin follow their personal trainer in some yoga exercises.

65

As sex therapist Roz Focker, Barbra gives Robert De Niro a massage in *Meet the Fockers*. The movie grossed over a half-*billion* dollars worldwide, making it the most successful live-action comedy in film history.

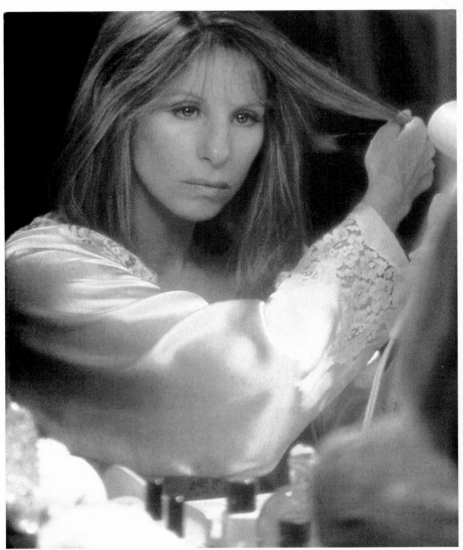

starting the film with Hubbell naming names before the House Un-American Activities Committee, as Pollack had wanted. So instead, the movie opens at the New York nightclub El Morocco at the end of World War II, with Barbra spotting Hubbell seated upright at the bar, radiant in his navy dress whites—and asleep. In a flashback, the film then recounts how they first met at Cornell—Hubbell the fresh-scrubbed, tousle-haired, all-American trust-fund kid, Katie the campus activist who is working her way through school waiting on her fellow students at the local malt shop.

The approach would set the tone of the movie and prove the key to its appeal. Perhaps no single scene was more memorable—or more uncomfortable for Redford—than the one early in the movie when Katie takes off her clothes and crawls into bed next to a naked and very drunk Hubbell. They make love—he is essentially comatose and on automatic pilot—and she is left with the bittersweet realization that, while she has bedded her college heartthrob, he doesn't know it.

By the time they filmed the lovemaking scene in California, Redford had let down his guard and warmed to Barbra. They had developed a genuine affection for each other, and a joking rapport. She often liked to hear him try to pronounce Yiddish words, and scenes of her hysterical reaction were incorporated into the film.

They were even able to overcome a technical problem that for a moment had seemed insurmountable—the insistence by both Redford and Streisand that they be shot from the left side only. "In Bob's case," Don Cash explained, "he has moles on the right side of his face that sort of pop out on camera. Very distracting." The solution? Veteran cinematographer Harry Stradling Jr. artfully shot the stars' face-to-face close-ups with "some sort of soft light behind them so there were no harsh shadows on their faces," Cash recalled. "There would be light from a flickering fireplace behind them, for example, so that the moles on the right side of Bob's face barely showed at all. Barbra? Oh, she was shot from the left—as always."

Streisand's continuing fascination with Redford had much to do with his attitude toward women in general, observed Cash, who had worked with both stars on several films. "Barbra is a good lady to work with—very professional, a lot of fun. But she had lousy taste in men. At that point, I knew Ryan O'Neal and Elliott Gould—and

they were both total jerks. And there would be more jerks later on. But Bob was very different. Even though he had some harmless fun calling her 'Blah-Blah' behind her back, he treated her with respect, and she was blown away by that."

"Barbra—I can't explain it," Redford said when asked about her appeal. "Her femininity brings out the masculinity in a man, and her masculinity brings out a man's femininity, vulnerability, romanticism, whatever you want to call it . . . that's what it boils down to."

But the scene in bed did present certain specific problems. Redford now acknowledged that his friendship with Barbra—and his proximity to her beneath the sheets—made the prospect of an embarrassing erection highly probable. While she wore a flimsy bikini beneath the covers, he wore not one but two athletic supporters. When the cameraman pointed out that the klieg lights made the double jockstrap noticeable underneath the bed linens, he whipped them off, stuck them beneath the bed, did the scene in the nude, and then reached under the bed and put them back on.

Redford's wife, Lola, was not happy with the growing familiarity between her husband and his costar. When he came home later than expected one night after rehearsing a different love scene with Barbra, she confronted him. A quarrel over Streisand ensued, and Lola reportedly hurled a glass of milk at her husband.

Beyond the few lighter moments they shared during filming, neither Streisand nor Redford was happy with the way things were going. Their doubts about the movie cast a pall over the set. In keeping with her usual approach, Barbra made no effort to talk with or even acknowledge the other actors. "It was very awkward," said a veteran actress who had a minor role in the movie. "The atmosphere was chilly, to say the least. She was very standoffish. I've been in this business a long time, and it was certainly the most unpleasant experience I've ever had on a set." And as warmly as he came to regard Barbra, Redford never got used to her incessant drive for perfection—or the fact that, as he saw it, she "talked everything to death."

It did not help that less than three weeks after *The Way We Were* wrapped on December 3, 1972, *Up the Sandbox* opened to mediocre reviews and disappointing box office. It was not the blockbuster Barbra had imagined, but *Up the Sandbox* did manage to make a

modest profit. In the end, the film was worthwhile for sentimental reasons. It was, she said, "my tribute to my son."

During Streisand's brief tour to promote the movie, Jason did seem more attached to his mother than ever. In their suite at New York's Sherry-Netherland, he careened around the room, again proclaiming himself to be "Jason Streisand! My name is Jason Streisand."

"Gould, darling," his mother corrected him. "Your name is Jason *Gould*."

"Jason Gould Streisand," he chanted as he whirled into an adjacent room. "My name is Jason Gould *Streisand*!"

At the time, Barbra had her hands full convincing the front desk at the Sherry-Netherland that she was a guest at the hotel. The second time an assistant manager called to insist she had never bothered to register, Barbra finally lost her patience. "What do you mean, nobody's registered?" she demanded, one hand on her hip, her foot tapping impatiently. "This is Barbra Streisand, and I'm here, so I must be registered!" She hung up the phone, and returned to the business of convincing Jason that his last name was Gould.

Barbra was more smitten than ever with the son she was raising in the absence of a father figure. "Once I was talking to him on a very simplistic level," she said at the time, "and he soared right above my bullshit and came straight to the point. He's so open, he knows so much . . ." She also knew that, like her mother before her, she would inevitably wind up creating emotional problems for her child. "I don't want to put my own crap in his head any more than I can help," she said, "but I'm resigned to the fact that there's no way I can *not* screw him up."

As upset as she was over the lackluster response to *Up the Sandbox,* Barbra was more outraged by Richard Nixon's huge margin of victory over her candidate, George McGovern. "I can't understand the Nixon landslide," she claimed. "Maybe people are afraid of change. It's as if they've grown almost comfortable with corruption. I mean, Nixon is so obviously dishonest . . . I don't know—it's all so destructive, so self-destructive . . . But then I believe the world is moving toward inevitable self-destruction."

Barbra's comments did not go unnoticed by the Nixon White House. Nor did the fact that she was a close friend of Nixon basher Bella Abzug, or that she had headlined the McGovern concert at the Forum. In April of 1973, she would rub more salt into the wound by raising $50,000 to help Pentagon Papers defendant Daniel Ellsberg pay his legal bills.

The precedent-setting case had started two years earlier, when former Defense Department staffer Ellsberg leaked classified Pentagon documents to the *New York Times* in an effort to discredit U.S. policy in Vietnam. Although the Supreme Court refused to bar publication of the documents on national security grounds, the Justice Department went ahead and charged Ellsberg with, among other things, espionage and conspiracy. The charges against Ellsberg would eventually be dropped, and eventually presidential aide John Erlichman—no relation to Marty—would go to prison for authorizing a break-in into the offices of Ellsberg's psychiatrist.

The fund-raising event itself was unique. Gathered under a tent on the grounds of a Beverly Hills estate were more than two hundred Ellsberg supporters, including John Lennon and Yoko Ono, George Harrison, Ringo Starr, Burt Lancaster, Rod Steiger, Hugh Hefner, and Joni Mitchell. Only Barbra performed, taking requests from the audience and anyone who happened to call in. One of the more offbeat requests came from comedian and director Carl Reiner, who called in and asked Barbra to sing "Twinkle, Twinkle, Little Star." She did.

Not surprisingly, Barbra ranked high on Nixon's famous "enemies list." On several occasions, the President confided to aides that of all "the Hollywood liberal types," he viewed Jane Fonda as the worst, with Barbra running a close second. "That Barbra Streisand is so obnoxious," he complained to White House press secretary Ron Ziegler. "Who can stand her? Her singing is so nasal, so *whiny*. And that nose—a real Jimmy Durante schnoz. But I guess she appeals to that whole New York crowd."

Despite the fact that she had frequently and stridently spoken out against Nixon, Barbra was shocked when, during the Senate Watergate hearings in June 1973, White House counsel John Dean revealed that she was on the Nixon enemies list. While dozens of politicians—including Edward Kennedy, Bella Abzug, George Mc-

Govern, Walter Mondale, and Eugene McCarthy—journalists, and activists made the list, only ten entertainment figures were deemed a sufficient "threat": Jane Fonda and comedian Dick Gregory, of course, but also Bill Cosby, Carol Channing, Steve McQueen, Gregory Peck, Paul Newman, Joe Namath, Tony Randall—and Barbra.

"I think it came as a complete and total shock to her that she had been targeted by the White House," Abzug told a New York State Democratic official. "She wanted to know what it meant—if she was in danger, if Jason was in danger. Nobody really knew what Nixon might do. It was a scary time, and I told her she had every right to be frightened."

While Paul Newman, Gregory Peck, Jane Fonda, and a few others said they considered being on the list a badge of honor, Barbra was "too practical to see it that way at the time," said a friend. "Of course she came to view it that way, but back then no one knew Nixon was going to resign. Just the idea that the people who ran the federal government had her on a list—it scared the shit out of her."

So much so that, with the exception of a single fund-raiser for her old pal Bella, Barbra would withdraw from the political spotlight for the next thirteen years. One of the people she called for reassurance was her old flame Pierre Trudeau. "She was," he conceded, "very upset."

Now Barbra's focus was on her career, and she needed *The Way We Were* to be a major success. But when she saw the finished product, she was not happy with the number of times her character was depicted weeping over Hubbell. "You're making Katie look like a sap," she told Pollack, demanding that he cut several of the close-ups of her sobbing. "She's a strong woman. She's not going to be destroyed by a guy. Any guy."

Not even Redford, although she gazed up at the screen adoringly when she first saw the finished product. Showing the film to her friends Alan and Marilyn Bergman, who would compose the film's theme song with Marvin Hamlisch, Barbra kept nudging Marilyn and murmuring, "Isn't he great? God, isn't he wonderful?"

"Redford's the best leading man she ever had," Marilyn Bergman said, "and she knew it."

Although Pollack refused to excise Katie's frequent crying jags, he would end up making a drastic last-minute edit. At a sneak pre-

view in San Francisco, Pollack and Stark noticed that the audience grew bored toward the end of the film with the scenes explaining the Hollywood blacklist, how Katie winds up on it, and her decision to leave Hubbell ("The studio says they're going to fire me because I have a subversive wife") rather than betray either her friends or her beliefs.

On the spot, Pollack dashed up to the screening room, borrowed a razor from the projectionist, and sliced more than ten minutes from the film. With the politics largely left on the cutting room floor—along with a clear explanation of their breakup—audiences from this point on never lost interest in the story.

That first sneak preview made an indelible impression on Marvin Hamlisch as well. Hamlisch, who was also working on another Redford blockbuster that would be released later that year, *The Sting,* had decided not to include the film's title song in the final, poignant scene when Katie and Hubbell meet years later in front of New York's Plaza Hotel. He felt the music would overwhelm the moment. But when he looked around and saw there were only dry eyes in the house, he realized he had made a huge mistake.

Hamlisch wanted to record the song again for the final scene, and when Columbia refused to ante up for the fifty-five musicians it would require, he wound up footing the bill himself. Not that Barbra was eager to cooperate. From the moment she first heard the song that had been written by Hamlisch and the Bergmans, she hated it.

"It does nothing for me, Marvin," she said. "It's too simple."

"So is 'My Funny Valentine,' " he reminded her.

"I *hate* 'My Funny Valentine,' " she shot back.

Barbra forced Hamlisch to write a more complex version of the same song, which she then pronounced worthy of her talent as a singer. But Hamlisch and the Bergmans clung to their belief that the original, more straightforward version was better. Both versions were tested as the musical backdrop for the closing moments of the film, and ultimately Streisand was outvoted.

Hamlisch, who had also written the score, employed the melody throughout the film as a kind of love theme. Now Barbra sang his haunting original version of *The Way We Were* over the closing credits, reducing the audience to tears.

Hamlisch would wind up taking home three Academy Awards for his work that year—for his score for *The Sting,* the score for *The Way We Were,* and the song "The Way We Were." For her part, the song Barbra hated would not only turn out to be her first number one hit single, but the number one single for the entire year. The official movie soundtrack would go gold, but it would not do as well as a separate studio collection Barbra put out under the title *The Way We Were.* That album would go platinum and climb to the top of the charts—her first number one album since *People* a full decade earlier.

Barbra was now the undisputed queen of both Hollywood and the recording industry. Redford, meantime, was the reigning king of Hollywood—a hit in Barbra's film but an even bigger one in *The Sting,* for which he would receive an Academy Award nomination in the Best Actor category.

Not everything Barbra touched turned to gold in 1973. Streisand would actually first learn that she was on the White House enemies list while she was in London taping her fifth and final special for CBS. With Dwight Hemion—the same director who had handled her first two specials—once again at the helm, there was every reason to believe that *Barbra Streisand and Other Musical Instruments* would be another Emmy-winning ratings blockbuster.

This time, however, the tension between Hemion and Streisand was palpable. Although they both believed in endless retakes—twenty-three for one number—director and star battled constantly over camera angles, lighting, costumes, and sets. Finally, Barbra delivered an ultimatum: "Dwight, *you* are going to have to adjust to me, I am not going to adjust to you."

Yet she was more than willing to adjust to the mysterious new man in her life. He was an outrageously wealthy, athletic, dynamic, smart, ruggedly good-looking, and—perhaps most important—politically active businessman. Barbra seemed content for her lover's identity to remain a secret, though she did not hesitate to admit that she was "head over heels" in love. Explaining breathlessly to a writer that she liked to "accompany him on his business travels," she admitted that she felt "terribly guilty having to work. He doesn't want to be around when I'm working, and I don't want him to be because my concentration goes right out the window." At one

point when her new love was visiting her at the studio, the musical director for the special asked her how she wanted a certain number done, and she waved him off. "I didn't know and I didn't care," she said with a shrug.

"It's a terrible thing," she explained, "but I actually enjoy being subjugated to him. It's far more important to a man's ego to have a career than it is to a woman's. I don't need to work anymore to feed my ego—I get all the ego nourishment I need from him."

Predictably, Barbra's infatuation with the hard-driving tycoon lasted a grand total of three months. And her career-dependent ego would never be more in evidence than it was at the Academy Awards ceremonies on April 2, 1974. *The Way We Were* had brought Streisand her second Best Actress nomination in five years, and she was up against favorite Joanne Woodward (for *Summer Wishes, Winter Dreams*), Glenda Jackson (*A Touch of Class*), Marsha Mason (*Cinderella Liberty*), and Ellen Burstyn in *The Exorcist*—a part, incidentally, that Barbra had turned down.

She had also turned down an invitation to sing "The Way We Were" on the Academy Award telecast that year. The show's producer, Jack Haley Jr., and everyone else involved with the movie—including her close friends the Bergmans—repeatedly begged her to sing the song on the show, but she refused. Finally, Peggy Lee agreed to cancel a club date in Toronto and fly in to sing the song at the awards.

Then, at the last minute, Barbra changed her mind. She told Haley that she really did not care if they had found a replacement. "I wanna do the song now," she said. "Get rid of Peggy Lee."

"No way," he replied to her. "I'm gonna fire Peggy Lee off the show? She canceled a club date in Canada to do it."

Barbra angrily turned on her heels and left, and as a parting shot told Haley that she had no intention of being part of the show. Keeping to her word, she did not sit in the audience where cameras could catch her reaction when the Best Actress winner was announced. Instead, she stayed backstage. When the Academy Award went to Glenda Jackson, who had already won once, for *Women in Love,* Barbra was indignant. Jackson had not even bothered to show up at the ceremonies.

Barbra believed that she lost what was essentially a popularity

contest. Clearly, Hollywood simply did not like her. "I felt I deserved the award," she said point-blank. "I was the best of those five for the year."

Backstage at the Oscars that night, Barbra leaned her head on the shoulder of the one man who understood. He was wiry, darkly handsome, with a neatly trimmed beard and thick black hair that spilled over his collar. At twenty-eight, he was also three years younger than Barbra, and as was so often the case with her lovers, he happened to be married to someone else. His name was Jon Peters.

Sing it, bitch, sing it!

—Barbra, alone, watching herself on screen

I'm scared to death of her.

—Kris Kristofferson

He was like Rasputin or Svengali with her. She ogled him, aahed over him. *She was a woman in love.*

—Director Jerry Schatzberg, on Barbra and Jon Peters

Our life together is fiery, really fiery.

—Jon Peters

Working with Barbra is like having a picnic at the end of an airport runway.

—Paul Williams, who wrote the lyrics for "Evergreen"

6

The candy-apple-red Ferrari roared up Carolwood Drive, paused as the electrically operated gates swung open, then screeched to a halt in Barbra's driveway. Within minutes, Jon Peters was being ushered inside Barbra's baronial, light-filled living room and asked to have a seat on the overstuffed floral-print couch. He carried his razor scissors, brushes, and other tools of the trade in a battered Gucci bag that he placed on the floor beside him. Peters was dressed to impress: dark glasses, fitted denim shirt unbuttoned almost to the waist, turquoise necklace, boots, faded jeans so tight that the outline of his comb was clearly visible—along with the fact that he wore no underwear.

Peters had always wanted to get his hands on her. For months that is what the millionaire owner of a small chain of hair salons had been telling his friends, coworkers, and clients. Peters and Streisand had never met, but that hadn't stopped him from telling the press she was a client. "In the last five years I've made a lotta, lotta, lotta money," he told *TV Guide* in 1970. "I hate actresses, though. I used to do Streisand and all the big stars and they drive me nuts! I'm not anybody's slave." When the story ran, his salon was flooded with new customers wanting the Streisand "look."

As luck would have it, Barbra—who hadn't read Peters's comment in *TV Guide* three years before—wanted to sport an entirely new look in her next movie, *For Pete's Sake*. At a party several nights before Peters's arrival at Streisand's home, she had admired the half-inch-long gamine hairstyle worn by comedian Harvey Korman's wife Donna. Both Donna Korman and the party's hostess, Mitzi

Welch, were clients of Peters and knew how much he wanted to be introduced to Barbra. "I have to meet her," he had pleaded, noting that since he had claimed she was a client, his business had shot up 40 percent. "I have to know where her head's at."

Peters was visiting a client in London with whom he'd been having an affair when he finally got the call. Barbra wanted him to come to her house as soon as he returned to Los Angeles. He was on a flight the next day.

Now he was sitting in Streisand's living room, waiting. And waiting. Soon Peters was pacing around the house, impatiently demanding to know where Barbra was and threatening to leave. After ninety minutes, the chronically late star made her entrance.

"Don't you *ever* do that again," he told her. "*Nobody* keeps me waiting."

"Well," she replied, "at least you've had a chance to look over my house."

As she turned away from him momentarily, he looked her over and offered an assessment. "You've got a great ass."

For Barbra, who intimidated nearly every man she met, the remark was more than a compliment—it was liberating. "He made me feel like a woman," she said, "not like some famous thing." Yet she was taken aback by Peters's studied gigolo look. "What *is* this person?" she thought.

John Pagano Peters was born at St. Joseph's Hospital in Burbank on June 2, 1945, the son of a half-Cherokee father and an Italian mother. Helen Pagano's family owned Pagano's, one of the most successful hair salons in Beverly Hills, but Peters preferred to create the illusion of a hardscrabble childhood. He claimed his father, a cook at a local restaurant, made him "a warrior. I learned to fight, to defend myself. I was Cochise's son."

John's first exposure to the movie business occurred in 1955, when the call went out for five thousand dark-skinned extras to appear in Cecil B. DeMille's *The Ten Commandments.* Hopping aboard a donkey, nine-year-old Peters played one of the Hebrews fleeing Egypt behind Charlton Heston.

An early tragedy shaped John's life, and explains in part why Barbra would make a deep emotional connection with him. Peters was

nine when he watched his father collapse suddenly and die of a heart attack. His mother remarried and—mirroring Barbra's feelings toward Louis Kind—John hated his stepfather.

John, prone to bullying and violence, routinely got into fights at school. He ran away from home three times, and at age eleven was arrested for car theft. Because of his age, he was released to his mother's care, but he soon proved too much to handle. At twelve, he was picked up for petty theft and spent six months laboring on a Youth Authority roadwork gang in the San Bernardino Mountains. Days were filled with manual labor—clearing brush, digging ditches, spreading tar and gravel on roadways. At night, he and the other "incorrigibles" in the group were literally handcuffed to their beds.

Unwilling to go back to junior high school upon his release, Peters was given a job sweeping up clippings at Pagano's salon. Although he was not yet thirteen, he knew instantly that this world—a world that afforded him close proximity to beautiful, wealthy women—was one he wanted desperately to be part of.

"I came from off the street, from jail and all that," he said. "I'd go into the salon and see ladies with diamonds, sophisticated people." Every day before work, Peters said, "I used to throw up because I was so frightened." After two years at his uncles' salon, Peters asked his mother to lend him the bus fare to New York, where he apprenticed at an East Fifty-seventh Street beauty shop.

In 1960, he married fellow teenager Marie Zambetelli, and the couple moved to Philadelphia. For the next four years he worked as a stylist at a local salon and, to let off steam, took up boxing.

Divorced at nineteen, Peters returned to California and went to work for the celebrated stylist Gene Shacove. (Contrary to myth, it was Shacove, not Peters, who was the model for Warren Beatty's womanizing hairstylist in Shampoo.)

Peters quickly learned about the beauty business, and the business of seducing rich, glamorous, well-connected women, from the master. Leaving Shacove in 1965, he managed to raise the $100,000 needed to start his own salon in Encino. Boasting a bold, minimalist interior design and offering geometric haircuts to match, the salon was an immediate hit. Peters started another in the San Fernando Valley, and eventually set up his flagship operation on trendy

Rodeo Drive in Beverly Hills. Although at this point he claimed never to have even *heard* of Barbra Streisand, he, too, dropped a letter from his first name. ("We didn't even know each other," Barbra would later observe. "Isn't it amazing how an affectation can bring two people together?")

At twenty-one, Peters began an affair with Lesley Ann Warren, the willowy actress who, ironically, had starred opposite Elliott Gould in 1965's ill-fated *Drat! The Cat!* and a year later received a measure of success on her own in a hit CBS television version of *Cinderella*. Peters and Warren married in 1967, and two months later she took him to see Barbra at the Hollywood Bowl. Ironically, it was Warren who admitted to being "obsessed" with Streisand ever since working with Gould in New York. Peters claimed he had "never heard of her before that night."

The following year, Warren gave birth to a son, Christopher. But the marriage began to falter, and Peters embarked on a series of affairs. Among the dozens of women he romanced during this period of frenzied sexual activity: Jacqueline Bisset, Elliott's *M*A*S*H* costar Sally Kellerman, and Ryan O'Neal's ex-wife Leigh Taylor-Young.

When he appeared in her living room on Carolwood Drive, Barbra had no way of knowing that Peters had a seventh-grade education. Nor was she prepared for his reaction when she asked him to make a short wig for her to wear in *For Pete's Sake*.

Jon was indignant. "You want me to do a wig?" he boomed. "I *never* do wigs! What an insult!" Peters's reaction was born of his conviction that a hairstylist was not just a "person of service. I would never do anyone's hair I didn't like," he said. "There is a certain tactile thing. If the man is straight and touches her, it's somewhat intimate."

Of course, Peters did agree to do the wig for the movie—provided he got screen credit. He also agreed to help Barbra shop for an entirely new, younger, *sexier* wardrobe to wear in *For Pete's Sake*. "The public," Peters told her, "should see this side of you—the sexy side, your legs, your ass, your breasts."

Barbra was intrigued by Peters's cocksure manner. "Maybe I liked him from the start," she later mused, "because he practically

told me to get lost. He was the man and I was the woman—that was very clear from the beginning."

Still, she was reluctant to get involved. When he continued to pursue her, she finally blurted, "Stop coming after me. You're not my type." Even after he beat her at tennis—a game he claimed he had never played before—she insisted that she "liked more distinguished men, men who smoke pipes."

The next time she saw Peters, he was wearing glasses, a velvet smoking jacket over a T-shirt and jeans—and smoking a pipe. He traded in his Ferrari for a Jaguar. "Jon never lets up," she sighed.

Six weeks after they met, *For Pete's Sake* started filming in New York. Over the last several years, Barbra had repeatedly shown that she was far from infallible when it came to picking projects. In addition to Ellen Burstyn's Academy Award–nominated part in *The Exorcist,* she had turned down the groundbreaking film about Depression-era dance marathons, *They Shoot Horses, Don't They?* because there was simply "too much dancing." The part brought Jane Fonda acclaim and her first Academy Award nomination; Fonda would win the Oscar for *Klute,* but only after Streisand passed on that role as well. Barbra also turned down *Cabaret,* which earned Liza Minnelli the Best Actress award, and Ellen Burstyn's Oscar-winning part in Martin Scorcese's *Alice Doesn't Live Here Anymore.*

From the very beginning, *For Pete's Sake* looked like yet another misstep. When she agreed to make the film, *The Way We Were* had not yet been released and she still harbored serious doubts about its chances for success. Hoping to reprise the success of earlier Streisand comedies like *The Owl and the Pussycat* and *What's Up, Doc?,* she jumped at *For Pete's Sake.*

Written by Maurice Richlin and Stanley Shapiro, the team behind such frothy comedies as *Operation Petticoat* and *Pillow Talk, For Pete's Sake* was intended to be another slapstick farce along the lines of *What's Up, Doc?* The story revolves around a Brooklyn housewife who becomes so concerned about her husband's financial woes that she borrows money from the Mob in hopes of making an overnight killing in the commodities market—specifically by investing in

pork bellies. When the ill-conceived investment tanks, she sets out to repay her debt—first by becoming a hustler, then a cattle thief. In the process, she unwittingly carries a bomb into the New York subway system.

There were frenetic chases and sight gags—not the least of which is Barbra's character riding a bull through (what else?) a china shop. Along the way, the supposedly politically attuned Streisand managed to offend feminists by portraying an emotionally dependent woman willing to do anything for her man. Barbra did nothing to change the characterization of her black maid in the film as ill-tempered and lazy, or prevent the actress playing the part from repeatedly referring to herself as "the colored woman."

Streisand also delivered lines like "*You* keep the Fruit Loops"— aimed at an effeminate grocery-store clerk—that left gays wondering if she'd forgotten her core audience.

Nor was Barbra making any friends on the set. While her nearly invisible leading man, Michael Sarrazin, saw Streisand as "vulnerable," "shy," and "kind," others in the cast felt she more than lived up to her bitchy image. Estelle Parsons, who had won her own Academy Award for *Bonnie and Clyde,* was cast in the role of Sarrazin's grasping sister in *For Pete's Sake.* Parsons was humiliated by Barbra's refusal either to talk to her off camera or to deliver her lines directly to the actress when the cameras were rolling. "I've worked with difficult people," Parsons said of Streisand, "but she defies all."

Throughout the shoot, Peters and Streisand burned up the phone lines between California and New York. Eventually, she got him on the studio payroll as a wardrobe consultant and moved him into the Plaza Hotel. Angry at repeatedly being kept waiting, he threatened to return to L.A.—until the night she called him in a panic because she had dropped her wig in the bathtub. By the time they returned to California together, tongues on both coasts were wagging about the superstar and the hairdresser.

For all Barbra's protesting to the contrary, Peters was very much her type—a take-charge, in-your-face, belligerent tough guy who was not remotely cowed by her fame. "Jon is a very macho man," gushed the woman who claimed to be partial to gentlemen. "He's got scars all over his hands from fighting."

It remained to be seen whether the battle-hardened Peters was any match for the Hollywood heavyweights. In the meantime, he did not shrink from telling Barbra what he thought about *For Pete's Sake:* "It's gonna bomb." And it would, with the critics and at the box office. "Doris Day," sniped *New York* magazine, "our Barbra isn't." According to *Newsweek,* the film had a script "beneath burning" and the "silly plot" made Barbra look like "Jerry Lewis with cleavage."

In the months following the making of *For Pete's Sake,* Barbra spent whatever free time she had at Jon's modest, rough-hewn house in Sherman Oaks. With its oversize Victorian mirrors, crystal chandeliers, Navajo rugs, lace curtains, burned-wood paneling and stucco exterior, the place reflected the couple's shared taste for the eclectic. Oddly, there were no couches or chairs but a hot tub on the deck. "Everything was very overgrown. Barbra's house is very manicured. My house has a Jacuzzi but no furniture. People took their clothes off."

Barbra had always been intrigued by people who defied stereotyping, and by any measure Peters was a mind-numbing tangle of contradictions: the former street tough who'd made millions styling women's hair, the shrewd entrepreneur with a seventh-grade education, the scarred boxer with a taste for Victorian mirrors and lace curtains. More than anything, she was intrigued by his fearless attitude—especially toward her. "Can't you be intimidated by me, Jon?" she would ask him jokingly. "Just a little?"

By December of 1973, Peters had taken charge of Barbra's personal life in a way no man had done before. He took her hiking through the Malibu mountains and horseback riding on the beach, exposing her to nature in a way she never had been before. "He's so vital, so virile, really terrific and alive," she said. "He's not frightened by the sea or the mountains or snakes or things that I'm afraid of. And I like a man who isn't afraid."

Soon it was obvious to all who knew them who had the upper hand. While recording her *The Way We Were* album the first week in December 1973, they had a fight and Jon stormed out. Not caring that the engineers and musicians were hearing every word, she phoned him minutes later and, sobbing, pleaded with him to return. While they would battle fiercely throughout their relationship,

Barbra clearly loved being dominated. Once, when he wanted to leave a party and go for a walk, Peters hoisted her on his shoulders and carried her off while she screamed in mock protest.

A few days after she broke down at the recording studio, Barbra was Jon's guest at the Christmas party he threw each year for employees at his salon. "She was very blond, very tanned, very happy," said another guest. "And she wouldn't take her eyes off him."

Jon and Barbra moved in together in early January 1974. In addition to occupying Barbra's house on Carolwood Drive, they purchased a small house on ten acres at the end of a narrow country road in Malibu's densely wooded Ramirez Canyon. Using distressed lumber from old barns that had been knocked down in upstate New York, Peters added onto the original white stucco dwelling. Outside on the deck, a fifty-year-old wine vat had been ingeniously transformed into a bubbling hot tub.

Barbra tackled the earth-toned interior, filling it with Tiffany lamps; art deco statuary; modern, Impressionist, and Surrealist art; feather boas; floppy hats; Navajo rugs; Georgian silver tea services; and glittering tchotchkes of every conceivable description. Their four-poster bed, hand-hewn by Peters, rivaled Barbra's French antique bed in size and bulk.

Not that building that first house together had been easy. Ultimately, five houses in distinctly different styles would go up on the twenty-four-acre property. "We each built our own," she would later concede, "because we fought too much when we built our first one together."

Yet, for the first time, the ultimate city girl was able to savor the great outdoors. She got down on her knees to dig in her English garden, went for an occasional bike ride along country roads, drove Jason to the nearby public beach ("Nobody recognizes me. They think, 'Nah, what would *she* be doing on a public beach?' "), and even whipped up meals in the open country kitchen. "Jon likes me in the kitchen, but that's okay," she said. "I like cooking for him."

Barbra had overcome her fear of animals and was right at home with Jon's dogs and horses. So much so that after she hinted that she might like a horse of her own, he gave her one named Cupid. But she kept a respectful distance when Jon placed a chain around the

neck of Leo, the pet lion he kept in a cage, and took him for a stroll around the grounds.

Barbra said that before meeting Jon she had "never breathed deeply before." Now she felt healthier, more alive, and certainly more connected to nature. As their Malibu hideaway—now simply called "The Barn"—evolved, Barbra also felt a renewed sense of family. Jason, now seven, had hit it off with the physical, rambunctious Jon almost immediately. Jon's son, Christopher, two years younger than Jason, rounded out the tribe. In contrast to Jason's room with its red velvet drapes, bedspread, and upholstery, Christopher's had an Aztec-print motif.

While Peters's wife and Barbra's ex-husband watched warily from the sidelines, the happy couple took the boys to Disneyland and ski vacations in Vail. "I went with Jon Peters," Barbra said of his take-charge attitude, "because he knew what to do on Sundays."

And, as it turned out, every other day of the week. To the surprise of even her closest friends, she let Peters pick out her clothes and help her shape a new, more burnished image. The jeans were tighter, the sunglasses darker, the platform shoes higher, the bra— gone. "He was instrumental in a new, younger me. This hipper, more sexual character. But it was very entrepreneurial," she conceded. "Jon just had that in him."

The one thing Jon wasn't was her hairdresser. "She wants me to back-comb it," he said. "I won't back-comb."

On the contrary. Said Barbra, "I wash and blow-dry *his* hair."

The "hipper, more sexual" Barbra did not shy away from talking about the more intimate details of her life with Peters. Jon, she proclaimed, had made her a "sexually aggressive woman" who now leafed through erotic art books for new positions to try out in the Jacuzzi or on the quilted, pillow-strewn mattress spread out before their massive stone fireplace. The key, Barbra said, was not having to "play the image game. I never even thought that I counted . . . I used to play parts with men—I had to be sweet and nice and all that." With Peters, she could be "just *me*. Crude at times, frightened, sweet, tough."

The "entrepreneurial" Peters was candid about what had drawn him to her. "I didn't fall in love with Barbra independent of her star trip," he said. "I was fascinated by her, and of course, by Hollywood."

They made a highly combustible couple. They fought loudly, frequently, and sometimes violently. Since each was wealthy by any standard—at thirty-two, Barbra could already claim to be one of Hollywood's richest women—it seemed incongruous that so many of their fiercest battles were waged over money. It was important to Barbra that no man, Jon included, take advantage of her financially.

Just so there would never be a dispute over what belonged to her, Barbra labeled virtually every item of value. Beneath every Steuben vase and Tiffany lamp, on the reverse of every Klimt and Toulouse-Lautrec, was a label describing the piece, the date it was purchased, and the amount Barbra paid for it. "Just in case," she explained, "I need to sell this stuff someday."

Even if the issue was something as mundane as who was supposed to pay the landscaper, they often fought, Peters said, "like wild animals." They screamed obscenities at each other, slammed doors, tore cupboard doors off their hinges, threw glassware and crockery. She kicked at him, and scratched him with those lethal-looking nails. She pulled back to slap him, and he grabbed her wrist. She spat in his face. He spat back. Spitting, in fact, was something they did a lot. "The other day Jon and I had a spitting fight," she confided to writer Colin Dangaard. "But when you're in love with somebody you can spit on them and it's very sexual, sensual, and real."

Peters's tantrums occasionally backfired. "Jon got so mad at something I said, he put his fist through a closet door," she said. "I'm so afraid he's going to hurt himself."

Hand-to-hand combat like this only proved to both Peters and Streisand that they were very much in love. "People who love each other deeply," he said, "occasionally really hate each other, too."

"He's a predator," an associate of Peters's observed. "Sharp, imaginative, and vulgar. But he's been important to Barbra because he's said no to her. They fought like tigers. Most of the time they lived on an adrenaline high."

Jon's street-thug persona excited Barbra, especially when it was deployed on her behalf. Acting as her last line of defense, he used his fists and sometimes his feet to fend off fans and pushy photographers alike. In March of 1974, he broke his right foot going after a

photographer who had tried to snap a photo of the couple as they left an ice cream parlor.

Once he moved in with Barbra, new signs appeared by the front gates: WARNING! GUARD DOGS TRAINED TO ATTACK. "He makes me feel safe," Barbra said. "Every woman wants that."

Each would bristle at the mere suggestion that the other had the upper hand. When Barbra surprised Jon by flying him to New York to see the historic Muhammad Ali–Joe Frazier rematch in January of 1974—the couple showed up wearing his and hers cowboy outfits—he fumed at press reports that they had landed their ringside seats because of *her* connections.

Not that Peters shied away from asking Barbra for favors— *important* ones. Pushed by her record label to have a new album ready for the holiday season, Barbra came up with a title right away. At that first meeting at the house on Carolwood Drive, Jon had told her she reminded him of a butterfly. Later, he gave her an antique silver butterfly pin. When she asked him to design the cover for *ButterFly,* Jon came up with a photograph showing a fly lighting on an unwrapped stick of butter. He also told Barbra he wouldn't set-tle for designing the cover; he wanted to produce the entire album. Understandably, Columbia resisted the idea, forcing Barbra to re-mind them her contract gave her complete creative control of all her recordings.

During the eight months it took to complete *ButterFly,* Jon and Barbra quarreled bitterly, oblivious to the engineers, musicians, and record-company executives who either squirmed nervously or merely watched in gape-mouthed amazement.

"This is bullshit, Jon," she yelled. "You're fucking fired."

"*I'm* the producer," he fired back. "I fire *you!*"

"Don't bother," she replied, heading for the door. "I quit."

"Oh, no you don't," Peters said, heading her off. "*I* quit."

Columbia executives were not happy when they heard the al-bum. Troubleshooter Kathy Kasper was brought in to fix what she could in exchange for a major credit, followed by recording engi-neer Al Schmitt. Hired to do a remix, Schmitt, a veteran of twenty-five years in the business, also wanted a production credit. Jon refused. "Essentially, Peters wants all the money," Schmitt said, "and

I'd be doing all the work." Schmitt was gone within seventy-two hours. (When the album came out, Kasper's name was not mentioned. "It must have been an oversight." Peters shrugged, promising to include her promised credits in future pressings.)

Barbra was stung by speculation that her bearded, coal-eyed, somewhat menacing boyfriend was exerting a Rasputin-like control over her career. "Do they think I would let Jon produce a record if I wasn't absolutely sure he could do it?" she asked. "I believe in instinct, I believe in imagination, I believe in taste. These are the important ingredients, and they're all things he has." As for her first Jon Peters–produced album: "This is possibly," Barbra insisted, "the best singing I've ever done."

A musical pastiche of jarring moods and styles, *ButterFly* ranged from the Ray Charles classic "Crying Time" to Bob Marley's "Guava Jelly." The record was panned by the critics, though the most wounding comment came from David Bowie, who claimed her version of his "Life on Mars" was "bloody awful . . . atrocious."

Not that it mattered. *ButterFly* would ride the coattails of her *The Way We Were* triumph all the way to number thirteen on the charts.

Although *ButterFly* was the focus of Jon Peters's existence for almost an entire year, Barbra had even weightier matters to contend with. Under the terms of their old contract, she still owed Ray Stark one more movie. She had passed on a script Marty Erlichman was developing called *Freaky Friday* (which would end up being the basis for *two* hit films) when Stark came to her with the idea for a sequel to *Funny Girl*. It would be called *Funny Lady*.

"You'll have to drag me into court to do that picture," she told Stark, heeding Jon's advice that she stop playing "Ray Stark's mother-in-law." But a compelling script by Jay Presson Allen, who had written *Cabaret,* apparently changed her mind. The film picks up where *Funny Girl* left off, tracing Fanny Brice's second marriage, to flamboyant songwriter-showman Billy Rose.

There was another reason Barbra decided to do the movie, and her name was Liza Minnelli. One of the few roles Streisand had regretted not taking was that of Sally Bowles in 1972's *Cabaret,* which brought Minnelli her Best Actress Oscar. "They all say they aren't jealous of each other's success," Truman Capote observed. "Barbra

definitely feels Liza nipping at her heels." By way of hedging her bets, Barbra insisted that as many members as possible of *Cabaret's* creative team be brought in to work on *Funny Lady.* In addition to scriptwriter Allen, Stark hired the *Cabaret* songwriting team of John Kander and Fred Ebb. There was no way to bring Bob Fosse, who had also won an Academy Award for directing *Cabaret,* on board; Herb Ross had already been chosen to direct. But Barbra did personally choose Fosse pal Ben Vereen to bring some of his mentor's dance moves to *Funny Lady.*

Finding the right actor to play Billy Rose posed special problems, since the second Mr. Fanny Brice was no matinee idol and stood barely four feet eleven inches tall. Robert De Niro and Dustin Hoffman both auditioned for the part of Rose. So did the short, husky Richard Dreyfuss and the even shorter and huskier Robert Blake. For a time it looked as if Blake, the scrappy star of television's *Baretta* who decades later would be charged with the murder of his wife, had the part—until Stark decided he needed a leading man with more sex appeal.

Enter handsome, lean (at five feet ten and a half inches and 165 pounds), rough-hewn James Caan. "It comes down to who the audience wants me to kiss," Barbra said. "Robert Blake, no. James Caan, yes."

The son of a kosher-meat dealer in Queens, Caan had a reputation as a tough-guy hell-raiser. After a string of hit films, including *The Godfather* and *Cinderella Liberty,* he began turning down lucrative acting jobs so he could rope steers on the professional rodeo circuit. Billing himself as "Hollywood's only New York Jewish cowboy," Caan liked to make fun of his macho reputation. "Everybody makes me out to be some kind of pig, humping women in the gutter. I do, but I put a pillow under 'em first."

Caan and Barbra got along just fine. He broke the ice by telling her off when she flubbed a line; she yelled right back at him. They called each other names. They dissolved in hysterics with such frequency that director Herb Ross was starting to get angry with them. "All I remember," Caan said, "is giggling—a *lot.*"

Caan was one of the few lucky ones. In typical fashion, she basically ignored the lesser actors (especially her former lover Omar

Sharif, called in to reprise the role of Nick Arnstein) and bombarded everybody from Ross on down with "suggestions" that no one dared ignore.

Barbra even gave the cold shoulder to twenty-six-year-old Prince Charles, who was on naval duty aboard the HMS *Jupiter* when his ship docked in San Diego. During a brief side trip to Los Angeles, he had asked to meet only one Hollywood personality: Barbra Streisand. "I'm sure they thought I'd say Raquel Welch," Prince Charles told his valet, Stephen Barry, "but I said Barbra Streisand. I wanted to meet the woman behind the voice."

For years, the future King of England had harbored a crush on Streisand. A large photograph of Barbra had hung on the wall of his room at Cambridge University, and in his private quarters in London. "Barbra Streisand is," he told Barry, "my only pinup." While his peers were immersed in the Beatles and the Stones, Prince Charles played her albums constantly. He was no less a fan of her as an actress; the Prince of Wales admitted to having seen *Funny Girl* three times.

Columbia viewed the royal visit as a publicity bonanza. The huge soundstage where Barbra was dubbing dialogue was cleared and the press kept at a safe distance. Standing in a roped-off area, fifty photographers snapped furiously as Barbra and the prince shook hands. "She appeared to be rather nervous," Charles said later, "and kept asking me endless questions in a rather tight-lipped fashion." Once the enforced photo op was over, they went into a corner and kibitzed for fifteen minutes over coffee. It was then that she told him she had no intention of ever doing a live show again because, Barbra told the prince, "I only like performing in front of people I know."

"Then why go on acting at all?" he asked her point-blank. Barbra merely shrugged.

Charles wanted to stay and "get to really know her," he later said, but Barbra had to get back to work. That night, he told his valet, "I think I caught her on a bad day. She had very little time and appeared very busy."

Undeterred, the heir to the British throne would harbor his secret crush on Barbra for decades. "People look at me in amazement when I say she is devastatingly attractive and with a great appeal,"

Charles wrote in his journal. "But I *still* contend she has great sex appeal after meeting her."

Had she known at the time, Barbra might have made more time for the prince. "Who knows?" she later said. "If I'd been nicer to him, I might have been the first *real* Jewish princess."

But throughout the making of *Funny Lady,* she made it clear that she was there to fulfill a legal obligation to Stark and not entirely of her own accord. "Figuratively speaking," Jay Presson Allen said, Barbra was "escorted to the set every day by a team of lawyers."

Peters, meantime, made his displeasure known. "You shouldn't be playing dowdy old women," he told her. "You're too damned sexy." Sulking, he returned to his salon every Wednesday and Saturday to cut hair.

Notwithstanding an obvious lack of enthusiasm, Barbra was still willing to take very real risks to make the movie work. In "Let's Hear It for Me," a number that hearkens back to her "Don't Rain on My Parade" sequence in *Funny Girl,* she rides a chauffeur-driven Rolls-Royce to an airstrip where she climbs into the open cockpit of a 1937 biplane. The two-passenger plane was supposed to be airborne just long enough to make the shot—ten minutes at most. Instead, it dove and swooped through the skies as heavy traffic delayed the landing for nearly forty minutes. Terrified, a trembling Barbra had to be helped down onto the tarmac. She had convinced herself while she was in the air that she was in the process of being abducted. Incredibly, Ross persuaded her to do one more take. "She never"—he sighed—"could resist just one more take."

Barbra was never in danger, but for one stunning moment, the person she loved most came perilously close to losing his life. Unbeknownst to Barbra, the cameras had barely started rolling on the film when a sixty-pound sandbag crashed to the soundstage, narrowly missing seven-year-old Jason. Knowing that Barbra would have been too shaken to complete the picture had she been aware of the episode, Ross never told her about it.

The film wrapped on July 9, 1974. With her legal obligations to him at last fulfilled, Barbra's parting gift to Ray Stark was an antique mirror with PAID IN FULL scrawled across it in red lipstick. She

also gave him an engraved plaque: "Even though I sometimes forget to say it, thank you, Ray. Love, Barbra."

As far as Streisand and Peters were concerned, *Funny Lady* marked the end of parts that Barbra viewed as "self-deprecating. This is the end of a cycle. I began with *Funny Girl* and now I'm ending with *Funny Lady*." No more lavish, hopelessly dated musicals. No more parts that required her to play women, like Brice in *Funny Lady*, who were actually her age.

Stark saw parallels between Brice's story and Barbra's evolution as both a woman and an actress. "She's changed like good wine," he observed. "We fight like hell, but they're all fights about creative opinions . . . She's just matured and become a lovely lady instead of a fiery, funny, kooky little girl."

Barbra would have none of it. "It's a goddamn pain," she said. "That person on the screen is not me. There's a lot of distortion in that. It's like this whole thing about Jon taking over my life. Every man I'm involved with has to be Nicky Arnstein. Jon doesn't even comb my goddamn hair anymore."

Barbra ended 1974 in a way she had never ended a year before— by celebrating Christmas with her Catholic boyfriend. That morning, she clung to her own heritage by noshing on a toasted bagel while Jason and Christopher ripped open the packages that were piled at the foot of the family's nine-foot Christmas tree.

She had begun a new chapter in her life, one that included Christian holidays, communing with nature, and scream-filled gestalt-therapy sessions with Peters and his estranged wife, Lesley Ann Warren. But Barbra had not entirely closed the last chapter in her life, the one in which mentor-rabbi-father-figure-überboss Ray Stark had played so large a part.

Even though it was to benefit the Joseph P. Kennedy Jr. Foundation's Special Olympics and she was being paid $100,000 to do it, Barbra had to be talked into showing up for a special Kennedy Center preview of *Funny Lady* on March 9, 1975. The show, billed as *Funny Girl to Funny Lady*, would be broadcast live over ABC.

When Streisand arrived in Washington the day before the concert, she was told that TWA had lost all her orchestra's arrange-

ments and that Stark had launched a massive nationwide search to find the music in time for that evening's nationally televised concert. For Barbra, who hadn't performed in public in over three years and was now suffering from a bad sore throat, the snafu was just enough to send her over the edge. She locked herself in a bathroom and threw up.

Fortunately, the arrangements finally turned up and Barbra managed to pull herself together. When she stepped onstage before an audience that included then-president Gerald R. Ford, much of the Kennedy clan, and half of official Washington, the black-tie crowd whipped itself into such a frenzy that it was a full two minutes before she could sing her first song. But as soon as she hummed the first few notes of *The Way We Were,* they were on their feet again.

The *Funny Lady* road show moved on to the Astor Plaza Theater in Times Square, where a phalanx of fifty policemen held back thousands of frenzied fans as Barbra emerged from a limousine and, with Peters at her side, dashed into the theater. Swathed in red fox, Streisand was thrilled—but also terrified. "Below the red Cossack hat," the *New York Times*'s Anna Quindlen observed, "those famous blue Streisand almond eyes were pure scared rabbit."

So scared, in fact, that at first she refused to attend the film's royal premiere in London. Stark reminded Barbra that the Queen of England was waiting to see her, but that only made the headstrong Streisand more intent on defying him. "Ray!" she screamed to Jon, who tried to act as intermediary. "I HATE HIM!"

Barbra would go to England, but she would not like it. At the command performance a few days later, she became even more upset when protocol forced Jon to stand behind her in the receiving line. Once Queen Elizabeth reached her, Barbra broke an important rule of etiquette herself by daring to speak to the monarch before being spoken to. "Your Majesty, why do women have to wear gloves and the men don't?" she asked.

The Queen, taken by surprise, paused for a moment. "Well, I'll have to think about that one. I suppose it's a tradition."

Barbra then turned back toward Jon. "Well," she muttered in earshot of the Queen, "I guess I *still* don't know. I think it's the men's sweaty hands that ought to be covered, not ours."

The reviews for *Funny Lady* were mixed, but the hype paid off

handsomely. Made for only $7.5 million, the film would go on to gross an impressive $50 million in 1975. That same year, Barbra would win two People's Choice Awards (as Favorite Female Singer and Favorite Movie Actress) and a Golden Globe as the World Film Favorite.

Jon was unimpressed. Months before, he had walked away from his hairstyling business so that he could produce the film he believed would take his girlfriend to "an entirely new level." It also dealt with themes that in some ways mirrored their relationship. "We're going to make this a love story," he explained. "They're the most beautiful people and the love they have for each other is the same feeling as Barbra and I have for each other."

The story was as old as Hollywood itself, and had in fact already been told in three films that spanned as many decades. For a time, the working title would be *Rainbow Road*. But Barbra and Jon would drop all pretense of originality and restore the name by which the story was known to generations of movie fans: *A Star Is Born*.

"You're not doing what I tell you to!" Barbra screamed, her voice being picked up by microphones and booming out over the loudspeakers at Arizona State University's Sun Devil Stadium. She was standing on the stage that had been erected for a rock-concert sequence in front of sixty thousand screaming fans—one of the key scenes in Streisand's much-anticipated remake of *A Star Is Born*.

"Shit! I got the director telling me one thing and you telling me another," Kris Kristofferson growled back in his unmistakable tequila-soaked drawl. "Who's the director? Get your shit together!"

Trouble was, Barbra had forgotten that more than one hundred reporters brought in as part of a press junket were inside the stadium and hearing *everything*. Their eyes widened as they realized this wasn't dialogue from the movie.

"Listen to me!" she demanded as he turned to leave. "I'm talking to you, goddammit!"

"Go fuck yourself!" Kristofferson shouted back.

Jon Peters rose to his girlfriend's defense. "You owe my lady an apology," he protested, heading for Kristofferson with clenched fists. "If we didn't have a movie to make, I'd beat the shit out of you!"

"Listen, if I want any shit out of you"—Kristofferson sneered in reply—"I'll squeeze your head."

Incredibly, it had taken three years to get to this preposterous moment. The married novelists Joan Didion and John Gregory Dunne would remember the precise time—one P.M. on July 1, 1973—that they came up with the idea of a rock-and-roll version of *A Star Is Born* starring James Taylor and his then-wife Carly Simon.

Warners loved the idea, in part because they owned the three previous versions of the Adela Rogers St. John tearjerker: 1932's *What Price Hollywood?*, 1937's *A Star Is Born* starring Fredric March and Janet Gaynor, and the one musical version done in 1954 that had Judy Garland belting out "The Man That Got Away" for James Mason.

Didion and Dunne claimed never to have seen any of the previous incarnations of *A Star Is Born* and planned to drastically alter the plot to fit the rock genre of their *Rainbow Road*. It would be a meandering road, to say the least. James Taylor and Carly Simon would pass on the grounds that the story—about an up-and-coming singer who marries an established rock star and surpasses him as he self-destructs via booze and drugs—simply hit too close to home. Early on, Streisand passed on the script; she told her agent Sue Mengers that the rock world bored her.

Meanwhile, *Rainbow Road* bounced from one director to another—Warren Beatty, Peter Bogdanovich, Mike Nichols, all turned it down. Mark Rydell (*Cinderella Liberty,* and later *The Rose* and *On Golden Pond*) finally came on board as director, only to be supplanted months later by Jerry Schatzberg (*Scarecrow*).

In the meantime, *Rainbow Road* was shown to Liza Minnelli and Diana Ross before it was finally offered to Cher. Having broken up with Sonny Bono and married rocker Greg Allman, Cher was riding high as a solo artist and knew all about the world depicted in the film. Determined to make the transition from pop star to serious actress (she was years away from earning her own Oscar for *Moonstruck*), Cher put herself through the humbling experience of auditioning for the part three times.

That all ended when Jon Peters stumbled on the script and convinced Barbra to reconsider. At this point, the protagonist Esther Blodgett became the more ethnic-sounding Esther Hoffman, and

her downward-spiraling lover was no longer Norman Maine. Searching for something more contemporary, the Dunnes had come up with "John Norman Howard."

This time, Barbra saw the parallels between the characters and what was happening in her life. After all, she pointed out, the male rocker in the story was now named John, "he drove a red Ferrari and had a red Jeep, which my Jon does, and he was a Gemini, which Jon is. It was kind of a mystical thing—it was destined to be."

Once Barbra took over—with Jon as producer, of course—Cher was unceremoniously dumped. "Barbra Streisand and Jon Peters just walked in and took over the project," Cher said. "Barbra doesn't know *shit* about rock and roll."

Not to worry. Barbra and Jon went straight to the top, flying to Las Vegas in April 1975 to offer Elvis the part of John Norman Howard. Presley, now forty and starring at the Las Vegas Hilton, was already bloated and befuddled from too many pills—not to mention too many peanut-butter-and-banana sandwiches.

Barbra and Jon were not prepared for what they saw when the King lumbered into their hotel suite. When he left two hours later, they realized that the very thing that made him perfect for the part—his obvious free fall—was the very thing that would keep him from being able to actually do it. Saving them the embarrassment of withdrawing the offer, Elvis's manager, Colonel Tom Parker, called to say his client wasn't interested.

Another hard-living rocker on the road to oblivion had wanted the part all along. With his deep-set eyes, Texas drawl, and country bad-boy aura, Kris Kristofferson seemed perfectly suited to the part. He had already made several films—*Cisco Pike, Blume in Love, Pat Garrett and Billy the Kid,* and, most notably, *Alice Doesn't Live Here Anymore*—and was ready to make the leap to over-the-title stardom.

Kristofferson had, in fact, been attached to the project at an earlier stage. But Barbra had been reluctant to share equal billing—a reticence that resulted in the scramble to find someone else to play opposite her.

At one point, she tried to strong-arm the director of the moment, Jerry Schatzberg, into letting Jon play the lead. "Jon is perfect for the part, Jerry," she said. "This is *our* story. The world is waiting to see us together."

"I don't want to shoot a documentary about you two," Schatzberg replied.

Barbra didn't care what Schatzberg wanted; she pressed for him to give the part to Jon.

"Can Peters sing?" Schatzberg asked.

"No," Jon interjected. "But you can shoot around me, just like you were going to do with Kristofferson."

"Look," Schatzberg tried to explain, "you can do that with a singer to make it look like his acting has more energy. You can't do it with an actor to make it look like he's a singer."

Barbra's reluctance to accept Kristofferson might have had less to do with the question of billing than it had to do with their torrid affair just five years before. "Jon was a very jealous guy who was capable of very scary behavior," said a former colleague of both Peters and Kristofferson. "It was going to be awkward for Barbra to be acting in these steamy sex scenes with Kris, and she was afraid of how Jon would react."

In fact, Peters was no longer interested in a part in the film. Now he wanted to direct. "It's a story only I could tell," Jon insisted. "I wanted to deal with it and not interpret it through another person. Barbra felt this was a wise choice, too." Neither paid much attention to the naysayers. "Directing is a thing I've done my whole life!" Peters shouted at one skeptic. "It's getting people to do what I want them to do!"

By now, *Rainbow Road* was back to being called *A Star Is Born* and Barbra fully intended for Jon to direct—or so she told Barbara Walters in a rare interview on NBC's *Today* show. Sue Mengers had, in fact, already called Peters at his salon with the news that Warners had given him the go-ahead to direct. Jon, clad in a checked sweater, platform saddle shoes, and skintight corduroys with no underwear, checked himself out in the reception room mirror while Mengers spelled out the details of the arrangement over the phone.

Then, as Hollywood writer James Bacon put it, "the shit really hit the fan." Neither Barbra nor Peters had anticipated the firestorm of controversy that was ignited by a damning piece in the magazine *New Times* titled "Collision on Rainbow Road." On the cover: a completely bald Barbra under the headline A STAR IS SHORN: A BEV-

ERLY HILLS HAIRSTYLIST STARTED WITH STREISAND'S HEAD—AND IS NOW TAKING OVER HER IMAGE, HER CAREER, AND HER NEWEST MOVIE. Jon had been interviewed extensively for the article, which started off by calling the *Star Is Born* remake "Hollywood's biggest joke" and went on to depict him as a strutting, vulgar, cravenly ambitious, semiliterate wannabe. For her part, Barbra came off looking like a woman who was so obsessed with pleasing her lover that she had become delusional. How else could one explain her desire to set Jon up as producer, lead actor, *and* director?

By way of damage control, Barbra started saying that she never seriously wanted Jon to play the lead. "It was a *joke,*" she now said, "blown completely out of proportion in the press."

Peters also tried to explain it away. "Barbra and I were kidding around at home reading the script, and I said, 'Hey! I can do this part. I've got the looks and the energy.' And Barbra said, 'You can do *anything,* Jon.' And somehow that got picked up by some schmuck who printed it." Besides, Peters added, "I like to make it on my brain, not on my looks. I'm more interested in the concept and the making of the film, not as an actor."

Jon was not merely out as a possible leading man. Streisand and Peters also agreed that there was no way, given the public outcry over Jon's perceived presumptuousness, that he could now direct.

That did not mean that Jon was about to back away from ownership of the picture. "*I* discovered this project!" he proclaimed. "*I* was the one who found it for Barbra and convinced her to do it." From this point on, he would repeatedly refer to *A Star Is Born* as "my movie" and "my story."

They stumbled on a solution to their problem while searching for yet another writer. After Joan Didion and John Gregory Dunne dropped out (on condition they would be paid a staggering 10 percent of the gross), no fewer than fourteen writers would drift in and out of *A Star Is Born*. Among them: Arthur Laurents, Jonathan Axelrod, Bob and Laurie Dillon, Buck Henry, Alvin Sargent, and Jay Presson Allen.

Late in the summer of 1975, screenwriter Frank Pierson was hired to rewrite the script yet again. Pierson, whose writing credits included *Cat Ballou, Cool Hand Luke, The Anderson Tapes,* and *Dog Day Afternoon,* said he would do it on one condition: that he be

hired to direct. Barbra said that she agreed—provided he let her "collaborate" with him as director.

As for Jon's role in the process: "I'm here to expedite," he told Pierson. "You need somethin', I'll kick ass to get it."

At one of his first meetings with Jon and Barbra in Malibu, she came up with one more candidate for her leading man: Brando. So what if he couldn't really sing? Why did it have to be a musical? she asked Pierson.

At the mention of Brando's name, Peters began yelling, "He was right here! He was cute! The son of a bitch, he wanted to fuck Barbra—I was ready to kill him! I take him off and I kiss him! He's beautiful! Right here! I love him, the bastard! They'd make a great pair. Imagine, Streisand and Brando!"

Of course, Warners was insisting that Barbra sing—a lot—in the film. "Shoot her singing six numbers," a studio executive told Pierson, "and we'll make sixty million dollars."

Grudgingly, and only after she decided against Mick Jagger because she didn't like the way they would photograph together, Barbra agreed to give Kris Kristofferson the over-the-title billing he had been holding out for.

If Pierson had any illusions about who was in fact directing *A Star Is Born,* they evaporated when Barbra told him to work with her on the script. "I could tell you what to write," she said brightly. As for personnel, Barbra was not even happy with Pierson's hiring of three-time Oscar-winning cinematographer Bob Surtees, then seventy and a certified film-industry legend. Barbra had never heard of him. "He's old," she said. "We should have someone *young* on this picture."

It did not take long for her to let Pierson know he was skating on thin ice as well. "I don't feel," she told him, "you really want to love me."

"I love you," Pierson replied, trying to reassure her. "I'm just not the demonstrative type."

Ultimately, Barbra conceded to Pierson that because of her own father's early death, she was always searching for a father figure—in her directors, in her boyfriends. Still, she admitted, "I can't stand for someone to tell me what to do. Ray Stark always used to bully me, the son of a bitch. You'll pay," she admitted to Pierson, "for every lousy thing Ray Stark ever did to me."

Not that Barbra was concerned about the feelings of her fellow actors. "You're too nice to the actors," she admonished Pierson. "You have to be hard on them. They'll walk all over you!"

Barbra's attitude toward her colleagues might have explained why she was also having a hard time finding someone to score the film. Record producer Richard Perry had dropped out, as had *Exorcist* composer Jack Nitzche. Barbra had worked with bearded singer-songwriter Rupert Holmes on her hit album *Lazy Afternoon* and offered the assignment to him. (Holmes would go on to achieve a certain fame as the man behind the phenomenal hit single "Escape," better known as "The Piña Colada Song.") For a time, Holmes, too, would run the gauntlet with Peters and Streisand. When he could no longer stand Barbra's pestering phone calls and Peters's frequent outbursts, Holmes fled back home to New York.

Before his hasty departure, Holmes did manage to write two songs that would be used in the movie. Kenny Loggins and the Bergmans also wrote a song that would be used, and Leon Russell collaborated with Barbra on yet another. Paul Williams and his collaborator, Kenny Ascher, were finally hired to write the rest of the score.

Williams, who had written hits like "Rainy Days and Mondays," "We've Only Just Begun," and "You and Me Against the World," soon blew up over Barbra's incessant meddling. "How can I write when I have to talk to her all the time?" the five-foot-tall Williams yelled at Pierson. "Nothing ever gets finished because before I finish the damn song she's already asking for changes."

At one point, Williams, angry that Jon and Barbra had allowed Kristofferson to make changes in the songs Williams had written, threw a punch at Peters. The two tussled, knocking over chairs before Williams stormed out.

Later, Williams would find time to sit down with Barbra and listen to her tentatively strum out a tune she had written on her guitar. Although he realized at that moment that this would be the movie's recurring love theme—and already knew that he wanted to call the song "Evergreen"—Williams frustrated Barbra by waiting until the last minute to finish writing the lyrics. "That," he said, "drove her *nuts*." (Years later, a controversy would arise when it was suggested—incorrectly—that Rupert Holmes had actually written

the music for "Evergreen" and that Barbra had taken credit for his work. Holmes emphatically denied it. "I am not in any way, shape, or form the composer of the popular song 'Evergreen,'" Holmes declared. "I did not create any part of its melody or lyrics. I have never sought credit for the writing of the song, for the very simple reason that I did not write it.")

Some of the biggest rows, not surprisingly, were between macho men Peters and Kristofferson. When Bruce Springsteen landed on the cover of *Time* and *Newsweek* the same week, Barbra and Jon both made the mistake of telling Kristofferson that he should try to sound more like The Boss.

"So, who shall I say says my music isn't rock?" Kristofferson demanded before the entire cast and crew. "Barbra Streisand's hairdresser?"

"It's SHIT!" Jon fired back. "I don't care who says it!" Barbra stepped between the two men before they came to blows.

For Peters, such confrontations were par for the course, and by no means confined to the set. During filming, he knocked out a man who heckled Barbra at a Muhammad Ali fight in Madison Square Garden. "Pow! I let him have it," Jon boasted. "He made a motion like he's gonna touch, maybe he's gonna hit Barbra: He's gonna hit my woman! I go crazy! Bam! Pow! They're pullin' me off him. The cops come take him away. You can't go anywhere with her! That's the meaning of *star*! We gotta get that in the picture!"

Barbra knew what Jon was capable of—and it terrified her. After they engaged in yet another screaming match on the set, she hid in the bushes until she spotted Pierson walking toward his car. "For God's sake," she whispered, ducking behind several parked autos, "take me home." According to Pierson, Barbra was literally trembling with fear as she slunk down in her seat. "He gets so furious. I don't know what to do."

Barbra had reason to be concerned when it was time to film a sexy bathtub scene. "For God's sake," she told Pierson before she climbed in, "find out if he's going to wear something. If Jon finds out he's in there with nothing on, naked . . ."

Pierson had wardrobe rustle up a pair of flesh-colored briefs for Kristofferson, who had indeed stripped off everything before sliding into the tub. "What the hell are they afraid of?" he protested.

Just to be sure that Kristofferson stuck to the script, Peters sent a female assistant to keep a watchful eye on the proceedings. "Do you think it's easy," he complained, "watching some dude make love to your woman?"

As moody and unpredictable as Jon Peters was, he had met his match in Kristofferson. Each day on the set, Barbra watched warily as her costar consumed a quart of tequila and two six-packs of beer. "I was out of control, no doubt about it," he later said. In fact, after seeing a rough cut of the film, Kristofferson would swear off alcohol completely and replace it with coffee and pot. But, he was quick to add, "Jon and Barbra were total pains in the ass."

When it came time to film the climactic concert scene, Barbra tentatively stepped out onto the stage and was visibly moved when the throng of college-age rock fans began cheering wildly. In order to entice the crowd of sixty thousand to Sun Devil Stadium, Santana and then–chart topper Peter Frampton had been hired to perform after the scenes for the movie had been shot—a privilege for which each person in attendance had willingly paid $3.50. "I didn't think you'd remember who I was," she told the crowd. She went on to explain the scenes that would be filmed, and to introduce Kristofferson in character as John Norman Howard. "So," Barbra continued, "in the lingo of the movie, I say, 'All you *motherfuckers* have a great time!' "

Her mood changed during a pivotal scene, when a stoned John Norman Howard loses control of his motorcycle and plows into the audience. Instead of watching the motorcycle, all eyes were on Barbra standing in the wings. Grabbing the microphone, she told the crowd to look at the motorcycle—not at her. "You *can't* look at me . . . What? You wanna look at me?" she half joked in exasperation. "Well, *fuck you!*"

Peters, for one, was impressed. "She's got balls," he said. "She's telling the crowd what she wants."

The screaming matches and tantrums would continue, and no one would be more shrill or offensive than Barbra. Every look at the dailies offered new opportunities for crying jags and screamed insults—despite the fact that, with her Jon Peters–designed halo of tight brown curls, she looked younger and more attractive than ever.

"This is shit!" she would shriek. "God, what are we going to do!? I told you not to do that, why did you do it? It's wrong!"

Her rage, Pierson would later recall in a scathing piece written for *New York* magazine, was "vomited back in a savage attack." Finally, after she dressed the director down in front of the crew, calling his work "total and complete *shit*" one too many times, Pierson took her aside.

He made no mention of the fact that he had just won an Academy Award for his *Dog Day Afternoon* screenplay. But he did tell his star what he thought of her. "You're rude," he said. "There's no reason to talk that way to me, so don't do it anymore."

Barbra paused for a moment, but rather than apologize, she demanded that she share his credit as director. She had wanted to direct the film from the very beginning, Barbra told the dumbfounded Pierson, but that would have proved crushing to her boyfriend's fragile ego. Now, apparently, she cared less about the survival of their relationship than she did about getting the recognition she felt she so richly deserved. Of course, she told the director, it was a decision "you'll have to make of your own free will." After all, she admitted, "enough people in this town hate me already."

Having failed to convince Pierson to make her codirector, Barbra sent Jon to pay him a midnight call. He "raved," Pierson said, for a solid two hours—shouting and hollering even as the director stood urinating with the bathroom door wide open. The intention, Pierson assumed, was to force him to quit. But he didn't.

"I'm sick of you," Peters finally screamed in frustration. "I'm waiting until the production is finished. Then I'm going to punch you out."

No sooner had Pierson shown Barbra his rough cut of the picture than she holed up in a half-million-dollar editing room set up at the Malibu house and began reediting herself. She did, after all, have final-cut approval.

"If this film goes down the drain," she had told Pierson, "it's all over for Jon and me. We'll never work again." Driven by panic and working alongside a team of editors headed up by Peter Zinner (*The Godfather* and *Godfather II*), Barbra set a feverish pace—twelve hours a day, seven days a week for the next several months. Primar-

ily, she pared down Kristofferson's part and built up her own until his was merely a supporting role. "Where are the close-ups?" she kept muttering to herself as she searched for beautifully backlit shots of herself to fill the screen. "There are never enough close-ups . . ."

To make up for being deprived of her director's credit, she took an editing credit and a wardrobe credit. "Why not?" she told an astonished Sue Mengers. "I worked hard on the editing, and the clothes are all out of my closet. I did the work and I want the goddamn credit!"

After the requisite shouting match, Mengers convinced Barbra that the unions would come after her, and she would be the "laughingstock" of Hollywood. Just weeks before the film landed in theaters, Barbra agreed to drop her demands.

Even when the film was released five days before Christmas 1976, Barbra was not yet ready to let go. "When setting the usual levels of sound," she wrote in a note to projectionists taped to every can of film, "please make sure that Reel 1 and Reel 2 are allowed to play AS LOUD AS POSSIBLE." She also included instructions on the proper settings for brightness. "Thank you in advance," she concluded, "and you should please take good care of my kid."

Barbra's friends and industry insiders who saw advanced screenings hailed *A Star Is Born* as "brilliant," but the reviews were uniformly scathing. *Newsweek* stated that Barbra's "constant upstaging of Kristofferson goes beyond run-of-the-mill narcissism," while *Time* sniped that the scene in which Barbra wins over the rock concert crowd was "a milestone of piquant absurdity, equivalent to having Kate Smith conquer Woodstock." Under the heading A STAR IS STILL-BORN, Rex Reed called the movie a "junk heap of boring ineptitude." The verdict from *Rolling Stone*: "*A Star Is Born*—Dead on Arrival."

Even arch Barbra booster Pauline Kael hated it for being "not convincing—even for a minute." She was not the only Streisand fan who trashed the movie. Frank Rich, then writing for the *New York Post,* claimed that the film had ended his "love affair" with Barbra. "*A Star Is Born* is truly the pits—it's the work of a madwoman . . . If you ever cared about Streisand, there's little fun in seeing her make a monumental ass of herself."

Crushed, Barbra cried every time someone was brave enough to

hand her a review. "I was in shock," she later admitted. "I'd just been hearing good things . . . from professional people I respected. It was like: Who's crazy? Can people call the movie brilliant, and can the same movie be called a piece of trash?" In what amounted to a blatant attack on the integrity of the critics, she stated that all that really mattered was how the film did at the box office, since moviegoers were "the only ones who can't be bought."

Once again, Barbra proved she was critic-proof. *A Star Is Born* would go on to become her biggest film up until that time, grossing over $140 million. The soundtrack would rocket to number one, as would the single of "Evergreen."

This time at the Academy Awards, Streisand showed up to sing the song she had written—the first time a woman had ever done that at the Oscars. Later, her old Erasmus Hall classmate Neil Diamond paused before announcing the winner for Best Original Song. "Before I mention the winner," he said, "about three weeks ago I was talking to Barbra and I said, 'You know, I love your song so much that no matter who wins I'm going to read your name.' But I have to cancel out on that, Barbra. So, if I call your name out you actually won it, and if I don't call your name out, you wrote a fantastic song first time out. We'll see . . . And the winner is, 'Evergreen.'"

"In my *wildest* dreams," Barbra said as she clutched her second Oscar, "I could never, ever imagine winning an Academy Award for writing a song. I'm very honored and excited."

Streisand's collaborator offered the evening's wittiest line. "I was going to thank all the little people," the diminutive Paul Williams said, "but then I remembered I *am* the little people."

From beginning to end, Barbra would concede, the making of *A Star Is Born* was "a long-running nightmare." At times, she felt like the wailing figure in Edvard Munch's *The Scream*. "You know," she said, "a scream with no sound."

I was a personality before I was a person.

She's an egomaniac.

—Elton John

I adore her. I have always adored her.

—Prince Charles

It's Streisand, not "Streizund!"
Jeez, how famous do you have to be?

—Barbra, on the frequent mispronunciation of her name

7

—

O H MY GOD!" Francesco Scavullo cried out as the reddish-brown blur streaked toward him. All he would remember of this moment was a fleeting glimpse of glistening white fangs—and then searing pain as they bit into him.

The celebrated fashion photographer had taken the famous shot of Streisand and a shirtless Kristofferson in the clinch, and now he had been invited to her Malibu estate. What Scavullo had not counted on was being attacked by Big Red, the ill-tempered Doberman that Jon made sure stayed that way. Peters's pal and fellow carouser Geraldo Rivera called Big Red "the scariest dog in captivity. This dog was always pissed off." So much so that he tried to tear the fender off Rivera's Jaguar with his teeth. At least Big Red was no threat to Sadie; Barbra's beloved poodle had died of natural causes during the making of *A Star Is Born*.

After the attack, Scavullo was whisked to the emergency room, but his wounds proved to be superficial. He decided, in the interest of maintaining a cordial working relationship with Hollywood's most powerful woman, to forget the whole thing. It was clearly the wise thing to do; Barbra would wind up hiring Scavullo to shoot no fewer than five of her album covers.

Other mauled guests would not be so politic.

When a woman named Muriel Harris arrived at the ranch for a meeting with Barbra in January of 1977, Big Red reportedly attacked her. She sued, and the case was settled out of court. And when Big Red nearly killed neighbor Joe Kern's schnauzer, Peters never said he was sorry. Nor was there any expression of sympathy.

However, Jon, fully aware that he and Barbra were vulnerable to yet another lawsuit, did pay the schnauzer's vet bills.

Unfortunately, Big Red was simply a canine reflection of his owner. "Jon was wild in those days . . . the same way with people who pissed him off," Rivera said of his friend and frequent sparring partner. "He had a hair-trigger temper. Jon was a pit bull waiting for a chance to pounce."

One afternoon Geraldo watched Peters "deck a crazed fan who was stalking Barbra at the ranch. Jon wasted him with a rising left hook." Sheriff's deputies bought Rivera's argument that Peters was simply acting in self-defense. Several years later in Aspen, Geraldo rescued Peters once more—this time when, during an argument with his gardener over unpaid wages, Jon allegedly inserted his Colt revolver into the gardener's ear.

Peters certainly had a way with the help, especially in the kitchen. When the resident cook asked him not to open the oven before a party one evening, Jon began ranting. "This is my house," he screamed at her, "and don't you ever tell me what to do in it!" With that, he flung open the oven door—and the soufflé that was cooking inside fell.

There was another fracas in the kitchen when Barbra turned thirty-five in 1977. Moments before the new chef, Bing Fong, was supposed to wheel in the birthday cake, Peters complained that the icing was "too hard." A tussle ensued, and Jon bulldozed Fong into the kitchen counter. The chef suffered a painful back injury as a result, but was willing to settle for just $5,000. Like Barbra and a growing number of others, Fong felt threatened by the increasingly belligerent Peters.

During their joint appearance on the first Barbara Walters special, which aired just days before the release of A Star Is Born, Peters was quick to say that he believed he and Barbra would grow old together. Barbra looked at him and added with a smile, "No one else would have us." Walters understood completely. Streisand had been so controlling about camera angles, lighting, and the set that, Walters admitted, "I nearly went out of my mind."

By this time, Jon had asked Barbra to marry him on three separate occasions. Each time she turned him down. "He's so strong,

unbelievably strong," she told a friend, "but he can be scary. I never know what he's gonna *do,* y'know?"

Yet Barbra would look back at this time as one of comparative domestic bliss. Physically and emotionally spent after devoting two and a half years of her life to *A Star Is Born,* she now concentrated on the home front.

She wanted to continue transforming the Ramirez Canyon compound—now expanded to twenty-four acres—into her own Shangri-la, with five separate residences in distinctly different styles. There was the Old Caretaker House, the Victorian House, the Art Deco House, the California contemporary Guest House, and the all-pastel Peach House. There were also hiking and riding trails, a black-tiled pool, a gazebo, a running brook, tennis courts, assorted grottoes and spas, bridges and wide red-brick paths, a parking lot just inside the main gate, and tens of thousands of dollars' worth of plantings.

They could well afford it. Under the terms of her arrangement with First Artists, Barbra reaped over $15 million from the film alone. That figure climbed to well over $23 million when revenues from record sales were factored in.

Yet despite their phenomenal wealth, Barbra and Jon soon garnered a reputation for refusing to pay their bills, usually on the grounds that they were "unhappy" with the end result. Supply companies, contractors, and pool builders would have to resort to placing mechanic's liens on the property if they wanted to get paid. "They were so goddamned cheap," said one subcontractor. "It was just sickening, when you saw how much they had."

This attitude is not altogether surprising, given the fact that Barbra appeared to have done so little to help her own sister, either financially or in terms of aiding her career. "The sad thing is," said Roslyn's manager, Ted Brooks, "Roslyn *is* a major talent. She can give more power, more depth, more 'belt' to a song." But Brooks, who was dropped from Barbra's music-publishing company when Streisand learned that he was managing her sister, could not persuade Roslyn to overcome her natural reticence. "She was as good as Barbra, maybe even better technically. There is a nasal quality to Streisand's singing that her sister doesn't have, so the sound is, well,

remarkable. But Roslyn lacked the will. I guess she didn't *need* it as much as her sister, and an audience can sense that."

By 1976, Roslyn appeared to have simply given up. She worked briefly as a clerk for a minor film studio and then collected unemployment until she decided to give performing another try. In the summer of 1977, Roslyn appeared at one of New York's hottest clubs, the Grand Finale.

Although Rosyln prayed her sister would show up on opening night to lend her appearance some much-needed publicity, Barbra didn't show. She did attend a few nights later, wearing a turban, with Jason in tow. Once again, Roslyn was being touted on television and in the press as Barbra's talented little sister, a rising star in her own right.

A few weeks later, Roslyn took her act to the Back Lot in Los Angeles. This time, Barbra was in the opening–night audience, and Roslyn was introduced by her former brother-in-law, Elliott Gould. The crowd responded enthusiastically, but Barbra was aware that all eyes were on her when Roslyn was taking her bow. At that moment, a man jumped up to make way for a woman who was leaving, and Barbra assumed that he was giving Roslyn a standing ovation. Not wanting to appear anything less than totally supportive, Barbra leaped to her feet—and the entire audience instantly followed suit.

Both club dates were sold out, and reviewers predicted that Barbra's heretofore overlooked little sister was on the verge of a breakthrough. But Roslyn's long-delayed dreams for a career of her own fizzled. "You've got to keep pushing, never stop, never let up until you are where you want to be," Barbra said. Agreed a family friend: "Barbra started at rock bottom, and she made it. Roslyn's first big dates were at the Persian Room and on *Ed Sullivan,* for God's sake. Roslyn could have had a pretty good little career singing in clubs just on the basis of being Barbra's sister, she sounded so much like her. But Roslyn didn't want to settle for that. So she just gave up."

In late 1978, Barbra bought a $200,000 Beverly Hills condo for her mother to live in, and soon Roslyn moved in as well. Soon Roslyn was making ends meet working at a Westwood bakery owned by the wife of her former manager, Liz Brooks. Wary of being bombarded with questions about her famous sister, Roslyn stayed in the back doing paperwork. The bakery, which had been in

business long before Jon Peters entered Barbra's life and produced her album of the same name, was called "Butterfly."

With polls showing that she was the top female movie star for the sixth time in seven years and *A Star Is Born* picking up five awards at the Golden Globes (for Best Picture, Best Actress, Best Actor, Best Score, and Best Song), Barbra was too hot to stay idle for long. Columbia wanted to follow up on the colossal success of the *Star Is Born* soundtrack, and on April 1, Barbra was back in the studio recording *Streisand Superman.*

The album, which featured a shot of Barbra in white shorts and a Superman T-shirt on its cover, contained her memorable rendition of Billy Joel's "New York State of Mind" and another chart-topping single, "My Heart Belongs to Me."

But Barbra's heart—and her career—clearly did *not* belong to her, at least not entirely. Jon would gradually take over as her manager, squeezing out the man who had believed in her from the very beginning, Marty Erlichman. In the fall of 1977, he would negotiate a new five-year, $8 million contract for Barbra with Columbia—not to mention a handsome deal for himself as a talent scout for the label.

Jon had wasted no time capitalizing on the success of *A Star Is Born.* Now very much in demand, he was overseeing no fewer than fifteen film projects. The first to actually make it to the screen was *The Eyes of Laura Mars,* about a fashion photographer who has eerie visions of murders before they happen. Barbra turned down the lead flat—"I *hate* thrillers," she said. "They bore me." Faye Dunaway wound up playing the part, though Barbra did make one contribution to her boyfriend's first solo effort: She sang the film's theme, "Prisoner."

Not that Barbra ever took her eyes off Peters during the filming of *Laura Mars* in New York. Amid rumors of an affair between Jon and Dunaway, Barbra flew to Manhattan to attend a party for the cast and crew of the film at Studio 54. There she danced with Jason, now ten, and basically upstaged everyone else—especially Dunaway. "My eyes don't go farther than Barbra," Peters told Studio 54 owner Steve Rubell. "She's the most exciting woman in the world—the

only woman in the world for me. Barbra's magnetic . . . more than I ever dreamed of having."

Satisfied that the rumors about her lover and Dunaway were only that—rumors—Barbra returned to Malibu. She interrupted her sabbatical only long enough to collect the honors and awards being heaped at her feet. Even though *A Star Is Born* had swept several Golden Globes the previous year and Barbra technically had nothing new in the running since, she was named World Film Favorite at the Golden Globes along with Robert Redford—her fourth win in the category. Two weeks later, *Seventeen* magazine named her the woman teens most admired, as well as their favorite film star.

On February 23, 1978, Barbra won two Grammys—one as Best Female Vocalist and another shared with Paul Williams for Best Song. In a tie reminiscent of her Oscar win a decade earlier, "Evergreen" shared the award with Joe Brooks's "You Light Up My Life."

As accustomed as she was to vanquishing her competition—and as often as she herself was called a force of nature, Barbra was no match for the genuine article. When torrential rains battered the California coast, she and Jon and a group of neighbors scrambled to erect a sandbag barrier that would prevent a rising creek from flooding their property.

At one point, Jon left with his son, Christopher, to pick up more sandbags, and when they returned they were stopped by a California highway patrolman who would not let them through without proper identification. Jon, who apparently had driven off the property without his driver's license, climbed back into his car, gunned the engine, and crashed through police barriers. He was pursued by California highway patrolman Patrick Meister for three miles. When he caught up with Peters, Jon came at the patrolman in what Meister called "an aggressive manner." Meister drew his gun and struck Peters on the legs with his baton before throwing him up against the car, handcuffing him, and reading him his rights. He was charged on the spot with reckless driving and resisting arrest.

Jon spent ninety minutes in jail before Barbra could ante up the $500 to bail him out. The charges were later dropped, and though he repeatedly vowed to sue for false arrest, Peters took Barbra's advice and dropped the matter.

Peters's life—and, by extension, Barbra's—would continue to be colored by threats, tantrums, and profanity on a scale seldom found outside a locker room. In his dealings on Barbra's behalf, he did not hesitate to scream at producers, writers, directors, and other industry heavyweights. Those who ran afoul of Peters were not unaccustomed to picking up the phone and—without Jon ever pausing to say hello or identify himself—being called "cocksucker," "motherfucker," or the old-standby "piece of shit."

One who shared Jon's testerone-fueled approach to life was his new client and fellow rabble-rouser Geraldo Rivera. "We'd hang out, work out, talk about women, and get drunk together," Geraldo recalled. "We were each involved with very dominant ladies, and we commiserated . . . We dreamed of our younger days, when we were free to roam and plunder and raise hell."

One day during that summer of 1978, Barbra's lover nearly lost his life while racing his motorcycle along Mulholland Drive at speeds of up to one hundred miles an hour. Turning onto Winding Way, a back road leading into Ramirez Canyon, both Geraldo and Peters lost control of their bikes and skidded to the edge of a cliff. Bruised and shaken, Jon said nothing to Barbra about his brush with death.

By the time Barbra started shooting her next movie a few weeks later, Jon was as antagonistic as ever. "When this thing is over," Peters told Ryan O'Neal on the set of *The Main Event,* "we're gonna get in the ring and I'm gonna beat the hell out of you!"

To be sure, it seemed odd that Jon would not only convince Barbra to do a comedy about boxing, but that he would agree to let O'Neal play her love interest in the movie. Both men were amateur boxers with a macho streak, and both saw themselves as rivals for Barbra's affections. "You couldn't mention Ryan's name in his presence," said a colleague of both men. "Jon went ballistic, totally nuts." Eventually, the two men did enter the ring together and sparred for thirty minutes. Neither drew blood, and when it was over observers agreed that streetfighter Peters had won the impromptu match.

Jealousy aside, Peters could not deny the success of *What's Up, Doc?* or the fact that Barbra would need that on-screen chemistry with her leading man if *The Main Event* was going to work. Origi-

nally titled *Knockout,* the script by Gail Parent and Andrew Smith tells the story of Hillary Kramer, a once-wealthy Beverly Hills businesswoman—she is the founder of a perfume company called, appropriately enough, Le Nez (The Nose)—whose world falls apart when her accountant runs off with all her money. Hillary's only remaining asset is the contract of a washed-up prizefighter, Eddie "Kid Natural" Scanlon. It turns out that the crooked accountant, knowing that Scanlon's fighting days were over, had purchased his otherwise worthless contract as a tax write-off. Hillary, seeing Scanlon as her only hope of recouping her fortune, sets out to whip "Kid Natural" back into shape. But first she must force the retired fighter to leave his comfy job as a driving instructor and climb back into the ring to duke it out with boxers half his age. Following the usual romantic-comedy formula, the independent, hard-driving alpha female falls for the lovable schlub.

Emboldened by the sex-kitten look she affected for her *Superman* album, Barbra hired fitness guru Gilda Marx as her personal trainer. She also dyed her modified Afro Titian red. Then she set out to rewrite the script, block the shots, fiddle with the costumes, and basically redesign the look of the movie. Dissatisfied with the look of a particular set, she went so far as to have two massive doors removed from their hinges at the art deco house and brought to the studio.

Barbra treated *Main Event* director Howard Zieff in much the same way as she had Frank Pierson. "Barbra had the last word," said a Warner Bros. executive. "This time there were no illusions about that. Howard didn't even try to put up a fight, the way the others did."

Once again, Barbra complained that she was left to make the hard decisions because no one else working on the picture seemed to have strong opinions one way or the other. "I need someone who feels as strongly as I do and is willing to defend their position," she said.

Much of the problem, she conceded, stemmed from the fact that members of the opposite sex found her intimidating. But, she insisted, "I very much like working with men. It's a challenge on several levels. It's not a battle. I don't go into a film looking to 'win.' I

am not competitive in that way . . . I can't understand why some men are afraid of me—that seems to be their own hang-up."

Notwithstanding her own strident feminism—reiterated at several fund-raisers she held for Bella Abzug during this period—Barbra was intent on showing off her body to best advantage. Braless in several scenes, she also wore satin short shorts, skintight pants, and leotards. Repeatedly told by Jon that she possessed "a world-class ass," Barbra instructed the cameraman to zoom in on her posterior whenever possible.

Once she got into the editing room, Barbra made sure that most of these titillating close-ups stayed in the picture. "Hey," she joked, borrowing a famous line uttered by Zero Mostel in *The Producers*, "flaunt it!"

O'Neal, who liked to call his new movie *Glove Story*, took it all in stride. He was not even miffed when Barbra, upset when he showed up for a boxing scene in a smelly sweatshirt, halted filming and ordered a wardrobe man to run out and get five new sweatshirts. She picked one out, then ordered that it be dirtied up for the shot. Unhappy that O'Neal was working up a sweat during the boxing scenes, she had his sweatshirt sprayed with Chanel No. 5 "so you won't stink quite so much. God, Ryan, my eyes are watering! Phew!"

Ryan got his revenge by taking every opportunity to drive Streisand's jealous boyfriend crazy. Whenever Peters was on the set, O'Neal made a point of nuzzling Barbra, letting his hand linger on her backside, or making a kiss last longer than necessary. "Jon hated it," said a crew member. "He would storm off muttering, 'That motherfucker.' Ryan loved putting him through hell like that."

During filming, Barbra took time out to knock off another hit single—this one the idea of Louisville, Kentucky, disk jockey Gary Guthrie. As a poignant good-bye to his soon-to-be ex-wife, Guthrie had combined Streisand's version of "You Don't Bring Me Flowers" with the one recorded by the song's composer, Neil Diamond. Columbia executives threatened legal action immediately, but they also recognized a good thing when they heard it. Streisand and Di-

amond were coaxed into the studio, and the result was their number one duet.

In addition to income from the single, both artists got extra mileage out of the duet by including it on their albums, Streisand's *Greatest Hits, Volume II* and Diamond's own *You Don't Bring Me Flowers.* To Diamond's chagrin, Barbra's was the more successful of the two, shooting to number one on the *Billboard* album chart and certifying *quadruple* platinum. As for Gary Guthrie, the Kentucky disk jockey who hatched the idea in the first place—Columbia agreed not to pursue its suit against him.

The Main Event opened in the summer of 1979 to lukewarm reviews, and a few critics managed to get off a few memorable zingers: the *Washington Post* called it *"The Maimed Event,"* while Patricia Goldstone wrote in the *Los Angeles Times* that she was unnerved by "the direction of the camera, which hovered around our star like a bumblebee at a church picnic, losing no opportunity to zoom to her frequently displayed behind."

At the same time as her backside was being ogled on more than a thousand screens nationwide, a porn film was circulating that claimed to show a young Barbra engaged in a variety of sex acts. Barbra and Jon were shown the hard-core movie and reacted in much the same way as when they had screened *Deep Throat.* "It's just terribly boring," she said. "Besides, that girl doesn't look *anything* like me. For one thing, I was really skinny when I was that age."

Barbra refused to react defensively by taking legal action. "They've been baiting us," she said, "but we're not going to give them a million dollars' worth of free publicity." She would feel differently about a photo that showed her bare-breasted in the hard-core magazine *High Society* later that year. The shot was lifted from the topless scene Barbra had done for *The Owl and the Pussycat,* and she was furious that the footage had not been destroyed as promised. "I was a complete *idiot*," she admitted, "for trusting them."

Barbra filed a $5 million suit against *High Society* in Manhattan Federal Court. In the complaint, which also demanded that the magazine hand over the negatives, Streisand's lawyers claimed that, "through her career, she has vigorously protected her reputation and privacy by refusing consent to the release of any film or publication in which she was not fully clothed." Eventually, she settled out of

court, dropping her suit after *High Society*'s publisher, Gloria Leonard, met certain demands. She agreed to send out telegrams to five hundred wholesalers asking them to tear the offending photos out, and tape over the word *nude* in connection with Barbra's name on the cover.

"Frankly," Leonard conceded, "there will be some distributors who'll just say, 'The hell with the wire . . .' " Interestingly, Leonard took issue with Barbra's claim that the nude scene had actually been taken out of all prints screened in theaters. "She says the shots didn't appear in the final print of the picture, but . . . there they were, right in the third reel. It's fascinating that she feels humiliated about them now, but evidently didn't feel that way when the movie was released."

Leonard was also intrigued by the text Barbra found offensive. "The table of contents carries the language 'Class act, class ass: Barbra Streisand nude.' The only word she made us delete was *nude*."

These were merely minor distractions for Barbra, however, as *The Main Event* proved once again that she was critic-proof. Grossing over $70 million, the movie would be one of Streisand's most successful efforts to date—in large part due to its hit title song.

The single "The Main Event/Fight" almost didn't happen. That year, Paul Jabara had won an Academy Award for his song "Last Dance," sung by reigning disco queen Donna Summer in the appallingly bad *Thank God It's Friday*. When Jabara approached Barbra with his idea for a song with a throbbing dance-club beat, she balked. It took the intervention of her son, Jason, now twelve and a die-hard Donna Summer fan, to convince her that it was a risk worth taking. "Mom, this is great," he told her after Jabara sang the song for her. "You have *got* to do this."

The Main Event leaped to number three and stayed on the charts for the rest of the summer. It was Streisand's first disco hit, but it would not be her last—or her biggest. Soon Jabara learned that Barbra was now getting ready to record a new album with a theme—it would be called *Wet* and every song would have something to do with water. With Jason's other favorite singer in mind, Jabara arranged for Donna Summer to drop by Streisand's Malibu estate to meet Barbra.

Jabara, who had had to lock Donna Summer in a bathroom to sell

her on singing "Last Dance," was used to overcoming resistance from singers. Jason would prove to be his secret weapon in convincing a reluctant Barbra to sing a duet with Summer. When Barbra objected on the grounds that "Enough Is Enough" wasn't sufficiently "wet" for the album, Jabara added the opening line "It's raining, it's pouring" and changed the title to "No More Tears (Enough Is Enough)." Again, Jason begged his mother to do the song, and remembering how right he had been about "The Main Event/Fight," she relented.

Streisand and Summers behaved less like dueling divas and "more like giggling high-school girls," claimed Jabara. But once in the studio, each was determined not to be eclipsed by the other. They were, Jabara acknowledged, "intimidated by each other, and each couldn't understand why the other person should be intimidated."

At one point, Barbra was having trouble adapting to the disco style, which requires staying on top of the beat, rather than behind it. "You're Barbra Streisand," an incredulous Summer said. "You're asking *me* how to sing?"

In the end, it was Summer who literally fell off her stool trying to hold a note as long as Barbra. Striking her head on the floor, Summer was jolted awake—only to realize that Barbra was looking down at her, still holding the note.

Once again, Barbra called in Francesco Scavullo to shoot the cover for her new single with Summer. When he suggested that they wear Merry Widow corsets for the shot, Barbra protested that they would end up looking "like old-fashioned whores." But Scavullo had no intention of showing the corsets in the shot. He wanted to use them to push the women's breasts up, so that all that would be seen were their ample cleavage, juxtaposed in contrasting skin tones. Barbra's eyes widened with the realization of what Scavullo was trying to accomplish. "Give me that," she said, grabbing one of the corsets for herself and heading for a dressing room to try it on. "What a *great* idea. I love it!"

"That is what makes her so brilliant," Scavullo said. "Barbra doesn't waste time fighting with you if you've got a good idea. She knows one when she sees one, and when she sees one she runs with it."

Released in October, "No More Tears (Enough Is Enough)"

went straight to number one not only in the United States but internationally. It would also propel Barbra's simultaneously released *Wet* into the top ten. Incredibly, Barbra, whose impact as an entertainer in the 1960s had been exceeded only by that of the Beatles, was now finishing up the 1970s as the decade's top film star and top recording artist.

Her union with Jon, however, was fast disintegrating. Over the course of their relationship, they had always been able to retreat to their respective houses at the Malibu compound whenever their arguments got out of hand. But by December of 1979, tensions over Peters's rumored infidelity and anger-management problems had finally worn Barbra down. Their fights had escalated in frequency and intensity. When he was angry enough, he grabbed her by the shoulders and shook her hard. It was not all one-sided: Peters claimed that she once clobbered him with a chair. She did not protest when Jon packed up and returned to the Sherman Oaks house he had lived in when they'd first met.

Barbra had found a new love—Judaism, or at least her own heritage as a Jew. She had been in therapy for over fifteen years now—alone and with Jon—and the road always led back to her long-dead father. Manny Streisand had been a teacher, a Talmudic scholar. Barbra believed if she were to ever truly understand her father, she would have to understand what he believed in and why.

Memories of her maternal grandfather, Louis Rosen, rocking back and forth in his prayer shawl were still vivid to Barbra. She was certainly vocal in her support of Israel; in 1978, she had sung the Israeli national anthem, "Hatikvah," in a globally televised all-star salute to Israel on its thirtieth birthday. But she seldom went to synagogue, and never considered herself particularly observant.

When Jason turned thirteen, however, Barbra took the occasion of her son's bar mitzvah to immerse herself in the teachings of Judaism. "I wanted it to mean something to me," she told her friend Marilyn Bergman. Over the course of several months leading up to the big event, Barbra and Jason met once a week with Rabbi Daniel Lapin. Occasionally they were accompanied by Jason's father, Elliott. They discussed Jewish law and philosophy, the principles contained in the classical texts. Based on her probing questions, Rabbi Lapin pronounced Jason's mother "brilliant. She turned out to be

one of the brightest and most sincere students I've ever taught. She has a natural, almost innate facility for Jewish learning."

Her newfound piety aside, Barbra pulled out all the stops to celebrate Jason's bar mitzvah. After the small ceremony for family and close friends at the Pacific Jewish Center Synagogue in Venice, two hundred guests were taken by minibuses to the Malibu estate. There, beneath three huge art deco tents, guests like Neil Diamond, James Caan, Sue Mengers, and Ray Stark dined on kosher food and a gourmet Chinese buffet. Since a solemn Elliott had taken part in the coming-of-age ceremony, Jon Peters thought it best not to attend either the bar mitzvah or the reception that followed.

Writer Michael Medved, who had founded the Pacific Jewish Center, recalled that Jason was "a sensitive boy with a beautiful, thoughtful face and surprisingly world-weary manner." But he seemed as serious as his mother when it came to connecting with his faith. "That Jason is really something else," she told Medved. "Know what he told me? He said, 'This party tonight, this is Hollywood. But in *shul* today, that was for real. It was really okay.'"

Jason's bar mitzvah was only the latest step in Barbra's ongoing spiritual awakening. She might not have attended synagogue regularly, but she was quick to point out that she had always believed in a higher power. When she was just six years old, she would argue with her atheist friend Rosalyn Arenstein about the existence of God. One day while they were sitting on a Brooklyn fire escape and looking at the people milling about below, Barbra fought back tears as she tried to convince Arenstein that there was a deity.

"I know He's there, I know it," she insisted, pointing at a man standing on the sidewalk below. "I'll prove to you that God is real. He'll prove it to you. Because right now—just at this moment—that man down there is going to turn at the corner and cross the street."

"I mean, I never prayed so hard in my life, you know what I mean?" she recalled. "Just please, show me!"

At that instant, the man turned the corner and crossed the street. "I've never forgotten that afternoon," Barbra told Medved. "And the last couple of years, it keeps coming back to me. I've always had that kind of special relationship with whatever it is that's out there."

A few days after Jason's bar mitzvah, Barbra flew to New York

and was soon seen out on the town with a handsome, middle-aged millionaire businessman. Liz Smith referred to Barbra's new escort only as "Mr. X," which was enough to send Jon Peters into a frenzy. He called Barbra and begged her to take him back. She did, though only reluctantly. "I missed him," she told a friend. "We fight like hell, but maybe that's what love is all about. I just wish he wouldn't get as mad as he does . . ."

Taking Peters back was easy, since she had never had any interest in pursuing a romance with "Mr. X." The stranger Barbra had been seen around New York with was aspiring Israeli film producer Arnon Milchan. She had hoped that Milchan would help her raise money for a movie project based on a short story by Nobel Prize winner Isaac Bashevis Singer. The story was called "Yentl the Yeshiva Boy."

On February 27, 1980, millions of television viewers tuning into the Grammy Awards were stunned when, suddenly and unannounced, Streisand and Neil Diamond appeared on opposite sides of the stage and began singing "You Don't Bring Me Flowers." As they walked toward each other and finally met in the center of the stage, pandemonium erupted in L.A.'s Shrine Auditorium. Then, at the song's conclusion, Diamond took Barbra's hand and kissed it. The entire scene had been elaborately choreographed by Barbra, who had phoned Diamond up hours before the show and given him his marching orders.

Barbra was genuinely shocked at the excitement she and Diamond had been able to create. "She still lived in a kind of bubble of insecurity," said a former employee. "She distrusted the public, really, and even though she worked like a Trojan and always seemed to have a hundred projects going at once, Barbra liked to call herself lazy. So these spontaneous outpourings of love always took her by surprise. She used to say, 'I thought they'd forgotten me.' Like she was Gloria Swanson or something."

Indeed, Streisand was already hard at work with another pop act—the biggest in the business at the time. The Bee Gees—brothers Maurice, Robin, and Barry Gibb—had managed to score an unprecedented six number one singles in a row after the release of their record-smashing *Saturday Night Fever* soundtrack album.

It would take nearly two years of hard negotiations between Barbra and the Bee Gees' flamboyant manager, Robert Stigwood, who at first insisted that the royalties on any album be divided equally among Barbra and *each* of the Brothers Gibb. In the end, Stigwood knuckled under to Barbra's demand that she get half the proceeds and the brothers share the rest.

Creatively, however, it was Barbra who knuckled under. While she worried that her voice might be overwhelmed by the Bee Gees' distinctive falsetto harmonies, Barry Gibb feared she would try to push the brothers too far into the background. "She was this great big star—the biggest, really—and of course we were kind of in awe of her," he said. "She knew *exactly* what she wanted, but so did I." He admitted that they both "treaded on eggs until we actually got to know one another . . . She wanted my ideas and she gave me a lot of leeway—but she also wanted me to listen to her ideas, which I was glad to do."

Streisand had offered up a half-dozen songs for the album, and Barry Gibb threw them all out. Instead, he began to write the entire album expressly for her—all the songs but one, "The Love Inside." Not only did he write the material, but he laid down all the tracks at his own studio in Miami without any input or interference from Barbra.

At the last minute, however, Barbra reneged on one of the songs. She simply refused to include it in the album, forcing Barry to quickly pen a replacement. The result, her duet with Gibb called "Guilty," would also provide the title for the album. Rocketing to number one on its September 1980 release, *Guilty* would sell twenty million copies worldwide and become the biggest-selling album of her career. Nearly as important to Barbra, the critics were jubilant. The verdict from the *New York Times: Guilty* was "just about perfect."

Streisand's pop collaboration with the Bee Gees would spawn three number one singles, "Woman in Love" as well as the title track and another duet, "What Kind of Fool?" It was a question Barbra could have asked anyone who wondered why in the fall of 1980 she was playing a supporting role in a suburban comedy called *All Night Long*—and being billed *below* star Gene Hackman, at that.

What kind of fool would turn down $4.5 million plus 15 percent

of the gross profits for twenty-four days work? The terms of Barbra's contract, worked out when actress Lisa Eichhorn was unceremoniously dumped from the film, set a new record for female film stars. "It's about time," Streisand said. "Why shouldn't I be paid as much as Robert Redford or Warren Beatty?"

Although her paycheck was, by the standards of the day, nothing short of phenomenal, Barbra believed she was doing a friend a favor. The director of *All Night Long*, Jean-Claude Tramont, just happened to be married to her longtime agent and pal Sue Mengers.

The role Streisand had agreed to play—for a price—was that of Cheryl Gibbons, the dizzy blond wife of a Southern California firefighter who dreams of becoming a country-western star. Hackman plays hapless store manager George Dupler, the man who eventually leaves his wife for the delightfully empty-headed Cheryl.

Like all of her leading men, Hackman started out casting a wary eye in her direction. "Yes," Hackman conceded, "she can be difficult. So can I." As for the fact that the script was hastily being rewritten to accommodate someone of Barbra's stature, Hackman had made it clear that these changes were not to cut into his screen time. "It's mostly my film," Hackman said, referring to Barbra's small part. "It's about my character, not hers."

All Night Long was a critical disappointment and a commercial calamity, making the poorest showing of any Streisand film. After just three weeks in theaters, Universal made the decision to pull it from theatrical release. It had cost $14 million to make, and earned less than $8 million at the box office.

For Barbra, it also signaled the end of her relationship with her agent and confidante Sue Mengers. While neither would discuss the reason for the breakup, it was reportedly triggered by Mengers's lack of enthusiasm for the next movie Barbra wanted to make—a film that had, over the course of a dozen years, become her all-consuming passion: *Yentl*.

Terrified, Barbra jumped up from the table, ran to the bathroom, and locked herself in. "Barbra?" her brother, Sheldon, asked through the door. "Are you all right?"

"No, I'm not *all right,*" Barbra replied. "For God's sake, Shelly, I am so scared."

It had all begun earlier on that crisp autumn day in 1979, when Barbra asked Sheldon to take her to Mount Hebron Cemetery in Queens to visit their father's grave. It was the first time she had been there in thirty years, and she asked her brother to take a picture of her standing in front of Emanuel Streisand's tombstone. When she got home and saw the photo, she was stunned to see the name "Anshel" carved on the tombstone next to her father's. In the Isaac Bashevis Singer story "Yentl the Yeshiva Boy," Anshel is Yentl's dead brother. She takes his name when she masquerades as a man in order to study the Talmud.

"I couldn't believe it," she recalled. "That's a very unusual name. I mean, it's not like Irving . . . To me it was a sign, you know, a sign from my father that I should make this movie."

It wasn't the only sign. Not long after the graveyard incident, Sheldon called his sister to tell her that he reached their father during a séance. "I can't tell you the experience I had last night," Sheldon said. "I talked to Daddy. We put our hands on this table, and the table moved its legs and started to spell out Daddy's name. Then the table followed me around the room."

Since Sheldon, a manager of real estate investment partnerships, had always been a solid citizen ("My brother is not a dreamer, he's structured in the right world, he's not a spiritualist or anything, he's not on drugs, he has a house on Long Island . . ."), she was intrigued. Barbra asked him to invite the psychic again ("a nice, ordinary-looking, Jewish lady with blond hair"), and this time she joined them. Barbra, Sheldon, and the psychic sat around a small wooden table with their palms flat on the tabletop and the lights out. Once the table started to move, Barbra became "very suspicious. I thought it was electrical energy moving the table."

Then the legs of the table began tapping out a message—one tap indicated the letter *a*, two taps stood for *b*, three for *c* . . . "The table was pounding away," Streisand said. "Bang, bang, bang! Very fast, counting out letters. Spelling M-*A*-*N*-*N*-*Y*, my father's name, and then *B*-*A*-*R*-*B*-*R*-*A*. I got so frightened I ran away"—straight into the bathroom.

After a few minutes, Sheldon was able to coax his sister out of the

bathroom and back to the table. This time the table spelled out *S-O-R-R-Y* and *S-I-N-G P-R-O-U-D*.

Barbra walked away from the séance more determined than ever to make *Yentl* a reality. "It sounds crazy," she conceded, "but I know it was my father who was telling me to be brave, to have the courage of my convictions, to *sing proud!*" And for that word *S-O-R-R-Y* to come out—I mean, God! It was his answer to all that deep anger I had always felt about his dying."

More to the point, she believed her father "was telling me to go ahead and make *Yentl*." The fact that Manny had "begun to exist" for Barbra had "a lot to do with *Yentl,*" she explained. "I want to dedicate this film to my father."

Barbra had actually wanted to bring Isaac Bashevis Singer's tale to the screen ever since she had first read it in 1969. She was hooked from the opening words: "After her father's death . . ."

Yentl tells the story of a rabbi's teenage daughter in turn-of-the-century Poland who is, despite prohibitions against women studying the Talmud, determined to become a Talmudic scholar. Following the death of her beloved father, she disguises herself as a boy, changes her name to Anshel, and attends a yeshiva. Soon she falls in love with her strapping male study partner, Avigdor. Then Yentl, eager to establish her credentials as a man, allows Avigdor to push her into marrying Hadass—the woman Avigdor actually loves.

In 1971, First Artists announced that it had hired Czech director Ivan Passer to direct the movie, based on a screenplay by Singer. The film was now retitled *Masquerade*. But Passer dropped out, and over the next several years Barbra would commission eight new versions of the screenplay from different writers. The curmudgeonly Singer, not surprisingly, became one of her earliest and harshest critics. "What do you know about Poland, the Talmud?" he demanded. "You're an actress—make a movie about acting!" As for her desire to be more than just the star of the film: "You want to be the writer, the producer, the director, the actress, and even the singer as well?" Singer asked incredulously. "This is artistic suicide!"

The response from Hollywood's moneymen was similarly negative. She would shop the movie to every major studio in Hollywood, only to meet with rejection at every turn.

By the time she was wrapping *A Star Is Born* five years later, Bar-

bra had to admit to herself that at thirty-four, she was too old to play the part. Now she would assume the mantle of director—a decision that would give studio executives a whole new set of reasons to turn her down. "I guess I couldn't blame them," she later said. "On the surface *Yentl* was anything but commercial—me, a first-time director telling a story about a Jewish girl at the turn of the century in Eastern Europe who dresses up as a boy in order to study the Talmud!"

At one point, Jon Peters became fed up with Barbra's grand obsession. She had turned down a $2 million offer to perform at London's Wembley Stadium, and more than $10 million to return to Las Vegas. "I *hate* this movie," she said while finishing up *The Main Event*. "I'm going to do *Yentl*."

"You're not going to do it," Peters shouted back. "You're not going to ruin your life and mine! You can't play a *boy!*"

Barbra studied Peters for a moment. "Just because you said that, I'm going to do the movie, NO MATTER WHAT!"

Later, Barbra thanked Peters for giving her the impetus to pursue her dream. "I needed a direct challenge—somebody like my mother to tell me I couldn't do it," she said. "Then I'd get mad and do it. Jon gave me the challenge. He told me straight out I'd never make the picture."

In fact, Barbra had pursued other roles—serious, nonsinging parts that would test her limits as a dramatic actress—while working behind the scenes to bring *Yentl* to the screen. Most significantly, she went after the title role in the film adaptation of William Styron's landmark novel *Sophie's Choice*. In addition to auditioning for the part, she offered to forgo her salary in exchange for a nominal percentage of the profits. Instead, the part went to the equally determined Meryl Streep, whose flawless Polish accent and ethereal beauty captivated director Alan Pakula. Streep would go on to win a Best Actress Oscar for her performance.

Despite persistent rumors to the contrary, one role Barbra did not persistently seek was the lead in the movie version of *Evita*. Again, Meryl Streep was a front-runner, as were Bette Midler, Cher, Olivia Newton-John, and the woman who had created the role on Broadway, Patti LuPone. The only point at which Streisand was ap-

proached occurred when Franco Zeffirelli thought he might direct
the movie.

"You know, I think people just WANTED me to do it," Barbra
later said. "The rumors always made it look as if I was dying to play
the role." But when she finally saw the play, she was disappointed. "I
didn't like it," she said. "I didn't want to play Eva Perón!" It would
take another nineteen years before *Evita* was finally brought to the
screen, with Madonna as its star.

It was not until 1978 that Barbra, at the urging of her lyricist
friends the Bergmans, decided to turn *Yentl* into a musical. Michel
Legrand, whose lushly romantic style would be perfectly suited to
convey the movie's Eastern European mood, was quickly brought
on board.

Theoretically, a musical would be much easier to sell to a
studio—particularly if Barbra was singing the songs. To convince
herself that she was not too old to tackle the part, she rented a cos-
tume, taped down her breasts, donned a hat and eyeglasses, stuck a
pipe between her teeth, and ambled into her Malibu bedroom at
two A.M. Peters was startled awake and almost attacked the strange
male figure in the doorway—until he realized it was Barbra.

Now, even Peters was convinced Barbra could play a boy. As for
being too old, Streisand merely raised the age of the character from
sixteen "to about twenty-eight."

All the while, Barbra became a voracious student of Judaism, dis-
secting every word and phrase in the Torah, attending weddings and
bar mitzvahs, seeking counsel from scores of rabbis representing the
religion's Reform, Conservative, and Orthodox branches. One of
the experts she consulted was bestselling author and rabbi Chaim
Potok. "She asks questions openly, unself-consciously," Potok ob-
served, "with no hint of embarrassment, and takes notes with the
assiduous concentration of one long committed to learning. I have
no way of gauging the depth of her comprehension. Her mind
leaps restlessly, impatiently, from one subject to another; she wishes
to know everything and quickly."

At times, Potok apparently felt that he was being exploited. He
had originally been assigned to interview her for *Esquire,* but she
made it clear that in exchange for sitting down with him, she

wanted not only his insights but help reworking the script. Potok said he began "to feel like a character in a bad novel."

At one point, Barbra asked, "I'm not taking advantage of you, am I, Chaim?" Potok remembered that she "says this seriously with no attempt to charm . . ."

"I am taking advantage of you," she admitted, "but we're both trying to do the same thing."

Most of the people who provided Barbra with valuable insights into Jewish laws, customs, and traditions received nothing in return. One New York woman who claimed to have given Barbra a crash course in Jewish music and culture went so far as to file a civil suit demanding $77,500.

Several institutions were rewarded handsomely by Barbra, particularly if they devised a way to memorialize her father's name. Her six-figure gift to Medved's Pacific Jewish Center would result in the center renaming its primary school the Emanuel Streisand School.

Another $500,000 was donated to the Hillel Center at the University of California at Los Angeles, where Streisand did a considerable amount of research. That donation went to establish the Streisand Jewish Cultural Arts Center at UCLA. Continuing her ongoing homage to her long-dead father, Barbra would give yet *another* half-million dollars to fund the Emanuel Streisand Chair in the department of cardiology at UCLA Medical School.

In September of 1980, Orion Pictures announced that it had agreed to produce *Yentl* with Streisand as both director and star. With that, Barbra headed off to Prague to scout locations and soak up the local atmosphere. She made a Super-8 home movie of herself walking the streets in the costume, and recorded a background tape of her singing several of the Bergman-Legrand songs written for the movie.

Not long after she returned to the United States, a film called *Heaven's Gate* bombed, losing an estimated $35 million for United Artists and sending the industry into a panic. Across the board, most films with projected budgets in excess of $10 million were axed. Barbra had just submitted *Yentl*'s $13 million budget to Orion, which acted swiftly. It canceled the picture.

Deflated, Barbra was once again forced to pound the pavement in search of a studio to back her film. And once again, she suffered one

humiliating rejection after another. The most crushing turndown came from Paramount's Sherry Lansing, who looked at the film Barbra had taken of herself in Prague, listened to Barbra singing the new songs, and then sat back while Barbra acted out the key scenes. When it was over, Lansing delivered her verdict: The story was too "ethnic" for Middle America. She told Barbra to come back to her with an idea for a comedy.

Streisand, crushed, wept as she left Lansing's office. "I couldn't believe," she said, "that a *woman* wouldn't understand how universal this story was." In the end, she said, *Yentl* was "a love story that would appeal to people around the world."

Coming off the huge box-office success of *Caddyshack* in 1980, Jon Peters teamed up with former Casablanca records honcho Neil Bogart and ex-Filmworks executive Peter Guber to form Polygram Productions (later renamed the Boardwalk Company). Apparently adhering to the old notion that any movie in which Barbra sang would be a hit, Peters agreed to produce *Yentl*.

"Boyfriends," Streisand cracked, "sometimes come in handy." But it was not to be. Jon and Barbra were soon battling over how the movie should be made, and she had no intention of letting anyone—not even her boyfriend of eight years—interfere with her vision of *Yentl*. Polygram dropped *Yentl,* and once again Barbra was reduced to toting her Super-8 home movie around town.

Curiously, United Artists—the very company that had shaken the industry to its foundations with its megaturkey *Heaven's Gate*—wound up coming to Barbra's rescue. To compound the irony, the decision to back *Yentl* was made by the studio's new chiefs, David Begelman and Freddie Fields. Back in 1969 when he'd been her agent, Begelman was one of the first people to tell Barbra that she was "totally nuts" to think she could "play a boy and get away with it."

Now that she had been given the green light, Barbra was terrified. But, she told Chaim Potok, "I *have* to do this . . . I'm tired of saying 'I could have done this.' I want to *do* it. Because life is growing short. Maybe because my father was so young when he died, I seem to have a drive to get it all in. I want to take chances now. I want to risk failure, I want to put my money where my mouth is."

She had, in fact, invested $500,000 out of her own pocket even

before United Artists agreed to finance *Yentl* to the tune of $14.5 million. Nor were the terms of her UA deal particularly generous. Before her old pal Begelman gave the nod, she had to accept a relatively modest $3 million to star in the movie and the Directors Guild minimum salary of $80,000 to direct it. She also had to give up script approval (although she actually wound up cowriting the screenplay with Jack Rosenthal), casting approval, and—most important of all—approval of the final cut. And if the film went over budget, any cost overruns would be paid for by Barbra. "Nothing mattered to me"—she shrugged—"except getting this movie made."

That was not entirely true. During this period, she also managed to record *Memories,* a collection of ballads that included just two new songs. One of those was "Memories" from the Andrew Lloyd Webber musical *Cats. Memories* would become another blockbuster, selling over three million copies and earning Barbra an estimated $5 million in royalties.

"It was time to put up or shut up," Barbra now said of *Yentl* and the daunting task that stretched before her. "I was terrified I would fail, but I was tired of playing it safe." With veteran character actor Nehemiah Persoff cast as Yentl's father ("I have a father now—I created him") and Steven Spielberg's future wife Amy Irving as Hadass, Barbra turned her attention to finding the right leading man. After first choice Richard Gere ("You can act in it or direct it, Barbra, but I won't be in your picture if you do both") and Michael Douglas turned it down flat, Barbra then considered John Shea, Kevin Kline, and Christopher Walken. Ultimately, Mandy Patinkin, who had won a Tony playing Che Guevara in the Andrew Lloyd Webber musical *Evita,* got the part.

In order to bring the film in on time and under budget, Barbra also agreed to shoot it in London and on the Continent, where production costs were less. "If I make the picture," she asked sixteen-year-old Jason, "will you come with me and go to school in London?" But Jason refused; a sophomore at the private Crossroads High School in Santa Monica, he had no intention of leaving his friends behind and trying to make new ones in a strange new city.

As she always did at moments like this, Barbra consulted her therapist. They decided that now was the right time to cut the apron

strings—at least for the year it would take to make *Yentl.* "I had to let go," Barbra said.

Shooting began on April 14, 1982—ten days before Barbra's fortieth birthday. Her first day on the set at London's Lee International Studios, she was presented with a gift by the crew—a personalized director's chair. The gesture "touched me," Barbra recalled.

She was also moved by the fact that, when she took a crew member's hand that first day, his palm was sweating. "Believe me," she told him and the rest of the crew, "there's no one more nervous than me. We're all going to make mistakes, especially me. I will make most of them. So I need you."

"That power is very humbling," she said of officially taking on the director's job for the first time. "And I found myself being very soft-spoken, feeling even more feminine than I have ever felt. More motherly, more nurturing, more loving. I had patience I never dreamed I would have."

Certainly Barbra, functioning simultaneously as coscreenwriter, producer, director, star, and self-confessed perfectionist control freak, had to deal with the inevitable confusion caused by wearing so many hats. "Sometimes I'd be talking to the director, but I'd really be talking to the actress," Patinkin said, scratching his head. ". . . And I certainly didn't want the *producer* to hear. Then I'd want the writer in on the discussion, and wait—the writer is here . . ."

Yet Patinkin was surprised that the legendary diva not only encouraged candor on the set, but demanded it. "We saw that she really wanted to know what we thought," he said, "so we really told her. She was demanding, yet flexible and compassionate," he said, "with the gentleness of a woman."

From London, cast and crew moved to Roztyly, a tiny village in the Czechoslovakian countryside. For more than five months, Barbra worked up to twenty hours at a stretch, rising before dawn, acting all day, then viewing the dailies and staying up until two A.M. to get ready for the next day's filming. She pushed herself to the brink of physical collapse, but never let it show. "I couldn't crumble," she said, "or everything else around me would crumble."

At no time did Barbra ever let even the smallest detail go unattended to. She had, after all, been going over the film in her head for years. "I never saw anybody plan and work like that in my life,"

Sydney Pollack said. "I mean, for five years before production she was talking to everybody she could about it. I'd go to a party and she'd come over and say, 'Now look, if I want to begin on the rooster on the weathervane on top of the church, how would I . . .' She was *consumed*."

"She was just so meticulous," concurred Amy Irving, who said that Barbra treated her "like her little doll that she could dress up. She'd fix my hair ribbons, brush an eyelash off of my cheek, paint my lips to match the color of the fruit on the table, or the color of the wallpaper . . ."

Barbra also made deft use of casting and camera angles to make herself look more masculine—to make it look as if she could pass for a young man. Patinkin, a strapping six feet and 175 pounds, made this all the more difficult, since by comparison Barbra looked tiny, almost delicate. So she kept to a minimum the scenes where Anshel and Avigdor occupied the same frame. In other scenes, she cast several young girls as boys in the yeshiva; the boys hired to play boys were slight and pale, with feminine features. To make herself look more masculine, for the first time she allowed herself to be shot primarily from the right.

Ironically, one of the most unsettling moments for Barbra came when, as Yentl/Anshel, she/he had to kiss her/his "bride." Although Amy Irving would have preferred that they practice the kiss, Barbra nervously avoided kissing Irving until the actual filming. Irving was disappointed that the kiss turned out to be perfunctory. "She cut it off a lot quicker than I would have," Irving said. As for Barbra's declaration that the kiss "wasn't so bad—it was like kissing an arm," Irving was insulted. "Gee," she said, only half-joking. "An *arm*. Thanks, Barbra."

Streisand also sang all nine songs in the movie. Patinkin was irked that he had not been given a single number, but he had to concede that Barbra's determination to bring the film in on time and on budget was "phenomenal." According to Patinkin, Barbra "never got more than four hours' sleep, and usually three. We were concerned for her. Yet she never flagged and looks wonderful on film. Some mysterious power sustained her."

It was no mystery to Streisand. "It was my father," she said. "He watched over me."

Filming on *Yentl* wrapped in October of 1982, and Barbra began dubbing the soundtrack. The studio insisted she do the job in six weeks, but she told them she needed ten. When the studio threatened to take the film away from her and hire another director to finish the job, she begged for the extra time. "Please, we're going to ruin the movie," she pleaded. "I'm going to die from the pressure. This is supposed to be a joyous experience!"

Yet Barbra also felt that taking on the challenge of making *Yentl* had only strengthened her already steely resolve. "I thought this kind of work would either kill me or make me stronger," she said. "And it has made me stronger because I survived."

When she was done editing the movie, Barbra asked her friend Steven Spielberg to take a look. "Don't change a frame," he told her. But when the *Los Angeles Times* ran a piece stating only that she had sought Spielberg's advice—leaving out his verdict that her cut was flawless—Streisand exploded. "It's so damn *insulting*," she said. "It's like saying, this woman . . . can't make a film without the help of a man." In truth, Spielberg told Barbra that *Yentl* was "the best directing debut since *Citizen Kane*."

No matter. Since *Yentl* had gone $1.5 million over budget, Barbra was forced to return half her salary to the studio as per the terms of her contract. In the meantime, Patinkin, Irving, and everyone else who worked on the picture had to scrupulously abide by the terms in their contracts—especially the one in which they were forbidden to speak ill of Barbra. "I know that Mandy was royally pissed off about a lot of things," said a colleague, "but it wasn't as if he was in a position to speak out."

On June 5, 1983, Roslyn married casting director Randy Stone in a small ceremony at the Malibu compound. Despite the fact that Barbra was a short drive away working on *Yentl,* she did not attend her little sister's wedding. Roslyn's marriage would break up after less than a year.

In the meantime, Barbra's own nine-year relationship with Jon Peters was, as she put it, at "a turning point." While she was obsessed with breathing life into *Yentl,* Peters traded in his jeans for a wardrobe of custom-made suits, shaved his beard, cut his hair, and transformed himself into the very image of a coolly professional executive. Without Barbra's involvement, he had already produced the

critically acclaimed Costa-Gavras film *Missing,* and would go on to make such diverse hits as *Flashdance, The Color Purple,* and *Rain Man.* "We were butting horns because I was passionately involved in *Yentl,*" she said, "and neglecting him. We had also been too dependent on each other. And you come to resent dependency. We needed to be apart."

Later, she would offer a simpler explanation: "I had to choose between my work and my personal life, and I chose my work." In the months before *Yentl's* release—and after they had agreed to split up—Streisand and Peters assiduously avoided each other. While lawyers sorted out the terms of their property settlement, Barbra threw up a fence between her portion of the property and his.

After he was seen with model Lisa Taylor in New York, Peters moved on to a tempestuous relationship with comely interior decorator Christine Forsyth—an affair that would ultimately lead to marriage. "Christine was blond, glamorous, and there was talk he was going to make her into a star," said a friend of Forsyth's. "Was Barbra Streisand jealous? You *bet* she was." Returning to Malibu one night, Peters parked his car on Barbra's side of the fence. He awoke the next morning to find that Barbra had had it towed away.

Streisand, as it turned out, had also moved on. After an on-again, off-again romance with Richard Gere that had actually begun when she tried to convince him to star with her in *Yentl,* Barbra reunited briefly with Pierre Trudeau.

Still, it was Jon Peters who escorted Barbra to the premiere of *Yentl* at the Cinerama Dome theater in Los Angeles on November 16, 1983. She had started out the day with a full-fledged anxiety attack. She dashed to the store, bought all the chocolate-covered marzipan and walnut cookies she could carry back to the car, and began stuffing herself. "I said the hell with it," she recalled. "That's how scared I was."

She was right to be apprehensive. After all, she had had the temerity to seize every major credit for herself. Many were hoping that *Yentl* would be an embarrassment, and that the famously narcissistic Miss Streisand would wind up with ego on her face.

That did not happen. Reviews for *Yentl* ranged from rapturous to tepid. *Time* loved it, as did *New York, The New Yorker,* and the *L.A. Times. Newsweek's* David Ansen proclaimed *Yentl* her best effort

since *Funny Girl*. *New York Times* critic Janet Maslin, on the other hand, accused Streisand of wearing a "designer yarmulke" and claimed that "technical sloppiness is evident throughout."

"Technical sloppiness!" yelled Barbra when she read the review. "That so-called designer yarmulke is an authentic one from the period. How can anybody not check such facts and be a critic?"

The dedication—*To my father—and to all our fathers*—angered Diana Kind, who made it clear to her daughter that she had felt snubbed. But clearly the act underscored the fact that *Yentl* had been, from beginning to end, a labor of love. The movie was Streisand's "chance to say kaddish for her own father," Peters said. "She created him on film so she could love him and say good-bye to him . . . I cried when I saw the movie. I sobbed, actually. I wish I had produced it."

There was another reason Peters wished he had produced *Yentl*: It was a solid hit here and abroad, raking in $100 million worldwide. Barbra pocketed an additional $6 million on the sale of the soundtrack alone.

All of which rankled Isaac Bashevis Singer. Barbra had paid him a grand total of $60,000—the last $20,000 installment of which had been paid to him the day the movie opened.

"As it is," Singer wrote in a *New York Times* article published more than two months after the film's release, "the whole splashy production has nothing but a commercial value." After stating point blank that he did not like Streisand's adaptation, he attacked her singing ("My story was in no way material for a musical, certainly not the kind Miss Streisand has given us"), her acting and directing ("One cannot cover up with songs the shortcomings of the director and the acting"), and her ego ("When an actor is also the producer and the director and the writer he would have to be exceedingly wise to curb his appetites. I must say that Miss Streisand was extremely kind to herself. The result is that Miss Streisand is always present, while poor Yentl is absent").

Barbra merely shrugged off the criticism as coming from a crotchety old man—one who, incidentally, was not sharing in the film's enormous profits. "If a writer doesn't want his work changed," she said, "he shouldn't sell it." She also believed Singer would never have made such harshly critical statements had she been a man. "Mr. Singer is a noted misogynist," she said. "I am not."

Barbra could take comfort in the fact that, on the very night be-fore Singer's scathing piece ran, she had picked up two Golden Globe Awards—as Best Director and for Best Motion Picture. Streisand was thrilled, but she also realized that the Golden Globes were bestowed by the foreign press. Recognition from her peers would not be so readily forthcoming.

Passed over by the prestigious Directors Guild, Barbra was also dealt a blow by her colleagues in the industry. *Yentl* would receive five Oscar nominations—one for Amy Irving as Best Supporting Actress, one for art direction, and three for the film's music. But Barbra would be pointedly ignored as screenwriter, producer, ac-tress, and—most devastating of all—director.

"She was very hurt and disappointed," Marilyn Bergman said. "To exclude *Yentl* that way defies understanding." Barbra felt she understood all too well. "Hmmm," she mused after hearing the news. "They really must hate me."

Barbra and Jon certainly did not hate each other, but by early 1984 there was no hope that the passion they once shared could be rekindled. On February 22, Jon sold his interest in the Malibu estate to Barbra, bringing an official end to their personal relationship. "Hey, it lasted ten years," she said. "That's a major accomplishment in this town!" Peters would, however, continue as her manager for several more years.

"Before I was afraid to be alone," Barbra said of her breakup. "There was a void inside me. Now I have *myself*. I feel filled from within."

At the Academy Award ceremonies in April 1984, protesters waved placards in the faces of celebrities filing into the Dorothy Chandler Pavilion. Borrowing from the best-known song in the film, "Father, Can You Hear Me?," one sign read OSCAR, CAN YOU HEAR ME?

Even those in the industry who had never counted themselves among Barbra's fans were outraged. "I know Barbra and don't par-ticularly get along with her, but the Academy hates her," said film producer Simone Sheffield, one of the organizers of the Oscar protest. "If Norman Jewison had directed it, *Yentl* would be up for Best Picture, he'd be up for Best Director, and she'd be up for Best Actress."

Barbra was in London promoting *Yentl,* but called to congratu-
late Michel Legrand and the Bergmans as soon as she learned they
had won an Academy Award for Best Score. In truth, the outrage
over Streisand's Oscar rebuff resulted in a publicity bonanza for
Barbra. As she moved from one glittering *Yentl* function to the next,
Barbra reveled in her new real-life role as the victim of rampant
sexism in Hollywood.

In London, she received a standing ovation at the film's royal pre-
miere. In Paris, designer Pierre Cardin threw a party for her at-
tended by the likes of Jeanne Moreau, Placido Domingo, Roman
Polanski, several Rothschilds, two barons, a baroness, two princesses,
and the Aga Khan. When she went shopping at Ungaro, ninety pho-
tographers gathered outside the store to snap her picture. In Rome,
she lunched with Fellini. In Jerusalem, she opened a new study cen-
ter at Hebrew University. "I'm so glad," she said, "that now women
can study Jewish philosophy without having to disguise themselves
as men."

There were rocky moments, of course. In Rome, two of Barbra's
bodyguards were arrested for roughing up a paparazzo. Streisand ran
afoul of secular Jews in Israel when she asked that *Yentl* not be
shown on the Sabbath. And, true to form, wherever she went, Bar-
bra kept people—important people—waiting an hour or more.

Despite the Oscar snub and the fifteen years it took to make
Yentl, she had no regrets. "See, all these years I was just looking for
a daddy in a way," Streisand said, "and then I realized I was never
going to get him. It was only through *Yentl* that I had a chance to
make a father . . ."

Barbra would come to view *Yentl* as her most important—and
satisfying—professional achievement. "The joy was in the work it-
self," she said. "It was wonderful . . . like being pregnant, every mo-
ment is creative. And frightening. And exhausting." Ultimately, she
said, the experience changed her. "Before, I was driven. Now I'm
doing the driving. It's easier being around me these days."

Certainly one unlikely suitor seemed to think so. Even before
Yentl's release, Barbra had begun a relationship with one of the most
enigmatic figures on the Hollywood scene—Emad Fayed, known to
his friends as Dodi. The Egyptian-born son of controversial Har-
rods department store owner Mohamed al-Fayed, Dodi al-Fayed

had been raised a Muslim but moved effortlessly among British, Greek, French, Egyptian, and American friends. He'd attended an exclusive Swiss boarding school and bounced from one home to another in London, France, Dubai, and Egypt. Nothing was denied Dodi. At fifteen, he was given his own apartment in London's exclusive Mayfair district—and a chauffeur-driven Rolls-Royce.

Like Jon Peters, Dodi was determined to become a major player in the film industry. Backed by his father's money, he established his aptly named Enigma production company in 1979. Dodi quickly realized his dream when just two years later he won the Oscar for Best Picture as executive producer of *Chariots of Fire*. Unlike Peters, Dodi, who was seated in the audience, was too shy to accompany producer David Puttnam onstage.

Dodi exhibited no such reticence with members of the opposite sex. During his Hollywood sojourn, he was linked at various times with Cathy Lee Crosby, Valerie Perrine, Mimi Rogers, Winona Ryder, Patsy Kensit, and Brooke Shields. Not surprisingly, several of his friends believed he was only collecting "trophy women."

Dodi's ex-paramours disagreed. They described him as generous, warm, attentive, romantic, and, given his great wealth, surprisingly modest. Quiet by nature, Dodi was also that rarest of commodities among the hard-driving men of Hollywood—a great listener.

Barbra had first met Dodi back when she was scrambling to get studio backing for *Yentl*. "She was impressed with Dodi because she had seen *Chariots of Fire* and, like everybody else, thought it was a masterpiece," said a friend of Fayed's. (Barbra eventually hired *Chariots of Fire* cinematographer David Watkin to shoot *Yentl*.) "Dodi just landed in town and boom, produced this wonderful movie for Warner Bros. more or less overnight. I think she just wanted to know how the hell he did it. And besides, I think he intrigued her as a person. Dodi was not your run-of-the-mill Hollywood shark. He was the anti–Jon Peters."

As immersed as she was in all things Jewish, Barbra did not have any reluctance about dating a Muslim. "Barbra had already fallen for one Egyptian," said a mutual friend, referring to Omar Sharif. "There was a warmth about Sharif, and Dodi had it, too." Dodi was also young—at twenty-seven, he was fully fifteen years Barbra's junior.

Dodi's women felt protected in his company, and Barbra was no exception. He surrounded himself with burly armed bodyguards, in part because he shared his father's abiding fear that he would be kidnapped and held for ransom.

Sometimes, he clearly went overboard in his desire to safeguard his girlfriends from the paparazzi. Just before he began dating Barbra, Dodi was involved with Koo Stark, the porn star whose scandalous 1982 affair with Britain's Prince Andrew was splashed across the front pages of newspapers around the world. When photographers tried to corner them as they left New York's Pierre Hotel, Dodi told his chauffeur to floor it. Stark held on for dear life as their car rocketed up Madison Avenue and came to a screeching halt only after a near collision with a cab. Stark was shaking, but Dodi seemed completely unaffected by their wild ride. "We could have been killed," she said, "but he didn't seem to comprehend that."

Unlike Stark, Barbra did not hesitate to speak up if she felt things were getting out of hand. When Dodi ordered his driver to speed up in order to escape paparazzi in L.A., she wasted no time telling him to slow down—especially along the treacherous roads that wound through Ramirez Canyon. "Hey," she said, "let's try not to get killed . . ."

Streisand's ardor for Dodi soon cooled. "I don't think they really had much to say to each other," said one acquaintance. "I think she needs more—fire."

Thirteen years later, Barbra would be shaken by the news that Dodi and Princess Diana had been killed in a Paris car crash—and by the realization that, at another time and place, she might have been sitting in the backseat with Dodi instead of the Princess of Wales. "Something," she said when she heard the news, "has *got* to be done about the paparazzi."

Not long after she dumped Dodi, Barbra fell for Richard Cohen, the fortyish ex-husband of one of Fayed's lovers, Tina Sinatra. The tall, sandy-haired millionaire businessman was with his live-in girlfriend Marjorie Wallace (a former Miss World) when he met Barbra at a birthday party. Cohen quickly left Wallace for Streisand, and for the next several months they were all but inseparable. But when Cohen could no longer tolerate Barbra's frenetic travel schedule to promote *Yentl* abroad, he called it quits in the spring of 1984.

As it turned out, Barbra had a spare. Several months earlier at a Christmas party, she had met tall (six feet three inches), handsome, curly-haired Richard Baskin. Once he came up to her to say how much he liked *Yentl,* Barbra asked, "So, your name is Baskin? Like in Baskin-Robbins?"

Baskin, who at thirty-four was eight years younger than Barbra, replied that indeed he was an heir to the ice-cream fortune. "Wow!" she shot back. "I love your coffee ice cream!" And, as it turned out, a lot more.

Not only was Baskin obscenely wealthy, but he was a talented musician and composer who had written several of the songs in Robert Altman's send-up of the country-music industry, *Nashville.* He was also a gentle bear of a man—soft-spoken, polite, even-tempered—all the things that Jon Peters wasn't.

For most of the next four years, Baskin would be Barbra's lover, confidant, sometime collaborator, and housemate. He would not, however, be her first priority. "My son is the man in my life now," Barbra said. "Before, I felt guilty and hid things from him—all my fears, my flaws. I tried to play mother. But now I've stopped preaching. I tell him what I think or feel, and if he doesn't accept it, that's fine . . . Now the love is just there. It's unconditional—and it's very strong."

Jason would need to know that—to believe it. He was seventeen and had shared everything with his mother. Well, almost everything. Jason had yet to tell his mother that he was gay.

I don't feel like a legend. I feel like a work in progress.

I know some people make fun of her nose, but she can smell a phony a mile away.

—Don Johnson

If a man did the same things I did, he would be called thorough—while a woman is called a ballbreaker.

8

——

The kid's gay," Jon Peters blurted to Arthur Laurents as they sped down Sunset Boulevard. "She should face it now."

Laurents was aghast. After all, at the time Jason was only twelve. "How do you know?" he asked.

"He's interested," Peters said gravely, "in antiques."

Laurents tried to control himself. The crass Archie Bunker remark was so typical of Peters. In fact, only a few months earlier, Peters had thought he might have misjudged Jason when he caught the boy sitting in Barbra's car with his hand up a young girl's dress. Barbra was livid, but Peters was, for a brief time, relieved.

Jason had, in fact, been grappling with the issue of his own sexual orientation ever since he'd experienced his first gay impulse at the age of eight. It was during a sleepover, and Jason recalled that he just "rolled over into the guy next to me, hoping he would touch me."

From the very beginning, he would feel "shame, guilt—this fear" about his sexuality. "It's very alienating. There's no support. Somehow you know that it's not okay to be who you are." Ironically, despite his mother's gay-icon status, Jason claimed "there were very few gay people around when I was a child." In a sense, that was fine with him. "I remember feeling a little scared around gay people," he said, "like they could see right through me."

In elementary school, Jason's best friend was an effeminate boy who was brutally teased by the other kids. From that point on, he was "so sensitive to the fact that it was not cool to be gay. I couldn't be gay in high school." In high school, Jason had crushes on mem-

bers of both sexes, but his first sexual experience at age sixteen was with a boy.

Jason would wait until he was twenty-one before he finally told his mother about his sexual orientation. "I think she probably already knew," he said, pointing to the fact that he was "very sensitive," made no attempt to "act macho," and "didn't play sports." As for Dad: "My father did not suspect. It was much more difficult for him."

Jason also picked up a significant trait from his mother—a crippling insecurity about his looks. "I always felt unattractive," he later said. "I used to walk around practically covering my face. In high school I was so self-conscious. I thought I was hideous, and sometimes I still do."

Whatever adolescent turmoil might have been roiling beneath the surface, Jason beamed as he picked up his diploma from Crossroads High School in Santa Monica in June 1984. Mom, Dad, and the rest of the family were on hand for the ceremony, then returned to the house on Carolwood Drive to screen an eighteen-minute short film produced, directed, and edited by Jason. "It's Up to You" starred Jason's father, his grandmother Diana Kind, and his aunt Roslyn. Barbra financed the project, both as a graduation present and as a show of support; the aspiring actor and filmmaker was headed for New York Film School in the fall.

Two months later, Barbra was busy making a short film—this one for MTV to promote her new album, *Emotion*. Once again, she had blurred the line between her private and professional lives, allowing Baskin to work on *Emotion*. Baskin also worked with her on her first two music videos for MTV—a six-minute film noir version of her single "Left in the Dark," followed by a more vibrant "Emotion" video costarring Mikhail Baryshnikov and Roger Daltry.

The videos aired frequently, but the MTV generation wasn't buying. *Emotion* was one of the worst-selling albums in Barbra's career, though with sales of over two million, it could hardly have been considered a disaster.

Disappointed with her inability to connect with a younger audience, forty-two-year-old Barbra decided it was time to sit back and take stock. It was another turning point for her. "Now,"

Baskin accurately pointed out, "she's been famous longer than she was unfamous."

For a time, Barbra joined her son in the world of academia, donning floppy hat and dark glasses to sit in the back row and audit a class at the University of Southern California on human sexuality. She would wind up giving $500,000 to the school to endow a Streisand Chair of Intimacy and Sexuality.

Around the time Barbra was attending lectures at USC, Diana Kind came to live with her and Baskin at the Holmby Hills house while recovering from bypass surgery. It did not take long for Diana to start "driving Barbra up the wall," said a friend. While their heated arguments were mostly a thing of the past, Diana's offhand remarks could be as cutting as ever. More important, Barbra was unaccustomed to having her privacy—and her still-smoldering romance with Baskin—intruded upon. As soon as she was capable, Diana returned to her modest apartment.

That fall of 1984, Barbra became the victim of another intruder; her darkest fears were realized when a former mental patient was arrested and held for psychiatric observation after breaking into her house in Beverly Hills. No sooner was he released than the stalker began sending her death threats in the mail. He was arrested a second time, and once again was placed under psychiatric observation.

Such incidents did not help assuage Barbra's persistent fear of singing in public. She had never gotten over the death threat that had resulted in her darting about the stage during her Central Park concert years earlier. Streisand's support of Jimmy Carter in his successful run against Gerald R. Ford in 1976 and his losing campaign against Ronald Reagan in 1980 was lukewarm at best. She despised Reagan as a reactionary, but didn't think Carter was liberal enough. Aware that former vice president Walter Mondale did not have a chance of ousting incumbent Reagan from office, Barbra chose to remain relatively silent during the presidential campaign of 1984.

Barbra did, however, zero in on the one race where she thought she might make a difference. In October 1984, she mailed out a fund-raising letter aimed at unseating Republican senator Jesse Helms of North Carolina. "I get so angry when I read the things Jesse Helms has to say about women, about blacks, and about Israel,

that I feel I must speak out," Streisand wrote. "It would be bad enough if Jesse Helms said these things as just one senator. But he doesn't speak as one senator; he speaks as the recognized leader of the Radical Right." Despite Barbra's efforts—or, suggested North Carolina Republicans, because of them—Helms was reelected in a landslide.

Along with the tinnitus that still plagued her, the remark of one particular critic still rang in Barbra's ears. "*Emotion* is Streisand's latest attempt to appear hip," wrote *USA Today*'s John Milward, "and one must wonder why she bothers. Her talent was nurtured in the world of Broadway and Hollywood. Her art is rooted in a voice whose beauty transcends hip."

Streisand agreed. Encouraged by the jaw-dropping success of *What's New,* Linda Ronstadt's Grammy-winning collection of standards from the thirties and forties, Barbra decided to return to her roots. "It's time," she said, "I did something worthwhile."

That "something worthwhile" was *The Broadway Album,* a collection of show tunes by Rodgers and Hammerstein, the Gershwins, Jerome Kern, and—most significantly—Stephen Sondheim, a composer whose work she'd rarely performed in the course of her twenty-three-year career.

Barbra phoned Sondheim up at his town house in New York's Turtle Bay neighborhood (Hepburn used to walk across their shared garden and bang on his window when Sondheim played his piano too loud) and began asking for his help. Their ensuing conversations dragged on for hours. What did the lyrics to "Send in the Clowns" mean? Barbra wanted to know. "I just didn't get it when I heard it the first time," she admitted. Could he write some lyrics for her? And could he also incorporate some of her ideas into a new, tailor-made-for-Streisand version of "Putting It Together?" Oh, and maybe he would be willing . . .

Sondheim, who scarcely knew Streisand, had never made such concessions for a star. Yet in Barbra's case, he did that—and more. "It turned into a process that was exhilarating," she said, "there were moments I was screaming with joy over the phone."

Flying out to Los Angeles, the composer—another sometimes aggravating perfectionist—joined her in the studio and helped her sculpt the album over the course of a recording session that

stretched over three weeks. As was always the case in the recording studio, musicians, producers, and technicians alike were pushed to the brink of exhaustion. They also witnessed the displays of frustration and temper for which Streisand was famous.

"I *hate* it!" Barbra whined as she listened to her last take of "Can't Help Lovin' That Man" from Jerome Kern and Oscar Hammerstein's *Showboat.* She protested that the trumpet, which had been brought in specifically at her request to create a sultry New Orleans jazz sound, was now drowning her out. The orchestra would record two other, completely different orchestrations for the number before she decided on the one she liked best.

On its release in November 1985, *The Broadway Album* was universally hailed as one of the greatest musical achievements of her career. It climbed to number one the following January and—with the help of her HBO special named after the Sondheim song "Putting It Together"—would ultimately sell more than three million copies. *The Broadway Album* would wind up being the biggest solo album of her career.

Gradually reasserting herself as a political activist, Barbra pledged the proceeds from "Somewhere," a single released from *The Broadway Album,* to three groups: an antinuclear organization, a pro-choice organization, and the AIDS research charity amfAR.

Closer to home, Streisand might have appeared markedly less generous. She had asked her old friend Paul Jabara, the man behind her huge hits "The Main Event/Fight" and "No More Tears (Enough Is Enough)," to coproduce three of the non-Sondheim songs on *The Broadway Album.* She later reportedly pleaded with him to forgo his cut of the royalties as co-producer. Jabara was not willing to make the sacrifice, however, and over the next several years—until his death from lymphoma in 1992 at age forty-four—complained that he was not always getting his royalty checks on time.

The Broadway Album was still riding high on the charts in December 1985, when Barbra and Richard Baskin bumped into Marty Erlichman while on a ski vacation in Aspen. It had been almost a decade since Jon Peters replaced Erlichman as her manager, and now that she had reconnected with her musical roots, Barbra was feeling nostalgic. Erlichman hadn't done badly for himself as a producer, having turned out such films as *Coma* and *Breathless.* But when Bar-

bra asked him to pick up where he left off as manager, Marty jumped at the chance.

Barbra had two main Martys in her life now. The second was Martin Ritt, the director of her next movie, *Nuts*. Based on the play by Tom Topor, *Nuts* is the story of Claudia Draper, a $500-a-night call girl who admits that she killed one of her clients, but only in self-defense. To avoid a murder trial, her mother and the stepfather who abused her as a child want Claudia declared legally insane and committed to a psychiatric hospital.

Still deep in therapy and grappling with the demons of her own childhood, Barbra admitted that she remained angry that her mother had looked the other way while Louis Kind tormented her emotionally. She *was* Claudia Draper, in a sense, and for that reason Streisand felt compelled to do the film. "Claudia isn't insane," Barbra explained. "She's just shockingly honest. But the truth is all she has, and she refuses to give it up."

Barbra had wanted to work with Marty Ritt, whose credits included such powerful and thought-provoking films as *Hud* (which won an Academy Award for Patricia Neal) and *Norma Rae* (which did the same for Sally Field). But no sooner had he been hired by Warner Bros. than Ritt made the candid and rather off-putting observation that at forty-five Barbra was "too old to play Claudia." After all, Ritt said bluntly, she had to look like the kind of woman a man would pay $500 to have sex with.

Barbra glared at Ritt for what seemed to him like an eternity. "She could have thrown me off the picture," he recalled of the moment. "After all, she was the boss. Her body stiffened. I noticed that."

Barbra then shook her head. "You're *wrong*," she told him, "and I'm going to prove it to you!"

First, she had to line up an actor to play the part of Claudia's court-appointed defense attorney, Aaron Levinsky. Her old lover Richard Gere turned it down flat. So did Brando, Paul Newman, Al Pacino, and Robert De Niro. Meanwhile, Sean Penn and John Malkovich were passed over for the part. Dustin Hoffman, Barbra's old pal from her days as a struggling actress in New York, had the role for a time, but when she refused to pay him the same salary she was getting—$5 million—Hoffman backed out.

Ultimately, Richard Dreyfuss agreed to a salary that was only a fraction of what Barbra was getting—$1.5 million—and got the job. Dreyfuss had won a Best Actor Oscar for *The Goodbye Girl* but was best known for his work on *Jaws* and *Close Encounters of the Third Kind*. He had no illusions about who was in complete control of the production. "Don't we know this?" he asked with a shrug. "I certainly knew it."

Barbra was nearly as obsessed with *Nuts* as she had been with *Yentl*. "She had a vision of this film from the start that was very complete," observed Teri Schwartz, the movie's co–executive producer. "She's a very inspired person. She probably hears music and sees images in her head all day long."

With best friend and coproducer Cis Corman in tow, Streisand spoke with more than a dozen psychotherapists and scores of emotionally disturbed women, primarily manic-depressives and schizophrenics. Barbra visited Bellevue Hospital in New York City; Elmhurst Hospital in Queens, New York; the psychiatric wing at UCLA hospital; San Fernando Valley's Mental Health Court; Rikers Island Women's Prison; and the holding cells at the Santa Monica Courthouse. At no time, she later said, did she ever feel anything but "totally comfortable" with the mentally ill women she interviewed.

"You certainly see a number of lawyers, judges, and psychiatrists who seem more irrational than the patients," she concluded. "The patients sometimes speak the truth without hesitation and the truth is not always pretty. The truth is not always polite. I find the lack of social etiquette, the directness, the honesty absolutely engaging and refreshing."

Streisand also spent some time with real prostitutes at one of L.A.'s pricier bordellos. As she waited in the foyer at the end of the day for a car to pick her up, several businessmen sauntered in, sized her up, and approached the madam. "How much," one asked, "for the Barbra Streisand lookalike?"

Not surprisingly, once shooting began, the headstrong director and his famously difficult star locked horns on several occasions. But there were none of the knock-down, drag-out scenes one might have anticipated. "They had their disagreements, of course," said veteran actress Maureen Stapleton. "These are two people who

have very strong ideas. But there weren't any blowups. Everything was quite civilized."

Once filming was completed and Ritt turned in his director's cut, he was pleased with the result. Unfortunately, Barbra was not. She took the film back to her elaborately outfitted editing room at the Malibu compound and began working in her usual frantic, nonstop fashion. Three weeks later, she emerged with a movie that looked very different from the one Ritt had handed her. Yet again, she had cut out other actors' scenes and, in an effort to make her part even more overwhelming than it already was, replaced them whenever she could with close-ups of herself.

Barbra also decided that she might as well write the score for the movie herself. "After all," she said, "who else would hire me—or fire me?!"

Despite compelling performances from Barbra, Dreyfuss, and a supporting cast that included Stapleton and Karl Malden, *Nuts* would flop at the box office when it was released the following year. The subject matter was simply too depressing. "I guess," said one cast member, "people just weren't in the mood to see a movie about a crazy whore who turned out to have been molested by her stepfather."

Obviously not. But Barbra was no longer interested in turning out musicals and screwball comedies. She wanted to tackle serious issues, to make movies of social significance—whether they were commercially successful or not. "It's not about money. I have enough money, thank God," she said. "Now the only reason I want money is to give it away."

The Barbra Streisand Foundation was giving away plenty by the mid-1980s—over a million dollars a year to fund AIDS research, shelters for battered women and abused children, and a number of civil rights, environmental-protection, and feminist groups. Yet Barbra, who had not fully recovered from the days when she'd found herself on Nixon's enemies list, remained in the background.

That changed dramatically on April 26, 1986, when an explosion at the Chernobyl nuclear power plant spewed radioactive material over the Soviet Union, Eastern Europe, Scandinavia, and eventually Western Europe. Barbra phoned Marilyn Bergman as soon as she heard the news that morning.

"Oh my God, Marilyn," she said, "we can't let that happen here. We've got to do something!"

"The only thing I know to do about it," said Bergman, pointing to the six Senate seats up for grabs that election year, "is to take back the Senate for the Democrats!"

Convinced that President Ronald Reagan was a dangerous right-winger whose policies would soon lead to a nuclear holocaust, Bergman joined several other liberal women in the film industry to form the Hollywood Women's Political Committee. The group's express goal was to influence government at the highest levels by raising millions of dollars for candidates. Bergman invited Barbra to join, and she soon would. But she wanted something more: She wanted Barbra to overcome her stage fright long enough to give a fund-raising concert for the six Democratic Senate candidates.

"I don't know, Marilyn," she replied. "I don't think I can. I HATE singing in front of people—you know that . . . I . . . I just can't."

"Well, Barbra," Marilyn replied, "you're just going to have to decide what's more frightening: singing in front of an audience or nuclear annihilation."

Barbra wasn't really sure. The idea of singing in front of a large number of people still terrified her. After all, she hadn't given a full-length concert performance since her Central Park triumph twenty years earlier. In order to convince herself that Chernobyl or something like it could happen again, and possibly on U.S. soil, Barbra told Marilyn that she would have to hear from the experts.

A series of dinners were arranged with a number of authorities in the field—but only those, of course, who were already outspoken critics of the Reagan administration's nuclear policies. "I offered to speak with her about the use of nuclear power for peaceful purposes," said noted physicist and Reagan adviser Edward Teller. "And I wanted to explain why it was important for us to develop new weapons systems to meet the very real threat from the Soviets. But they only wanted to hear one side of the argument."

Finally, she agreed to do the concert—but only if it was limited to invited guests and held within the familiar confines of her Malibu estate. "I could never imagine myself wanting to sing in public again," Barbra said in the audiotaped invitation that went out to

three hundred of the most prominent liberals in the entertainment industry. "But then I could never imagine Star Wars, Contras, apartheid, and nuclear winters."

Few if any were dissuaded by the hefty $5,000-per-couple admission price. Within days, all three hundred checks were in the mail. "I've spent more than a few sleepless nights wondering what I could do that would be worth five thousand dollars a couple," she said. "I figured it out that I was going to sing 3,924 notes. That comes to a little over a dollar a note."

The take from Barbra's *One Voice* concert, as it was now being billed, would go far beyond revenues from the ticket price. Marty Erlichman had contacted HBO chairman and chief executive officer Michael Fuchs and asked if the cable network was interested in turning Barbra's backyard concert into an HBO event. Erlichman had gone to HBO because the major broadcast networks could no longer afford to pay the going price for a televised Barbra Streisand. Fuchs agreed to ante up $250,000 to defray the cost of putting on the concert, and Barbra brought in Dwight Hemion, who had worked on most of her television specials, to direct.

A gentle breeze blew through Ramirez Canyon the night of September 6, 1986, as the crowd gathered in Barbra's Malibu backyard. A small amphitheater had been erected on the property, and chairs were arranged in a semicircle so that no one in the audience would be farther than fifty-six feet from Barbra as she sang.

As she waited in a small dressing area backstage for opening act Robin Williams to finish his fifteen-minute routine, Barbra peeked out at an audience that included her old lover Warren Beatty and Beatty's sister, Shirley MacLaine; Jack Nicholson; Whoopi Goldberg; Bette Midler ("I like the Democrats, but I *love* Barbra Streisand"); Whitney Houston; Goldie Hawn; Jane Fonda; Sally Field; Bruce Willis; Barbara Walters; Hugh Hefner; Chevy Chase; ex-husband Elliott Gould; her ex-lover Jon Peters; and even her old *Hello, Dolly!* nemesis, Walter Matthau.

After Robin Williams was done with his manic opening act, Barbra, dressed in a white turtleneck sweater and a long white skirt slit up the side, made her entrance singing "Somewhere" from the score of *West Side Story*. The audience jumped to its feet and gave

her a standing ovation. "You're nice. You're all friends. Thank you for being here."

For the next hour, with a group of eight musicians backing her up, Barbra sang such Streisand staples as "People," "The Way We Were," and "Evergreen," as well as "Over the Rainbow," "Send in the Clowns," "Papa, Can You Hear Me?" from *Yentl*, and, in duets with Barry Gibb, their hits "Guilty" and "What Kind of Fool?" The audience was on its feet again for "Happy Days Are Here Again," and stayed there for Barbra's moving rendition of "America the Beautiful."

The event alone raised a staggering $1.5 million—$500,000 more than a star-studded fund-raising dinner for President Reagan the next night. In the end, all the candidates who received money from Barbra's *One Voice* concert were elected, and the Democrats won back the Senate.

Incredibly, the $1.5 million was only a fraction of what Barbra's backyard show would eventually bring in. In addition to the HBO special, CBS/Sony marketed a *One Voice* video and Columbia released a *One Voice* album that would go platinum. By the time all the proceeds were added up, the concert had grossed an *additional* $7 million—all of which was doled out by the Streisand Foundation to groups ranging from the Sierra Club and the Citizens Leadership Project to the National Coalition for Black Voter Participation, the Rainforest Action Network, the NAACP, and the ACLU.

"That was a turning point for Barbra, I think," said her old political ally Bella Abzug. "She had always been active behind the scenes, and she came out to support a few lucky friends like me. But when she did that concert and saw what tremendous power she could have—power to effect change—that's when Barbra decided she was ready to kick some Republican butt."

"Barbra was thrilled with the results of that election," another activist friend said. "The money she raised had helped deliver the Senate back to the Democrats. You could see the wheels turning in her head, you know: 'Now, what can I do next . . . ?'" One of the guests at another fund-raiser Barbra attended around this time was surprised at the animosity Streisand appeared to harbor toward Ronald Reagan. "Of course, we all disagreed with Reagan's poli-

cies," she said, "but I got the distinct impression Barbra despised him. She obviously thought he was a warmonger, a reactionary, and not terribly bright." As for the First Lady: "Oh, *please*. Barbra thought Nancy Reagan was the real power behind the throne—a real dragon lady."

After the *One Voice* concert, Barbra went back to her day job. For the next several months, she was consumed with putting the finishing touches on the ill-fated *Nuts*. She took time out to accept her eighth Grammy as Best Female Vocalist of the year—for her work on *The Broadway Album*—and bask in yet another standing ovation from her peers in the recording industry.

That August, Barbra put her Malibu estate on the market for a staggering $18 million. Keeping the five houses up and running to her lofty standards was now proving to be too tasking without the help of someone like Jon Peters. "If there's a heavy rain I'm left wondering which roof it was that leaked this time," she said. "It's a lot of responsibility." But she also indicated that perhaps she was just putting the house up for sale to test the waters. "Maybe I never will sell it," she said with a shrug. "Who knows?"

Whatever she decided, Barbra would soon be living alone. She was stunned when, in the fall of 1987, Richard Baskin abruptly packed his bags and left. They had been together for four years, and the shy, sweet-natured ice-cream heir had given no indication that he was unhappy. "I don't get it," said a longtime acquaintance of the couple. "She loved Richard, and it always seemed he was ready to do anything for her."

Barbra brooded over the end of yet another love affair—but not for long. She decided to spend the holidays in Aspen and was one of the guests at a Christmas party thrown by Marilyn and Alan Bergman. At the time, no one at the party was a hotter commodity than Don Johnson. Voted prime time's number one male star by *TV Guide* in 1986, the blond Beau Brummell with the rolled up jacket sleeves and perpetual five o'clock shadow had shot right to the top as Detective Sonny Crockett on the hit NBC series *Miami Vice*. By late 1987, however, the series was in trouble, having slid from fifth to forty-ninth in just two seasons. By way of hedging his bets, he had signed on to do a feature film with Susan Sarandon, *Sweethearts' Dance*.

Johnson, who had met Barbra briefly at the Grammys ten months earlier, walked up to her at the Bergmans' party, took her by the arm, and led her off to a quiet corner where they could talk. Barbra was thrilled. Most men were far too intimidated to approach her. "So if a guy makes the first move," she said, "he's already a step ahead."

Unlike the bashful, well-behaved Baskin, Johnson was a throwback to the macho likes of Ryan O'Neal and Jon Peters. Tall, blond, and boyishly handsome, Johnson was eight years younger than Barbra. And like O'Neal and Peters, he had a reputation as a ladykiller. "When he turns it on," said *Sweethearts' Dance* director Robert Greenwald, Johnson could "charm Hitler."

Barbra and Johnson quickly discovered that they had quite a lot in common. He, too, had experienced a less-than-idyllic childhood. Born in Flat Creek, Missouri, Johnson had lived on his grandparents' farm until he was six, when his family moved to Wichita, Kansas. Five years later, his parents divorced. "In one instant, life changed," he remembered. "Suddenly there were major choices I had to make, decisions that you shouldn't have to make when you're eleven years old. I realized it was dog eat dog, every man for himself."

It didn't take long for Johnson to start getting in trouble. At twelve, the same year he lost his virginity by seducing his seventeen-year-old babysitter, he was arrested for hot-wiring cars. Mirroring Jon Peters's experience, he also spent a year in a juvenile detention center, the Lake Afton Home for Boys. Not long after his release, he moved in with a twenty-six-year-old cocktail waitress.

After playing the lead in a high-school production of *West Side Story*, Johnson was hooked on acting. He wound up attending the University of Kansas on a drama scholarship, and by his sophomore year had moved in with one of his female professors. When she went to the American Conservatory Theater in San Francisco, he tagged along.

Johnson's first break came when veteran film actor Sal Mineo cast him in a Los Angeles production of *Fortune and Men's Eyes*. The play featured a nude rape scene between Mineo and Johnson that caused a sensation and attracted the attention of Hollywood producers. Signed to an MGM contract, he made his first film, the forgettable *Magic Garden of Stanley Sweetheart*, in 1970.

Three years later, he doffed his clothes again for *The Harrad Experiment* and began a relationship with costar Melanie Griffith, Tippi Hedren's precocious fourteen-year-old daughter. Johnson racked up two failed marriages—one to a dancer and another to a musician—before he got around to wedding Griffith in 1976. Griffith was sixteen at the time. They were divorced the following year.

Johnson's reputation as a serial womanizer would soon rival that of another of Streisand's ex-lovers, Warren Beatty. Among the more colorful of his conquests were two of Mick Jagger's on-again, off-again girlfriends, Pamela Des Barres ("Miss Pamela") and actress Patti D'Arbanville. According to Des Barres, who wrote a book about her eye-opening sexual escapades titled *I'm with the Band,* Johnson was easily the most well-endowed lover she had ever had.

By 1980, Johnson and D'Arbanville, who had acted with Barbra in *The Main Event,* were living together. When D'Arbanville became pregnant with their son, Jesse, in 1982, she joined Alcoholics Anonymous. The following year, Johnson climbed aboard the wagon right behind her, giving up not only liquor, marijuana, and cocaine but cigarettes as well. Nevertheless, they split up.

In stark contrast to Barbra, Johnson struggled for fifteen years to make it. After six flop films and a handful of acting jobs on television (most memorably a 1980 made-for-TV movie in which he played Elvis), Johnson finally hit the jackpot with *Miami Vice.* But he and Streisand still had a surprising amount in common. For starters, Johnson admitted that he "couldn't stand" his mother. "I mean, I love her to death, you know, but I can't stand her."

Johnson and Streisand were also workaholics and maddening perfectionists; like Barbra, he had opinions about everything from camera angles to dialogue and didn't hesitate to voice them— loudly. "Don is smart and opinionated," said a cast member of *Miami Vice,* "and he has a certain way he wants things done. Does he have a temper? Oh, yes."

Johnson was also a singer. By the time he met Barbra, he had already recorded a gold album and a pop single, "Heartbeat," that made it all the way to number five on the *Billboard* chart.

Barbra was, yet again, swept up by the romance of it all. A week after meeting at the Bergmans', she held her own New Year's Eve party in Aspen. Oprah Winfrey was there; so were Jack Nicholson,

Bruce Willis, and Michael Douglas. Three weeks later, after she and Johnson had been spotted cozying it up in New York and Los Angeles, they went public at the Mike Tyson–Larry Holmes bout in Atlantic City.

"It was the first time I enjoyed my celebrity," Barbra said after the HBO cameras zoomed in to show her holding hands with Johnson. "I wasn't having to apologize to the man for getting all the attention, because he got as much attention as I did."

They caused a similar stir when they attended a Lakers–Sonics game at the L.A. Forum, and at the ShoWest Convention in Las Vegas for theater owners and operators, where Streisand was crowned Female Star of the Decade. Later that day, she and Johnson flew to Miami, and on February 26, 1988, Barbra made a brief walk-on appearance on *Miami Vice,* in an episode titled "Badge of Dishonor."

"Don's the perfect man for me," Barbra gushed to her friend Cis Corman. "I'm not going to let him go. He's got it all—looks, brains, personality. He doesn't need anything from me except love." True to form, Barbra was again blending her love life with her professional life. In addition to trying to boost ratings for her new boyfriend's flagging series, she was reading his scripts and looking for a musical project they might collaborate on.

Despite the high-profile nature of their affair—wags now referred to Johnson as Streisand's "Goy Toy"—this time Barbra did not invite him to move in with her. But for a time they were inseparable. When he paid $1 million for a two-story, red clapboard house in Aspen's Woody Creek district, she took it upon herself to decorate it. When they weren't lounging around the house or cavorting on the slopes of Buttermilk Mountain—he was an expert skier, Barbra stuck to the bunny trails—the glittering new couple-of-the-moment were spotted holding hands and nuzzling at local spots like Abetone, Pinion's, and Gordon's. During this period, Barbra had also grown fond of six-year-old Jesse, Don's son by D'Arbanville.

In the fair-haired boy from Flat Creek, Missouri, Brooklyn-bred Barbra claimed to have found a kindred spirit. "Like me, he's often misinterpreted and called tough and difficult—and it's not true," she told the *Daily Mail.* "That is one of our common bonds. He is very gentle, sensitive, and nurturing . . . He makes me happy. I have never been so happy before . . ."

Barbra was now telling friends that she hoped someday to remarry—and while she wasn't quite sure if her libidinous boyfriend was really marriage material, she wasn't ruling it out. "Will it last? How do I know?" she said in a rare unguarded moment. "All I know is this moment . . . Don't ask me if I would marry him. I don't know . . ."

For his part, Johnson tried to be as gallant as a man who boasted of sleeping with "thousands of women" could be. "Streisand is supreme, unequaled in all the ways that count. I love her strengths, her direct approach to music, acting, people, and, yes, making love."

After Don and Barbara showed up at a surprise birthday party for Quincy Jones in March, Hollywood was abuzz with rumor that they were planning a wedding in September. Three weeks later, Johnson left for Calgary to shoot a new John Frankenheimer thriller, *Dead-Bang,* with twenty-four-year-old Penelope Ann Miller.

Barbra, meanwhile, bided her time at her home in Holmby Hills and her Malibu estate, taking long walks and tending to her gardens. Over the years, Streisand had become such an expert on flora that she had memorized the Latin names for hundreds of species. She also worked on various projects she was trying to get off the ground, including a film biography of the fearless *Life* magazine photojournalist Margaret Bourke-White. More intent than ever on working with Richard Gere, she approached him to play the part of Bourke-White's husband, the novelist Erskine Caldwell.

Barbra waited anxiously for Johnson to show up at the lavish forty-sixth-birthday party Jon Peters threw for her at his home. When Don didn't show, claiming that he could not leave the set of *Dead-Bang,* Barbra was crushed. Amid rumors that he was cheating on her, Barbra flew up to Calgary to spend a few days with him. When she returned to L.A., he picked up where he had left off with several women. Johnson even brought one of them, Patricia Loubman, back to Aspen to spend some time with him and Jesse. An attractive former aerobics teacher, Loubman had been hired to play Johnson's wife in *Dead-Bang.*

Johnson was still filming *Dead-Bang* when his ex-wife Melanie Griffith called to say that she was checking herself into rehab that very day. They had always maintained a cordial relationship, and

Johnson did whatever he could to keep her spirits up with letters and phone calls. When she emerged, Johnson was there to meet her. By midsummer, the onetime spouses were once again in the throes of a passionate affair.

Barbra, undaunted, pressed on. Neither Johnson nor Streisand could have been unaware of the impact she could have on his musical career. And there was no doubt that Johnson was not satisfied merely acting in movies and on television. "I want to be a rock star," he said point-blank, "because I *can*." By the same token, Barbra clearly benefited from being linked to the virile, consummately cool *Miami Vice* star. The mere fact that he found her desirable gave her much-needed confidence in the wake of her unexpected breakup with Baskin. And photos of the two hand in hand at openings and prizefights lent Streisand—now a household name for over a quarter of a century—a certain youthful cachet.

In early September 1988, Barbra and Don recorded a duet, "Till I Loved You," to be included on her forthcoming album of the same name. Everywhere he looked at the studio—in the reception area, on the walls of the hallways, in the studios themselves—were Barbra's framed gold and platinum records, magazine covers, and movie posters. Some of them, it turned out, had gone up only hours before his arrival—on Barbra's orders. "Why she went out of her way for this putz," said one studio technician, "beats the hell out of me."

The following week, Barbra and Don caused pandemonium when they waltzed into the premiere of his film *Sweethearts' Dance*. The film flopped, but "Till I Love You," despite a drubbing from the critics ("Johnson sounds like he's gargling with gravel," sniped one) turned out to be a modest hit.

As September came and went, the much-ballyhooed wedding of Streisand and Johnson failed to materialize. But, oddly, Johnson did start to sound as if he intended to take a march to the altar soon. The notion of eventually marrying again was, he said coyly, "always in the back of my mind—and I'm encouraged of late."

Suddenly Barbra was back in the running—or so she thought until she began hearing that the man she said made her happier than she had ever been was actually back in the arms of his former wife. Johnson would wait until December, when Melanie Griffith was

being hailed for her Oscar-nominated performance in the Mike Nichols comedy *Working Girl,* to slip a four-carat, $80,000 diamond engagement ring on her finger. Griffith, already the mother of a son with actor Steven Bauer, was pregnant.

"Barbra was floored," said one of her few confidantes. "She didn't say anything about it. I think she really loved him, and you could see it in her demeanor, hear it in her voice—she felt betrayed."

Johnson saw no reason why Barbra would be surprised. He claimed, in fact, it was Barbra who sat him down and told him that he was "a family man at heart," and that, as she put it, "it may be that you've never stopped loving Melanie."

Yet he admitted that at the time "Barbra was willing to stay" in their relationship. "We genuinely tried to make it work. But we'd reached a point where we had to make a commitment or let it go."

Johnson and Griffith would not marry until the spring, and their daughter, Dakota, was born shortly thereafter. This second try at matrimony, marred by drug abuse and infidelity, would prove even more turbulent than the first. They would divorce in 1995, after Melanie ran off with married Spanish heartthrob Antonio Banderas.

In the meantime, Barbra joined the stable of Johnson's contented exes. "We all consider each other family," Don said. "Patti's part of the family, Miss Pamela is part of the family. Barbra is part of the family." So, one would presume, was Melanie Griffith.

Johnson, as it turned out, also became part of Barbra's extended family of lovers, their spouses, exes, children, and stepchildren. During their volatile marriage, Jon and Christine Peters had adopted a little blond girl they christened Caleigh and asked Barbra to be her godmother.

Around this time, Barbra's belief in Peters's business acumen was validated when Sony bought out Jon and his partner Peter Guber for $200 million, then installed them at the head of Sony's newest acquisition—Columbia Pictures, which they promptly renamed Sony Pictures. While there was no chance that she and Peters would ever get back together, Barbra would forge a close bond with Caleigh, taking care of the cherub-cheeked girl with the sunny disposition whenever she could. "Caleigh," she told a friend, "is the daughter I never had."

In addition to Caleigh and Christopher Peters, she also remained

close to Dakota Johnson, as well as Don's son Jesse and Melanie's son Alexander Bauer. Then there were Molly and Sam, Elliott's children by Jenny Bogart. Barbra remembered them all with birthday gifts and Valentine's Day cards. "We all love Barbra," Melanie Griffith insisted. "She's really sweet."

But as 1988 came to a close, Barbra was without a man for the first time in years. It wasn't only Don Johnson and Richard Baskin she was missing (though Baskin would continue to escort her to certain high-profile events). It was Jason. Barbra's artistic, sensitive, enigmatic son had moved out that summer, purchasing a two-bedroom condominium in West Hollywood. Before he left, he told both of his parents that he was gay.

Dad did not take it well. "That's his preference, his business," Gould admitted to writer Corinna Horan. "It's something new to me, and it's an acutely delicate subject. But I'm more than just empathetic. Whether it's been a problem for Barbra, I don't know. It's really important not to be prejudiced, and both of us are devoted to him."

Despite her having been surrounded by gays for all her adult life and her status as a gay icon arguably without equal, Barbra's knowledge of the gay lifestyle was not extensive. As Jason himself would often point out, "I grew up in a very heterosexual household."

To fill in the gaps in his mother's knowledge, Jason brought her several books to read on the subject of homosexuality. She devoured them. Yet no matter how much she managed to come to terms with her son's sexuality, there was one aspect of it that deeply upset her. "I think she would love to have a grandchild," Jason allowed, "and I think that is probably the greatest disappointment to her. But you know, she may still get one. But I want to get a dog first . . ."

While Barbra coped with these seismic shifts in her personal life, she also began to cast about for the kind of project that would make her forget everything else. "I need," she told her friends, "another *Yentl.*"

Don Johnson might have broken Barbra's already battered heart when he took advantage of her star power to benefit his recording career, hinted at marriage, and then ran off with a pretty blond twentysomething shiksa. For weeks Don had been pushing Barbra

to sit down and read Pat Conroy's riveting novel about a suicidal South Carolina poet, the twin brother who loves her, and the New York psychiatrist determined to free them both by confronting their family's long-suppressed secrets. Johnson had hoped that Barbra would turn the book into a movie, and that they would star in it together.

Barbra would in fact bring Conroy's haunting tale to the screen. She would not only star in it—without Johnson, of course—but she would also produce and direct *The Prince of Tides*.

I never think what I do is good enough.

There's a lot of gruntin' and mumblin' going on, but it's not that many people who really sing anymore.

—Quincy Jones, on Barbra's return to the concert stage

We're from different worlds, but we collided.

—Andre Agassi

I can't blame anybody. Blame keeps you a victim, and I'm not a victim.

—Barbra on once again being passed over for an Oscar nomination as Best Director, this time for *The Prince of Tides*

9

—

"hy the hell isn't he returning my goddamn phone calls?"
Barbra demanded. "Jesus, is it that he doesn't like me?
Maybe he's afraid of me? I mean, I wanna make his book into a
great movie, for Christ's sake!"

In fact, *Prince of Tides* author Pat Conroy was convinced that the
messages he was getting were merely part of an elaborate practical
joke. Barbra, meanwhile, was becoming increasingly agitated. "I was
disturbed," she later said. "I was hurt."

By the time she finally tracked him down at a Los Angeles hotel
months later, Barbra had cowritten several drafts of the script with
Becky Johnston, hired most of the cast, and convinced Columbia—
with the help of the studio's new chief Jon Peters—to pay her $6.5
million to produce, direct, and star in *The Prince of Tides*. Still not
convinced that it was really Streisand at the other end of the line,
Conroy reportedly asked her to sing "People." After five notes, he
was convinced—and mortified that he'd been ignoring her.

As soon as he read the script, Nick Nolte desperately wanted to
play Tom Wingo in *The Prince of Tides*. A South Carolina high-
school football coach with a shaky marriage, Wingo confronts some
painful truths about his childhood with the help of New York psy-
chiatrist Susan Lowenstein. After Robert Redford and Warren
Beatty passed on the part, Streisand met with Nolte to discuss the
nuances of the characters and the plot.

Nolte, she realized, was no less tormented than the character he
wanted to play. He had never even met his father until he was three.
At ten, he slipped while climbing over a picket fence and impaled

himself, severely injuring his groin. Like several of Barbra's boyfriends, he got into trouble as a teenager; before flunking out of Arizona State, which he attended briefly on a sports scholarship, he was sentenced to five years' probation after being convicted of selling phony draft cards to his fellow students.

After rocketing to stardom in the ABC miniseries "Rich Man, Poor Man," he made a series of hit films including *The Deep, 48 Hours, Teachers,* and *Down and Out in Beverly Hills.* But his personal life was a shambles. A hard drinker and a notorious party animal, Nolte had racked up one eight-year relationship and three failed marriages by the time he approached Barbra for the male lead in *The Prince of Tides.*

"I saw a lot of pain in his work, in his eyes," she recalled. In talking to him, she said she realized Nolte "was at a vulnerable place, ready to explore feelings, romantic feelings, sexual feelings, and deep, secretive feelings."

Barbra had to overcome her own doubts about her suitability for the role of Lowenstein, described in the book as simply "breathtakingly beautiful." She invited Conroy to her house in Holmby Hills and asked him point-blank, "Do I look like Lowenstein?" When he said she didn't, Barbra asked, "Does *this* look like Lowenstein?" and flipped a switch. Up came a huge image of Barbra in character, standing in the book-lined office of a psychiatrist.

"Yeah," Conroy replied, stunned. "That's Lowenstein."

He might have been dubious at first about Barbra, but Conroy had no doubts that Jason Gould would be perfect as Lowenstein's son, Bernard. She protested that Jason was skinny for the part, but Conroy assured her that he was an ideal choice. Barbra was, she later conceded, a typical Jewish mother when it came to her son's weight. "It's true. I always think he should eat more," she said. "I'm his mother."

Barbra actually worried more about her son's lack of ambition. She claimed that ever since he had arrived via cesarean section ("He didn't have to struggle through the birth canal"), things had just come to him effortlessly. As a result, he lacked ambition, focus. "Jason is very gifted," she said, "but he's not ambitious. He just isn't driven like I am."

Before she could agree to hire her son for the part, she wanted

him to agree not to talk back when, in her role as director, she told him what to do. He said okay. She also wanted him to realize that they would both inevitably be attacked for nepotism, and that, no matter how good his performance was, he would be especially vulnerable to criticism simply because he was Barbra Streisand's son. He could handle it, he told her.

Once she had decided to hire her son, there was one small matter to attend to. Chris O'Donnell, the tall, blond, athletic actor who had already been cast as Bernard, would have to be fired. Under the terms of the contract she had with O'Donnell (who would later go on to stardom in *Scent of a Woman* and as Robin in *Batman Forever*), Barbra was forced to pay him off.

Two weeks later, both mother and son were jolted by a tabloid headline: STREISAND'S SON HANGS OUT IN GAY CLUBS NEAR HIS BACHELOR PAD—AND WORRIED MOM BARBRA IS FRANTIC. The story went on to say that Jason had been spotted at two gay clubs near his West Hollywood apartment, Rage and Studio One, and that Barbra was "heartsick" because she feared he might be exposed to the AIDS virus.

Barbra promptly dismissed the story as "garbage" and "a new low in rag journalism." But she was, in fact, desperately concerned that her son might contract AIDS.

That summer of 1990, Barbra was consumed with the job of producing, directing, and starring in *The Prince of Tides*. During four months of filming in South Carolina and New York, she drove the cast, crew, and even the locals to distraction with her passion for perfection. At one point, she complained that the lemon in a teacup saucer did not look squeezed, and that the tag on the tea bag was not hanging at precisely the right angle. The gardenias in a vase had to be long-stemmed, because in the book, Tom Wingo's social-climbing mother, Lila, fancied the long-stemmed variety. When it came to flowers, Barbra was more particular than most—something Jon Peters knew better than anyone. The day *The Prince of Tides* began shooting in the South Carolina town of Beaufort, Peters sent Barbra twenty dozen white and pink roses.

Just three weeks into filming, Barbra was dealt an unexpected

blow when her eighty-two-year-old mother underwent another coronary bypass operation at UCLA Medical Center. In much the same way she had touted *Yentl* as a tribute to her father, Barbra viewed *The Prince of Tides* as a tribute to her mother. Streisand was using the film, she said, as a way to explore their complicated, love-hate relationship. Barbra's conclusion: "I saw she did the best she could, you know?"

As arduous as the filming was—particularly in South Carolina, where temperatures hovered in the nineties—nothing threw Barbra more than her love scenes with Nolte. When they were in bed together, she recalled, "he was getting turned on, and I was embarrassed. Every time it got a little hot, I yelled, 'Cut!' " The reason: "I wondered, 'Where is it going to go? Is he going to take off all my clothes and we're going to screw on the floor?' I'll never use it. So why go to those places?" Eventually, she realized her reticence was getting in the way. "If I cut the camera anytime when it's really going good," she told him, "don't let me do that!"

For Jason, cast in his first major role in a major film, the pressure was enormous. Complicating matters was the fact that many of his scenes—including one where he and Nolte toss a football around Central Park and another where he plays the violin in Grand Central Station—took place in front of hundreds of gawkers. Other times, he bristled at being corrected by the director. "Listen, let's work on it," she told him when he botched a particular line, "and don't be mad at me as your goddamned mother!"

Once the cameras had stopped rolling on *The Prince of Tides,* Barbra's personal life was once again fodder for the tabloids as she began dating the man she had hired to score the movie, composer James Newton Howard. A former keyboardist for Elton John, Howard had been married to actress Rosanna Arquette.

Like Richard Baskin and Don Johnson before him, Howard was tall, boyishly handsome—and precisely eight years younger than Barbra. And, as she had done with Baskin and Johnson, Barbra began seeing him during the Christmas holidays. By summer, however, she had moved on—to Irish actor Liam Neeson, another one of her "flings." At thirty-eight, Neeson was *eleven* years younger than Barbra.

Whatever intrusions on her private life Barbra had to contend

with, they were nothing compared to the headline that ran on the front page of a London tabloid on July 1, 1991: BARBRA WEEPS OVER GAY SON'S WEDDING. The accompanying story provided a detailed account of Jason's alleged wedding to underwear model David Knight. The two men had actually never even met.

"At the time, I was so shocked," said Jason, who had been called by the tabloid before the story ran and asked if it was true. When Gould replied that the story was "ridiculous—totally false," the tabloid reporter claimed he had seen the wedding album.

Jason considered suing, but decided that "would have just drawn more attention to the whole thing . . . But it was shocking to me— how they used and manipulated me. It was such an ugly part of being in the public eye, to me, that I withdrew."

Eventually, he would come to terms with the article that effectively dragged him out of the closet. "It was a ridiculous story," he said. "It was funny in a way."

Barbra, on the other hand, would never see the story as anything but reprehensible. "Who makes up a story like that? It's so untrue on so many levels," she said. What seemed to bother Streisand most was the story's assertion that she was so upset that she refused to attend the fictitious wedding. "To even suggest that I would be angry over anything about his life—if my son got married to a chimpanzee, I'd be there."

The tabloids were one thing, but when the very respectable *Vanity Fair* confronted her with complaints from an AIDS activist that she had not done enough for their cause, she was livid. "Of all the celebrities who should have done more for gay men during the AIDS crisis, it's Barbra," an "industry bigwig" was quoted as saying. "Whenever you call Madonna or Bette or Liz Taylor, they're there, no questions asked." The bigwig added that Barbra was hiding "behind this stage-fright crap," that she was interested only in raising money for politicians. "We are the people who discovered her, who have loved her. Where is she? It's shameful."

"That's their opinion," Barbra replied, pointing out that she had given money—in fact, she had already given more than $400,000— not only to pediatric AIDS research, but also to amfAR. She pointed out that Taylor, amfAR's official spokesperson, had really only the one cause to promote—AIDS research—while Streisand doled out

millions to a wide range of charities. As for public appearances: "Madonna and Bette like to perform—and I don't."

The *Vanity Fair* piece had been timed to coincide with the release of her four-disk boxed autobiographical album *Just for the Record*. One of the people she dedicated the album to was Herb Ross's assistant choreographer Howard Jeffrey, who had died of AIDS in 1988. Unfortunately, she misspelled his surname "Jeffries" in the dedication. She also dedicated the album to her old friend Peter Daniels, who had died of cancer. The day after Daniels's death, she sent his widow, Lainie Kazan, a gardenia bush and followed up with a phone call. The two women talked about Daniels, their families, and their lives for over an hour. "Barbra realized at last that Peter had been an important part of her life. But it was very sad, because now she wanted to tell him how she felt—and it was too late."

"Can I just see the difference if you put that one lightbulb on right there?" she asked the *60 Minutes* cameraman. "Now, come in closer on the back camera . . ."

Mike Wallace winced. *The Prince of Tides* was about to be released, and Barbra was sitting down with the CBS newsman, who had given her so much valuable TV exposure on his *PM East* show thirty years earlier. Wallace, however, was growing angrier by the second as Barbra tried to direct *his* show.

"Start the interview, *please,*" he snapped. Reminiscing about the old days, Wallace told Streisand, "You know something? And I don't think you liked me, either. I really didn't like you back thirty years ago." She admitted that at the time, she thought he was "mean, very mean."

Things heated up as the interview progressed. When he chided her about her decades of psychotherapy, she barked, "Why do you sound so accusatory?" Wallace's mocking tone when he asked her about her stepfather triggered another outburst. "Why do you do that? You don't believe me? Like I have to convince you of this or what?"

Finally, Barbra broke down while talking about both the Kinds— the stepfather who emotionally abused her and the mother who al-

lowed it to happen. She seemed to be most upset when Wallace quoted Diana Kind as saying her daughter could not get close to anyone. "She says you haven't got time to be close with anyone. To anyone," Wallace said. "That's your own mom."

"You like this," Barbra replied, dabbing angrily at her tears with a tissue, "that forty million people have to see me do this." Upset with herself for having lost control, she asked that the cameras be turned off for a few moments so she could regain her composure.

Later, Barbra would say she was shocked by Wallace's behavior. "I came to him with love," she said. "I felt we were part of each other's story." The interview, she said, was akin to being "date-raped." Wallace, she went on, "has a bit of a mean streak, sad to say . . ."

But Barbra did admit that she was not exactly immune to crying jags. At one point in *The Prince of Tides,* Tom Wingo breaks down and sobs uncontrollably in Lowenstein's arms. "Well, that actually happened to me," she confided to her friend Gloria Steinem. "I was beginning to remember [her childhood abuse], and the therapist just reached out and touched my hand—and suddenly I couldn't stop crying."

When *The Prince of Tides* finally hit theaters, she experienced another sensation. "It's like being a railroad train that goes nonstop and then comes to a halt," she said. "My body is still shaking."

She stopped shaking when the reviews—and the box-office reports—came in. "Streisand is an *outstanding* director," raved Gene Shalit on the *Today* show, while *Variety* agreed that, with the picture, "Streisand puts herself indisputably into the front ranks of directors." *New York Times* critic Janet Maslin wrote that "nothing about Barbra Streisand's previous acting or direction is preparation for her expert handling of *The Prince of Tides*." Conversely, *Rolling Stone* named it the second worst film of the year, behind Bruce Willis's megaflop *Hudson Hawk.*

What upset Barbra most was criticism from psychiatrists and others in the mental-health field who blasted her for, in Streisand's words, "glorifying a psychiatrist who victimized her patients" and "setting back the entire therapeutic process." In a first for Streisand, she used the guest column "My Turn" in *Newsweek* to defend her portrayal of Susan Lowenstein in the movie. She pointed out that

The Prince of Tides was not a documentary "but a work of fiction . . . about family dysfunction and love and healing." As for the film's accuracy: "I did a great deal of research about therapy and therapists," she wrote. "Many therapists have told me they recommend that their patients see the movie."

When Academy Award nominations were announced on February 19, 1992, *The Prince of Tides* received an impressive seven—including Best Picture, Best Actor (for Nolte), Best Supporting Actress (Kate Nelligan), Best Screenplay Adaptation, and Best Cinematography. Incredibly, Barbra—who was only the third woman ever to receive a nomination from the Directors Guild of America—was once again overlooked in the Best Director category. (The award would ultimately go to Jonathan Demme for the year's Best Picture winner, *Silence of the Lambs*.)

Barbra was attending the royal premiere of her film in London, and had just met Princess Diana, when she got the news. She was delighted with the movie's seven nominations, but did not try to conceal her disappointment for being snubbed by her fellow filmmakers a second time. "She never had a chance," said one member of the DGA who voted for her. "People think she's egomaniacal, demanding, and, frankly, a great big pain in the ass. As perverse as it sounds, each success seems to make Hollywood *want* to hate her more and more."

Once again, feminists were outraged. Barbra shared the widely held belief that had she been a man, she would have not only been nominated but won Oscars for *Yentl* and *The Prince of Tides*. "We've come a long way," she said. "Not too long ago we were referred to as dolls, tomatoes, chicks, babes, broads. We've graduated to being called tough cookies, foxes, bitches, and witches. I guess that's progress."

But not everyone agreed. Journalist Jack Kroll said the snub was "less sexism than Barbism. Many in Hollywood consider her self-absorbed, difficult, and controlling." Her friend, producer Sandy Gallin, felt it had more to do with plain jealousy. "The community said, 'Who is this singer, comedienne, actress who thinks she is going to direct and produce?' and they've never gotten over it. I think it stinks."

The music industry obviously felt more warmly toward Streisand.

Three days after the Oscar events she was in New York to accept the Grammys' Living Legend Award from Stephen Sondheim. Before she did, Streisand accepted an invitation from *Saturday Night Live* executive producer Lorne Michaels to watch comedian Mike Myers perform his popular "Coffee Talk" segment as Streisand superfan Linda Richman. This time, guest stars Madonna and Roseanne Arnold would be on the couch next to Richman—Arnold playing Linda's mother and Madonna as another rabid Streisand fan, Liz Rosenberg (which also happened to be the name of her publicist).

During the live broadcast and unbeknownst to anyone but Michaels, Barbra watched the proceedings on a monitor in a back office. She shook her head and giggled as the "Coffee Talk" gals all agreed that Barbra's nails, legs, and *The Prince of Tides* itself were "like buttah." Then, Myers as Linda Richman began fanning herself with the back of her hand and announced that she was feeling "a little *fahrklempt*. I need a moment . . . Talk amongst yourselves."

At this point, Barbra had made her way down the maze of hallways at NBC's Rockefeller Center studios to the set. A collective gasp went up from the audience, the crew, and the cast as Streisand, dressed all in black, sidled up behind them and said, "All this talk about food is making me hungry, girls." Myers, Roseanne—even the normally unflappable Madonna—sat gape-mouthed as Barbra walked away and the audience roared. "Gee," she said to Michaels, as if still surprised her mere presence could evoke such a reaction, "that was fun."

Fun is what Jon Peters was aiming for when he transformed his twelve-acre Beverly Hills estate into "Barbra's Magic Castle" in honor of her fiftieth birthday. Borrowing a page from Michael Jackson's Neverland, Peters augmented his own menagerie of ponies, pigs, goats, and peacocks with a circus elephant, stilt walkers, clowns, face painters, and carnival games. Greeted by footmen in velvet coats and powdered wigs, Barbara's three hundred guests—including Frank Sinatra, Meryl Streep, Nick Nolte, and Warren Beatty and Annette Bening—as well as their one hundred children sang "Happy Birthday" to Barbra before cutting into the three-foot-tall castle-shaped cake.

Now that she had reached the half-century mark, Barbra was se-

riously considering plastic surgery. "I arrived in Hollywood without having my nose fixed, my teeth capped, or my name changed," she said. "That's very gratifying to me."

Still, she conceded that she would, in fact, have a nip or a tuck—if it weren't for the fact that she was terrified of doctors, hospitals, and anesthesia. In short, she would not relinquish control of her body any more than she would give up control of her work. "I wish I had the guts to have my eyes done, but I'm so scared that I just couldn't do it," she insisted. "I don't even have pierced ears!"

Now that she had reached the mid-century mark, Barbra told her friend and fellow feminist Gloria Steinem that she wanted to be a mother again. "When I saw the abandoned wards of children in Romania, I wanted to adopt one of those babies," she said. "I'd like a chance to be a mother again, to a little girl this time, and see if I could give her all the love and freedom to be her true self. It's partly a way of giving totally, as one would to a man. I have a need to give to something outside myself, and since there's no man right now . . ."

Barbra did not adopt a child, but she did find a man—actually, two. In 1992, she began spending time with actor Peter Weller, who'd played the title role in the hit science-fiction film *Robocop*, and who, like Barbra, was an aspiring director. But Weller was only five years younger than Streisand, and like many males facing a midlife crisis, she seemed ready to embark on a new romance with a newer—and decidedly younger—mate.

Tennis champion Andre Agassi had been so touched by *The Prince of Tides* that he called Barbra to thank her for making the film. The two-hour-long conversation that followed led to a series of discreet dates in New York, Aspen, and Los Angeles. At twenty-three, Agassi was twenty-seven years Barbra's junior—and three years *younger* than her son.

The press went into a frenzy when Barbra showed up at the U.S. Open in Forest Hills to cheer him on. After Agassi had won his match, he and Barbra left for Manhattan in her limousine. "Andre," she gushed, "is very intelligent, very, very sensitive, very evolved—more than his linear years. And he's an extraordinary human being. He plays like a Zen master. It's very in the moment."

Andre waxed no less mystical. "We're from different worlds, but

we collided," he told a British writer. "From that moment, we knew we wanted each other. With some people, there's an instant connection. That's what happened to us."

Needless to say, Andre's fiancée, Wendi Stewart, was less than thrilled. "That woman is old enough to be your mother!" she reportedly shouted at him. "She's trying to rip us apart and you're letting her!" On another occasion, she supposedly got so angry at Agassi for playing a Streisand CD while they were riding in his car that she snatched it from the player and threw it out the window "like a Frisbee."

While they were never together for long stretches at a time, the icon and the tennis stud did manage to keep their affair alive for nearly a year. In July of 1993, Barbra showed up at Wimbledon to cheer Andre on from the stands in the quarter finals. "Go, go, go. Beautiful, baby!" she yelled from the stands, jumping to her feet and waving to Andre whenever the match with Pete Sampras seemed to be going his way. "Yes, yes! Beautiful!" The once-hirsute Andre, who caused a stir by shaving his chest hair (reputedly at Barbra's behest), frequently looked up to exchange loving glances with his new flame.

Agassi lost his Wimbledon crown to Sampras ("It was very exciting, but of course I'm disappointed," said Barbra), but that hardly mattered to the celebrity-obsessed British press. Andre told one journalist that his affair with Barbra was "one of the sweet mysteries of life . . . I'm not sure I can fully explain it. Maybe she can't either. But it doesn't matter."

After Wimbledon, the affair fizzled. Soon Agassi would marry a willowy actress closer to his age, twenty-seven-year-old Brooke Shields. Barbra took it all in stride. After all, the entire time she was seeing the young tennis heartthrob, another man was occupying her thoughts and dreams. He was closer to her own age, pudgy, far from rich—and very married to a woman who was every bit as strong-willed as Barbra. His name was Bill Clinton.

"Raising money—that's the real use of power, if I have any."

She was not that impressed with Bill Clinton—at least not at first. As the 1992 presidential campaign heated up, Barbra devoutly

wished that New York's fiery Democratic governor, Mario Cuomo, would seek his party's nomination. When it became clear that he wouldn't, Barbra intended to back liberal Iowa senator Tom Harkin. After Harkin was trounced in the primaries, Barbra was introduced to Clinton at a small meet-the-candidate gathering at the home of Interscope Records owner Ted Field. Impressed, Barbra joined the rest of the liberal Hollywood pack behind the charming, prematurely gray Arkansas governor with the Elvis drawl.

"That's great!" Hillary Clinton told her husband when they learned Barbra was on board for a key Bill Clinton–Al Gore fundraising concert. Even though the event would also feature Tammy Wynette, Dionne Warwick, and bring the comedy team of Mike Nichols and Elaine May back together for one night only, the Clinton team had been desperate to get Barbra on board. "Streisand is worth the rest of them put together," Hillary said. "She brings in the *major* money."

Bill and Hillary were also well aware of the size of Barbra's own fortune, now conservatively estimated at $100 million—as much, if not more, than many of the Hollywood moguls the Democrats had relied on so heavily in the past. "When Barbra Streisand believes in something or someone," said a California state Democratic Party official, "she gives—and I mean, she gives a *lot*. The Clintons knew that, too. They wanted a piece of that."

More than a thousand of Hollywood's wealthiest and most well-connected citizens gathered at Field's Beverly Hills estate to hear Barbra sing eight songs, including "People," the FDR anthem "Happy Days Are Here Again," and a rousing "God Bless America." All the while, Clinton sat in the front row, beaming in gape-mouthed wonder. It was at this point that Barbra, thrilled at the expression of unalloyed delight on the candidate's face, realized she was backing the right Democrat.

"I used to be a director," Barbra joked, "and now I've become a backyard singer!" On a more serious note, she took an opportunity to blast incumbent President George H. W. Bush and his vice president, Dan Quayle. It would be nothing short of a "disaster," she said, if they were reelected. Streisand was so worked up that she was now threatening to move to England if the Republicans managed to hold on to the White House.

In the end, the "backyard singer" was given the lion's share of the credit for luring in the biggest contributors, most of whom would not have dug so deeply into their pockets to hear Tammy Wynette. The event, broadcast via closed-circuit television to contributors in Washington, San Francisco, New York, and Atlantic City, raised over $1.5 million.

After the concert, Bill took Barbra aside and told her about his troubled childhood—the father who died before he was born, his violent, alcoholic stepfather, and the mother who taught him to believe he could achieve anything. From then on, she told her friends, "I totally identified with Bill. When you grow up without a father—it's really the defining thing in your life. People like us, I think we're more sensitive to others, we feel things more deeply."

On November 3, 1992, William Jefferson Clinton was elected the forty-second president of the United States, though he had failed to win a majority of the popular vote. Bill had received 43 percent, Bush 38 percent, and third-party candidate Ross Perot 19 percent.

Barbra dismissed the fact that 57 percent of the electorate had *not* voted for Bill. That night she fired off a telegram to him: I'M SO VERY EXCITED FOR YOU, FOR ME AND FOR THE REST OF AMERICA. YOUR VICTORY RESTORES MY FAITH IN THE PEOPLE OF THIS COUNTRY.

Convinced that she had played a significant part in sending Bill Clinton to the White House, Barbra did not shy away from making her own feelings known two weeks later when she showed up to accept the Commitment to Life Award from AIDS Project Los Angeles (APLA).

The *West Side Story*–themed APLA event at Los Angeles' Universal Amphitheater ranged from confessional (gay entertainment mogul David Geffen talking about his own journey to self-acceptance) to camp (Elton John, in pearls, twittering "I Feel Pretty"). Barbra sang two songs with Johnny Mathis before being introduced to the crowd by a former lover, Warren Beatty.

There were those in the audience who still felt that Barbra had not done enough to deserve the award—that she had spent millions on her houses and her vast art and furniture collections. In fact, in 1988 she spent more on one 1903 Gustave Stickley oak and wrought-iron sideboard—$363,000—than she had given to AIDS research up until that time.

In truth, Barbra's willingness to speak out on gay issues coincided with her discovery that her own son was homosexual. "She worked behind the scenes, sure," said an acquaintance of Jason's. "But she was never really *out there* until Jason told her he thought he was gay." Jason would never take credit for his mother's support of gay rights. But, he allowed, "she certainly got a more inside perspective from me."

Ignoring the criticism that had been leveled at her by members of the AIDS community, Barbra wasted no time blasting Ronald Reagan and George Bush. "Few of us have responded with enough urgency to meet this crisis of catastrophic proportions, certainly not the last two presidents." She went on to say that Republicans dismissed AIDS as a "gay disease with that official, homophobic wink—implying that those deaths didn't really matter."

She then went on to accuse President Reagan of genocide. "I will never forgive my fellow actor Ronald Reagan," she declared, "for the genocidal denial of the illness's existence, for his refusal to even utter the word *AIDS* for seven years, and for his blocking funding for research and education that could have saved hundreds of thousands of lives."

Barbra also denounced "the vote for hate in Colorado"—a newly passed state referendum that overturned long-standing laws banning discrimination based on sexual preference. "There are plenty of us who love the mountains and rivers of that truly beautiful state," she intoned, "but we must now say clearly that the moral climate there is no longer acceptable, and if we're asked to, we must refuse to play where they discriminate."

By the time Streisand was done with her speech—one of the evening's most bitterly partisan—some audience members were shouting "Barbra for President." Later, she came back out to close the proceedings with the bittersweet ballad "Somewhere."

The next morning's papers said little about Barbra's allegation that Ronald Reagan was guilty of genocide. Instead, her call for a boycott of Colorado ignited a firestorm of controversy. Her statement angered not only the people of Aspen—who'd voted three-to-one against the referendum and for gay rights—but also the scores of Hollywood heavy hitters who were about to make their annual holiday-season pilgrimage to the fabled ski resort. "In boy-

cotting Aspen," Cher pointed out in a statement, "you're lashing out at the wrong target."

"People who have real estate in Aspen were just freaked out at Barbra," one producer told the *New York Times*. Within days, she backtracked, claiming that she had not really called for a boycott, but that she would agree to one "if we were asked to" by a group "like the American Civil Liberties Union."

"Quite inadvertently, it seems, she broke one of the town's cardinal rules," observed the *Times*'s Bernard Weinraub, "which is that the issues that Hollywood speaks out about should remain as remote as possible, like . . . hunger in the third world. The farther away the better. In Hollywood, a political issue is embraced as long as one is not personally touched by it."

While Aspen's economy was reeling from Barbra's call for a boycott, she signed a record-breaking new ten-year, *$60 million* deal with Sony. Under the terms of the contract, she would produce five albums (at $5 million each, with a *42 percent* royalty for Streisand). Sony would also hold on to her forty-nine-album catalog and, for $20 million, own the rights to any Barwood films made over the next decade. The movie portion of the deal did not include whatever salary or fees Barbra might demand for directing, producing, or starring in a film.

There was no way of telling at this point what stratospheric sum she might command if she returned to performing live. "She could pretty much name her price," record-industry legend Clive Davis said. But the question was moot. While she would do what she had to in order to raise money for her political causes, Barbra still suffered from stage fright. She cringed at the thought of singing in front of people—no matter how small the audience. While spending time with her pal Donna Karan at Karan's rented Sun Valley house, Streisand watched in amazement while Liza Minnelli got up to sing during a cocktail party.

"I can't believe how you do this," she told Liza.

"Oh, come on, Barbra, *you* go up and sing," Karan said.

"Oh, no," Streisand said, shaking her head. "I can't. I can't . . ."

With that, Karan burst into song to prove that "*anyone* can get up there and sing." It was, the designer later said, "one of the most embarrassing moments of my life." But it was also the point at which

Streisand began to think that maybe, just maybe, she would be able to overcome her crippling stage fright.

Bill Clinton's inauguration-eve gala boasted a stellar lineup that included Aretha Franklin, Bob Dylan, Stevie Wonder, Elizabeth Taylor, Michael Bolton, Kenny Rogers, saxophonist Kenny G, and Diana Ross. Fleetwood Mac reunited to sing Clinton's campaign song, "Don't Stop (Thinking About Tomorrow)," Judy Collins sang "Amazing Grace," and Michael Jackson led everyone onstage in a stirring rendition of "We Are the World." But Barbra, straight blond hair flowing over the shoulders of her gray pinstripe Donna Karan suit, was undeniably *the* star of the evening. CBS certainly felt so. Based largely on the fact that Barbra Streisand would be headlining the gala, network executives agreed to pay $8 million for the broadcast rights.

Bill had told her that his favorite Streisand number was "Evergreen," and before she sang it, Barbra dedicated the song to "you and Mrs. Clinton." She moved on to Sondheim's "Children Will Listen" and "God Bless America," and when she was done, the President-Elect rushed up to give her his trademark rib-crushing bear hug.

The next day, Barbra was among the dignitaries who watched the swearing-in ceremony from VIP seats. Later, she watched the parade and joined the Clintons at the inaugural ball thrown by the Clintons' home state of Arkansas—one of eleven held that night.

At one point earlier in the day, a number of performers who were rehearsing for the Arkansas ball—Carole King, Michael Bolton, Kenny Loggins, Kenny G, Bruce Hornsby, and others—took to the stage for an impromptu jam session. "It was exciting, electrifying," said a longtime Friend of Bill's from Arkansas. "All the stars were so warm and friendly. Everyone was just ecstatic to be there." Then, as the FOB joined a friend backstage, the two women spotted Barbra sitting on a table, legs dangling.

"Oh, Miss Streisand," said one of the women. "I just wanted to let you know I heard you sing last night and you were wonderful— just amazing."

Barbra nodded faintly.

"We were just wondering," the woman continued meekly, "will you be singing tonight, too?"

"WHAT?!" Streisand screamed, throwing back her head and slapping the surface of the table with both hands. "You have GOT to be kidding! I *never* sing two nights in a row!" Then she climbed off the table and stormed out, leaving the two startled women in her wake.

"I've always been a huge fan of Barbra Streisand, and always just assumed all the stories about her were exaggerated," said one of the women. "But now we know they aren't. What a power-packed *bitch*."

Barbra could be much kinder to the people who were closest to the President. At the Arkansas ball, Bill introduced Streisand to his flamboyant, high-living mother, Virginia Kelley. Then Clinton told his mother that her younger son, Roger, an aspiring singer, was performing at the MTV ball nearby. "Can I go see him with you?" Barbra asked.

With that, Virginia took her by the hand, and they walked off together.

The President told the two women that he "had a feeling" that they would really get along. "They did more than that," Clinton recalled years after he left office. "They became fast friends, and Barbra called my mother every week until she died. I still have a picture of them walking hand in hand on that inaugural evening."

Barbra's first manager saw Barbra's blossoming friendship with the First Family as "par for the course with her. Here was the new president, and of course there was Barbra just doing everything possible to ingratiate herself. Of course a woman like Virginia Kelley couldn't have gotten within a million miles of Barbra if she hadn't been the president's mother. Barbra has no interest in, or use for, regular people. She can't even stand her own fans!"

By Bill Clinton's own admission, Barbra Streisand and the President's mother made the oddest of couples. Indeed, the Brooklyn-bred superstar and the Hot Springs divorcée had little in common besides their crimson fingernails and their abiding belief in Bill. But, virtually overnight, Barbra became closer to Virginia than she had ever been to her own mother.

Curiously, the President's hard-partying, four-times-married

mom was everything Diana Kind was not. Warm and outgoing, at times loud and profane, Virginia Kelley had a fondness for shorts, open-toed shoes, Minnie Mouse eyelashes, and hot-pink lipstick ("I always figure the brighter the better"). Her hairstyle was . . . unique: a bouffant, dyed black on either side, with a white "skunk stripe" down the middle. A die-hard fan of both Elvis and Streisand, the First Mother liked nightclubs, casinos, and betting on the horses.

Most important to Barbra, Virginia was unabashedly proud of her son, who in turn credited her with encouraging him on every step of his lifelong journey to the White House. This was something Streisand could not say about her own childhood, and the woman who had done everything she could to stifle her dreams and even now did not seem to grasp the sheer magnitude of her daughter's stardom.

Still, whenever Streisand complained to Virginia Kelley about her own mother, Kelley came to Diana Kind's defense. Kelley never revealed that she, too, had had a difficult mother. In fact, President Clinton's maternal grandmother was a tireless taskmaster and an unrelenting control freak; she could also be moody and violent, and often beat her hapless only child, little Virginia.

All of which made the President's mother and Barbra kindred spirits. "I think Virginia was much more fond of Barbra than she was of Hillary," said a friend of Kelley's from Little Rock. "Hillary had a mother who paid a lot of attention to her. She didn't need another one. She was pretty hard-boiled, anyway. But Barbra was very much a little girl in some respects, very soft, very needy emotionally, from what I understand. And Virginia always wanted a daughter, so it really was a perfect mother-daughter match in that sense."

In exchange for her interest and the unwavering public support Barbra gave her son, Virginia was on tap to offer Barbra loving words and sage advice. For example, it was Virginia Kelley who helped Barbra overcome her paralyzing fear of performing in public and encouraged her to return to the concert stage. In the meantime, Kelley served as Barbra's principal conduit to the President. Through her weekly calls to the politically savvy First Mother, Streisand monitored what was going on behind the scenes at the

White House. "If she needed to get a message to Bill," said the friend, "she could count on Virginia to get it to him."

Barbra's own mother, meanwhile, was living with a full-time housekeeper/companion in the modest condo Streisand had purchased for her in 1980. The third-floor apartment faced Burton Way, one of Beverly Hills' most well-traveled streets, and the din from the traffic below filled every room. Street people pushed shopping carts loaded with their possessions up and down the street in front of her building, and ambulances racing to and from a nearby hospital added to the cacophony. The alleyway behind the building was covered in graffiti, and garbage spilled from overturned trash cans.

Inside the apartment, the walls were drab, the furniture worn, and the rugs soiled. At one point, Diana's cable TV was disconnected because she hadn't paid her bill. Streisand, who picked up the tab for her mother's housekeeper, had reportedly been giving her mother the same $1,000 a month for years. Rather than ask for additional help—which at this stage in their relationship Streisand would almost certainly have provided—or simply send her bills to Barbra, Diana apparently remained silent. Now eighty-four and confined to a wheelchair, she hesitated to bother her world-famous daughter.

For the next few days following the inauguration, Barbra was battered in the press—not for her ill-conceived call to boycott Colorado or her preachy remarks between songs at the gala, but for her outfit. Specifically, the seductive slit that ran up the skirt of her Donna Karan suit. In the *New York Times,* Anne Taylor Fleming upbraided Barbra for trying to look like a "femme fatale" in her "peekaboo power suit."

Undeterred, Barbra realized full well that Bill Clinton was in the White House because she'd helped put him there. "Hollywood money was absolutely essential for the success of the Clinton campaign," said a former Clinton aide. "Streisand had raised millions for the Democrats, and was going to raise millions more. She's in a pretty powerful position, and she knows it."

The next evening, David Letterman made a backhanded reference to Barbra's newfound status in Washington with his "Top Ten

Signs the Presidential Honeymoon Is Over: Number Six: No longer a cinch to nail Barbra Streisand." A few days later, Letterman offered the "Top Ten New White House Rules: Number Eight: Barbra Streisand may take nuclear secrets home overnight, but must return them in the morning." Several months later, the President's continuing infatuation with his top Hollywood groupie would also be the subject of Letterman's "Top Ten Signs You May Be Bill Clinton's Long-Lost Half Brother: Number Three: You instinctively feel the need to get it on with Barbra Streisand."

Two weeks after the Clintons moved into the White House, several influential New Yorkers contacted Barbra and told her they felt their state's incumbent Democratic senator, Daniel Patrick Moynihan, wasn't liberal enough. Would she, they wondered, be at all interested in challenging him in the primaries?

"She was absolutely thinking about it," said one of the New York Democrats who had broached the idea. "She had given a couple of speeches and discovered that, instead of being terrified, she actually *enjoyed* it. She was warming to the political life."

Less than a week after Clinton's inauguration, Barbra issued a statement through Marty Erlichman: "Several people have approached me and I find it very flattering," she said. "I enjoy being of service and helping to bring about change. Where that will take me, I don't know. But it is intriguing."

Within hours, Barbra realized she had made a mistake. It made no sense, other party leaders were telling her, to cast doubt on the future of a respected Democratic senator—particularly when the margin in the Senate was so close. "Running for the Senate is out of the question," she now told reporters. "There should be no confusion between someone with political passion and someone with political ambition."

SEN. YENTL FLIP-FLOPS was the inevitable headline in the next day's *New York Post*. But former vice presidential candidate Geraldine Ferraro thought Streisand would make a "dynamite" candidate. "I'd love to see her run," Ferraro said, so long as she waited two years to challenge incumbent Republican senator Al D'Amato, and not Moynihan. Cracked then-Congressman (and later Democratic senator) Charles Schumer, "It's more probable that Pat Moynihan

would win a Grammy than that Streisand would run against him—
and I've heard Moynihan sing."

No matter. Over the next several months, Barbra would make
her presence felt in the nation's capital—and take full advantage of
her newfound status as the single most celebrated FOB (Friend of
Bill). Streisand's first-among-equals standing was underscored by
People magazine, which described the President as "the First FOB
(Friend of Barbra)."

Just how friendly with Barbra was the famously unfaithful Bill
Clinton? Late in March 1993, she was one of several entertainment-
industry power brokers who showed up at the White House for a
special briefing on Hillary's ill-fated plan to revamp health care in
America. Later, the President asked Barbra to come to the Oval Of-
fice for a one-on-one meeting. For nearly an hour, they discussed
ways to increase federal appropriations for AIDS research.

On March 27, heads swiveled and forks dropped when Barbra
appeared unannounced at the annual Washington Press Club Grid-
iron Dinner. The White House had called to ask that a room be set
aside for Barbra as a last-minute "houseguest" of the President.
While Barbra chatted with Eleanor Clift, John McLaughlin, and
other Washington pundits, the President, clad in a black sequined
tuxedo, cast several furtive glances in her direction. Then he ap-
peared onstage and, to Barbra's delight, swayed with his saxophone
to the Coasters' "Yakety Yak."

As it happened, Hillary, whose father had suffered a stroke a few
days earlier, was not in Washington at the time. Over the next two
weeks, she would shuttle to and from Hugh Rodham's hospital in
Little Rock as he hovered between life and death.

While Hillary was keeping a vigil at her dying father's bedside,
deciding whether he should be removed from life support, she was
unaware that Streisand was spending time with the President in the
White House. Barbra had not come empty-handed. That night, she
gave the President a special preview of her forthcoming album, a se-
quel to her huge *Broadway* album called *Back to Broadway*. "Bill *loved*
it!" she gushed when she got back to California. "He's a musician—
he has such a marvelous ear."

It was only after her father died and she flew back to Washington

that Hillary was told that Barbra had actually been at the White House playing her new album for Bill before spending the night in the Lincoln Bedroom. A steward who had been working at the Residence, the First Family's private quarters at the White House, decided to make his exit to the sound of slamming doors and shouting. "For Christ's sake, Bill," Hillary could be heard yelling from behind closed doors. "I'm down there with my dying father and you're up here with Barbra . . . I mean, did she have to stay overnight? How in the hell do you think that makes me feel? How do you think it *looks*?"

In the wake of the Gennifer Flowers scandal that had nearly derailed his candidacy, Hillary was more keenly sensitive than anyone to appearances. She was also painfully aware of her husband's propensity to stray—and the fact that he was, by his own admission, hopelessly starstruck. But Hillary's friends would say that it was Bill's insensitivity—the fact that he was entertaining the world's biggest female star in their home while his wife spent hours at her father's deathbed—that she found most reprehensible.

Presidential press secretary Dee Dee Myers would have her hands full at the next morning's routine press briefing. Reporters clamored to ask about the claw marks on President Clinton's neck and face. At that point, Myers had not seen the lurid gash running from his right earlobe down his jawline and a smaller cut on his neck. No, Socks the family cat had not scratched the President, Myers insisted. The President, she had been told, had simply nicked himself shaving.

"Then I saw him," Myers later said. "It was a big scratch, and clearly not a shaving cut. Barbra Streisand was clearly around at the time." The President, apparently making little effort to keep his story straight, then came up with an even less plausible story. "I got it playing with my daughter, I'm ashamed to say," he stated. "Rolling around, acting like a child again. I reaffirm that I'm not a kid anymore." The idea of thirteen-year-old Chelsea "rolling around" on the floor with Daddy seemed almost as unsettling as the unexplained wounds.

White House communications director George Stephanopoulos tried to laugh it off. "We'd better get to the bottom of this! Sounds like a real scandal!" Soon there were rumors that somehow Barbra

had accidentally inflicted the scratch with her famously long finger-
nails, though the reports of a violent argument between the Clin-
tons the previous night indicated otherwise. Either way, Hillary
banned Barbra from staying at the White House.

It was only a matter of months, however, before Barbra got
to spend some quality time with the commander in chief closer to
home. Even before his election, Bill Clinton was accustomed to
spending time in California with major figures in the entertainment
industry—thanks in large part to his old Arkansas buddies Harry
and Linda Bloodworth-Thomason, who had gone to Hollywood
and produced such major sitcom series as *Designing Women* and *Eve-
ning Shade*. "Bill Clinton knew his way around Hollywood," said
White House adviser David Gergen. "It was a world he very much
enjoyed. He loved the glitz and glamour of it all."

According to Mike McGrath, chief White House steward from
1993 to 1996, Bill and Barbra became "pretty playful" on a presi-
dential visit to California after he invited her up to his hotel suite.
Secret Service agents in the room told McGrath that the President
"chased her around the piano."

Back in Washington, however, Hillary's orders still stood. "Barbra
got her notch, he got his notch," observed one frequent White
House guest. "Hillary was livid, but Barbra was too important to
the Clintons as a fund-raiser to alienate. So Hillary gave orders that
Barbra was never to be at the White House when the First Lady was
not there."

Streisand, of course, had plenty of other places to stay in Wash-
ington. Her favorite D.C. hotel at the time: the Jefferson, where
management obligingly covered the bathroom floors with white
rugs so Barbra's feet would not have to touch cold marble.

Hillary's dictum aside, Barbra proceeded with her conquest of
the nation's capital. At Bill's request, she returned in May for a
weeklong crash course in power politics. Barbra's Washington blitz
began with the annual White House correspondents dinner, where,
thirty years before, she had instantly charmed JFK by greeting him
with "You're a doll." Clad in an off-the-shoulder white satin gown
and a bejeweled white choker, Barbra swept into the ballroom of
the Washington Hilton on the arm of former beau Richard Baskin.
Relaxed and smiling in an atmosphere she would later say felt unex-

pectedly comfortable, Barbra schmoozed with the likes of then–Joint Chiefs of Staff chairman Colin Powell ("In the end he's just a guy from the Bronx and I'm just a girl from Brooklyn") and did something she rarely did without complaint—she autographed dinner programs and napkins for anyone who asked.

Barbra was delighted when she picked up the papers the next morning and read the headlines: BARBRA TURNS HEADS OF STATE, BARBRA STEALS SHOW AT CORRESPONDENTS' GALA, and BARBRA'S THE MAIN EVENT. Said Streisand: "I was like a little girl, thrilled, you know?"

Over the next few days, she dined with Attorney General Janet Reno, sat in the audience at the House Armed Service Committee hearings on homosexuals in the military, toured the FBI headquarters and the Holocaust Museum, and attended a Democratic congressional dinner as the guest of a very grateful California senator Barbara Boxer.

Inevitably, there were those who accused Barbra of a blatant power grab. "On a clear day in Washington," sniped the *New York Times,* "you can see Barbra Streisand forever."

"What do I have to do? Leave the country or stay in my house?" she asked. "I can't be a tourist? I can't meet the attorney general of the United States without getting flak?" Barbra theorized that the press was "jealous of the people who have some access to Clinton."

Barbra made it clear that while she would not be seeking elective office, she would not object to an appointment to, say, a presidential commission dealing with one of the issues she was interested in. The President, meanwhile, was looking into the possibility of appointing her to an ambassadorship—specifically, to the State of Israel.

At fifty-one, trumpeted the *New York Times,* Barbra enjoyed "a cultural status that only one other American entertainer, Frank Sinatra, has achieved in the last half century. On top of her longevity as a star . . . her friendship with Bill Clinton has propelled her to a new peak of power in Hollywood."

Not surprisingly, not everyone welcomed Barbra's rise to political prominence. In a *Washington Post* editorial titled "Miss Marmelstein Goes to Washington," Jonathan Yardley warned, "Watch out, D.C., here comes Hurricane Streisand." He went on to deride Barbra as "a political savant . . . It is all well and good to wring one's hands over nuclear annihilation and AIDS research . . . it is another

thing to think them through clinically and objectively. This the Hollywood mind is simply incapable of doing . . . So here they come, traipsing down the Yellow Brick Road: La Barbra and her legions of the terminally vain."

Undaunted, Barbra stepped up her partisan assault on the "genocidal" administrations of Reagan and Bush and the "right-wingers" in Congress who dared to disagree with the Clinton agenda. When she ridiculed well-heeled Republicans at an AIDS benefit that June of 1993, her cohost for the event, Elton John, was "horrified. Some of them got up and left." Pointing out that AIDS is not a partisan issue, John blasted Barbra not only for being rude, but for alienating important contributors. John's opinion of Streisand: "She's an egomaniac."

Even more of one, perhaps, after the release of *Back to Broadway* a few days later. On the strength of advance sales alone, the album debuted at number one—a first for a Streisand solo album. With its release, Barbra became the first star to have number one albums in the 1960s, 1970s, 1980s, *and* 1990s.

To celebrate, songwriter Carol Bayer Sager threw a dinner party for Barbra attended by, among others, Clint Eastwood (whom she had briefly dated back in the mid-1980s); former lover Warren Beatty and his wife, Annette Bening; Bette Midler; Carol Burnett; and Neil Diamond. Toward the end of the evening, Barbra, who attended the party with old flame Baskin, told the glittering crowd that she intended to thank them for coming by singing a few songs from the new album. She left to make a costume change and, minutes later, appeared under a spotlight singing "Somewhere." Once she was finished, the room exploded in applause. It was only when she was halfway through her second song that someone turned around and spotted Barbra standing in the back of the room, doubled over with laughter. The "Streisand" who was serenading the celebrity crowd was actually Streisand impersonator Jim Bailey. "He was," said Eastwood, "awfully darn good."

Amazingly, even as she collected an estimated $7 million from *Back to Broadway* alone, Barbra was strapped for cash. Out of the blue, she called her old friend Barry Dennen. "I'm broke," she told him. "My money is all tied up in real estate and investments. The taxes are killing me. I've got these cash-flow problems. I got no cash!"

To be sure, Streisand had always had trouble keeping her overhead in check. Alone, she bore the crushing burden of income taxes, property taxes, and the cost of maintaining her properties in Malibu, Holmby Hills, and Manhattan—not to mention the battalion of gardeners, maids, cooks, drivers, bodyguards, secretaries, hairdressers, accountants, lawyers, and assorted hangers-on that it took to keep her world running smoothly. She was still worth well over $150 million, but, as she whined to anyone who would listen, "it isn't *liquid*. I need cash!"

Dennen offered a one-word solution: "Concertize." While she still suffered from crippling stage fright, the once-reclusive Barbra was no longer content to sit at home—or, more accurately, in one of her seven homes—alone. "Now," she said, "I'm trying to push myself out there in the world."

But she needed another push to get her onto the concert stage, and her old friend Kirk Kerkorian would give it to her. Barbra had opened what was then the biggest hotel in the world, Kerkorian's Las Vegas International (later acquired by Hilton), twenty-four years earlier. Now he wanted her to do an encore—this time to christen his newest hotel, the MGM Grand Hotel and Casino. With over five thousand rooms, once again, Kerkorian could boast that his was the world's largest hotel.

Kerkorian made Barbra an offer she couldn't refuse: If she agreed to perform two concerts, on New Year's Eve and New Year's Day, 1994, he would pay her *90 percent* of the gross. He would also throw in $3.5 million for her favorite charities. In addition, HBO would pay Barbra $5 million for the rights to tape the New Year's Eve concert, and she would share in the sale of merchandise sold at the concerts. Reluctantly, she agreed.

Even at between $500 and $1,000 a ticket (with scalpers getting as much as $3,000 per ticket), both shows sold out within hours. In the end, Barbra's total take for the two nights' work would exceed $15 million.

With the Bergmans helping to pick her material—songs that would trace not just her career but her entire life story—and her old pal Marvin Hamlisch hired to conduct a sixty-four-piece orchestra, Barbra rehearsed for weeks in New York, then Los Angeles. Hamlisch bowed to her legendary obsession with perfection. "Marvin, I

love you," she told him during one run-through, "but the drums have got to go!"

Donna Karan was brought in to design Barbra's wardrobe for the concerts. Karan, whose father had also left his family when she was very young, ranked behind best friend Cis Corman but alongside Evelyn Ostin (wife of longtime Warner Bros. Records chief Mo Ostin); International Creative Management executive Ellen Gilbert; "psychospiritual therapist" Joanne Segel; Cis's husband, Harvey Corman; the Bergmans; and now Virginia Kelley in Streisand's tight circle of true friends.

Karan and Streisand worked together on the designs, but in this, as in all things Streisand, the star would have the final word. When she could not decide between two Karan skirts in different lengths to wear during her act, Barbra merely had the two stitched together to make one two-layer design.

Once she was finally bound for Las Vegas, Streisand panicked. She would not sleep for the next two days, began losing weight, and, after nerves had her fleeing to the bathroom, started downing the antidiarrheal medication Lomotil. Still, she had to admit that over and above the millions she stood to make for just four hours' work, there would be an added benefit for the woman who'd suddenly found herself with no special someone in her life. "At least"—she sighed to herself—"I won't be alone on New Year's Eve."

*I'm a shy person. I don't **need** to keep doing this.*

She wants to be famous and anonymous simultaneously.

—Chaim Potok

I was thinking, Why aren't I finding a fabulous man to love me? Then boom—destiny.

10

—

December 31, 1993
Las Vegas

She stood at the top of the wide staircase, a solitary figure in a low-cut black velvet gown. The spotlight hit her, and for one brief moment, one could detect the slightest flicker of fear in those cerulean-blue eyes. Rising up from the orchestra were the first haunting bars of Andrew Lloyd Webber's poignant "As If We Never Said Goodbye."

"I don't know why I'm frightened," Barbra sang, allowing her voice to quaver almost imperceptibly—just enough for full dramatic effect. "I know my way around here . . ."

Indeed she did. Once she had brought that first song, the show-stopper from Lloyd Webber's *Sunset Boulevard,* to its spine-tingling conclusion, the audience jumped to its feet—the first of ten standing ovations. "Aren't you nice," she said, as if genuinely surprised. "What a wonderful audience."

The rest of *The Concert,* as Barbra's much-ballyhooed comeback to live performing would be solemnly called, would be punctuated by shouting, clapping, cheering, whistling, and stomping. At times, Barbra seemed genuinely shocked by the reaction she could still elicit from an audience.

"I was really frightened," she later admitted. "My heart was pounding. Why would I put myself through this agony?" Barbra asked herself. Most of the time, however, she seemed surprisingly

relaxed as she moved around the pillared, all-white Palladian stage. Meticulously furnished with of-the-period antiques, the set was modeled after Thomas Jefferson's quietly elegant tearoom at Monticello—a room that had inspired Streisand during her trip to Washington and Virginia earlier in the year. Between numbers—which ran the gamut from "Don't Rain on My Parade," "The Way We Were," and "You Don't Bring Me Flowers" to "People," "He Touched Me," and "The Man That Got Away"—Barbra lounged languidly on a settee, sipped herbal tea from period china, and expertly delivered "impromptu" wisecracks that scrolled on teleprompters clearly visible to many in the audience.

The faces of the fifteen thousand people jamming the MGM Grand's Grand Garden—some of whom came from as far away as Australia, South Africa, Germany, and England—were little more than a blur to her. It was this invisible "curtain" between Barbra and her audience that made it possible for her to perform at all.

The faces she *could* make out in the first few rows were memorable indeed. They included Michael Jackson, Mel Gibson, Prince, Coretta Scott King, Michael Douglas, Quincy Jones, Steven Spielberg, Kim Basinger and her then-husband Alec Baldwin, Richard Gere and his then-wife Cindy Crawford, Gregory Peck, L.L. Cool J, Shirley MacLaine, First Brother Roger Clinton, Roseanne Arnold, and Jay Leno. Elliott Gould was there with their son, Jason (to whom she would sing a touching rendition of Sondheim's "Not While I'm Around"), Jon Peters with her adored goddaughter, Caleigh (to whom she would sing a medley of Disney tunes), and a few of the other men in her life—namely Peter Weller, Richard Baskin, and Andre Agassi.

After closing her first act with a rafter-rattling rendition of "On a Clear Day You Can See Forever"—it had taken 2,700 hours of therapy before she felt she could really sing the song, Barbra cracked—she made a calculated costume change. She reappeared wearing a white georgette suit with a daring slit up the side of the skirt—much like the one she'd worn to the inaugural gala. Streisand launched into a spiel about Anne Taylor Fleming's "peek-aboo power suit" remark in the *New York Times* when suddenly someone stood up in the audience.

"Don't listen to that woman, Barbra!" shouted "Linda Richman."

Mike Myers, in full "Coffee Talk" drag, started making his way to-
ward the stage. "You look sensational! You're like *buttah!*" When
Richman said that merely standing in the presence of La Streisand
left her feeling *fahrklempt,* Barbra shot back, "You're *fahrklempt?*
I've got *schpilkes* in my *genecktegezoink!*" With the audience howl-
ing, Barbra gestured to the audience. "Talk amongst yourselves,"
she said, borrowing another classic Linda Richman line. "I'll give
you a topic: *The Prince of Tides* was neither about tides nor princes.
Discuss."

Meticulous planning aside, some of the most winning moments
of the evening came when Barbra showed her vulnerability. At one
point, she botched the lyrics to "Evergreen," but rather than be-
coming flustered, she made a joke of it. "And it's my own song!"
she said sheepishly.

Less winning were Barbra's carping remarks about the MGM
Grand, from the room rates to the fact that there were no soap
dishes in the bathrooms. "You'd think for the money they were
paying her," one person in the audience remarked, "she could bring
her own soap dish."

Toward the end of the program, Barbra introduced the widow of
Martin Luther King from the audience and dedicated her next
song, "Happy Days Are Here Again," to Virginia Kelley. Barbra's
surrogate mother then stood up to take a bow.

While her journey to self-discovery through psychoanalysis
seemed to be the overriding theme of the evening, Barbra could not
resist plugging her favorite politician. Her stirring rendition of
"Happy Days Are Here Again" was delivered against a backdrop of
images from the Great Depression, followed by what amounted to a
video tribute to the eleven-month-old presidency of Bill Clinton.

Barbra's own mother, who apparently preferred not to share the
spotlight with Virginia Kelley on opening night, stood up and took
a bow at the *second* concert. Earlier, she had mock-innocently asked
her daughter, "Why are they paying you so much money to sing?"

Clearly, Streisand was determined to give them their money's
worth. After the crowd clamored for more, she delivered two of her
best performances of the evening—a stirring "My Man" and a
wistful rendition of the bittersweet standard "For All We Know."

When it was over, Barbra squealed, "I did it, I did it, I did it!"

as the last standing ovation washed over her. She was ecstatic—justifiably so. She had just given her first paid concert in twenty-two years. She was proud of herself for overcoming her stage fright; she had even repressed the urge to throw up that had overtaken her so many times before.

"I think I even enjoyed myself. It went well, don't you think?" she asked Marty Erlichman. "Just wonderful, wasn't it?" She sought similar reassurance from Hamlisch, who had, as always, received little thanks for his huge contribution to the concert's success. But it did not take long before Barbra launched into her customary, soul-numbing postmortem. Was her phrasing on "My Man" okay? Did the gown she wore in Act One show too much cleavage? Not enough? Should she have worn more jewelry? Did she come in too late on "Someday My Prince Will Come"? The special lyrics Sondheim had written for "I'm Still Here"—"One day you're hailed for blazing trails, next day you're nailed for fingernails"—were great . . . but did it go on a little too long? Huh, what about the lighting?

There was one thing that would have made the evening even more exciting. Until the last minute, Barbra had clung to the hope that Bill Clinton would attend. But when asked why neither he nor the First Lady would be there to cheer on someone who had raised millions for his campaign, Dee Dee Myers replied simply that it "was not on the President's schedule." What did they do instead? The Clintons spent the closing days of 1993 in Arkansas, going to a Razorbacks basketball game and attending a Renaissance weekend. "I walked on the beach, played touch football with the kids, and golf with my friends," he later recalled. "I enjoyed the company."

Bill Clinton had, in fact, also enjoyed Barbra's company just two weeks before the concert, when they both attended a $25,000-a-plate Clinton fund-raising dinner at the Beverly Hills home of billionaire Marvin Davis. Barbra stood up and purred "Bill," the love song from *Showboat,* directly to the President. Clinton beamed back as she looked into his eyes and delivered the song's key "my Bill" lyric. Later in the evening, they reportedly disappeared for a private chat. Thanks to the presence of Bill and Barbra, the dinner raised $2.1 million.

Hillary had had no idea that Barbra Streisand was going to be

there, much less sing a love song to her husband. When word of the touching scene got back to her, she warned her husband not to make one of his last-minute schedule changes in an attempt to catch Streisand's concert. "We are *not* going to Barbra's concert, Bill," Hillary told her husband. "I'm not going, and you're not going. God, don't be such a starfucker. You're the *president*."

To make matters worse, the same week Barbra serenaded Bill Clinton, several Arkansas state troopers went public with the charge that they had procured women for him when he was governor of that state—allegations that, even after withering attacks from Clinton partisans like Barbra, the troopers never backed down on. The allegations "hit Hillary hard," Clinton later admitted.

Said another friend from Arkansas, "Whether or not she had any reason to be, Hillary was jealous of the attention Bill was showing Barbra. Given what she had had to put up with all those years, you really couldn't blame her."

Virginia Kelley, however, had vowed to go—even though she had just endured a grueling round of chemotherapy for breast cancer that had left her bald. She now wore a wig, dyed with the wide white skunk stripe right down the middle. Virginia had agreed to spend that Christmas week at the White House, President Clinton recalled, only "when I promised I'd take her home in time to get ready for Barbra Streisand's much-heralded New Year's Eve concert. Barbra really wanted her to come, and Mother was determined to go. She loved Barbra, and in her mind, Las Vegas was the closest thing she'd seen to heaven on earth."

Barbra was impressed with how well her friend Virginia looked; the First Mom was still rather plump, robust, and as flamboyant as ever. On Barbra's opening night, she wore a sequined black top with the bold design of a glowering leopard wrapped around her shoulders. Virginia attended both of Barbra's performances, applauding wildly throughout.

During the week Virginia spent in Las Vegas, her son tried to reach her, but she never answered the phone in her hotel room. When she got back to Arkansas on January 5, 1994, Virginia called the White House to tell the President that "she had been out day and night, having the time of her life in her favorite city," Clinton remembered. "She had loved Barbra Streisand's concert and was

especially pleased that Barbra had introduced her and dedicated a song to her. Mother was in high spirits and seemed strong; she just wanted to check in and tell me she loved me."

Within hours, Virginia Kelley was dead. A devastated Barbra flew out to Arkansas two days later for a private viewing for close friends and family at a Hot Springs funeral home, followed the next day by a funeral that was attended by more than three thousand admirers. At the service, Barbra sat with the family, directly behind the President. When a longtime Clinton family friend, Janice Sjostrand, belted out "Holy Ground," Barbra touched Bill's shoulder and, he recalled, "shook her head in amazement."

"Who is that woman and what is that music?" Barbra asked the President after the service. "It's magnificent!" Inspired, Barbra obtained a tape recording of the funeral service, and would eventually use it as the blueprint for another smash album, *Higher Ground*.

Hillary was well aware of how close Barbra and her mother-in-law had been, but she was apparently still miffed about Barbra's visit to the White House and her tête-à-tête with Bill in California. Barbra cozied up to the Clintons as they left the funeral, hugging the President and his brother, Roger, before walking with them to the long line of limousines waiting to take them to the cemetery. "I don't want Barbra riding in the family car," Hillary told an aide as she settled in the back of the stretch limousine that could comfortably accommodate six. "*I mean it*. Just tell her there isn't enough room."

"Hillary resented Barbra Streisand the same way she resented so many other women in her husband's life," said one White House insider. "It wasn't Barbra's fault at all. Hillary knew that Bill was caught up in all the Hollywood glamour. She was afraid of what he might do . . ."

Once she returned to Holmby Hills, Barbra made the first donation—$200,000—to a breast-cancer research fund bearing Virginia Kelley's name. "I am so grateful for the time I was able to spend with her," Streisand said of her friend. "She died as she lived, with grace and dignity, full of enthusiasm and the joy of life. This new effort to combat breast cancer is endowed with that glowing spirit."

In the wake of losing her close friend, Barbra decided to do something hopeful and life affirming. She drove to the Northridge Mall

and bought a new bichon frise puppy. The next morning, however, Barbra—along with a sizable chunk of Southern California—suffered a jolt. An earthquake registering 6.7 on the Richter scale rolled through the Los Angeles area, killing fifty-seven people and causing nearly $3 billion in damage. Knocked out of bed, she made her way downstairs with a flashlight and found the puppy behind a heap of pots, pans, and other smashed objects in the kitchen. "He was quite calm and calmed me," she said. "The fact that he was alive mattered—not the objects."

Then she assessed the damage. Among the casualties: three chimneys, a rare "jack-in-the-pulpit" Tiffany vase, ten rare rose-colored early-twentieth-century ceramic jugs, a Stickley clock, a large mirror from the American Arts and Crafts movement, and one of her nine Grammys. "My house," she later said, "looked like a war zone."

Fortunately, the bulk of her impressive art and furniture collection had already been shipped to New York to be auctioned off at Christie's. She had always been a great believer in signs and omens, and the Northridge Quake convinced Barbra that she had made the right decision to empty out her houses in Malibu before donating the entire twenty-four-acre estate to the Santa Monica Mountains Conservancy.

Of course, the move also made financial sense: Unable to find a buyer, Barbra could now take a huge tax write-off for making what amounted to a $15 million charitable contribution. The compound would now be used for research in ecosystems and be called the Streisand Center for Conservancy Studies. "I'll miss my gardens," she said, "and all those organic vegetables and scented cabbage roses." (Later, incensed over plans by the conservancy to rent the property out for special occasions, she demanded that her name be taken off the center. The estate was redubbed Ramirez Canyon Park.)

By this time, Barbra felt that she had gone "about as far as you can go" collecting art deco and art nouveau pieces. Moreover, the obsessive lengths she had gone to showcase them at the Malibu estate had been staggering. Rooms in the art deco house, for example, had been decorated entirely in two color ranges—burgundy to pale rose, and black to gray. Not even the slightest deviation from this scheme

was permitted. "I don't put a black vase in the gray-and-burgundy room," she explained. Or pink roses in the gray-and-burgundy room, or burgundy flowers in the rose bedroom. Every detail had been color-coordinated—right down to the wrappers on the candy in the candy dishes.

None of this was new, of course. Film director Jerry Schatzberg remembered a time years earlier when he'd stood with Barbra in her master-bedroom closet "for a solid hour helping her figure out where she should hang her *belts,* and whether or not they should be allowed to touch the floor. She really agonized over things like that."

It took a year for Barbra to find precisely the right gray tassels to hang from a silk-rope handrail in a stairway. After making an extensive study of photographs and drawings of the period, she designed many of the architectural details herself—including ceramic-tile patterns, doors and door handles, stair rails, ceiling designs, friezes, carpets, bath fixtures, and a shower curtain. She also designed clothes and a necklace to "harmonize" with the interior of the house.

Determined to make every facet authentic, she even had the garage reconstructed to accommodate her art deco automobiles: a 1933 burgundy Dodge convertible roadster with a rumble seat, and a 1926 Silver Ghost Rolls-Royce. "By the time I finished," she conceded, "I was sick of art deco."

Streisand's obsessive approach to decorating extended beyond the deco house. She turned a $400,000 Tiffany peony lamp into the centerpiece of one of her living rooms, picking out draperies, upholstery, rugs, pillows, throws, even the fresh-cut flowers brought in each day, to match the lamp's colors.

Barbra approached collecting the same way she approached recording and moviemaking. "Doing business with Barbra is a living nightmare," one New York dealer said. "Barbra is a genius in the entertainment industry, but she thinks it carries over to the decorating world."

In setting up the Christie's sale of art deco collections, Barbra insisted on complete control and veto power. She also demanded that the auction house waive its usual seller's commission and agree to

pay for the shipping costs. "She finds time for every little detail," said Ushe Subramaniam, Christie's twentieth-century decorative-arts specialist. "She doesn't let anything slide."

Not that Barbra was done collecting. Ever since she began visiting her friends in the White House, Streisand had developed a keen interest in eighteenth-century American furniture. "She likes the Federal Adamsesque look of swags and tassels," said another dealer. Barbra offered a less complicated explanation. "I'm feeling patriotic," she quipped.

Actually, she had long ago replaced her deco obsession with a newfound passion for late-nineteenth- and early-twentieth-century American Arts and Crafts pieces. With its carved wood ceiling, long Mission sofas, book-lined walls, and dark oak furniture, her Holmby Hills house was now a shrine to Frank Lloyd Wright, Gustave Stickley, Dirk van Erp, and, of course, Louis Comfort Tiffany.

Her own case of art deco overload notwithstanding, more than one thousand well-heeled aficionados of the period flocked to Christie's New York on March 3, 1994, eager to snap up anything bearing the Streisand provenance. Barbra worked out with her personal trainer in Beverly Hills and listened over a speakerphone as the gavel came down on one record-breaking sale after another. When *Adam and Eve* by Tamara de Lempicka, which Streisand had bought ten years earlier for $135,000, broke the $1 million mark, she screamed. Eventually, the painting was sold for $2 million—a record for Lempicka. Among the other items that had Barbra and her trainer jumping for joy were a jade Cartier clock that went for $316,000, an Émile Galle vase decorated with elephants that fetched $145,500, and a Tiffany cobweb lamp that Barbra thought was "ugly-great" that sold for $717,500.

The total take for the 535 items placed on the auction block: a whopping $6.8 million—$1.8 million more than Christie's had originally guessed the auction would net. When someone pointed out that a few items had gone for less than the estimate, Barbra laughed. "My motto is: 'Be a bull, be a bear, but don't be a pig.' "

The unexpectedly large haul was enough to convince Barbra that auctions could generate considerable amounts of cash for her foundation. Over the years, through major houses like Christie's and via

the Internet, Streisand would raise millions by unloading everything from costly antiques and jewelry to movie costumes, old shoes, and kitchen appliances.

By the time she deposited her $6.8 million check from Christie's, Barbra had made it official: Since she had survived the Las Vegas appearances and the show was up and running anyway, she agreed to embark on a six-city, twenty-two-show tour of England and the United States—her first tour in twenty-eight years. In one frenzied hour on March 17, 1994, all 250,000 tickets—ranging in price from $50 to *$500*—were snapped up. The remaining 4.75 million who jammed Ticketmaster phone lines would have to find other ways to see their idol live—either by pulling strings or paying up to $3,000 to scalpers.

Once again, Barbra found herself at the center of a controversy. 500 BUCKS A TICKET? HAS BARBRA GONE NUTS? blared a headline in the New York *Daily News*. The outrage seemed justified. Streisand's ticket prices at the time far exceeded those charged by such top touring acts as the Rolling Stones, Bruce Springsteen, and Paul McCartney. For a self-professed liberal Democrat who often accused Republicans of being avaricious and out of touch with "the common man," Barbra's apparent desire to squeeze as much as she could out of her fans seemed particularly egregious.

"Her tour is designed to gross $2 million per show, which is greed," said *Performance* magazine's Bob Grossweiner. "No one else has asked for this kind of thing." Record-company publicist Michelle Roche was "pretty appalled by the prices." Agreed New York booking agent Bob Lawton, "To me, it's incomprehensible."

When scalpers in New York began selling those $3,000 tickets outside Madison Square Garden (which had sold out in less than thirty minutes), the New York City Department of Consumer Affairs and the state attorney general's office launched an investigation into price gouging.

At first supposedly "horrified" by the soaring price, Barbra agreed to sell thousands of tickets to twenty-two charities for $350 apiece, with the proviso that they could resell those tickets for up to $1,000—the difference in price would then be considered a tax-deductible charitable donation.

Barbra's bizarre "solution" would do nothing to affect her even-

tual take for the truncated tour: *$45 million* direct to Streisand from ticket sales alone. Barbra would later complain that her overhead—the cost of paying the orchestra, building the elaborate set, even carpeting each arena to ensure maximum sound quality—would cost her $16 million. But given the fact these were tax-deductible business expenses, she would still conservatively net $37 million.

This did not include, of course, the ancillary income from such sources as merchandise—everything from $20 programs to $60 ties to official Barbra Streisand tour jackets for $400. The merchandise would move so quickly that "Barbra Boutiques" were set up in major department stores around the country.

"I guess money," said Roche, "overpowered her stage fright." Sniffed tour publicist Ken Sunshine, "Everybody I've talked to thinks she's *underpriced* the show. She could have charged a thousand dollars for a good percentage of the house, and they would have sold out."

In the end, Barbra deemed the ticket price "fair. If you amortize the money over twenty-eight years, it's $12.50 a year. So is it worth $12.50 a year to see me sing? To hear me sing live? I'm not," she added incorrectly, "going to do it again."

The Concert kicked off at London's Wembley Stadium on April 20, 1994. At the second show five days later, she sang "Someday My Prince Will Come" to a blushing Prince of Wales as a clip of their nervous meeting on the set of *Funny Lady* ran overhead. "You look pretty good after all these years," Charles said after he went backstage to meet her. "You look pretty good yourself," she replied. Princess Diana, already formally separated from Charles, did not attend the concert.

As she moved from city to city, Barbra did what she liked best—rather than freeze the show, she added and subtracted songs and reworked her patter. "It has to be fresh and real every time, every moment," she explained. Added Marilyn Bergman, "Barbra never says, 'That's good enough.' People who don't understand or appreciate this process might find it threatening or tiresome. But she is indefatigable."

Because of these constant changes, Streisand relied heavily on the teleprompters that hung high above the audience—a crutch that irked some of the London critics. She began confronting the issue

head-on. "Look, I use teleprompters!" she declared to each audience, pointing out that in 1967 she had forgotten the words to her songs in front of 135,000 people in Central Park. "I couldn't do this if I didn't have my security blanket. Some people have worry beads; I have teleprompters."

Barbra also insisted on controlling her personal environment as much as humanly possible as she moved from city to city. At each hotel, she would reserve an entire floor for herself. White rugs were placed over existing carpeting, framed family photographs were placed around the suite, and vases were filled with fresh-cut flowers—but only blooms that matched each room's predominant color scheme.

She was equally particular about her dressing room at each venue—so much so that the furnishings traveled with her. Again hewing to her fondness for a monochromatic palette, the carpeting, couches, and draperies were all in white. Framed photographs of Jason, Caleigh, and Caleigh's little sister, Skye, were placed on dark wood tables, and huge crystal vases brimmed with elaborate, color-coordinated floral arrangements. (This decor would remind Barbra of the downstairs study in her Holmby Hills house, done entirely in shades of white.)

One request confounded even the most jaded dressing-room designer. At each venue, Barbra demanded that gardenias be placed in the bowl of her toilet. When the plumbing at Madison Square Garden couldn't accommodate the gardenias without becoming clogged, designer Mary Fellows collected rose petals off the stage and floated them in the toilet bowl before Barbra would agree to use it.

Once back in New York, Barbra spent the last weekend in April with an old love, former Canadian prime minister Pierre Trudeau. The two went to the theater one night—trading kisses in the middle of the show—and the next attended a glittering dinner at the New York Public Library honoring Hillary Clinton. "It was really like old times," Barbra told friends, and in at least one obvious respect she was right: their hand-holding, hugging, and assorted displays of affection sent the tabloids into overdrive.

At the dinner, Barbra took the opportunity to try to win over the First Lady—and in the process turned it into a diatribe against sexism. "There is no one in this country," Streisand intoned, "who would deny the competence, intellect, stamina, warmth, and courage of Hillary Rodham Clinton." But, she went on, "the criticism of Hillary Clinton has again demonstrated that the strong, competent woman is still a threatening figure in our culture."

In a clumsy reference to accusations that trading procedures had been violated so that Hillary could reap a huge profit in cattle futures, Barbra sniffed, "A man who invested wisely would be admired, but a woman who accomplishes this is treated with suspicion . . . I detest these attacks on someone who gives so much of herself to make this a better country." What Barbra ignored was the fact that Hillary, then the wife of the Arkansas governor, had left the table with a $100,000 profit on an investment of $1,000—a 10,000 percent return on her investment. The *Journal of Economics and Statistics* studied Hillary's trades and determined that the odds of this occurring were 1 in 250 million. The First Lady's explanation: "I was lucky."

Barbra kicked off the U.S. leg of her tour on May 10, 1994, in Washington, and starstruck TV journalists flocked backstage to meet her. "We are little children," CNN White House correspondent Wolf Blitzer said after he met Streisand. "We get excited when we meet big stars." Barbra told Blitzer that she was "a big CNN watcher," and NBC's *Meet the Press* host Tim Russert that he was her favorite Sunday-morning talk-show host. "My view is—I like her voice, she likes *Meet the Press*," Russert said, beaming. "Such a deal!"

Russert's NBC colleague Andrea Mitchell also lined up to meet Washington's foremost quasipolitical personage, as did *Nightline*'s Ted Koppel and CBS's Rita Braver. "I've been a fan since I was ten or twelve," Braver said. "It's great to meet someone with talent."

Nonnews personages did not fare so well. Determined not to tarnish her credentials as a serious thinker, the most savvy woman in the recording industry claimed never to have heard of R.E.M. when the hugely popular, multi-Grammy-winning group's lead singer, Michael Stipe, ambled backstage to pay homage. "I only listen to classical music," sniffed Barbra, who was visibly relieved when *both* Bill and Hillary Clinton showed up for her second show.

From Washington, Streisand moved on to the Detroit suburb of Auburn Hills, where she reminisced about her first singing engagement outside New York City at Detroit's Caucus Club in 1961. She talked about how the friends she made there invited her to their homes for dinner ("I *never* forget people who feed me") and hunted down her old Caucus Club pianist, Matt Michaels, so she could introduce him from the audience.

Now Streisand was no longer paralyzed by stage fright. Instead she was consumed with the idea that, at fifty-two, she might not have the stamina to keep singing thirty songs each night. "I don't know how I'm going to get through these next fifteen shows," she thought to herself in Detroit. After all, most singers trained their voices and their bodies for weeks before they went on the road; Barbra didn't. Nor did she vocalize, like most singers, so she could summon the amount of lung power needed onstage. "I don't practice," she said. "It's the most boring thing you can imagine, doing scales. So I just said, 'Fuck it, I can't.' I'm too tired . . ."

She had valid reason for concern. Stricken with viral laryngitis in Detroit, she was forced to postpone four concert appearances in Anaheim. She bounced back in time, however, to open at Arrowhead Pond in Anaheim and respond playfully to critics who suggested that she had just taken the time off to relax. Borrowing a page from David Letterman, she offered her "Top Ten Reasons" for taking a break from the tour. Among them: "Number Three: I thought my concert tour needed more publicity. Number Two: It took me three days to read Dan Quayle's book, and four to correct the spelling, and Number One: There was a shoe sale at Nordstrom's."

Barbra did take time between concert dates to attend the Clintons' first state dinner at the White House, held to honor Japanese emperor Akihito and his wife, Empress Michiko. Barbra wanted to ask her old flame Pierre Trudeau to escort her, but he declined to change his plans. Barbra asked ABC News anchor Peter Jennings instead.

At the time, the dashing, Canadian-born Jennings was in the process of divorcing his third wife, writer Kati Marton. Sweeping into the White House—Barbra in a stunning off-the-shoulder beige satin gown, Jennings in white tie and tails—the glamorous couple easily upstaged everyone else at the dinner.

They also set tongues wagging coast to coast. BARBRA'S DREAM
DATE, ran the next day's headline in the *New York Post*. In fact, Bar-
bra had been seeing Jennings for over a month. Between her Wash-
ington shows, she invited him to a dinner party at the house of
Clinton's newly appointed ambassador to Portugal, tobacco scion
Smith Bagley. Later, she showed up at a cocktail party Jennings gave
at his house in the Hamptons.

A high-school dropout, Jennings was nevertheless regarded as
one of the most intellectually gifted journalists in television. He
certainly was one of the best-looking and the most polished. "Bar-
bra was very intrigued by Peter Jennings at first, because he con-
ferred a kind of legitimacy on her, obviously," said a former
colleague of Jennings. "And he was blown away by her. Peter was
a complete sucker for all the Hollywood stuff, and you couldn't get
any bigger than Barbra Streisand. The trouble was, she wanted to
be taken seriously—she wanted people to listen when she talked
about politics and policy—and there was no way he was going to
do that."

Even as Barbra complained about the gossip, she was clearly
thrilled at her very public pairing with the brainy, urbane Jennings.
After Jennings interviewed Haitian general Philippe Biamby, he told
Barbra the first thing Biamby wanted to know was: What is your re-
lationship with Barbra Streisand? Barbra thought it was "hysterical,"
and did not hesitate to tell the story to anyone who would listen.

Meanwhile, one week after their headline-grabbing White House
date, Jennings was in the audience with dozens of other celebrities
when the Streisand juggernaut landed at Madison Square Garden.
For the next three weeks, Barbramania had a grip on New York as
the press covered Streisand's every move. Under the headline DES-
PERATELY NEEDING STREISAND, *New York* magazine proclaimed her
"the last star" and the "alpha and the omega," while the New York
Daily News declared that it was a case of BARBRA, BARBRA, EVERY-
WHERE! The *New York Post,* meanwhile, offered readers a daily "Bar-
bra Watch" feature. The paper's critic-at-large, David Hinckley,
likened Streisand's homecoming to "MacArthur returning to the
Philippines. De Gaulle to Paris."

Even Streisand was taken aback by the outpouring of unbridled

adulation at each show—so much so that at times she paused to take deep, calming breaths. She plugged the Knicks, the Rangers, Brooklyn's long-since-demolished Loews King Theater, and the Gay Games, which were being held at the same time in the city. "I can walk down the street and not be recognized," she cracked, "because there are so many impersonators."

All of which was grist for the mill of New York–based David Letterman, who carped each night about the stratospheric prices Barbra was commanding and the lack of available tickets. In the middle of her stay in New York, she suddenly walked onto Letterman's stage and handed him a pair of tickets. "Stop kvetching, already," she told him, and walked off.

As a "gift" to the people of New York, Barbra broadcast the last song of her last show on the giant Sony Jumbotron screen over Times Square. When she waved into the camera and said, "Hello, Times Square!" the crowd of thousands clogging the streets at the heart of the theater district went wild.

When the tour finally ended in Anaheim on July 24, 1994, Diana Kind was wheeled backstage. Barbra leaned down to hear her. "You did good," she told her daughter, rather unconvincingly. "I'm proud of you."

"We get along better now," Barbra told writer Michael Shnayerson. "We're able to say 'I love you' to each other. I have forgiven my mother: I know she did the best she could."

Over the next month, Streisand holed up at home editing the footage shot at her last two concerts for a two-hour HBO special. Working nonstop for twenty-seven hours, she handed the tape in to the network just ninety minutes before it was scheduled to air. "I thought," she told Richard Baskin, "I was going to have a fucking heart attack!" When it aired on August 21, it was the highest-rated original program ever broadcast on HBO.

Yet Barbra was taking time to smell the roses—literally. In her bathroom, a Victorian cranberry glass vase was filled with roses at Barbra's nose level—so, she boasted, "while I'm brushing my teeth, I stop to smell the roses."

The subject was also roses with her new friend Martha Stewart. Streisand asked her fellow diva what roses would grow best on the terrace of her New York apartment. "It's pretty hard to grow roses

on a terrace with the winds blowing and the sun broiling," Stewart said. Nevertheless, she spent hours advising Barbra on what to plant, and had $25,000 worth of plants delivered to her apartment. Months later, Martha was stewing over the fact that Streisand, who had thought the advice and the plantings had been supplied by Stewart out of friendship, had yet to write a check. "She's never paid me!" Stewart complained bitterly.

Neither was Barbra continuing to shell out thousands of dollars each year on a shrink—the concert was her farewell to over thirty years of psychoanalysis. But she was exploring other avenues of spiritual self-discovery. At an Arizona retreat run by New Age guru W. Brugh Joy as well as at the Maharishi Vedic Health Center in Massachusetts, Barbra delved into transcendental meditation, yoga, and the interpretation of dreams. She was also intrigued by the works of poet Robert Bly, inner-child theorist John Bradshaw, and mythographer Joseph Campbell.

"There are advantages to growing older," she mused. "You get off yourself more. You realize there are things too ingrained to change." There were signs that Barbra had loosened up a bit. For example, she no longer seemed quite so terrified at the prospect of being recognized in the street. When she was caught in traffic and needed someone to move over so she could make a turnoff, she rolled down the car window and stuck out her head. "People," she sang, "People who need peee-pul . . ." Once they regained their composure, the other motorists let Streisand's car through.

For all her newfound self-acceptance, Barbra was finding it hard to be without a man in her life. "I want a partner," she told Larry King. "I've had love and passion, and I want it again. I want the masculine to my feminine and the feminine to my masculine."

On those occasions when she did venture out on a date, she was "unbelievably nervous" beforehand, said one friend, "like a teenager getting ready for the senior prom." Her relationship with Peter Jennings seemed to have stalled when an old acquaintance dropped into town unexpectedly. Barbra was among the scores of celebrities who turned out for a gala honoring Prince Charles, in Los Angeles for his first visit in more than two decades.

Several days later, Barbra secretly visited the Prince of Wales at his

suite in the secluded Bel-Air Hotel. Over the years, Charles had cheated both on his wife, Diana, and his mistress, Camilla Parker-Bowles. Yet he admitted to having harbored feelings for Barbra before he knew any of these other women—including Camilla.

Now that the two were alone together in a hotel for the first time—away from the prying eyes of the press—romance seemed "inevitable," said *Burke's Peerage* managing director Harold Brooks-Baker. "The official explanation was that Prince Charles and Barbra Streisand had a private tea. Well, Charles has 'had a private tea' with quite a long procession of women over the years. From what I understand, he was absolutely besotted with Barbra Streisand. Did anyone ever turn Charles down? Not to my knowledge."

The following August, Barbra boarded a Concorde jet bound for London to attend a dinner for Prince Charles's favorite preservationist group, the Foundation for Architecture. Traveling with her was the man she had been dating on and off for months, Jon Voight. Barbra had long been friends with Angelina Jolie's movie-star father, who had shot to stardom in *Midnight Cowboy* and won an Oscar for *Coming Home*. Now Streisand and Voight were holding hands, stealing kisses, and dodging the paparazzi in New York, L.A., and Europe.

By the time they landed in London, however, it appeared that their relationship had cooled off just as another was heating up. When Elton John arrived at Highgrove, the prince's official country residence in Gloucestershire, for a private dinner, he was "surprised" to find Barbra there. According to a former member of the household staff, Prince Charles had gone to elaborate lengths to keep Fleet Street and, more important, his then-mistress Camilla Parker-Bowles, from finding out. "The prince and Miss Streisand were very affectionate toward each other," the staff member said. "I entered the room at one point and obviously interrupted them . . . they were quite flustered."

"Diana knew that Charles was infatuated with Miss Streisand," said a close friend of the princess, Lady Elsa Bowker. "She would not have been surprised if they had an affair. I think she would have found it terribly amusing. I don't know why he bothered to conceal this from Camilla . . . Camilla was never threatened by Charles's other women—and there were many. She would have been absolutely *thrilled* at the idea of Charles and the American movie star

being lovers. That would have excited her, I think." (In a bizarre way, Barbra's own earlier involvement with Dodi Fayed brought the Streisand–royals saga full circle.)

Once her secret rendezvous with Prince Charles was over, Barbra once again focused on her work. Nothing escaped her exacting eye for detail. When *The Prince of Tides* aired on television for the first time in 1995, she noticed that the commercials were significantly louder than the movie. She immediately called the network control room and told them to turn the sound down by two decibels. They did.

In the wake of her tour, Barbra now juggled plans for a concert album and projects for both the big and small screens. When Colonel Margarethe Cammermeyer, a Bronze Star Vietnam veteran, was discharged from the National Guard in 1992 for admitting that she was a lesbian, Barbra was outraged. She invited a reluctant Cammermeyer to her house and convinced her on the spot that she could be "a catalyst for change" if her story were told in a made-for-television movie.

Cammermeyer, a longtime Streisand fan, agreed. With Glenn Close in the title role, *Serving in Silence: The Margarethe Cammermeyer Story* aired on NBC in February of 1995. Cammermeyer would say she felt a kinship with Barbra—another strong, outspoken woman who was routinely criticized for bucking the status quo. "What is it about her that these men find so threatening?" Cammermeyer wanted to know. "What is it?"

Society's approach to homosexuality was also the subject of another film project Barbra had been working on for nearly a decade, *The Normal Heart*. Since first optioning Larry Kramer's groundbreaking play on the early days of the growing AIDS crisis and the government's appallingly complacent attitude toward it, Barbra had been determined to bring it to the screen. "I see it as a movie about everyone's right to love," said Streisand, who was set to play *The Normal Heart*'s wheelchair-bound protagonist Dr. Emma Brookner (based on the late AIDS crusader Dr. Linda Laubenstein). "I want to re-create what I experienced when I saw that play—the *rage,* and the compassion I felt for these characters."

It was important to Kramer, in his own way every bit as driven and passionate as Streisand, that the film be made—and soon, since

he himself was suffering from AIDS and other serious health problems. He was also convinced that a Barbra Streisand–produced screen version of *The Normal Heart* would both raise awareness and funding for AIDS research.

Over the years, Kramer had conferred countless times with Barbra at her home in California and his apartment in New York, and they burned up the phone lines between the two cities comparing thoughts and notes. By 1995, he had written twenty drafts of the screenplay—five specifically for Barbra. "She'll challenge you on every word," Kramer said. "She'll act out the words . . . She'll recall Draft Four when you've forgotten every previous draft."

Kramer felt that Barbra wanted *The Normal Heart* to be her "ultimate gift of love" to her son, Jason. So the playwright was crushed when she decided once again to put the project on hold while she made another, more commercial film called *The Mirror Has Two Faces*.

A romantic comedy by Richard LaGravenese, *The Mirror Has Two Faces* is about a homely academic who enters into a platonic marriage with a handsome colleague (played in the film by Jeff Bridges) and then has cosmetic surgery so that he'll become interested in her sexually. In the end, she learns to love herself—and that, in turn, makes her truly beautiful.

For Barbra, a scene between her character and Lauren Bacall as her beautiful, overbearing mother, had special significance. When Streisand asks Bacall if she was a pretty baby, her mother gives the same answer Diana Kind gave Barbra decades earlier: "What's pretty, anyway? Look what good it did your sister."

Barbra's decision to cast Bacall in the role—for which Bacall would receive an Oscar nomination as Best Supporting Actress—came thirty years after their first meeting. Bacall had been seated at Jule Styne's table at the opening-night party for *Funny Girl*. Bacall walked up to Streisand and said, "You're so damned good, I think maybe I should slap you."

Kramer knew the feeling. Understandably enraged over Barbra's decision to give priority to *The Mirror Has Two Faces,* he angrily confronted her. "Why are you doing this piece of shit?" Kramer demanded.

"It's not a piece of shit!" she replied.

"Well, Jason says it's a piece of shit."

Barbra was shocked, but not entirely surprised. Kramer and her son had become friends, and Jason had always pushed his mother to give *The Normal Heart* top priority.

But Barbra also believed in *The Mirror Has Two Faces* and its deeper message about "the external vs. the internal." She also felt that a strong commercial success would put her in a better position to get the financing needed for a film as grim and fraught with controversy as *The Normal Heart.*

The following year, Kramer would give an interview to *Variety* in which he accused Barbra of putting *The Normal Heart* on the back burner so she could make a frivolous film about "a woman who gets a face-lift. I don't think that was decent of her to do to me, her gay fans, and the people with AIDS she talks so movingly about." He also pointed out that his health was deteriorating. "I would very much like to see the movie made," Kramer said, "while I'm alive."

Barbra felt betrayed that Kramer had gone public with his frustration. She was especially angry that he had denigrated *The Mirror Has Two Faces,* since so much hinged on it. In a tersely worded statement, she announced that after a decade, she was pulling the plug on her involvement with *The Normal Heart.* "I am painfully aware of the ticking clock," she said. "Therefore, I am now stepping aside and will no longer be involved with the project. I wish Larry only success in getting *The Normal Heart* made."

She followed up a few days later with a letter to Kramer blasting him for being ungrateful—and self-destructive. "Oh, horse shit," Kramer later said. "I love her, but she has pissed on this project for ten years."

At the time, Kramer felt Barbra had been "looking for an excuse to get out . . . If she had made the movie in 1986, perhaps it might have affected the course of history. That's why I was willing to put up with all the Sturm und Drang that comes with working with her. She became increasingly nervous with showing the intimacy that is in the script between two men. She kept going on about how she wanted a gay *The Way We Were.* I got all the Sturm und Drang, but not the movie."

Sturm und Drang is exactly what Barbra had in mind when she was invited to speak at Harvard's John F. Kennedy School of

Government. She had envisioned her speech, "The Artist as Citizen," as a thoughtful reply to those who would have celebrities stick to singing and moviemaking and keep their political opinions to themselves. In a sense, she also intended it to be her own State of the Union address—a rare opportunity to use a prestigious podium to expound on a wide range of issues, establishing her credentials as a serious political thinker.

Toward that end, she spent more than three months working on the speech, consulting theologians, historians, politicians, and journalist friends like *Los Angeles Times* correspondent Robert Scheer and, of course, Peter Jennings. The speech did, in fact, cause a rift in her relationship with the ABC anchor.

"Oh, Jesus," Jennings said after reading one passage, "I wouldn't say this." And later, "Oh no, no, no, Barbra, you can't say *that*." At other times, he merely shook his head and groaned—or worse, laughed.

Barbra was distraught over Jennings's reaction—and angry at his superior, dismissive attitude. "He just made me feel really awful."

In the end, Barbra did say "this" and "that" precisely as she wrote it. Later, when it was reported that Jennings had helped her write the speech, Barbra repeatedly asked him to issue a statement declaring that this was "an absolute lie."

Jennings refused. "Oh, Barbra, forget it," he told her. "What does it mean?"

Barbra, furious, refused to speak to him—ever again.

Streisand justifiably felt she deserved full credit—or full blame—for an address that she had agonized over. The night before, she paced the floor of her flower-filled $1,500-a-night suite at the Charles Hotel, rehearsing every line.

Barbra, who had been escorted on a tour of the campus the day before by John F. Kennedy Jr., waited patiently before jokingly prompting acting Harvard president Albert Carnesale to end his lengthy introduction. Then, after conceding that she was especially anxious to be delivering an address at Harvard, she launched a teleprompered attack on her critics.

Visibly nervous throughout, Barbra proclaimed herself "very proud to be a liberal" because liberals "fought slavery, fought for women to have the right to vote, fought against Hitler, Stalin,

fought to end segregation, fought to end apartheid . . . Liberals put an end to child labor, they even gave us the five-day workweek. What's to be ashamed of?"

The main thrust of Streisand's forty-minute speech, which included references to Michelangelo, Marian Anderson, Franklin Roosevelt, Plato, and of course JFK, was a defense of celebrities who speak out on serious issues. "For thirty years Paul Newman has been an outspoken defender of civil liberties and a major philanthropist," she said. "Would it be better if he just made money and played golf?" Similarly, she said she would "rather have America listen to Elizabeth Taylor on the subject of AIDS than to Jesse Helms."

Although she joked that she had promised herself she would not "get too partisan—some of my best customers are Republican," Streisand wasted no time in slamming the opposition. She asked why Helms, then–Speaker of the House Newt Gingrich, and the entire Republican-controlled Congress were "so petty and mean? Is God really against gun control and food stamps for poor children?"

During the question-and-answer session, she berated a student in the audience for referring to her as a member of the "cultural elite." ("I resent that. Why all the name-calling?" Streisand whined.) But she had no qualms about calling conservatives "reactionary . . . petty and mean" and bringing up the fact that Gingrich's personal life "can hardly be called exemplary."

She also blasted Gingrich for his suggestion that some children might be better off in orphanages than in homes where they are threatened by poverty, drugs, and violence. "He proposes taking children away from poor mothers and placing them in orphanages," she said. "If that's an example of mainstream culture, let me say I'm happy to be a member of the counterculture."

Barbra blasted politicians of both parties as well as the media for exploiting celebrities, then turning on them. "We can attract a crowd and raise astounding amounts of money for the politicians and make good copy," she said, "which is precisely why we are courted and resented by both [politicians and journalists]." As for the journalists who cover Hollywood: "You can just hear them thinking, 'You make money, you're famous. You have to have political opinions too?'"

At one point, a young woman prattled on endlessly in praise of Streisand, until Barbra finally cut her off by asking, "You got a guy for me?" Although even Harvard's liberal students could only summon up a smattering of applause when Streisand praised the scandal-plagued Clinton administration for "doing a good job," in the end she received a standing ovation.

Mike Wallace was unimpressed. "I don't think anybody pays a lot of attention to her political ideas," he said. "Her real function is in raising huge sums of money. I daresay no matter how devoted Bill and Hillary are . . . I doubt that [Bill] comes to her for advice."

Barbra neglected to mention that the media attention cut both ways, providing millions of dollars' worth of free publicity for her own commercial projects. While she had been invited to speak at Harvard a year earlier, she wound up speaking at a rather opportune time—just two days before the first broadcast of *The Prince of Tides* on television, and three days before the debut of *Serving in Silence: The Margarethe Cammermeyer Story*.

That spring of 1995, Barbra spent $2 million on yet another house—this time high atop a bluff overlooking the Pacific at Point Dume, in the area of Malibu grandly referred to as "The Queen's Necklace." Unwilling to settle for anything less than perfection, she quickly set out to transform the property into yet another showplace.

There was also time to bask in the glory of her past achievements. At the Grammys in March, Stephen Sondheim presented her with a coveted Lifetime Achievement Award. A few weeks later, President Clinton praised her in his opening remarks at a Jewish Federation Council dinner at the Beverly Wilshire Hotel. She then jetted to New York to pick up the George Foster Peabody Award for HBO's version of *Barbra: The Concert*. Later in the year, she and John Voight would show up together at the Emmys, where *The Concert* would pick up five awards.

None of these could compare to the honor she received from Brandeis University. On May 21, 1995, the academic institution conferred an honorary doctor of humane letters degree on Barbra for "her outstanding contribution to the arts, her work to ameliorate relations between blacks and Jews, and for her many philanthropic

activities in support of women's equality, human rights and civil liberties, children at risk, and preservation of the environment." "My father," she said, "would be very proud." Ironically, for someone who once had ranked high on Nixon's notorious enemies list, one of the other recipients from Brandeis that year was conservative Republican publishing mogul Walter Annenberg, one of Richard Nixon's close friends and benefactors—and at one time Nixon's hard-drinking, headline-grabbing ambassador to Great Britain.

Now that her intellectual credentials were secure, Barbra went sailing up Long Island Sound with a fellow liberal Democrat, Connecticut senator Christopher Dodd. Dropping anchor near Mystic, they drove to Foxwoods casino, where Barbra turned five dollars into twenty-five dollars at a blackjack table. Unbeknownst to Barbra, the dealer had been stacking the deck so she would win. He was later disciplined.

Although Barbra was still temporarily involved with Voight, Bill Clinton was never far from her thoughts. On his forty-ninth birthday in August, Clinton was trail-riding with friends in Jackson Hole, Wyoming, when walkie-talkie-equipped Secret Service agents informed him that Barbra Streisand was on the phone back at the house. He rode back to the main house, picked up the phone, and listened to Barbra sing a breathless version of "Happy Birthday, Mr. Pres-i-dent" reminiscent of Marilyn Monroe.

Her playful streak aside, Barbra was all business when it came to preparing for *The Mirror Has Two Faces*. Casting a picture that dealt with the dicey subject of feminine beauty presented special problems—not the least of which was the fact that Barbra, now fifty-three, was more self-conscious than ever about how she compared to others on camera.

Streisand did not hesitate to sign up Jeff Bridges and Pierce Brosnan—both handsome but well into middle age—for parts in the picture. But when it came to casting a young actor to play her teaching assistant, she balked at hiring strapping, dark-haired Calvin Klein underwear model Michael Bergin. Already famous for being the ex-boyfriend of John F. Kennedy Jr.'s wife, Carolyn Bessette, the twentysomething Bergin would later don a Speedo as a regular cast member of television's *Baywatch*. Streisand had to watch Bergin's audition tape for only a few seconds before delivering her verdict.

"I'm not," she blurted, "going to be on screen opposite *that*." When a member of her staff pointed out that she had not hesitated to be shown in bed with Robert Redford in *The Way We Were,* an irritated Barbra replied, "That was twenty years ago."

Dudley Moore, who had achieved stardom in such comedies as *Arthur* and *10,* did get a part in the movie—as Jeff Bridges's best friend. When Moore had trouble remembering his lines, director Barbra confronted him. "I admit it," Moore later said. "I forgot my lines. I wasn't on any drugs or drunk. I just couldn't remember them."

Retake after retake, Moore kept flubbing his lines—and Barbra grew increasingly angry. "This made me extremely nervous," Moore recalled. After several more takes, Barbra finally had Moore's lines written on huge cue cards. "I couldn't believe she was doing this," Moore said. "I became even more nervous and wasn't even able to read them off the cue cards."

Later, Barbra summoned Moore into her office. "What happened?" she demanded. "I want to know what happened!"

"She lectured me about how she was a professional," remembered a wounded Moore. "I was thinking to myself that I just didn't fall off the peanut truck. I'm not some novice movie actor."

The next morning, Barbra fired Moore and replaced him with her old *Owl and the Pussycat* costar George Segal. "I was shocked," Moore said. "I had one bad day and it cost me a part in the movie."

Tellingly, a crew member said that when Moore attempted to read his lines, "it sounded like brain damage." Amid rumors that his longtime substance-abuse problem was to blame, a depressed Moore sank even deeper into despair. Two years later, he would be diagnosed with progressive supranuclear palsey (PSP), an irreversible Parkinson's-like disorder worsened by drugs and alcohol. Moore succumbed to the disease in 2002 at the age of sixty-six.

Moore was not the only casualty of *The Mirror Has Two Faces,* however. In the end, no fewer than fifteen people—including the cinematographer (who reportedly had not made the star look attractive enough in the dailies) and the editor—would be fired and replaced by Streisand. Then there were the usual stories about her tantrums and her obsessive demands. For example, she shot one scene over repeatedly because an extra who was supposed to

squeeze fruit at a produce stand and then decide not to buy it didn't
squeeze the fruit convincingly enough. For added authenticity,
Streisand stacked the fruit herself.

Barbra became agitated when, during a wedding-party scene us-
ing three hundred extras at New York's Tavern on the Green, the
crowd kept blocking her shot of Pierce Brosnan. "Don'cha know
who he is?" Streisand hollered, only half joking as she cleared the
extras aside. "He's James Bond!"

Apparently not satisfied with their on-camera chemistry, Barbra
spent three days on a single kissing scene with Bridges. "It was the
opposite of what she felt with Nolte," a studio executive who had
visited the shoot observed. "It just wasn't coming across as hot. Bar-
bra insisted on take after take after take, fiddling with the lighting
and the camera angles and their technique until she was satisfied the
kiss was passionate enough. Jeff Bridges's lips were practically
bleeding."

When shooting was delayed and there were no leaves on the trees
in Central Park, Barbra paid $8,000 *per tree* to have fake foliage lit-
erally glued to the branches. At one point, while filming a late-night
love scene with Bridges on an Upper West Side street, the cast and
crew were pelted with eggs by residents who were trying to sleep.

Undaunted, Barbra kept shooting—until she noticed a strange
glare.

"Where the fuck is that light coming from?" she demanded to
know.

"It's five-thirty A.M.," a crew member volunteered cautiously. "I
think it's the sun."

"Well," Barbra snapped, "*do* something about it!"

"People are dying to be off this shoot," one crew member admit-
ted. Said another of Streisand: "Her reputation is that of a perfec-
tionist. Point of fact, she's a meddler. She doesn't let anyone do
their job." Inside the Manhattan production offices for the film,
where Barbra seldom ventured, staffers mounted a tongue-in-cheek
"wall of crosses" shrine with one cross bearing the name of each of
the fifteen coworkers who had either been fired or quit the film be-
fore it wrapped.

When word leaked out about what one person working on the
film called her "insulting" and "imperious" behavior, she ordered

that no one was to speak to the press. "We were basically all told to keep our mouths shut," said one junior staff member, "or we'd be fired. We all saw what happened to poor Dudley Moore, so we knew it was no idle threat."

Screenwriter LaGravenese was one of those who felt his boss was being unfairly maligned. "She was trying to make a good movie," he said. "She had a billion details inside her head." Pierce Brosnan agreed. "I've seen male directors throw tantrums and nobody says a peep," Brosnan offered. "If this picture makes big bucks, no one's going to give a flying whatever about how it got made."

With all that was going on, it hardly seemed possible that Barbra would have time to shop for antiques at one of the stores she was using for a location shot. For several minutes, she haggled with the store on the prices of several items, including a painting (she got him to knock $50 off the $275) and a plate (another $15 off). Satisfied, the woman whose personal worth was now well in excess of $125 million went back to work.

Once *The Mirror Has Two Faces* wrapped in May of 1996, Barbra returned to L.A. to tackle the arduous and all-consuming task of overseeing postproduction. Before editing the movie, Barbra wrote a love theme for the end credits and, at the suggestion of a producer friend, sent it to rocker Bryan Adams. Streisand and Adams recorded the ballad together—a duet that would become an instant hit and earn Barbra another Academy Award nomination for Best Original Song. The title—"I Finally Found Someone"—would turn out to be prophetic. "Because," Barbra explained, "when I least expected it, I finally did."

I'm a feminist, Jewish, opinionated, liberal woman.
I push a lot of buttons.

She has mellowed a lot, I think—except, of course,
when it comes to politics.

—Lainie Kazan,
singer and actress and Barbra's understudy in *Funny Girl*

Now I know what it's like to have a father.

—Barbra on her marriage to James Brolin

11

She reached up and ran her fingers through his hair—or rather what was left of it, a bristly quarter inch of copper that he intended to let grow out in its natural white. "Who," Barbra asked the man seated next to her, "screwed up your hair? Who screwed up your *hair*?"

"She touched me," James Brolin recalled of that first meeting. "It was like a wand. I went 'bing.' I was sure smitten."

Brolin had not even wanted to attend the dinner party thrown by Christine Peters, Jon's now ex-wife, that night. When he walked into the private dining room at Mr. Chow in July of 1996 and saw three round tables set for ten people each, he winced. "I need this," he thought, "like a hole in the head."

Barbra was no more enthusiastic about the prospect of a blind date than Brolin. "It is very unusual for me to like a date," she recalled of the evening. "And I resented the fact that I had to drive to this party to meet James, because it took me away from work." She was in the middle of editing *The Mirror Has Two Faces*.

For her part, the moment she saw Brolin, Barbra thought he looked like "a bullet with stubble." But within two minutes, she was "totally infatuated. We talked all night about flying, computers, music." Brolin could hardly have been called a fan; he had never seen *Funny Girl* or been to one of her concerts. She knew less about him, and had never even seen the long-running 1970s series that had first made him a TV heartthrob, *Marcus Welby, M.D.*

As it turned out, they had almost met years earlier, when she was looking for an apartment to buy in New York and declined because

it did not have air-conditioning. The next person to look at the place was Brolin, who was told that Barbra Streisand had just been there and did not want to buy the place. "Well, I'll buy it," he said, and spent the next few months sweltering in the summer heat. "We almost met then," Barbra later said. "Our paths crossed, but I guess the time wasn't right . . ."

The son of a prosperous Los Angeles contractor, James Bruderlin changed his name to Brolin after a producer friend of the family urged him to take up acting. At age twenty-five, he married Jane Agee just twelve days after they met. On the eve of the nuptials, he later confessed, "I knew I was making a mistake." By that time, he had already appeared in the TV series *Bus Stop* and had supporting parts in such films as *Take Her, She's Mine, Von Ryan's Express, Our Man Flint,* and *Fantastic Voyage.* Years later, he would land his best-known feature-film role in the original *Amityville Horror.*

Agee, an assistant casting agent, was actually instrumental in getting Brolin his career-making part on *Marcus Welby.* The marriage would wind up lasting twenty years, and the Brolins would raise two sons—Jess and Josh, who in the next millennium would appeal to a whole new generation of moviegoers.

While Brolin landed yet another hit series, *Hotel,* in the 1980s, his marriage fell apart. When he married Jan Smithers, one of the stars of the comedy series *WKRP in Cincinnati,* in 1986, first wife Jane accused him of bigamy. Their divorce, she pointed out, had not yet been finalized. Brolin countered that his second wedding ceremony was merely "symbolic," and that he and Smithers intended to apply for a license later. That marriage would last nine years and produce a daughter, Molly. The year his second marriage ended, Brolin was devastated by the news that his first wife had been killed in a car crash at age fifty-five.

Although Barbra was supposed to return to the editing room the night they met to resume work on *The Mirror Has Two Faces,* she didn't. "I'm taking you home," he told her.

"What?" she replied. The other guests perked up.

"I said, 'I'm taking you home.'"

"What about the guys in the editing room?"

"Call them and tell them to go home."

And she did. When they got to her house, they stood awkwardly

in the foyer and talked—until four A.M. "I was quite polite," he said of the evening.

"God, no, nothing happened!" she later said, not even a good-night kiss. "We were shy. But I went to sleep that night with a smile. I was amazed—like you could actually want to see someone again."

They ran into each other again at another party. But this time, Barbra said, "it was very unpleasant. So I went home and ate a lot of ice cream and said, 'I can't deal with this.'"

Nothing happened until Jason stepped in. "Ma," he said, "call him." So she called Brolin, and the two went to the movies. "This is very awkward," she told him. Again, they talked for hours afterward. Barbra considered their next date a "great test" of whether or not they might have a future together. Brolin brought a video home for them to see—a French film called *The Hairdresser's Husband*. She loved the movie; Brolin had passed the test.

Ten days later, he left for the Philippines to work on a movie. Brolin spent more than $10,000 phoning Barbra, sometimes several times a day, over the course of several weeks. "Then, when I came back, we were hot," he said. "Yeah, it was great!"

While their romance heated up that fall, Barbra went back to work raising money for the President's reelection campaign in September. This time, at a $12,500-a-head dinner at the estate of silent screen star Harold Lloyd, Barbra sang a Clintonian version of "The Way We Were": "The White House won't permit a third-term president/but with Al Gore/maybe eight more . . ." The total take: $4 million.

Barbra had originally been approached by John F. Kennedy Jr. to appear on the cover of *George* to celebrate the magazine's first anniversary, which happened to coincide with President Clinton's fiftieth birthday. But when he asked her to pose as Marilyn Monroe blowing out the candles on a birthday cake ("Happy Birthday, Mr. Pres-i-dent") Streisand was horrified. Drew Barrymore, however, agreed to the pose. Kennedy was delighted with the controversy and the inevitable boost in newsstand sales. "If I don't find it tasteless," he said, "I don't know why anyone would."

Barbra did appear on the cover of *George*'s special election issue two months later—as Betsy Ross sewing the first American flag. By

this time, however, she regarded herself as a full-fledged policy wonk—and with some cause. The White House, eager to make Hollywood's biggest political donor happy, did everything it could to make Barbra feel as if she were in the loop. On an almost daily basis, she received faxes from the White House explaining the administration's positions on issues ranging from welfare to Bosnia. "I don't want to give the impression that she's on the White House staff," said George Stephanopoulos. "But when the President speaks to her, he values what she has to say."

No wonder. Under the direction of organizer Margery Tabankin (who had headed the VISTA program under Jimmy Carter and also ran Steven Spielberg's Righteous Persons Foundation), Barbra's political arm, the Streisand Foundation, had already parceled out nearly $11 million to grassroots liberal groups as well as national organizations. Given her generosity to the liberal cause, she did not look kindly on Democrats like Senate Majority Leader Tom Daschle, who mocked the Hollywood Women's Political Committee in the press. "I don't think politicians should take our money and try to disassociate themselves from us afterward."

The day her favorite candidate was swept back into the White House, Barbra flew to Little Rock to celebrate with the Clintons. "Hillary made the usual big show of embracing Barbra," said one of the Clintons' longtime Arkansas friends, "but the truth is she just doesn't like her."

Once again, leading Democrats in New York and California sounded Barbra out on the possibility of seeking elective office. "I don't want to stand around shaking hands," she said, "and having babies pee on me."

Five days after the presidential election, *The Mirror Has Two Faces* opened. The critics hated it, but audiences still flocked to see the latest Streisand film, pushing the movie's gross to over $65 million.

With the help of Brolin, she was now coping with a private tragedy. Several weeks earlier, Barbra had invited her mother to come to the premiere. "Movie? What movie?" Diana replied. Not long after, she was diagnosed as being in the early stages of Alzheimer's.

A week later, she brought Brolin to meet her eighty-six-year-old

mother for the first time. "Your daughter," he told her, "is a wonderful filmmaker."

"Is she? Really?" Diana answered.

Barbra took solace in the fact she and her mother had at long last bridged the emotional gap that had separated them. "I can say words like 'I love you, Mom,'" she told the *Today* show's Katie Couric, "and she can say them to me—which I never heard for maybe forty-some years."

Streisand had also reached a watershed in her romantic life, coming to the conclusion that, after one marriage and countless affairs, she had finally found her "soul mate. He's very strong and masculine, yet totally unafraid of his feminine side, totally accessible emotionally," she said of Brolin. "He's very proud of me, very supportive. It's like a dream. A dream man."

"Dream Man" Brolin, who by now had taken to calling Barbra "Beezer" ("Schnoz"), was also a Democrat—though not a particularly active one. He remembered the day in 1986 when, while stars gathered to hear her famous *One Voice* concert, he drove by and, in his words, "wished I was invited."

Nor was his career on quite the same trajectory. At the time he drove by Barbra's house on the night of her famous concert under the stars, his most recent movie had been *Pee-wee's Big Adventure*. By 1994, he would be reduced to shedding his clothes in *Indecent Behavior II*. In the low-budget thriller, Brolin had a steamy nude scene with ex-*Playboy* playmate Shannon Tweed.

"I'm not well endowed," he insisted, contradicting reports from the set. "I want you to know that it's very tough to stand in front of people and pose when you're stark naked." Brolin worried that stills from the film might sabotage his relationship with Barbra. "Now I've found what I think is the most wonderful girl I've ever met," he said. "I just really hate to see this kind of thing injure what we've got."

In the fall of 1996, they rented a thatched-roof cottage outside Galway, Ireland, where Jim was directing his first feature film, *My Brother's War*. Barbra played hausfrau, getting up at five A.M. to make sure the cook had prepared breakfast for him and making sure that the fire was lit by the time he got home.

When they returned to the United States, Brolin left his two-bedroom Pacific Palisades condominium and moved into Barbra's clifftop estate in Malibu with its Olympic-size pool, lush gardens, and three separate houses. Here, too, they wallowed in domestic bliss. They usually holed up in Barbra's bedroom with its view of the Pacific—sometimes for days at a time. "We can bring newspapers, books, and food into bed and have a wonderful time," she said.

Not that she had stopped playing diva. Once again, although Barbra planned to attend the Academy Awards with Brolin, she refused to sing her Oscar-nominated song from *The Mirror Has Two Faces*. Natalie Cole agreed to sing "I Finally Found Someone," but when Cole was suddenly taken ill, Barbra volunteered to step in. Too late, Streisand was told—Celine Dion had already rehearsed the number and would go on in Cole's place.

Dion and Streisand were not strangers. Barbra had invited Celine to record a duet with her, "Tell Him," for her new *Higher Ground* album of inspirational songs dedicated to Virginia Kelley.

Amid persistent rumors of tension between the two divas, Dion took the stage and, as she sang, searched the first few rows of the audience to catch Barbra's reaction. She would not find her. While Dion was belting out Barbra's song, Streisand was cooling her heels in the ladies' room.

In the wake of what to many appeared to be an obvious slight, Barbra was pilloried in the press. An interview on ABC's *20/20* provided an opportunity for some much-needed damage control. "They don't have it printed in the program when the songs are," she tried to explain to Barbara Walters. "And so I went what I thought was during an intermission, come back, and the song's over. Now, I was heartbroken. Because I knew that this would be a wonderful moment on television. To have her singing, flash to me next to my love, Jim Brolin, a song that I wrote called 'I Finally Found Someone.' This is a wonderful moment to capture on tape, right? Why would I miss it? Is the press this cynical? To make up a story that I have deliberately done this to her?"

Brolin was also beginning to feel the sting of Barbra's rejection. Over the course of six months, he had proposed repeatedly to her without success. Finally, in April of 1997, he slipped a ten-carat diamond ring on her well-manicured left hand—and this time she

said yes. The ring was another matter. Deeming it "too flashy," Bar-
bra dragged Brolin to a jeweler and picked out a simpler, less osten-
tatious solitaire.

"Beneath that world-famous icon there's a little girl," gushed her
friend (and Elvis's ex-girlfriend) Linda Thompson, "and Jim sees
the vulnerability and tenderness. He gets her. It's like she's finally at
home."

That August, Barbra was jolted out of reverie with everyone else,
however, by the shocking news that Princess Diana had been killed in
a Paris car crash. What made it all the more upsetting to Barbra was
the fact that Dodi Fayed had died with Diana, and that it appeared at
the time that pursuing paparazzi might have caused the fatal crash. It
was a fate Barbra had long feared might befall her. "Those goddamn
photographers!" she said. "Jim, somebody's gotta stop them before
that happens here." Toward that end, she would later be instrumental
in getting an anti-"stalkerazzi" law enacted in California.

Later that year Brolin, eager to hold up his end of the relation-
ship, went to work as the star of a new syndicated television series
about naval aviators, *Pensacola: Wings of Gold*. Although he stood to
earn as much as $1.8 million a year from the series and had just
signed a new seven-year, $7 million deal as AAMCO's television
pitchman, it was hard to compete with Barbra. In November, *Higher
Ground* debuted at number one and would go multiplatinum, selling
well over five million copies. The conservative estimate of her take
from this one album alone: $12 million.

Accordingly, it took Barbra's team of managers and lawyers sev-
eral months to hammer out the details of their prenuptial agree-
ment. If they were to divorce before their tenth anniversary, Barbra
allegedly agreed to pay $1 million in cash and $300,000 for every
year the marriage lasted. If a divorce occurred after the ten-year
mark, Brolin would receive a flat $10 million.

For the next several months, speculation would run wild over the
couple's wedding plans. At first they were to be married on Block
Island, then on Martha's Vineyard. At one point in January 1998,
they took a side trip to honky-tonk Laughlin, Nevada, on the way
home from Lake Tahoe and seriously considered having a drive-
thru wedding. "We could have done it," Barbra said, "without get-
ting out of the car."

Brolin agreed that the whole idea was "very tacky"—but then, given everyone's expectations, tacky had its advantages. Finally, it was Barbra who brought an end to the temporary madness by asking, "Will our memories be right?"

As headline grabbing as their impending marriage was, it paled in comparison to the scandal that threatened to topple Bill Clinton's presidency. On January 21, 1998, the *Washington Post* led with the story that the President had been having an affair. The piece went on to say that Special Prosecutor Ken Starr was investigating allegations that Clinton had encouraged the young woman to lie about it under oath. "The hysteria," Clinton later recalled, "was overwhelming."

The day the news broke, Barbra stopped screaming at the television long enough to get a call through to the White House. She offered her friend words of encouragement and urged him to stay strong. As the scandal would unfold over the coming months, Barbra would not entertain the possibility that Lewinsky—like Paula Jones, Gennifer Flowers, Dolly Kyle Browning, former Miss America Elizabeth Ward Gracen, Juanita Broaddrick, Kathleen Wylie, and others—just might be telling the truth. On national television, she would later call the Lewinsky affair "overrated," and when asked if she would stand by her man if Clinton were *her* husband, she said "most definitely. He's a wonderful president."

As for Lewinsky and the other women bringing these charges, Clinton's defenders branded them as "trailer trash," "stalkers," "bimbos," and worse. Barbra, Hollywood's überfeminist, apparently agreed. Like Hillary, she merely dismissed Clinton's accusers as faceless pawns of the extreme "right-wing conspiracy" out to get the Clintons.

On the morning of January 27, Hillary appeared on the *Today* show to brand the charges false and part of "a vast right-wing conspiracy" to bring down the Clintons. Barbra cheered the First Lady's remarks, and from that point on would often invoke the right-wing conspiracy argument even when leading members of Clinton's own party were calling for him to resign.

The following week, Barbra and Jim were at the White House state dinner for British prime minister Tony Blair and his wife, Cherie. After Elton John and Stevie Wonder performed, Barbra

found a private moment with the President to tell him to "stand strong" against "the right-wingers."

Notwithstanding her pep talk, Barbra might have been disappointed that once again she had been barred from staying overnight at the White House during her stay in Washington. This time Hillary argued that during this delicate period when the President's morals were yet again being called into question, it was inappropriate for an unmarried couple like Barbra and Jim to stay together under the White House roof.

Streisand and Brolin wanted to make their relationship legal, but not if it meant getting married in the middle of a media circus. Just two weeks after the Tony Blair state dinner, Brolin tussled with New York *Daily News* photographer Richard Corkery after Corkery shot them coming out of a Tribeca movie house. "James started ramming him like a bull and hit him with his head," said eyewitness Anita Talbert. "Then James kind of laughed this cavalier laugh and got into the limo." It felt, said Corkery, "like getting slammed by a train."

Treated for minor head and neck trauma, Corkery filed harassment charges. So did Brolin. "The guy was blocking my path," Barbra's fiancé insisted. "My only thought when we're out in public is making sure Barbra is protected." In the end, all charges were dropped.

When they finally did wed at Barbra's Point Dume estate on July 1, 1998, the happy couple made sure they controlled the coverage—and reaped the profits. While they ordered that earsplitting rock music be blasted at reporters to keep them at bay, the seven-figure deal they negotiated with *People* magazine was sweet, even by Barbra's standards.

Once they returned from their brief Channel Islands vacation, Barbra was swept up with the rest of the nation in the unfolding Lewinsky scandal. "She was on the phone to the White House several times a week," said one Clinton aide, "wanting to know how the President was holding up, what she could do for him. Things were so crazy, there were a lot of calls he normally would take that he couldn't. He didn't always take Al Gore's calls, or even Hillary's, but he *always* took calls from Barbra Streisand."

Later, when Hillary explained that her husband's philandering

stemmed from his family history of alcoholism and violence, Barbra jumped on the bandwagon. Finally acknowledging that the President had been "reckless," Streisand would suggest that the traumatic absence of a father, as she herself well knew, might have led to Bill's questionable behavior.

But for now, Barbra was not angry with Clinton, but rather with those Democrats who were wavering in their support of him. She took her cue from the first lady. Hillary, understanding that the 1998 congressional elections were nothing less than a referendum on Bill, barnstormed the country on behalf of Democrats. Streisand jumped on the bandwagon, firing off an angry letter on September 24 to congressional leaders exhorting them to fight.

"We can't let them keep a majority in Congress, we must get out the vote!" Barbra wrote. "Don't let the Republicans use the President's sex life to distract people's thinking away from issues that will directly affect their lives . . . These are very dangerous times—the President's rights are being violated and therefore, so are yours and mine." As usual, she also put her money where her mouth was, joining with Tom Hanks, Steven Spielberg, Norman Lear, and other entertainment heavyweights to contribute $2.2 million to the Clinton Legal Defense Fund.

Larry Klayman, chairman of the conservative Judicial Watch organization, wasted no time taking direct aim at Barbra's credibility. As a backer of Paula Jones in her sexual harassment suit against Bill Clinton, Klayman threatened to subpoena Barbra to testify on the "true nature" of her relationship to the President. "Boy, they sure know how to fight dirty," Streisand replied. "This is what the right wing does. With threats of malicious prosecution, they try to intimidate not just me, but everybody." Barbra's Clintonesque parsing of words did not, it was pointed out, constitute a flat denial that they had been lovers.

When it was all over, the GOP had nearly lost the House, barely held on to their slim majority in the Senate, and lost several governorships. To Barbra's delight, the Republican defeat led to the ouster of Newt Gingrich as House speaker. She called the White House to congratulate the President. "Isn't that *great?*" she said. "I mean, come on, what kind of a name is 'Newt,' anyway?"

In the midst of the political fray, Barbra was still reveling in her

life as a newlywed. On the same day she announced the creation of a new hybrid "Streisand rose" she intended to market within two years, Barbra started work on a collection of love songs dedicated to her husband. On its release ten months later, *A Love Like Ours* would debut at number six on the *Billboard* Top 200.

Not all was romance and roses as 1998 drew to a close. Barbra was stunned to read that her brother was now locked in a bizarre legal battle with John and Caroline Kennedy. In the late 1970s, Jackie had entered into a real-estate investment partnership with Sheldon Streisand through a trust set up for her children. In return for 99 percent of the profits, the trust invested $780,000 in Western Properties Associates, which built shopping malls in Utah, the state of Washington, and California. Sheldon, who managed the partnership for a minimal investment, received the remaining 1 percent.

To Barbra's chagrin, John and Caroline Kennedy had taken legal action against Sheldon, claiming that he gave a half interest in the partnership to his wife without asking their permission. The Kennedys charged that Sheldon had engaged in the "rankest form" of double-dealing and that his actions were "blatant and deceitful—a sordid saga of partnership pilfering." Sheldon assured his sister that none of it was true, and denied all claims of wrongdoing.

It might not have been entirely coincidental, then, that around the same time JKF Jr. decided to take a swipe at Sheldon's famous little sister in *George*. Kennedy used his "Editor's Picks" column to charge that Barbra "went too far" when, based on her "blind faith in Clinton," she urged everyone to vote for the Democrat running for Congress in his or her district.

"The next time you write something," Barbra demanded in a blistering letter to John, "it would be good to check your facts, not to mention the Constitution. Who could have imagined that in this day and age, journalists would question a person's right to express his or her views? So much for freedom of speech. What will be next: Do I dare say freedom of the press?"

In the meantime, Barbra's faith in Clinton was never in question. She kept in close contact with the White House and made phone calls to key Democratic leaders as the Clintons fought off the inevitable House vote on December 19 to impeach. On February 12,

1999, the Senate voted 55–45 to acquit the President of perjury charges and tied 50–50 on obstruction-of-justice charges—both votes short of the two-thirds necessary to convict. Within hours, Barbra was on the phone to congratulate the President.

Both Clintons were grateful to Barbra for her unwavering support. This time, when she invited the President to brunch at her Malibu compound on May 16, 1999, Hillary raised no objections—especially since Bill had made it clear that Barbra's husband would also be present. After a tour of the grounds and the requisite small talk, they got down to business: In a wide-ranging policy discussion, Barbra laid out her priorities for the rest of Clinton's term, telling the President what she thought he should do about everything from welfare and health care to abortion. At this point, she was far from shy about her influence. When Barbara Walters later asked if she advised the President on legislation, Streisand's answer was immediate. "Of course," she answered.

While she railed against country club Republicans and their ilk, Barbra plunked down $1 million for a marble-and-granite mausoleum for herself near her father's grave at Mount Hebron Cemetery in Queens. Carved in large letters above the doorway to the tomb: STREISAND.

The longtime critic of capitalist greed also found she had a knack for playing the market. In the past, she had always left investment decisions up to her financial adviser, Todd Morgan. But at the height of the Lewinsky scandal, Streisand became fascinated when a doctor friend told her about Viagra, Pfizer's new wonder drug for impotence. "Wow," Barbra said. "You're telling me this will *cure* impotence? Brilliant!"

Streisand promptly bought thousands of shares of Pfizer on line at $89. A few weeks later, Barbara Walters talked about Viagra on television for the first time, and the stock rocketed to $120. From that point on, she began watching CNBC religiously and studying publications like *Forbes, Barron's,* and the *Wall Street Journal.* She installed a real-time stock ticker at home and started waking up at 6:30 to catch the opening of the New York Stock Exchange.

After she told her buddy Donna Karan that she had made $130,000 in a single month trading eBay stock, Karan gave her $1 million to invest. Within five months, Barbra had nearly doubled

Karan's investment, running it up to $1.8 million. While cruising off the coast of Greece, Jim Brolin started talking about America Online. Wasting no time, Barbra called her broker from their yacht and bought it at thirty-one dollars a share. In less than a year, the stock had quadrupled.

All the trading made Barbra a nervous wreck. "I can't stand to see red in my profit-or-loss column," she said. "I'm Taurus the Bull, so I react to red. If I see red, I sell my stocks quickly."

No stock loss could compare with the beating Barbra took on the sale of her 4,100-square-foot apartment at 320 Central Park West. The property languished on the market for four years while the co-op board turned down one possible buyer after another as "unsuitable"—including pop star Mariah Carey. Finally, Barbra sold the place, but only after dropping the price from $10 million to just over $4 million. The day before the new owners moved in, Elliott Gould, who still often flopped there when he was in town, came by to pick up his belongings. "I've been here," he sighed, "thirty-five years . . ."

With the approach of the new millennium, Barbra saw a chance to recoup her losses. She was asked by the MGM Grand to repeat her 1993 New Year's Eve triumph, for which she would be rewarded with another seven-figure payday—at least $10 million from ticket sales for the two concerts alone.

Timeless: The Millennium Concert offered another retrospective of Barbra's life and career, only this time boasting a larger supporting cast and staged along the lines of a Broadway show. Through the ingenious use of videotape, there was a medley of duets with stars both living and dead, including Judy Garland, Ray Charles, Neil Diamond, Barry Gibb, Bryan Adams, and Celine Dion. This segment of the show was capped off by Frank Sinatra and Barbra singing "I've Got a Crush on You." There was also a reprise of the office-chair-bound "Miss Marmelstein" number that had propelled her to stardom in *I Can Get It for You Wholesale,* all the Streisand standards, and even some of the disco-era hits like "Main Event/Fight" that she had not sung in years. The topper: what would be hailed by some critics as the most moving rendition of "Auld Lang Syne" ever sung.

With tickets selling for up to $2,500 apiece, Barbra's millennium concerts would ring up over $14.7 million (90 percent going to her)—more than any other concert in history, breaking the record set by the Three Tenors. Polls would show that Americans regarded Sinatra as the greatest male singer of the twentieth century, and Streisand as the century's greatest female singer.

In spite of her fame—or, more accurately, because of it—Barbra was more terrified than ever of being kidnapped or attacked. When she and Brolin were followed for two hours on the freeway, they called the police and had the driver, photographer Wendell Wall, arrested.

Wall wasn't just any photographer. One of the Brolins' Malibu neighbors, he had long been a thorn in Barbra's side. Alleging that twenty-eight-year-old Wall had "repeatedly pursued" them over the previous five years, Barbra and Jim claimed the situation had become "even more ominous for the couple because of the fact that Mr. Wall resides on their street."

Prosecutors disagreed. After locking Wall up for three days, the L.A. County district attorney released him on the grounds that the Brolins had failed to prove "evidence of a credible threat." "I'm going to continue to take pictures of Barbra Streisand," Wall pledged as he emerged from jail. "I'm no stalker. Do I look like a stalker? I've had my name trashed across the press and the world."

While Wall languished in jail, Barbra worked on the inevitable *Timeless* television special—this time on Fox—and a *Timeless* CD that would go platinum. But this time, at her husband's urging, she decided to take her act Down Under, performing concerts in Sydney and Melbourne. But bad weather and technical problems—by one account the acoustics in Melbourne's unfinished Colonial Stadium made her sound like she was "singing in an echo chamber"—marred the Australian tour. Although more than 115,000 Aussies attended the concerts, Streisand still reportedly racked up losses in excess of $6 million.

Yet, for the first time, Barbra did not feel sick to her stomach or need to take Lomotil to stave off a diarrhea attack. "My priorities are different now," she mused. "I don't have to be perfect."

There was also a lessening of tensions between Barbra and her mother. During rehearsals for the show back in the United States,

Barbra discovered that, in an odd way, her mother's Alzheimer's was continuing to bring them closer. "She's much happier. She forgot to be angry," Barbra said. "She seems calmer and more loving. So there's a curse and there's a blessing."

At one point, Diana came backstage in her wheelchair. When Barbra asked her mother if she remembered the time they recorded a song together when Barbra was a little girl, Diana brightened. "It's interesting how the mind works," Barbra said. "She would not remember what she had for lunch that day, but she remembers a song she recorded in 1955. So we sang 'One Kiss.'"

Nevertheless, Barbra had had enough. "I don't like performing," she told Brolin. "I feel like I'm in a beauty pageant, like I'm eighteen and strutting around the stage." At the end of September, Barbra gave four concerts—two at Los Angeles's Staples Center and two at Madison Square Garden—that she *insisted* would be her final paid concerts. Even die-hard fans were skeptical. After all, Marty Erlichman had strongly hinted that the 1993 Las Vegas concerts might be his client's last, and made similar pronouncements when she toured in 1994 and again when she announced plans for the millennium concert at the MGM Grand. BARBRA SET TO BOW OUT sniped the headline in the *New York Post,* YET AGAIN.

When the dust had settled and Barbra had pocketed another $30 million—a figure easily reached when tickets went for as much as $2,500 each—her friend Jesse Jackson visited her backstage. Said the reverend: "We demand an encore!"

For all her phenomenal wealth—estimates of her personal fortune never dipped below nine figures—Barbra never stopped trying to squeeze the most out of a dollar. Stories about her penny-pinching ways abounded. At the Santa Monica Vintage Expo, she haggled loudly over the price of a pair of Gucci pumps. When the dealer refused to come down on the $250 price, she stomped off. "That's okay," she hollered back, "they were too small for me, anyway!"

One morning she noticed a "Sale" sign in the window of a Malibu store where she had shopped weeks before. Checking out the merchandise, she realized the sale prices were for some of the items she had purchased, so she rushed back home, grabbed the clothes and the receipt, and returned to the store demanding a credit. The manager refused at first, but eventually caved in.

When the woman who did her nails raised her rates a few dollars for the first time in a decade, Streisand reportedly told her, "Well, I'll just have to take my business elsewhere." After leasing a house in the Hamptons, she allegedly left behind an unpaid $1,200 electric bill (which she later settled).

Dining with Brolin at Arnie Morton's in Beverly Hills, she pulled out a crumpled, one-year-old discount coupon to help pay the $180 dinner bill. Then she took a calculator from her purse and figured a 15 percent tip—but only on the $80 she had to pay. To some, it seemed as if Barbra's sometimes boorish behavior was rubbing off on Brolin. On another evening when the Brolins were dining with film executives at Morton's, a waiter who approached them was dismissed by Brolin in no uncertain terms. "Get away from this table!" he snapped. Then he cornered the waiter and the maître d' and ordered for the entire table. "Under *no* circumstances are you to approach the table," he commanded. "Miss Streisand is having a very important meeting."

One afternoon she stood in line to buy a three-cent stamp to mail a letter because her assistant was on vacation, and she refused to waste another thirty-three-cent stamp to cover increased postage rates. "Thirty cents," she told another woman standing in line, "is thirty cents!"

Spending habits aside, in the summer of 2002, Barbra was starting to focus on one thing: keeping the White House in the hands of the Democrats. Not that she backed Vice President Al Gore from the beginning. "If it's Gore, it's Gore," Streisand allowed, her voice tinged with resignation. "But I like [New Jersey senator Bill] Bradley, too. But Gore is a good guy. You watch and think, 'You need [media] lessons.' Bradley is much more comfortable."

Both men were desperate for her support. But when Gore called Barbra for advice from Air Force One, she didn't take the call. "I was in the middle of something," she shrugged.

As it turns out, she might have been arguing with her new English gardener. Barbra had hired sixty-five-year-old Keith Mansfield during her stay at the exclusive Gidleigh Park Hotel in Devon, where he had been tending the grounds for seventeen years. But after one week in Malibu, he quit.

"She was always rushing around, shouting out of the windows

and telling me where to put my hollyhocks," said Mansfield, who offered an employee's-eye view of the private Streisand. "I've been gardening for fifty years—I know what I'm doing. But she wanted to be in charge. She told me she didn't want to see any dirt in a garden!"

She was equally forthcoming with the Democratic nominee for president. Once she made the decision to back him, Barbra told Gore he should not even bother trying to appear more comfortable on camera. "You should be authentically wooden," she told him, "because the public senses when you are trying to be something you're not."

Gore seemed to be following her advice to the letter when he delivered his acceptance speech at the Democratic National Convention in Los Angeles that August. Afterward, Barbra headlined a fund-raiser for the candidate at the Shrine Auditorium. Her attention to detail was, as usual, unsparing. During a six-hour rehearsal, she demanded that a small table be set up onstage, and that a pot of hot tea be placed on the table. But she hated the beige tablecloth, and the green one that replaced it. After two hours and a half-dozen tablecloths (blue, yellow, white, red and white checks), she finally settled on one in cranberry. The table, as it turned out, would be invisible to most of the audience.

The performance itself went off without a hitch. Between songs, she railed against the Republicans, denounced George Bush's record as governor of Texas, and prattled on about abortion, health care, campaign finance reform, health care, the environment, and gun control.

"The first three reasons to vote for Al Gore are the Supreme Court, the Supreme Court, the Supreme Court!" Barbra shouted over the cheers of the throng. "Our whole way of life is at stake. I shudder at how a more conservative court can put at risk all we hold dear—reproductive rights, civil rights, consumer rights, etc."

Midway through her comments, Barbra caught a glimpse of herself on one of the huge monitors and cringed. "It's all in profile!" she said, aiming her comments to the folks in the control room. "Where are the shots from the *front*?"

After her performance, Barbra ran into the dressing room and began wailing. "I looked TERRIBLE!" she said. "The lighting was awful! Why did the camera keep shooting me in profile! Goddammit!"

"But, Barbra . . ." said one of her handlers, "everybody loved you."
"I looked like SHIT!" she shot back, oblivious to the fact that the
crowd was still roaring its approval. In the end, the concert's $5 mil-
lion haul for the Gore campaign was impressive, even by Republi-
can fat-cat standards.

That fall, Barbra was dealt an unexpected personal blow when
Jason was reportedly diagnosed as HIV positive—a secret he had
presumably carried around for months. Once she got over the ini-
tial shock, Streisand kept a close eye on her son's condition. Jason
was showing no symptoms of AIDS, and it was important to keep in
mind that people who had tested positive for HIV—most notably
basketball star Magic Johnson—could live AIDS-free for years.

On November 3—just four days before the 2000 presidential
election—Barbra agreed to be interviewed by Barbara Walters on
ABC's *20/20* so long as a four-minute clip of her speech at the
Gore fund-raising gala was included. When the network decided to
cut out her partisan remarks, Streisand was livid. The next day, she
called a C-SPAN live election special to complain about the *20/20*
cuts, and on November 6, Rosie O'Donnell ran Barbra's pro-Gore
pitch on her talk show—after getting her audience emotional with
a tape of Barbra singing "Send in the Clowns" at her farewell per-
formance earlier that year. Streisand knew she could count on
O'Donnell to air what ABC would not. A Streisand fanatic since
childhood, O'Donnell recalled that Barbra's singing had helped
her cope with her mother's death from breast cancer when she was
only ten.

In the end, Barbra would be right about one thing: the impor-
tance of the Supreme Court. It would be the closest presidential
race in history, seesawing between Gore and Bush as their respective
legal teams battled it out all the way to the Supreme Court. Barbra
was furious when, despite the fact that her candidate had won the
popular vote by more than a half-million ballots, the Supreme
Court voted 5–4 to stop recounting votes in Florida—giving that
state's electoral votes, and the presidency, to the Republicans. She
burst into tears as she watched CNN report the high court's deci-
sion handing the election to George W. Bush.

On December 20, Bill Clinton bestowed the National Medal of

Arts on Barbra, and that night she and Jim attended a White House dinner honoring her and other medal winners. It would be her last dinner there for at least the next eight years.

At this point, even Gore and the Clintons were willing to put aside partisanship and wish Bush the best as Inauguration Day approached. "Soon George W. Bush would be President of all the people," Bill Clinton wrote in his memoirs, "and I wished him well."

Not Barbra. She remained bitter to the end. "The Democrats have been too conciliatory," said Streisand, who spent a week lobbying Democratic senators to block Bush's nominee for attorney general, former Missouri senator John Ashcroft. "Maybe they don't realize how far to the right this man is. Bush is shamelessly arrogant. He says he's a uniter, and he's putting together a cabinet of far-right people."

After attending two inaugurations in a row, she refused even to watch this one on television. "I won't watch," she sniffed. "Bush didn't win, so I won't watch. Bush didn't win anything. He didn't get the votes, and he has no mandate."

For the next five years, Barbra would hammer away at the Bush administration in any way she could. A month after "W" took office, Streisand became the first female director to be given the American Film Institute's prestigious Life Achievement Award. While she had no idea who was scheduled to speak and what they would say, she did spend two hours before the event playing director, tinkering with the lights and camera angles to make sure they were precisely to her liking.

Flanked by her husband and her son, Barbra beamed, sighed, and laughed as one star after another paid her tribute. One by one, Elizabeth Taylor, Jack Nicholson, Clint Eastwood, Sidney Poitier, Shirley MacLaine, Lauren Bacall, Quincy Jones, Kris Kristofferson—as well as a few from the early days like Phyllis Diller, Dom DeLuise, and Robert Klein—stood to sing Barbra's praises. Dustin Hoffman remembered the early Barbra chewing a "huge wad of gum" and with a "talent so big I thought I would never speak to her again!" Jeff Bridges spoke of the "two Barbras—the diva perfectionist and the lovable, adorable, funky girl," while ex-lover Ryan O'Neal reminded her that "love means never having to say you're sorry."

There were also taped messages from John Travolta, Bill Clinton (who pointed out that Barbra tries to direct things offscreen as well as on), and another ex-lover, Warren Beatty, who praised her "intelligence, integrity, and eroticism."

By April, Barbra had worked herself into such a froth over George Bush that she fired off a blistering three-page memo to top congressional Democrats. "What has happened to the Democrats since the November election?" she wrote. "Some of you seem paralyzed, demoralized, and depressed." Denouncing W as "destructive," she accused him of engineering a "Supreme Coup" by exploiting "family ties, arrogance, and intimidation." She demanded that Democrats in the House and Senate filibuster future "right wing" nominees.

Barbra read the letter to House Minority Leader Dick Gephardt; producer Norman Lear; Warren Beatty and his wife, Annette Bening; and several other liberal movers and shakers at a party she threw at the Malibu compound. Then she suggested, among other things, that they pool their resources to buy their own left-leaning cable-TV news network—one devoid of what she derisively called "Republican talking heads." According to one person who attended the meeting: This was "just one of several ideas that were floated, and the feeling was just that it would be almost impossible to pull off."

She may have been the Democrats' new La Passionaria, but Barbra had plenty of other things on her plate. Stepson Josh Brolin was about to wed British actress Minnie Driver, and Barbra had taken upon herself the arduous and anxiety-producing task of planning a lavish wedding at the Malibu estate. Over the ensuing months, Driver and Streisand clashed on everything from the size of the wedding—Minnie wanted something casual in the Caribbean, where she'd spent her early years, Barbra lobbied for a major Hollywood event—to who would design the dress. Driver wanted Vera Wang, and Barbra, not surprisingly, pushed for Donna Karan.

By early fall, Minnie and Josh would go their separate ways amid reports that Barbra's constant interfering had only aggravated an already rocky relationship. Barbra denied the stories, claiming that she was "heartbroken" over the breakup. She was, in fact, fond of Driver and the two had forged a warm understanding. But Driver would eventually admit that she also bristled at her would-be

mother-in-law's controlling ways. Their relationship was, in a word, "tense." What would it have been like to be Streisand's daughter-in-law? Driver was asked. "It would have been . . . colorful," she replied coyly.

At around the time she was planning Josh Brolin's ill-fated wedding, Barbra was rushed to UCLA Medical Center complaining of chest and stomach pains. Just two days after she received her diagnosis—she had suffered a stress-induced anxiety attack—Donna Karan's husband, sculptor and businessman Stephan Weiss, succumbed to lung cancer. Barbra and Brolin immediately flew to Karan's side in New York, where they went to Weiss's Greenwich Village studio to sit shiva, the traditional seven-day Jewish observance of mourning.

Still grieving with her friend, Barbra returned to Los Angeles to choose the songs for a new album of holiday songs, *Christmas Memories*. She asked Dean Pitchford, who with Tony Snow had written the song "Closer," to rework the song's lyrics so that they reflected the loss of a loved one rather than a desire to rekindle a Christmas romance. She planned to dedicate the song to Weiss.

Backed by a ninety-piece orchestra, she completed the Christmas album on September 7, 2001. "I can't explain it," Barbra later said, "but I had a feeling something was coming. And then, oh my God, it's here, this nightmare, this horror. I was overwhelmed."

This "nightmare" was 9/11—the September 11 terrorist attacks that took the lives of nearly three thousand Americans. In a strange twist, Pitchford lost his sister at the World Trade Center. "For the first time in my life," the songwriter said, "no words come to me. The last words I wrote were for 'Closer' [the lyrics Barbra had asked him to write] and they in a way became my sister's epitaph."

The national tragedy left Barbra in a "state of confusion. One day I tell myself, 'Screw everything, I'm getting a Carl's Jr. hamburger and eating fried chicken three nights in a row. I don't care about my weight,'" she confessed. "The next day, my optimistic side takes over and I think, 'Wait a minute, life goes on, people will get wiser, justice will prevail. Maybe I *should* watch my diet.'"

In the immediate wake of 9/11, Barbra removed some of the anti-Bush diatribes she had posted on her website, which devoted a considerable amount of space to attacking the Republicans. But she

could not contain herself for long. "It's dangerous when someone says, 'Watch what you say' . . . That's why the presidential election was so horrific. Every vote is supposed to count."

With the Emmys postponed from the original September airdate to November 4, Barbra agreed to close the show; it would be her only live performance in 2001. But, she repeatedly asked herself, "Will terrorists blow up the Emmys?" To cover herself, she asked that her appearance not be announced beforehand "because I might get cold feet."

When it turned out that she had actually won an Emmy for her *Timeless* concert special, Barbra did not go onstage to accept—a move that once again had critics griping about her imperious behavior.

"I was focused on my song and my stage fright," explained Streisand, who would end the show by singing a heart-stopping rendition of "You'll Never Walk Alone" in front of a wall covered with the names of 9/11 victims. "I kept thinking, 'How am I going to stop my voice from trembling?' . . . The song was my top priority. I was there to give something, not get something."

In the weeks following 9/11, Barbra felt the tragedy "brought out the best in people. I was so touched by the outpouring of human kindness and compassion. There it was: the sacrifice. You realize you have to live every day, every moment, with the understanding of how fragile life is."

That hit home in early 2002 when Barbra's mother broke her neck in a fall at her apartment. After undergoing surgery at Cedars-Sinai Medical Center to repair two fractured vertebrae, Diana awoke to find Barbra at her bedside.

On March 27—four days after presenting her old *The Way We Were* costar Robert Redford with an honorary Oscar—Barbra received the phone call she had been expecting. Her mother was dead at the age of ninety-three. Devastated, Barbra wept in her husband's arms. Their peculiar mother-daughter relationship had always been less than ideal, but Streisand knew it was the wellspring of all she had achieved. "It was because she *didn't* believe in me that I became something—just to show her that I could do it," she said. "So my mother is really the reason for everything I've done, for all my success. If she had believed in me, I would have been a typist."

A month later Barbra faced another sobering reminder of her

own mortality—her sixtieth birthday. John Travolta and Kelly Preston, Warren Beatty, Richard Baskin, and her sister, Roslyn, all showed up at the Beverly Hills home of Streisand pal Sandy Gallin to celebrate with the birthday girl—although no one was allowed to make a birthday toast or, God forbid, sing "Happy Birthday."

Brolin took his wife's mind off her milestone birthday by taking her on a $500,000 three-week second-honeymoon cruise off the coast of Italy aboard a chartered sixty-foot yacht. Ironically, Barbra had come up with the idea when she was helping Minnie Driver and Josh Brolin make plans for a honeymoon that was never meant to be.

That summer, Barbra worked on her fifty-ninth album—a collection of duets with the likes of Ray Charles, Josh Groban, Vince Gill, and even herself—and culled through a dwindling number of film offers. Among other projects, Miramax's Harvey Weinstein asked her to direct the screen version of *Chicago* and took her to see the show. Squeezing with Weinstein into the cramped box office during intermission, Barbra screamed, "This is all dancing, Harvey. Jews can't dance!" With another director, *Chicago* would go on to win the Academy Award for Best Picture.

It was around this time that she once again ran into her old *Funny Girl* understudy Lainie Kazan, who had long since made a name for herself as both a singer and an actress in such hit film comedies as *My Favorite Year* and *My Big Fat Greek Wedding*. "We were at a function, and she was sitting across the room with Martha Stewart," Kazan recalled. "Then she came over and sat down next to me and we talked about some very personal things. She was really very candid and open with me, and I was very surprised—and very pleased. Before I knew it, she was back on the far side of the room, and barely waving good-bye to me. Maybe she suddenly got scared about having told me too much. I don't know. Every time I see her, her behavior winds up striking me as . . . well, bizarre. But frankly, when you think of how she became this larger-than-life figure at such an early age—when people are always fawning all over you and you don't know who's real and who isn't—I think all that adulation and power really bent her personality. But I still admire her tremendously. She is an incredible talent. Kudos to Barbra for all that she has accomplished . . . But she's still not a very friendly person."

Kazan would concede, however, that Barbra seemed to have "mellowed" over the years. Yet she was anything but mellow when it came to pushing the causes she believed in. In her role as an avowed environmentalist, Barbra devoted a considerable amount of time to lecturing the public at large on ways to best conserve energy. Among other things, Barbra—who reportedly kept the sixteen rooms of her unoccupied Central Park West penthouse so well air-conditioned that she could store her furs there—urged citizens to keep their thermostats set at seventy-eight degrees when they were at home and at eighty-five degrees when they were out.

She also suggested that people should use clotheslines rather than machines to dry their clothes, turn off all lights and appliances when not in use, and use more fuel-efficient cars. Given the fact that she often traveled by private jet and limousine, and that she maintained three houses on her Malibu estate (one of which boasted eight climate-controlled bedrooms and eleven bathrooms), Barbra obviously consumed vast amounts of energy. In addition to the houses themselves, there were two pools, hot tubs, saunas, a private gym and a screening room—not to mention the extensive landscaping tended to by ten full-time gardeners.

"She never meant," a Streisand spokeswoman replied, "that it necessarily applied to her."

Around the same time, Barbra would become embroiled in a legal battle over the right of another environmentally conscious Californian to take aerial photographs of her property. After Kenneth Adelman sold a company he had founded to Cisco Systems for $115 million, he set out to photograph every inch of the California coastline by helicopter from an altitude of five hundred feet.

Adelman's final "album," christened the California Coastal Records Project, contained 12,700 frames that were posted on the Internet. But when Barbra found out she dispatched her lawyers to have the single frame of her home removed on the grounds that her privacy had been violated. In a series of letters that became increasingly hysterical in tone, Barbra's lawyers branded Adelman a "self-appointed vigilante of the skies" who "might next want to swoop down . . . and take pictures of homes . . . all under the pretext that he is documenting the environment. No one would be

spared." As for Barbra, she lived in fear of being "stalked by obses-
sive personalities with an unnatural urge to stake her out at all
times."

When Adelman refused to remove the photo of her property
from his website on the grounds that he was protected by the First
Amendment, Barbra sued him for $50 million, claiming he was in-
vading her privacy and violating California's antipaparazzi laws.

"It is inconceivable to me," said the Sierra Club's Mark Massara,
"that someone who proclaims herself an environmentalist would
threaten to dismantle one of the greatest high-tech projects to pro-
tect the California coast just because they chose to place their back-
yard on a coastal bluff. At some point, someone needs to sit her
down and tell her the public interest is at stake here!"

Despite the pleas from Massara and other environmentalists, Bar-
bra continued to press her case in the courts. Adelman pointed out
that prior to her lawsuit, the photos of her property had been
downloaded six times in three months. After she made a fuss, an av-
erage of 108,000 people viewed the photo *per day.*

With a personal fortune that matched Barbra's, Adelman could
afford a protracted legal battle. Ultimately, an L.A. Superior Court
judge ruled that Streisand had abused the judicial process and or-
dered her to pay Adelman's legal bills to the tune of $177,107.54. "I
think fighting her is a real public service," Adelman concluded.
"Someone has to stop her."

But Adelman was not Barbra's most formidable foe—far from it.
She was determined to help the Democrats wrest control of Con-
gress from the Republicans and to block the Bush administration at
every turn. In conversations with Democratic leaders around the
country, Barbra made no effort to tone down her antipathy toward
the President. "I CAN'T STAND THAT MAN!" she screamed
over the phone at one party official in New York. "He has no right
to be in the White House! Bush is ruining the country. Don't people
get that?" To another: "I thought Reagan was bad—he's Franklin
Roosevelt compared to this guy."

In the wake of 9/11, Streisand was particularly upset at the
amount of praise even Democrats were willing to heap on President
Bush for his handling of the crisis. "I refuse to believe," she told her

political strategist, Margery Tabankin, "that the American people are that dumb."

On September 25, Barbra and Tabankin watched Democratic Senate Majority Leader Tom Daschle give a televised speech blasting President Bush's decision to take military action against Iraq on the grounds that Saddam Hussein backed terrorism and harbored "Weapons of Mass Destruction." The two women, Tabankin said, became "very emotional"—especially Barbra, who was brought to tears by the forcefulness of Daschle's address.

With Tabankin's help, Barbra then sent off a blistering memo to Dick Gephardt saying it was "time for the Democrats to get off the defensive and go on the offensive . . . the Democratic Leadership must not continue to take this lying down." Much, perhaps unfairly, would be made of Streisand misspelling Gephardt's name "Gebhardt" in her hurried attempt to send the memo, and of her later reference to *Iranian* dictator Saddam Hussein.

Four days later, Barbra headlined another celebrity-packed Democratic gala in Los Angeles. Donors paid between $500 and $250,000 to attend, bringing the total take for the evening to $6 million. Calling Bush, Vice President Dick Cheney, Defense Secretary Donald Rumsfeld, and Attorney General Ashcroft "frightening," she charged that Republican control of the House over the previous two years had caused "poison in the water, salmonella in the food, carbon dioxide in the air, and toxic waste in the ground." The man who "stole the presidency" was not only poisoning "our air and water—he's poisoning our political system as well."

To illustrate why she felt Bush was "frightening," Barbra repeated a joke W had told shortly after his election. "If this were a dictatorship," she quoted him as saying, "it would be a heck of a lot easier, just so long as I'm the dictator."

"You know," Barbra said, "people never really joke. That was very revealing . . . a taste of things to come . . . the arrogance of wanting unlimited executive power."

Streisand also offered the crowd a parody of "The Way We Were":

Mis'ries,
Seems that's all that fills the news.

Blame the fellas in the White House
For the way we are . . .

Barbra also had time to work in a quote from William Shake-speare's *Julius Caesar*—or so she thought. "You know, really good artists have a way of being relevant in their time," she said solemnly, "but great artists are relevant at any time. So, in the words of William Shakespeare, 'Beware the leader who bangs the drums of war in order to whip the citizenry into a patriotic fervor, for patri-otism is indeed a double-edged sword. It both emboldens the blood, just as it narrows the mind . . . The citizenry, infused with fear and blinded with patriotism, will offer up all of their rights unto the leader, and gladly so. How do I know? For this is what I have done. And I am Caesar.'"

The quote, a veritable Mixmaster of metaphors, was certainly not from Shakespeare. It was right off the Internet—not just a fake, but, as should have been obvious to anyone reading it, an excruciatingly *bad* example of writing by anyone. The quote was, said Georgetown University Shakespeare scholar Lindsay Kaplan, "just a very clumsy piece of writing."

On election night 2002, Barbra sat glued to CNN and C-SPAN. This time, it was no squeaker. Led by Bush, who had barnstormed the country on behalf of Republican candidates, the GOP regained their majority in the Senate and widened their margin in the House. Barbra put her head in her hands and wept in frustration. "She was more angry than anything else," said a leading Demo-cratic fund-raiser in California. "She kept shaking her head and ask-ing how people could be so goddamn stupid."

The following March, Barbra showed up at the seventy-fifth Academy Awards to present Eminem with a Best Song Oscar for "Lose Yourself" from *8 Mile*. She showed no sign of having recently learned that Jason had been treated at a Los Angeles hospital for chicken pox, a potentially serious disease for someone reportedly in-fected with the AIDS virus. Fortunately, he quickly recovered.

Barbra, meantime, was having a difficult time coping with the way she looked at the Academy Awards. Her eyes were puffy, the

skin around her chin and neck sagged. As a practical matter, she was now forced to face the fact that she would have to do something about her looks if she was going to keep working in the movies. After years of resisting plastic surgery, she checked into a Beverly Hills clinic on July 30, 2003, and paid $35,000 to have the wrinkles smoothed out and her jawline tightened. To calm her nerves, she brought a "spiritual healer" with her. Together, they recited prayers and chanted as she was prepped for the outpatient procedure. The nose, she still insisted, was to remain untouched.

Wearing a straw beekeeper's hat and veil, she emerged from the clinic with several nurses and was taken by limousine to the nearby Peninsula Hotel, where she spent the next two days recuperating.

Barbra, who had worried that her bags and sags were costing her film roles, now looked ten years younger. Once again, she wore her hair straight, long, and blond. Ironically, the old Barbra would have done just as well for the next movie role she was about to play.

Keeping her weight under control now that she was over sixty would also become a major issue. Barbra's penchant for starting and ending meals with dessert ("Sometimes I like to have ice cream for dinner"), gobbling down an entire pecan pie before bed, and stuffing fistfuls of hors d'oeuvres in her purse at parties ("It's not a pretty sight, but she's Barbra Streisand," said a waiter) was wreaking havoc with her waistline. Barbra's approach to dieting: eating one thing—her favorite thin crust pizza, for example—and nothing else until, she said, "I'm so sick of it I can't face it for months."

For the moment, however, Barbra had a score to settle. She had long held Ronald Reagan accountable for not addressing the AIDS epidemic sooner. Now that her only child was reportedly infected with the virus, she despised the former president more than ever. When Brolin was asked to play Reagan in a four-hour CBS miniseries planned by her friends and former Barwood coproducers Greg Zadan and Neil Meron, he balked at the idea.

"It was the most absurd idea I've ever heard, playing Reagan," he said. But Barbra encouraged him to take the part. Ultimately he decided that in Reagan he had found his "Quasimodo—not that Reagan was Quasimodo, but wonderful characters like this so rarely come along."

With Australian actress Judy Davis cast opposite Brolin as a

Machiavellian Nancy Reagan, *The Reagans* provoked the pre-
dictable public outcry once it was revealed that "Mr. Barbra
Streisand" would be playing the revered former president. Adding
to the sense of outrage was the fact that Reagan was ninety-two and
in the final stages of Alzheimer's disease.

While *The Reagans* did give the former president much of the
credit for ending the cold war and portrayed him as someone who
stuck to his principles, it also suggested that Reagan was already
suffering from the effects of Alzheimer's in office by stressing his
forgetfulness. More important, it portrayed Reagan as being insen-
sitive to the needs of AIDS patients. In one scene, when Nancy
pleads with Ronnie to help AIDS victims, he replies, "They that live
in sin shall die in sin."

Trouble is, Reagan had never said that. And Streisand *knew* that
he never said it. While first acknowledging this, she nonetheless
went on to say another of Reagan's statements contained the same
"sentiment." After admitting that the "live in sin . . . die in sin" line
was a total fabrication, she then inexplicably claimed that "public
records and multiple sources show that everything in the film, in-
cluding his controversial statement about AIDS, is based on ir-
refutable facts."

Although she would continue to insist that she had had nothing
to do with the project, had spent only four hours on the set, and had
not even read the script, Barbra seemed awfully familiar with the
material when she spoke to *The Advocate*. When asked if it was
"strange" seeing her husband play Reagan, she said, "At first it was,
but not after I saw some of the film, which is really kind of telling it
like it is—like it was . . . It's kind of what we know about Reagan,
the man who didn't say the word AIDS for seven years" (italics
added). Clearly, Streisand knew quite a lot about what had gone
into *The Reagans*—enough to defend it as "a balanced portrait of a
complicated man."

In a lengthy "Truth Alert" on her website, Barbra argued that
"Republicans, who deify President Reagan, cannot stand that some
of the more unpleasant thoughts about his presidency might be de-
picted in the movie, along with his positive actions . . . Reagan is
glorified by conservatives because what other Republican leader of
recent history are they going to point towards? Richard Nixon?

George H. W. Bush? Newt Gingrich? Are these men worthy of exalt?" She then went on to say that "this is what the Right Wing does . . . they spread vicious lies and attacks and scream and yell until they get their way."

While Reagan admirers demanded that viewers boycott CBS if it refused to yank *The Reagans* from its lineup, Barbra found time to promote *The Movie Album* (her sixtieth album and the thirtieth to go platinum) on *Oprah* in October 2003—but not before faxing a nine-page list of demands to the producers. For someone who claimed to be more relaxed since her marriage to Brolin, Barbra gave no sign of being eager to relinquish control.

Dressed in a white knit turtleneck, white pants, and white boots, Barbra even sang into a white microphone. Oprah, who was using a standard black microphone, asked Streisand where she'd managed to find a white mike. "It's yours," Barbra answered. "I painted it." After Streisand left, Winfrey turned to one of her staffers. "Can you believe it? She painted my mike *white!*"

One of the more emotional moments in the show revolved around her singing the poignant ballad "Smile." Just two days before she went into the studio to record the song, her nine-year-old bichon Sammy died of cancer. She nicknamed the tune "Sammy's Song," and the Humane Society picked it as its official "Anthem of Spirit" for anyone grieving over the loss of a pet. In an attempt to boost his wife's flagging spirits, Jim gave her a rare white Coton de Tulear puppy, which she promptly named Sammy.

The controversy over *The Reagans* reached its climax in early November, when CBS chairman Les Moonves, a Democrat, pulled the show from the network's schedule. Instead, it would air on Showtime, the cable network owned by CBS's parent company, Viacom. Moonves claimed it was "an absolute lie" to claim he caved to political or corporate pressure. "It was a moral decision, not an economic or political one," he said. While the producers had promised him that *The Reagans* would offer a balanced view of the former First Couple, said Moonves, "it did not"—not even after some of the anti-Reagan sentiment had been considerably toned down at the insistence of the network.

Barbra was furious. She denounced the network for "caving in to right-wing pressure" and went on to say that it was "a sad day for

artistic freedom." But not even Patti Davis, the Reagan daughter who had for so long aligned herself with such Hollywood liberals as Streisand and Jane Fonda, agreed. The show's producers, Davis said, were guilty of "astounding carelessness and cruelty" and praised CBS for "doing the right thing" in pulling it.

When *The Reagans* finally ran on Showtime in December 2003 in its more muted form, reviews were decidedly mixed. "Neither a deification nor a demonization of President Reagan," wrote *USA Today*'s Robert Bianco, *The Reagans* is "an impeccably produced movie propelled by a strong performance from James Brolin and an extraordinary one from Judy Davis." *Entertainment Weekly*'s Karyn L. Barr called the script "aggressively corny, depicting the First Lady as a pill-popping, astrology-obsessed Mommie Dearest."

Brolin, who would be nominated for both a Golden Globe and an Emmy (one of *The Reagans*'s seven Emmy nominations), would wind up splitting with his wife on the subject of Ronald Reagan. "In the end, I really liked the guy," he said. "There was nothing malicious about him. He was straightforward, he was truthful about how he felt, even though you may or may not have agreed with him."

Barbra, in the meantime, had been bombarded with calls from a young director named Jay Roach. He was pleading with her to take a supporting part in his next film—a sequel to the 2000 Ben Stiller hit comedy *Meet the Parents*.

In *Meet the Fockers,* the moment male nurse Gaylord ("Greg") Focker has been dreading finally arrives: He must take his fiancée's CIA agent father (in a role reprised by Robert De Niro) and WASP mother (Blythe Danner) to meet his parents, randy stay-at-home dad Bernie (Dustin Hoffman) and sex-therapist-to-the-elderly Roz Focker.

Stiller, whose parents Jerry Stiller and Anne Meara had headlined with Barbra at the Blue Angel in 1963, wanted Streisand from the beginning. "But we'll never get her in a million years to do it," he told Roach. "There is no way we'll actually get her to do it."

In truth, it had been eight years since she appeared on screen in *The Mirror Has Two Faces,* and Barbra was eager to return— preferably in a comedy. Her friends, however, argued against taking a supporting role in a sequel. Still, the role of the earthy, randy

Mother Focker appealed to Barbra. She remained on the fence for months, and was just about to formally turn the part down when Ben Stiller called from London.

"It was the scariest call of my life," admitted Stiller, who nonetheless managed to convince Barbra that the script could be rewritten to make her role a centerpiece of the film.

In the end, Stiller's pledge—and the knowledge that she would be joining an ensemble that included De Niro and her old friend Hoffman—convinced Barbra to take the risk. Now that she had had her face done, lost fifteen pounds, and dyed and straightened her hair, she donned a curly brown wig, a billowy peasant blouse, and tinted granny glasses to play Ben Stiller's aging hippie mom. "I love Roz Focker," she told British journalist Mike Godridge, "but it's not like I was dying to play her, you know what I mean? I wasn't passionate about it. It was an experiment."

Oddly enough, Streisand did not draw on her own experiences with Jason to summon up her maternal instincts for the role. Instead, she brought her new dog, Sammy, to the set. "Yeah, the way I thought the best mother I could be to [Ben] was the way I am with my dog. The way I am with Sammy."

The on-screen chemistry with Hoffman, whom she had known for forty-four years but had never worked with, was immediate. "So," he asked their first day on the set in early May, "how much sex do you get?" Between the two of them, they determined they got about seven days a week of sex: "I was once," Hoffman said, "and she was six times!"

Each day when he arrived on the set, Hoffman walked up to Barbra and whispered in her ear, "I love your breasts. They look great today." It worked, Hoffman said, "because Barbra loves her breasts. She's very proud of them."

On the set, Hoffman marveled at how little Streisand had changed from the days when he was cleaning toilets at the Cherry Lane Theater and she was babysitting to pay for acting lessons. "Whatever you had on you," Hoffman said of her behavior on the *Fockers* shoot, "she always said, 'How much did you pay for that?' Whether it was a hamburger or a BLT sandwich, she'd be like, 'Did they give you that free?'"

As Roz Focker, Barbra got to deliver some of the movie's better

lines. After a fully clothed Roz is done teaching Tantric sex techniques to a group of senior citizens, she tells one octogenarian fellow to "practice at home." When he calls her a "Semitic temptress," she replies, "Keep it in your Depends."

Still, Streisand was convinced she needed a scene where there was physical contact between De Niro's uptight, by-the-book character and the freewheeling Roz. After screening several sex-therapy tapes and working out the choreography with her masseuse, Barbra straddled a prone De Niro to perform a bit of sexually suggestive "massage" on his back.

Barbra took the opportunity to let people know that her sex life was better than ever and to offer some advice to her peers. "Later in life, when you have a relationship," she said, "keep it hot—keep it sexual. Never let that die because it is a life force. And it's fun!"

The end result notwithstanding, Barbra did not enjoy making *Meet the Fockers*. "It was not fun," she stated flatly. "Fun for me is not getting up at five A.M., being made up, putting on a wig, and working in the heat. No, it's not fun. The days I didn't have to be there were fun."

"Like all great artists," Hoffman observed, "there's this wonderful energy that's creative and strong, but at the same time quite fragile. Steven Spielberg told me that before he starts a movie, on the way to work he pulls over to the side of the road and throws up. To this day. The stronger the talent, the more frightening it is."

Nothing, however, compared to the shock Barbra received in the fall of 2004 when doctors told her they had detected something unusual during a routine colonoscopy. Told that she would have to undergo a procedure to remove what doctors believed to be a single noncancerous polyp, the self-described lifelong hypochondriac was understandably shaken. Despite reassurances from her husband and friends like Cis Corman and the Bergmans, Streisand, fearing the results of the biopsy, put the procedure off until early December—barely three weeks before the release of *Meet the Fockers*. Fortunately, as predicted, the single polyp doctors finally removed turned out to be benign.

Barbra was still recovering from her cancer scare when she was suddenly confronted with more tabloid headlines—this time generated by her troubled stepson Josh. On December 19, 2004, less than

five months after they were wed in a quiet ceremony on his ranch north of Los Angeles, Josh Brolin was arrested for assaulting his wife, Diane Lane, the stunningly beautiful star of such films as *Unfaithful* and *Under the Tuscan Sun.*

Lane, who had a daughter from her marriage to actor Christopher Lambert, had been a Malibu neighbor of Barbra's when she met Josh Brolin. Divorced from actress Deborah Adair, with whom he had two children—Trevor and Eden—Josh turned to alcohol in 1995 after the auto accident that took his mother's life. Three years later, at the urging of his father and stepmom, Barbra, Josh checked himself into rehab.

After his arrest, Brolin was fingerprinted, posed for a mug shot, and then released on $20,000 bail. The misdemeanor domestic-battery charge was dropped, however, when Lane insisted that the whole episode had been a "misunderstanding" and that she was embarrassed the matter "went this far."

Whatever the problems in her marriage, Lane relied heavily on her mother-in-law for advice and encouragement. "Some people have more talent poured on them in the cards they are dealt in life and Barbra is one of those people," Lane mused rather awkwardly. "She's also very interested in other people. She absorbs people, learns from them, and grows from having met them. Life moves into her and inspires her like no one I have ever met. A lot of us are very content to just be affected by her."

Was Barbra intimidating? "I'm sure, if she chose to be," Lane said cautiously. "But with me, she has only been a really warm and loving person."

Like nearly all of Barbra's films, *Meet the Fockers* would turn out to be critic-proof when it was released in 2004. Not only would it turn out to be the most commercially successful film of Hoffman's, De Niro's, *and* Streisand's career, but *Meet the Fockers* would rank as the top-grossing live-action screen comedy of all time with total sales exceeding $510 million—making it the first live-action comedy ever to break the half-billion-dollar barrier.

Barbra, who confided to friends before the film's release that she worried she might have made a mistake by accepting the role, was more surprised than anybody by the film's record-smashing performance at the box office. "Who knew?" she said, laughing.

By that point, Streisand felt she could use some good news. In late June 2004, Barbra had once again headlined a Democratic fundraiser—this time for the party's presidential nominee, Senator John Kerry of Massachusetts. For this event, she parodied her signature song, "People," with special lyrics by the Bergmans:

> *People*
> *I mean G.O.P. people*
> *Who'd believe there's such people in this world?*

Kerry supporters were ecstatic; they coughed up $5 million that night, making Barbra's concert the most profitable single fundraising event of the 2004 election year.

Even after Bush was reelected—this time by a margin of three million votes—Barbra hammered away at his policies. While promoting *Meet the Fockers* in early 2005, she invariably offered unsolicited critiques of W. "What about the lies of this administration about the Iraq war?" she asked one startled entertainment reporter. "Lies, lies, and more lies. To me, that's high crimes and misdemeanors, leading people into war unnecessarily. Why doesn't Bush step down?"

Astonishingly, Streisand used her website in April of 2005 to compare Bush with Nazi Reichsmarschall Hermann Göring, Hitler's right-hand man and head of the Luftwaffe during World War II. Under the heading "A Country Controlled by Fear," she wrote, "Bush's actions remind me of Hermann Goering's quote during the Nuremberg Trials, where he stated: 'It's always a simple matter to drag the people along whether it's a democracy, a fascist dictatorship, or a parliament, or a communist dictatorship. Voice or no voice, the people can always be brought to the bidding of the leaders . . . all you have to do is tell them they are being attacked, and denounce the pacifists for lack of patriotism.' "

When she wasn't likening Bush to Caesar or a Nazi, calling for his impeachment (as she did on October 26, 2005), branding the Republican administration as a "corrupt, power-hungry, greedy group of incompetent leaders," and talking about Bush's African-American secretary of state sitting "in the back of the room," Barbra accused the other side of "fighting dirty. I don't know why it is

that we need to denigrate, to knock down. It's so unhealthy for the culture. It's so sick."

The same website Barbra used as her bully pulpit was also continuing to generate millions for her foundation by auctioning off Streisand's used possessions on eBay. Even as she railed against "the hypocrites in the White House," she was actively wooing every Secondhand Rose who surfed the Web. On one of the days she blasted "Bush's War," Barbra was offering a "yellow dress by Annabella" for $81, a "vintage top with cashmere pants" for $24, and for $99, "three pair of Nine West shoes."

As Bush ambled into his second term, Barbra now concentrated on the possibility that the Clintons might retake the White House with Hillary at the head of the Democratic ticket in 2008. Yet, while Streisand insisted that she and New York's junior senator were friends, those close to the Clintons insist Hillary sees Barbra primarily, one former aide puts it, as "the deepest pocket in America. Hillary doesn't want to do anything to offend Barbra—God knows she'll need her in 2008—but are they buddies? No."

In contrast, by all accounts Barbra and Bill Clinton have managed to stay in more or less constant touch—and without ever alerting Hillary to the fact. By 2005, Barbra's main "pipeline to Bill Clinton," as one Clinton associate put it, was former White House aide and longtime FOB Marsha Scott. A former Miss Arkansas, Scott liked to refer to herself as the former president's "old hippie girlfriend" and would eventually admit to spending many nights alone with Bill in the family residence. (When White House counsel Vince Foster committed suicide in 1993, Scott told Ileene Watkins, wife of assistant to the president David Watkins, that she had spent the night "with Bill in his bed.")

Barbra and Bill would continue to see each other on the rare public occasion. She was present (along with Bush) in Little Rock on a rainy November 18, 2004, for the opening of the Clinton Presidential Library, and in September of 2005 attended Bill's Global Initiative Conference in New York. "And of course, as expected, our forty-second president, Bill Clinton, was brilliant," Barbra later reported breathlessly on her website. "His intellect and command of the issues . . . was astonishing." After three days at Clinton's conference, Barbra left "feeling intellectually stimulated and inspired."

Yet there were other encounters between Barbra and Bill Clinton that the public would never know about. Now, on a routine basis, Barbra would call up Scott and ask, "May I talk to Bill?" Often within minutes, Scott would see to it that Clinton returned the call. "That way Barbra and Bill can talk on the phone or set up times to meet without Hillary ever knowing," said a longtime Arkansas friend. "I wonder if James Brolin knows . . ."

Ready to return to the recording studio, Streisand found time in the summer of 2005 to complete a project that had been sitting on the back burner for a quarter of a century—the sequel to her block-buster *Guilty* album, *Guilty Pleasures*.

Working with Barry Gibb in Los Angeles and at Gibb's recording studio in Miami, Barbra once again demanded retake after retake after exhausting retake. "She is relentless," said a technician at the Miami studio. "There were times when I thought Barry was going to strangle her. But she knew what she wanted, and as far as any of us could tell, she was always right." A full month before its September 2005 release, *Guilty Pleasures* was charting at number one on Amazon.com.

For the first time Barbra, frustrated by Bush's reelection and his refusal to pull U.S. forces out of Iraq, used a cut from her latest blockbuster album to make a political statement. In the video for the single "Stranger in a Strange Land," shots of Barbra singing in a studio are interspersed with footage of American soldiers returning home to loved ones from the First and Second World Wars, Korea, Vietnam, the Persian Gulf, Afghanistan, and Iraq. While one of the first lines in the song is addressed to "somebody's sweetheart fighting someone else's war," Gibb pushed Barbra to tone down the anti-Bush sentiment. As a result, "Stranger in a Strange Land" would actually turn out to be—whether Streisand intended it or not—a bittersweet, patriotic tribute to the sacrifice of U.S. soldiers overseas.

"This war is kind of senseless," she said of the song's allusion to U.S. involvement in Iraq, "and I don't know why we're there. Just the sadness of it . . . we don't want to have those people in harm's way, and yet we do have to support the troops. It's kind of

painful . . . it's like history repeating itself—here we are again. That was the meaning of the song to me."

As she approached her sixty-fourth birthday in April of 2006, Barbra appeared on the surface to be more content than ever. She was heavier than she had been in years, and it did not seem to bother her. "I put on a few pounds because I love to eat. So what?" she said. "I've *earned* the right to enjoy myself."

These days, "Beezer" and her husband liked to spend lazy afternoons at "Grandma's House," a clifftop cottage a hundred yards from the main house at Point Dume. Set back on an expanse of emerald-green lawn, the cottage offered jaw-dropping views of the Pacific. It was a place where she could forget the war in Iraq, her son's reported battle with the AIDS virus, and the pressures inherent in being one of the world's most famous, respected, envied, and— yes, even hated—figures. Barbra offered only one word to describe the time spent with her husband at Grandma's House: "Heavenly."

Was this the new, more content, less driven Barbra? The most successful woman in entertainment history pondered the question. "I am the old Barbra, and I'm the new Barbra," she said, smiling. "I'm all the Barbras."

She is, to be sure, a mind-spinning tangle of contradictions: the ugly duckling regarded by millions as an exotic beauty, the boldly confident upstart riddled with self-doubt, the thrift-shop refugee who became a style icon, the generous philanthropist with miserly habits, the demanding diva in search of a father figure, the liberal firebrand with the queenly lifestyle, the electrifying performer crippled by stage fright.

Yet, even as she has clung to the top of the show-business Everest for over forty years, one thing has remained constant in the life of Barbra Joan Streisand—a never-ending, soul-gnawing need for perfection. She will never achieve it, of course. But in that quixotic quest, Barbra will continue to do what she has always done best: astound us.

ACKNOWLEDGMENTS

"Now, I knew Fanny Brice," Kate Hepburn once told me as we talked about Barbra in the living room of her New York brownstone. "Fanny could swear like a longshoreman but she was also one of the most sophisticated women you will ever meet—absolutely regal. Barbra Streisand was *nothing* like Fanny Brice, but who the hell cares? She was damn good in that picture, *Funny Girl*. Damn good." There was a pause while Kate the Great, who as Eleanor of Aquitaine in *The Lion in Winter* shared the Best Actress Oscar with Streisand in an unprecedented tie, mused on the subject of Barbra. "Can't really see that we have much of anything in common," Kate said with a shrug, "except for one thing: We are monsters of our own creation."

Hepburn meant this as a compliment—more or less. There were huge differences between them, to be sure. Unlike Barbra, Kate was obsessively punctual, could not sing, had no desire to have children, and had no time for such self-indulgent pursuits as psychoanalysis and Method acting.

Still, the Bryn Mawr–educated Connecticut Yankee and the Jewish kid from Brooklyn had more in common than they knew. Both women were pitched headlong into the world of make-believe by childhood tragedies—in Kate's case, the suicide of her beloved brother Tom, in Barbra's case the absence of a loving father figure. Both knew from an early age that they were destined for stardom, and, since both were born under the sign of Taurus, pursued that goal with bullish determination. Both first achieved success on the Broadway stage and would earn their first Oscars at the age of

twenty-six. Despite the fact that at the time neither was thought conventionally pretty—Hepburn was considered too bony and patrician, while Streisand had to overcome the sizable nose and slightly crossed eyes—both would redefine the concept of beauty. Both would break the rules when it came to fashion, and come to be regarded as style icons in the process. Both would be involved in a series of high-profile affairs. Both were demanding perfectionists, and both had unshakable ideas about everything from art and architecture to politics. Both were outspoken to the point of rudeness— and sometimes beyond.

It goes without saying, then, that such glorious "monsters" deserve biographies that are equally forthright, equally outrageous, equally, well, rude. In that, I hope I have succeeded.

For the eleventh time, I have the great pleasure of working with one of the finest teams in publishing. I am especially grateful, yet again, for the passionate commitment of my editor, Maureen O'Brien, who as executive editor of HarperCollins Entertainment has had plenty of experience dealing with divas. My thanks, as well, to my many friends at HarperCollins—particularly Jane Friedman, Michael Morrison, Lisa Gallagher, Debbie Stier, Stephanie Fraser, Michelle Corallo, James Fox, Mark Jackson, Beth Silfin, Chris Goff, Kyran Cassidy, Richard Aquan, Brad Foltz, Kim Lewis, Betty Lew, Christine Tanigawa, Jo Ann Metsch, and Camille McDuffie and Lynn Goldberg of Goldberg-McDuffie Communications.

It has been nearly twenty-four years and as many books, and Ellen Levine and I are going stronger than ever as agent and author—and, equally important, as friends. I am also indebted to her talented associates at the Trident Media Group, including Maria Auperin, Claire Roberts, and Melissa Flashman.

To begin at the beginning, I owe my parents, Edward and Jeanette Andersen, a debt that I can never repay. My beautiful, talented daughters, Kate and Kelly, give every indication that they are divas-in-training. Their mother, Valerie, may be responsible for this; she occasionally wears a silver pin that proclaims her to be "Queen of the Entire World."

Additional thanks to Lainie Kazan, Phyllis Diller, Arthur Laurents, Joan Rivers, Buck Henry, Karl Malden, Barry Dennen, Robert Schulenberg, Neil Wolfe, Johnny Mandel, Katharine Hep-

burn, Larry Kramer, Arnold Scaasi, Orson Bean, Ted Rozar, Allan Miller, Jerry Schatzberg, Mike Berniker, Ernest Lehman, Norman Schimmel, Abba Bogin, Estelle Parsons, Donald Softness, Matt Michaels, Garson Kanin, Anne Francis, Edward Isseks, Alley Mills, Ginger Rogers, Don Cash Jr., Don Palmer, the late William Paley, Lou Antonio, Alfred Eisenstaedt, Skitch Henderson, Angela Lansbury, Si Litvinoff, Elly Stone, Isabel Harkins, Paul Libin, Margaret Chaplin, Lonny Chapman, Tommy Cole, Chuck Liotta, Flo Kind, Milton Fuchin, Ruth Gordon, Parker Ladd, Bill Harrah, Tom Freeman, John Bryson, Richard Grant, Kitty Carlisle Hart, Sheree North, Larry Klayman, Scott Tilden, Tiffany Miller, Dudley Freeman, Cranston Jones, Shana Alexander, David McGough, Dolly Soto, Jordan McAuley, Jean Chapin, Octavio Zapata, Barry Schenck, Michelle Franklin, Lee Wohlfert, Dawna Shinkle, Max Tieman, Larry Schwartz, Jamie Abzug, Arturo Santos, the Gunn Memorial Library, Kim Briggs, the New York Public Library, the staff of the Center of Motion Picture Study at the Academy of Motion Picture Arts and Sciences, the University Research Library of the University of California at Los Angeles, the Lincoln Center Library for the Performing Arts, the Silas Bronson Library, the New Milford Library, the Southbury Public Library, Barbraarchives.com, the Litchfield Business Center, the Brookfield Library, the John F. Kennedy School of Government at Harvard University, Corbis, Reuters, the Associated Press, the *Boston Herald,* the *New York Times,* AP/Wide World, and Globe Photos.

SOURCES AND CHAPTER NOTES

The following chapter notes are designed to give a general overview of the sources drawn upon in preparing *Barbra*, but they are by no means all-inclusive. I have respected the wishes of those interview subjects who asked to remain anonymous and accordingly are not listed here or elsewhere in the text. These include colleagues from Streisand's years onstage and in the film, recording, and television industries, friends, neighbors, relatives, and employees. In the course of her remarkable forty-five-year career, Streisand has been extensively covered by the Associated Press, United Press International, Reuters, and other news agencies around the world. She has also generated thousands of articles in publications ranging from the *New York Times*, the *Los Angeles Times*, and *The Times* of London to *Vanity Fair, Time, Newsweek, Life, Look, The Saturday Evening Post, Paris-Match*, the *Wall Street Journal, Vogue, New York, The Advocate, Esquire, The New Yorker*, and the *Washington Post*. Only a small representative sample of this coverage is offered here.

CHAPTERS 1 AND 2

Based in part on interviews and conversations with Barry Dennen, Robert Schulenberg, Allan Miller, Si Litvinoff, Don Palmer, Joan Rivers, Wendi Rothman, Abba Bogin, Edward Isseks, Norman Schimmel, Chuck Liotta, Lou Antonio, Paul Libin, Lonny Chapman. Published sources included news stories on the marriage of Barbra Streisand and James Brolin in the *New York Times*, the *Los Angeles Times*, the *New York Post*, the New York *Daily News*, the *Washington Post, USA Today,* CNN, CBS, NBC, ABC, and other news organizations; James Spada, *Streisand: Her Life* (New York: Crown Publishers, 1995); Susan Schindehette, Todd Gold, and Jill Schary, "The Way They Were," *People*, July 20, 1998; Belinda Luscombe, "Well, Hello, Brolin," *Time*, July 13, 1998; Jeannie Williams, "Down the Aisle, Into the Sunset," *USA Today*, July 9, 1998; Pete Hamill, "Goodbye Brooklyn, Hello Fame," *The Saturday Evening Post*, July 27, 1963; Barbra Streisand, "I Was an Ugly Duckling," *Coronet*, March 1964; Randall Riese, *Her Name Is Barbra* (New York: Birch Lane Press, 1993); Holly Sorensen, "The Way They Are," *McCall's*, March 1998; "Success Is a Baked Potato," *Life*, September 20, 1963.

CHAPTERS 3 TO 5

Information for these chapters was drawn in part from conversations with Lainie Kazan, Phyllis Diller, Arthur Laurents, Katharine Hepburn, Buck Henry, Allan Miller, Ernest Lehman, Mike Wallace, Orson Bean, Ted Rozar, Neil Wolfe, Matt Michaels, Angela Lansbury, the late Garson Kanin, Robert Schulenberg, Ruth Gordon, Elly Stone, Benny Goodman, Richard Rodgers, Barry Dennen, Sheree North, William S. Paley, Anne Francis, Bill Harrah, and Donald Softness. Among the published material consulted: Jerome Weidman, "I Remember Barbra," *Holiday,* November 1963; Ray Kennedy, *Time* cover story, April 10, 1964; "Coming Star," *The New Yorker,*" May 19, 1962; Tom Prideaux, "Funny Girl with a Frantic History," *Life,* April 7, 1964; Chandler Brossard, "Barbra Streisand: New Singing Sensation," *Look,* November 19, 1963; Shana Alexander, "A Born Loser's Success and Precarious Love," *Life,* May 22, 1964; Liz Smith, "Barbra Streisand: The People-Need-People Girl," *Cosmopolitan,* May 1965; Shaun Considine, *Barbra Streisand: The Woman, the Myth, the Music* (New York: Delacorte Press, 1985); Diana Lurie, "They All Come Thinking I Can't Be That Great," *Life,* March 18, 1966; Rex Reed, "Color Barbra Very Bright," *New York Times,* March 27, 1966; Gloria Steinem, "Barbra Streisand Talks About Her 'Million Dollar Baby,' " *Ladies' Home Journal,* August 1966; Jerome Robbins, "Barbra in Some Notes," *McCall's,* October 1966; Ira Mothner, "Mama Barbra," *Look,* July 25, 1967; John Hallowell, "Funny Girl Goes West," *Life,* September 29, 1967; Martha Weinman Lear, "Her Name Is Barbra," *Redbook,* January 1968; Pete Hamill, "Barbra the Great: Talented Girl on a Triumphal March," *Cosmopolitan,* February 1, 1968; John Gregory Dunne, "Dolly's Dilemma," *Life,* February 14, 1969; Nora Ephron, "The Private World of Barbra Streisand," *Good Housekeeping,* April 1, 1969; Judy Klemesrud, "Now Who's the Greatest Star?," *New York Times,* October 5, 1969; Barbra Streisand, "Who Am I, Anyway?," *Life,* January 9, 1970; Joseph Morgenstern, "Superstar: The Streisand Story," *Newsweek,* January 5, 1970; Virginia Lee Warren, "Streisand House Getting Set," *New York Times,* April 19, 1970; Grover Lewis, "The Jeaning of Barbra Streisand," *Rolling Stone,* June 24, 1971; James Spada, *Barbra, the First Decade: The Films and Career of Barbra Streisand* (New York: Carol Publishing, 1974); Guy Flatley, "Bewitched, Barbra'd and Bewildered," *New York Times,* January 21, 1973; Earl Wilson, "Barbra's Back in Town," *New York Post,* March 12, 1975.

CHAPTERS 6 TO 11

For these chapters, the author drew on conversations with, among others, Arthur Laurents, Arnold Scaasi, Johnny Mandel, Larry Kramer, Jerry Schatzberg, Si Litvinoff, Don Cash Jr., Francesco Scavullo, Lainie Kazan, Mike Berniker, Shana Alexander, Barry Dennen, Wendi Rothman, Larry Klayman, Paul Libin. Published sources included Jean Cox, "Barbra & Jon: The Way They Are," *Women's Wear Daily,* March 4, 1974; Anna Quindlen, "Barbra Streisand, Superstar," *New York Post,* March 15, 1975; Frank Pierson, "My Battles with Barbra and Jon," *New West,* November 15, 1976; Shaun Considine, "Has Ex-Hair Stylist Jon Peters Put a Crimp in Streisand's Career? Barbra Says No Way," *People,* April 26, 1976; Frank Rich, "The End of a Love Affair," *New York Post,* January 15, 1977; Sally Ogle

Davis, "Streisand: Superhate," *Sunday Mirror* of London, January 23, 1977; Roderick Mann, "The Man Who Washed His Socks in Barbra's Bath," *Sunday Express,* March 6, 1977; Lawrence Grobel, "The *Playboy* Interview: Barbra Streisand," *Playboy,* October 1977; Richard Warren Lewis, "The *Playboy* Interview: Elliott Gould," *Playboy,* November 1977; Janet Maslin, "Street Smarts, Says Jon Peters, Are What Make a Producer," *New York Times,* January 29, 1978; Robert Gutwillig, "Barbra and Jon: The Main Event," *Look,* June 11, 1979; Chaim Potok, "The Barbra Streisand Nobody Knows," *Esquire,* October 1982; Jerry Parker, "For Streisand, a One-Man Show," *Newsday,* November 13, 1983; Cliff Jahr, "Barbra Streisand's Biggest Gamble," *Ladies' Home Journal,* December 1983; Brad Darrach, "Celebration of a Father," *People,* December 12, 1983; Stephen M. Silverman, "Flatbush Remembers When Her Name Was 'Barbara,'" *New York Post,* May 15, 1986; Kevin Sessums, "Queen of Tides," *Vanity Fair,* September 1991; Michael Danahy, "Busin' for Babs," *Los Angeles Times,* September 14, 1986; Julia Reed, "The Unguarded Barbra," *Vogue,* August 1993; Dale Pollock, "I Caught Myself Saying, Well, I'll Ask the Director . . . ," *Los Angeles Times,* October 16, 1983; Pilar Viladas, "*Architectural Digest* Visits Barbra Streisand," *Architectural Digest,* December 1993; Dana Kennedy, "Ticket Master," *Entertainment Weekly,* April 15, 1994; Michael Shnayerson, "A Star Is Reborn," *Vanity Fair,* November 1994; Margaret Carlson, "Of Barbs and Barbra," *Time,* February 13, 1995; Jack Newfield, "Diva Democracy," *George,* November 1996; Judy Wieder, "Barbra Streisand," *The Advocate,* August 17, 1999; Bill Hutchinson, "Barbra Streisand Wows Throng at New York Farewell Show," Knight Ridder/Tribune News Service, September 28, 2000; Todd Gold, "The Farewell Interview," *Us,* October 9, 2000; David Bahr, "This Boy's Life," *The Advocate,* January 16, 2001; David Matthews, "Family from Hell: Dustin Hoffman, Barbra Streisand and Ben Stiller Chat About *Meet the Fockers,*" the London *Mirror,* January 28, 2005; David Usborne, "A Star Is Reborn," *The Independent* of London, January 29, 2005.

BIBLIOGRAPHY

Beaton, Cecil. *Cecil Beaton's Diaries, 1963–1974*. London: Weidenfeld & Nicholson, 1978.

Blye, Nellie. *Barbra Streisand: The Untold Story*. New York: Pinnacle Books, 1994.

Brady, Frank. *Barbra: An Illustrated Biography*. New York: Grosset & Dunlap, 1979.

Conroy, Pat. *The Prince of Tides*. Boston: Houghton Mifflin, 1986.

Considine, Shaun. *Barbra Streisand: The Woman, the Myth, the Music*. New York: Delacorte Press, 1985.

Dennen, Barry. *My Life with Barbra*. Amherst, N.Y.: Prometheus Books, 1997.

Edwards, Anne. *Streisand: A Biography*. Boston: Little, Brown, 1997.

Griffin, Nancy, and Kim Masters. *Hit & Run: How John Peters and Peter Guber Took Sony for a Ride in Hollywood*. New York: Simon & Schuster, 1996.

Holt, Georgia, and Phyllis Quinn, with Sue Russell. *Star Mothers*. New York: Simon & Schuster, 1988.

Jordan, Rene. *The Greatest Star*. New York: G. P. Putnam's Sons, 1995.

Laurents, Arthur. *The Way We Were*. New York: Harper & Row, 1972.

Liberace. *Liberace: An Autobiography*. New York: G. P. Putnam's Sons, 1973.

McClintick, David. *Indecent Exposure*. New York: William Morrow, 1982.

Miller, Allan. *A Passion for Acting*. New York: Backstage Books, 1992.

Monti, Ralph. *I Remember Brooklyn*. New York: Birch Lane Press, 1991.

Reed, Rex. *Do You Sleep in the Nude?* New York: New American Library, 1968.

Riese, Randall. *Her Name Is Barbra*. New York: Birch Lane Press, 1993.

Rivera, Geraldo, with Daniel Paisner. *Exposing Myself*. New York: Bantam, 1991.

Rivers, Joan, with Richard Meryman. *Enter Talking*. New York: Delacorte Press, 1986.

Sharif, Omar, with Marie-Thérèse Guinchard. *The Eternal Male*. New York: Doubleday, 1977.

Spada, James. *The First Decade: The Films and Career of Barbra Streisand.* New York: Citadel Press, 1974.

———. *The Woman and the Legend.* New York: Doubleday, 1981.

———. *Streisand: Her Life.* New York: Crown, 1995.

Swenson, Karen. *Barbra: The Second Decade.* New York: Citadel Press, 1986.

Teti, Frank, and Karen Moline. *Streisand Through the Lens.* New York: Delilah, 1983.

Trudeau, Margaret. *Beyond Reason.* New York: Paddington Press Ltd., 1979.

Zec, Donald, and Anthony Fowles. *Barbra.* New York: St. Martin's Press, 1981.

INDEX